THE MARQUIS DE SADE AND THE AVANT-GARDE

THE
MARQUIS
DE SADE
AND THE
AVANT-GARDE

Alyce Mahon

**PRINCETON
UNIVERSITY PRESS**
Princeton and Oxford

Copyright © 2020 by Princeton University Press
Requests for permission to reproduce material from
this work should be sent to Permissions,
Princeton University Press
Published by Princeton University Press,
41 William Street, Princeton, New Jersey 08540
In the United Kingdom: Princeton University Press,
99 Banbury Road, Oxford OX2 6JX

press.princeton.edu

Cover illustration: Detail from Leonor Fini,
illustration for deluxe edition of Pauline Réage,
Histoire d'O, pen, ink, and wash (Paris: Éditions Cercle
du livre, 1962). Estate of Leonor Fini, Paris.

First paperback printing, 2025
Paper ISBN: 978-0-691-26462-2
Cloth ISBN: 978-0-691-14161-9

All Rights Reserved

The Library of Congress has cataloged the
cloth edition as follows:
Names: Mahon, Alyce, author.
Title: The Marquis de Sade and the avant-garde /
Alyce Mahon.
Description: 1st. | Princeton : Princeton University
Press, 2020. | Includes bibliographical references and
index.
Identifiers: LCCN 2019026576 | ISBN 9780691141619
(hardback)
Subjects: LCSH: Arts—Experimental methods. |
Sade, marquis de, 1740–1814—Influence.
Classification: LCC NX449.5 .M34 2020 | DDC
702.8—dc23
LC record available at https://lccn.loc.gov/2019026576

British Library Cataloging-in-Publication Data
is available

Publication of this book has been aided by a grant
from the Millard Meiss Publication Fund of CAA

Designed by Jo Ellen Ackerman / Bessas & Ackerman

This book has been composed in Monotype
Baskerville and Bauer Bodoni

Printed in Italy

This book is dedicated with love
to Mark, Anouk, and Adam

CONTENTS

ACKNOWLEDGMENTS

My first debt of gratitude goes to the artists and writers whose work has inspired and challenged me to write this book. I have had the great privilege of enjoying the company of some of them, notably Jean Benoît and Mimi Parent, Pierre and Denise Klossowski, Annie Le Brun and Radovan Ivsic, José Pierre, Jean-Jacques Pauvert, and Jean-Jacques Lebel. I am also indebted to others who have generously opened their doors and collections to me: Richard Overstreet for access to the Leonor Fini archive in Paris and for many animated conversations on my findings there; Aube Elléouët for graciously allowing me to cite and reproduce works from André Breton's archive; and Diego Masson for assisting me with my research on André Masson. Others kindly helped with queries and requests for illustrations: in Paris, Marcel Fleiss of the Galerie 1900–2000, Thomas Michel Gunther, Alain Kahn-Sriber, Adrien Ostier, and Gilles Berquet; in New York, Adam Boxer of the Ubu Gallery, Neil Zukerman of CFM Gallery, and Katherine Siboni of the Greene Naftali Gallery; and in Connecticut, Carol Greunke of the Max Waldman Archive; and, in Moscow, Svetlana Bedrak in The State Historical Museum. Many librarians and archivists were generous with their time during my research: thanks to the staff at the Bibliothèque nationale de France; the Archives nationales and the Bibliothèque Kandinsky in Paris; Institut Mémoires de l'Édition Contemporaine in Caen; the British Library, London; the Bodleian Library, Oxford; the Rare Books Department at Cambridge University Library; the Modern and Contemporary Performance Archive of the Victoria & Albert Museum, London.

My completion of this book also owes much to the generosity of the University of Cambridge and to the Master and Fellows of Trinity College Cambridge, who have supported my work with research grants and sabbatical leave for which I am most grateful. My thanks also go to my colleagues in the Department of History of Art, as well as to my many undergraduate and graduate students, who have helped me think through my ideas on the dialogue between representations of the body and the body politic in so many conversations, lectures, and seminars. A special thanks must also go to my fellow *avant-gardistes* in and outside of Cambridge who have supported my research or helped me develop my Sadean narrative in conversation, seminars, or conferences—notably Dawn Ades, Stephen Bann, Mary Ann Caws, Katharine Conley, Martin Crowley, Brad Epps, Axel Heil, Mary Jacobus, Jean Michel Massing, Carol Mavor, Mignon Nixon, Didier Ottinger, and Sarah Wilson.

Fellowships from the Arts and Humanities Research Council; The Paul Mellon Centre; Columbia University Institute for Scholars, Paris; and the Department of Art and Archaeology at Princeton University were crucial for my early-stage thinking on this project. I also thank Patrick O'Donovan, University College Cork; Dorthe Aagesen of the Statens Museum for Kunst, Copenhagen; and Kirty Topiwala and the Wellcome Collection, London for invitations to publish essays and give plenary talks on my ideas on Sade, sexology, and the avant-garde. In 2015, I cochaired with my dear friend Nebahat Avcioglu a lively College Art Association conference strand, "Unfolding the Enlightenment," with Thomas Beachdel, Maryam Ekhtiar, Rena Hoisington, and Stefaan Vervoort, which helped me reflect on my broader conceptual frame; and the invitation from Lissa Rivera to serve as the curatorial adviser for the first major exhibition of Leonor Fini in the United States, at the Museum of Sex, New York, in 2018, gave me the great pleasure of helping to bring Fini's all-too-neglected art, including her most Sadean works, into the public arena.

At Princeton University Press, I'm very grateful to Hanne Winarsky for her enthusiasm for the book at the start of my research; to my excellent editor Michelle Komie and the team at the Press, including Pamela Weidman, Sara Lerner, and Steven Sears for their expertise and support in bringing it to completion; and to Beth Gianfagna for her precision in copyediting. I thank the anonymous peer reviewers of my manuscript for their astute and generous reports. A Millard Meiss Publication Grant from the College Art Association, which has gone toward the costs of images in this volume, is also hugely appreciated.

Those who deserve the greatest thanks are, as always, my family. My heartfelt gratitude goes to the Shiel family, James Mahon and Nicole Walker, Amy Mahon and Dan Marsh. I am ever grateful to my parents, Joseph and Evelyn Mahon, who sowed the seeds of my obssesion with the Left Bank and all things feminist, and who are always ready with words and acts of encouragement. My husband, Mark Shiel, proved the truly "divine" one in this project with his support, intellectual challenge, and love. And I thank my daughter, Anouk, and son, Adam, who have grown up alongside "the book" and more than tolerated its many demands on my time; they brought immense joy and laughter and much-needed diversion over the course of my research and writing. Being the mother of two young children while writing about the Marquis de Sade and his legacy has pushed my aesthetic and ethical boundaries in ways that no art historical training could prepare me for, but it has also made the project and its defense of the imagination all the more urgent.

Introduction

Yes, I am a libertine, that I admit. I have conceived everything that can be conceived in that area, but I have certainly not practiced everything I have conceived and certainly never shall. I am a libertine, but I am neither a criminal nor a murderer.

MARQUIS DE SADE, letter to Madame de Sade, February 20, 1781

Since the Enlightenment, one of the most persistent countertendencies in Western art and writing has evolved around the ideas and narratives of Donatien Alphonse François de Sade, otherwise known as the Marquis de Sade (1740–1814).[1] In Sade's own lifetime his libertine novels were published anonymously but became best sellers: *Justine, ou Les malheurs de la vertu* (*Justine, or The Misfortunes of Virtue*; 2 vols., 1791, followed by five editions in ten years); the equally explicit but more pedagogical *La philosophie dans le boudoir* (*Philosophy in the Bedroom*; 2 vols., 1795), which contained the now infamous political tract "Français, encore un effort si vous voulez être républicains" ("Yet Another Effort, Frenchmen, if You Would Become Republicans"); and *La nouvelle Justine, ou Les malheurs de la vertu, suivie de L'histoire de Juliette, sa soeur* (*The New Justine, or the Misfortunes of Virtue, Followed by the Story of Juliette, Her Sister*, 10 vols., 1797).[2] *Les 120 journées de Sodome, ou L'école du libertinage* (*The 120 Days of Sodom, or The School of Libertinism*), which Sade wrote on long scrolls in his cell in the Bastille in 1785, was presumed lost until it resurfaced and was published in 1904. In his own lifetime Sade experienced repression, imprisonment, and censorship and narrowly missed the guillotine, but he was considered an icon of free and subversive expression by much of the twentieth-century avant-garde, and his distinctive concept of "philosophy in the bedroom" was seized as a radical engagement with sexual desire, society, and politics.[3] Many writers, artists, dramatists, and filmmakers embraced Sadean sexual terror and taboo as a means to make people see and think differently. They recognized that while it is not easy to read Sade's fiction, it is impossible to forget it once you have: his work brings sex and terror, aesthetics and ethics, crashing together, demanding an active engagement with what I call "the Sadean imagination."

The Sadean Imagination

By Sadean imagination I mean a Sadean world, created in the imagination, in which our understanding of humanity is expanded through an exploration of humankind's dark, sexually explicit, violent, and cruel nature.[4] Within this imaginary locus, power is played out by and on sexual bodies without any concession to law, religion, or public decency, in keeping with Sade's assertion that "[m]orals do not depend on us; they have to do with our construction, our organization."[5] In this way, it is not only the imagination and its every possible terrifying desire that are unbridled in the Sadean universe but the very notion of taboo itself and its civilizing mission. My focus in this book is on the avant-garde's turn to the Sadean imagination for the creation of individual or collective situations and experiences that propose, hypothesize, or imply the possibility of a better reality. The writers, artists, dramatists, and filmmakers I concentrate on adhere to a particular sense of art as praxis, a progressive weaponizing of the imagination and

creativity. Some approach Sade's writings by indirect inspiration—Man Ray (1890–1976), André Masson (1896–1987), Hans Bellmer (1902–75), and Pier Paolo Pasolini (1922–75). Some created pastiches of the Sadean novel—Guillaume Apollinaire (1880–1918), Robert Desnos (1900–1945), Dominique Aury (born Anne Desclos, 1907–98). Others execute biographical depictions of a fictionalized Sade—Peter Weiss (1916–82) and Peter Brook (b. 1925), or celebrate the collective and transgressive potential of the Sadean imagination—Guy Debord (1931–94) and Jean-Jacques Lebel (b. 1936). They all insist that "one must allow one's imagination free play," to borrow the words of Sade's heroine Juliette.[6]

Whether one is disgusted or excited by Sade's fictional plots, with their obsessive cruelty and abject detail, whether one sides with his virtuous Justine or the amoral Juliette, Sade's storytelling draws the reader into an active world of eighteenth-century libertinage where liberty itself is the real protagonist.[7] In the twentieth century, notably with the birth of the new avant-garde movement of surrealism and contemporary movements such as existentialism, situationism, and happenings, a complex dialogue developed between Sade and visual artists and writers who were inspired by his persona and writings. Further, their efforts ensured that Sade and his writings had to be taken seriously by intellectuals and philosophers. Sade's fiction seemed to offer a pitiless mirror of humanity but also a series of metaphors of subversive value, allowing for the exploration of political, sexual, and psychological terror. It pushed the boundaries of the body and body politic, offering a literature of "absolute solitude" and "absolute domination," as Maurice Blanchot claimed in 1949.[8] According to Peter Bürger in his influential study *The Theory of the Avant-Garde* (1974), the avant-garde's intent was to make art the organizing center of life, to abolish the idea of autonomous art, and integrate art into "the praxis of life."[9] When the avant-garde's sociopolitical ambitions are conjoined with the Sadean imagination, we find an uncensored aesthetics of terror wherein the forces of the unconscious are unleashed and libidinal drives are configured as sources of emancipatory revolution.

This book traces an arc from the French Revolution to the early twenty-first century. In the earlier period, my analysis revolves around the "Terror," a particularly repressive phase of the French Revolution, when the Committee of Public Safety enacted a draconian regime of political repression against its domestic enemies in 1793–94, which resulted in tens of thousands of violent deaths.[10] In this era, the *Dictionnaire de l'Académie française* of 1798 defined terror as "[e]motion caused in the soul by the image of a great evil or a great danger; dread, great fear"—a definition that resonated with new force following the Terror, which came to serve the French Revolution and its association with revolutionary tribunals and the guillotine, and which persists to this day.[11] Indeed, it was after the fall of

Maximilian de Robespierre (1758–94) on July 27, 1794, and his execution on July 28, 1794, that the alignment of terror with revolution that had marked his reign quickly changed to the alignment of terror with tyranny, complete with the coining of a new term "terrorist" to denote "an agent or partisan of the regime of the Terror, which took place as a result of the abuse of revolutionary measures."[12]

In the twentieth century, the idea of terror as a physical response to a text or image was seized on by writers and artists to craft a form of resistance, aligning their terrifying art with revolutionary goals and discourse. Their strategy emerged at a time when the use of the term "terror" expanded greatly to describe oppressive regimes from European imperialism to Nazism, Stalinism, and beyond. They chose to depict or imply a threat of violent death to the body in order to take a stand against despotic regimes of terror while not simply equating one with the other. Unlike horror, terror does not involve paralysis; rather, it elicits a response, as its etymology suggests (from the Latin *terreo* and *tremo*, "to tremble").[13] We might recall Sade's contemporary Edmund Burke, who interpreted terror as the ruling principle of the sublime (though he did not equate them): it typically overwhelms, but when experienced from a distance can cause delight: "When danger or pain press too near, they are incapable of giving any delight, and are simply terrible; but at certain distances, and with certain modifications, they may be, and they are delightful."[14] Sade and his modern-day followers exploited this tension between danger and delight as they aimed for immersive explorations of terror, whether through excessive syntax, orgiastic descriptions or improvisations, a scream, or a blank cinema screen.

Virtue, Vice, and Gender Politics

Sade's idea of "philosophy in the bedroom" has been hugely influential even if it has rarely won widespread support.[15] It has created especially heated debate among feminist cultural critics. For example, in an interview in 1998, Nancy Miller insisted libertinage was an intrinsically male will to master that could not be framed within a liberationist politics.[16] Yet in the same decade, Camille Paglia argued that "[n]o education in the western tradition is complete without Sade. He must be confronted, in all his ugliness."[17] For Paglia, Sade does enable liberationist, feminist politics, especially through the figure of the "Great Mother," a supreme fictional character she describes as a "pagan cannibal, her dragon jaws dripping sperm and spittle."[18] It is Sade's particular focus on feminine virtues and on the female protagonist in his libertine novels that is the focus of my feminist analysis of his "philosophy in the bedroom" and his cultural legacy. *Vertu* (virtue) took on near mythical powers during the French Revolution, when it fused politics and ethics and became the terrifying

embodiment of republicanism itself. Robespierre would famously align terror and virtue in his speech of February 5, 1794, to the French National Convention, stating, "If the mainspring of popular government in peacetime is virtue, amid revolution it is at the same time [both] virtue and terror: virtue, without which terror is fatal; terror, without which virtue is impotent."[19] Soon after, Louis de Saint-Just (1767–94) asserted, "Monarchy is not a king, it is a crime; the republic is not a senate, it is a virtue."[20] Etymologically "virtue" is gendered: its Latin root is *vir*, meaning "man," aligning it with rational (masculine) control and indicating that the moral good of the individual benefited the moral good of the public.[21] Fusing a critical consideration of the politics of virtue with feminist theory allows Sade's sexual and textual terrorism to be appreciated in new ways. The role of the female in Sade's libertine philosophy and novels links all the chapters in this book as well as my selection of artistic case studies—from my reading in chapter 1 of the popular caricatures of Marie Antoinette (1755–93) as a bad mother and insatiable harlot in pornographic prints and pamphlets in Sade's day, to the tortured young girl, Renata, in Pier Paolo Pasolini's feature film *Salò, o Le 120 giornate di Sodoma* (*Salò, or the 120 Days of Sodom*) of 1975, discussed in the conclusion.

My stance is indebted to both French and Anglo-American feminist debate on Sade. Especially pertinent to my analysis is Luce Irigaray's observation of 1976 that Sade's fiction brought women's pleasure into play, the libertine text enticing women to enjoy each other sexually and forcing the reader to reflect on "the function of women's sexual pleasure" in the process. However, I do not see his libertine women as "phallocrats," trained in a quintessentially masculinist, phallocentric sexual economy, as she does.[22] Rather, I agree with Jane Gallop that Sade's writings may be read as examples of thinking and writing "through the body," with readers finding "the image of their own unspeakable, aggressive desire" in his monstrous characters.[23] But I also want to think about how Sade's female roles go beyond the traditional feminine body—of mother and whore, young virgin and old crone—and focus on the female as libertine philosopher. This new imago may be of any age and brings the body and mind seamlessly together in libertine acts and speech. For example, in Sade's fictional sisters Justine and Juliette we find two radically different female characters, one the embodiment of innocence, the other of libertinage, despite sharing the same sex, family, and education. Nature and nurture are thus put to the test in their shared story, which Sade rewrote three times, elaborating his pedagogy with more lavish, detailed forms of "education" for each. Justine reveals nature at her cruelest, despite her virtuous ways, and ultimately dies at her hand (a bolt of lightning), while Juliette is the executioner of nature's cruelty, as exemplified by her torture of her father, as we shall see in chapter 1. Traditional roles and supposedly natural female instincts are challenged

or done away with in their tale, and a brave new world of cruelty and terror that knows no gender boundaries is promoted in its place.

Gender is often queered and the phallus mocked in the Sadean school of thought. Consider, for example, the twenty-year-old nun Madame de Volmar in *Juliette*, whose three-inch clitoris enables her "to play the role of a man and a pederast," as Iwan Bloch, the sexologist and first biographer of Sade, puts it in his analysis of tribadism in Sade's novels in 1901.[24] Or the banker Durcet, who owns the château in *The 120 Days of Sodom* and has feminine breasts, hips, and buttocks, a small penis, and a penchant for coprophilia—details in which Pasolini revels in his later film homage to Sade, *Salò*. The opening up of sexuality beyond heteronormative boundaries was central to the turn to Sade of the 1960s counterculture, as witnessed in Jean-Jacques Lebel's happening *120 minutes dediées au divin Marquis (120 minutes dedicated to the divine* Marquis, 1966), in which a key role was played by the transsexual Cynthia, as we shall see in chapter 4.

The various artists I examine in this book search for innovation in expression and for radical change in the sociopolitical realm as they turn to Sade, some playfully, some more seriously, all sharing an open or "sliding" (*glissement*) notion of Sadean transgression.[25] While I have no desire to glorify or absolve Sade's writings of their terror, or to celebrate transgression for its own sake, the open applicability of the transgressive Sadean imagination across moments in the history of the avant-garde is central to an operation which demands that the boundaries of both society and nature, the self and sexuality, are continually challenged. Sade's belief that the creative act must go beyond the real still resonates for art and society today. He writes in "Notes on the Novel" (1800): "Let [the novelist] give way to the mastery of his imagination; let him embellish what he has seen . . . let your inventions be well presented; you will not be pardoned [for] putting your imagination in the place of truth, except where this is done in order to ornament and dazzle."[26]

The Marquis de Sade: Man and Myth

Beginning in the early twentieth century, the Marquis de Sade became an almost mythical embodiment of the total freedom of the imagination. However, his name was invoked considerably earlier to define "sadism" in the *Dictionnaire universel de la langue française* (Universal dictionary of the French language, 1834), which described it as a "terrifying aberration of debauchery, a monstrous and antisocial system that revolts nature."[27] In that same year, Jules Janin published an essay on Sade in which he deemed his writings to be "foul" (*ordurier*).[28] His synopsis of Sade's imaginary world remains an apt one—"bloody corpses, children torn from the arms of their mothers, girls having their throats cut at the end of an orgy, cups full of blood and wine, extraordinary tortures . . . in every page in every line."[29]

Also memorable is his synopsis of the challenge such a world imposed on the reader: "How his hands tremble . . . he finds himself beset by these wretched phantoms."[30] Sade's works were known to only a small group of writers in the nineteenth century—notably, Stendhal (1783–1842), Gustave Flaubert (1821–80), Charles Baudelaire (1821–67), Guy de Maupassant (1850–93), Arthur Rimbaud (1854–91), and Algernon Swinburne (1837–1909), who described Sade as a fatalist who "saw to the bottom of men and gods."[31] *Les crimes de l'amour* (*The Crimes of Love*), published under Sade's own name in 1800, was widely available in France, and English translations of three stories ("Florville and Courval, or Fatality," "Dorgeville," and "Faxelange") appeared in *The London Pioneer: Utility, Instruction, Amusement and Information, for All Ages, Sexes, and Classes*, on February 17, 1848.[32] His name was better known in medical circles, however, as evidenced in Richard von Krafft-Ebing's *Psychopathia Sexualis, with Especial Reference to the Antipathic Sexual Instinct: A Medico-Forensic Study* (1886), in which von Krafft-Ebbing effectively criminalized Sade by stating he was a "monster" for whom sexual satisfaction only occurred "when he could prick the object of his desire until the blood came."[33] In "Three Essays on the Theory of Sexuality" (1905), Sigmund Freud explained sadism as an "instinct for mastery" linked with the second pregenital, anal phase of the infant's sexual organization, when the child realizes he/she holds power over the parent (the external object) through the production or withholding of feces.[34] This phase is not to be read as gender specific (masculine or feminine) and is pre-Oedipal, but if the infant does not progress beyond it, he/she may turn to sadism or masochism in later sexual life. Further, Freud noted that sadism and masochism are interchangeable, writing, "A person who feels pleasure in producing pain in someone else in a sexual relationship is also capable of enjoying as pleasure any pain which he may himself derive from sexual relations. A sadist is always at the same time a masochist, although the active or the passive aspect of the perversion may be the more strongly developed in him and represent his predominant sexual activity."[35]

It was not until the poet Guillaume Apollinaire published *L'oeuvre du Marquis de Sade* (The works of the Marquis de Sade) in 1909, with the aim of rescuing Sade's writings from the forbidden collection or "hell" [*Enfer*] of libraries, that Sade's work became not just more widely circulated but specifically promoted by vanguard writers and artists and aligned with freedom.[36] The scroll of Sade's *The 120 Days of Sodom* took on cult status, not least as material proof of the compulsive power of the imagination, even when an individual is deprived of freedom. Sade wrote the book in an erotic reverie over thirty-seven days in October and November 1785, when he was in prison in the Bastille on criminal charges of poisoning and sodomy. He was unable to smuggle the manuscript out of his cell when he was transferred in the middle of the night, "naked as a maggot," to the Charenton asylum on

July 3, 1789.[37] It was thought to have been taken by Madame de Sade when she cleared Sade's Bastille cell of its belongings—his papers, his library of six hundred books, furniture, and personal effects—on July 9, 1789, or destroyed in the storming of the Bastille on July 14. It was actually secreted away from his cell by one Arnoux de Saint-Maxim and later purchased by a Provençal aristocrat whose family kept it until the turn of the twentieth century. It was then discovered and published in Berlin in 1904 in a limited subscription edition of two hundred copies by Iwan Bloch, who introduced the work as an exploration of "the sexual life of man" in his preface.[38] In 1929, the scroll was bought by the French nobleman and patron of the avant-garde Charles de Noailles and his wife, Marie-Laure de Noailles, a descendant of Sade; they shared it with many members of the surrealist circle in Paris.[39] A distinctive aura grew around the document not only for its notoriously shocking content but for its association with the French Revolution and the destruction of the Bastille, a symbol of despotism to this day.[40] Indeed, the scroll's history has continued to resonate: it was given an estimated valuation of six million euros when put on display at the Hôtel Drouot auction house in Paris in December 2017, only to be declared a national treasure by the French government and withdrawn from the sale.

Because Sade, as figurehead of the repressed author and thinker, increasingly became a subject of great interest and inspiration, so his portrait came to fascinate avant-garde artists. In a lecture delivered in London in 1936, the surrealist poet Paul Éluard (1890–1976) glorified the libertine while reminding his audience that "[t]here is no portrait of the Marquis de Sade in existence. It is significant that there is none of Lautré-amont either. The faces of these two fantastic and revolutionary writers, the most desperately audacious that ever were, are lost in the night of the ages."[41] However, two nineteenth-century "fantasy" portraits were known to the surrealist circle, and a pencil portrait would be discovered in the aftermath of World War II. The fantasy portraits were effectively carica-tures of the libertine that served the dominant image of him as a monstrous mind and threat to the status quo. In the first, Sade appears as a Romantic rogue with dark curls and a dandy bow tie in the frontispiece to Janin's *Le Marquis de Sade* (1834) (fig. 1), in which Janin explained that "in all the libraries [Sade] sits on a certain mysterious and hidden row that one always finds; it is one of those books that are normally placed behind St. John Chrysostom, or Nicole's *Traité de morale* [*Treatise on Ethics*], or Pascal's *Pensées* [*Thoughts*]."[42] The second was an engraving made in the Restoration period and published in Henri d'Alméras's *Le Marquis de Sade: L'homme et l'écrivain* (The Marquis de Sade: The man and the writer, 1906) (fig. 2) and Apol-linaire's *L'oeuvre du Marquis de Sade*. There, Sade is a more devilish figure, surrounded by two satyrs, a crest consisting of a whip and a jester's hat, and a vignette showing him writing in his prison cell.[43]

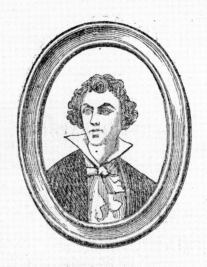

1. *Le Marquis de Sade (Collection M. de la Porte)*, **frontispiece to Jules Janin,** *Le Marquis de Sade* **(Paris: Chez les marchands de nouveautés, 1834).**

In contrast to these fictional images, *Portrait de jeune marquis de Sade (Portrait of the Young Marquis de Sade)* (fig. 3) is said to have been drawn by Charles Amédée Philippe Van Loo around 1760–62, when Sade was fighting in the Seven Years' War (1756–63) as a captain of the Burgundy Cavalry. A pencil portrait, it was most likely a preparatory work for an oil painting destroyed during the revolution.[44] Around 1950, a member of the Sade family showed it to the writer Georges Bataille (1897–1962), who negotiated its purchase by his good friend, the writer, art critic, and collector Robert Lebel (1901–86).[45] In Van Loo's portrait, Sade appears with an almost girlish

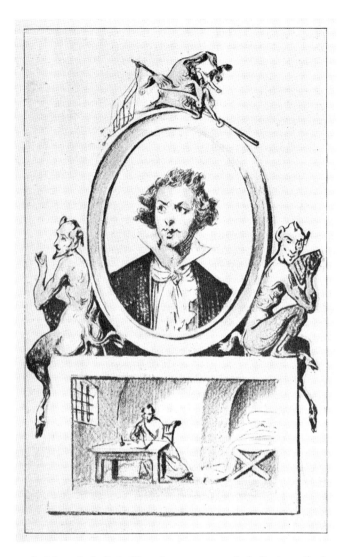

2. *Le Marquis de Sade (d'après une gravure de la Restauration)*
(*The Marquis de Sade [After an Engraving from the
Restoration]*), **frontispiece to Henri d'Almeras, *Le Marquis de
Sade: L'homme et l'écrivain* (Paris: Albin Michel, 1906).**

profile in keeping with contemporary accounts of his "delicate, pale face"
and "feminine charm" at that young stage of his life, as recounted by
Bloch.[46] It is a romantic image, completed for a larger work just prior to his
marriage in May 1763 to the wealthy Renée-Pélagie de Montreuil (1741–
1810).[47] A modest and traditional work in composition and style, it still
reveals much about self-fashioning in the mid-eighteenth century. As
Michael Fried asserts in *Absorption and Theatricality: Painting and Beholder in the
Age of Diderot* (1980), "[P]ortraiture could never be de-theatricalized: it was
always predicated, even in the private realm of domesticity, on the presence

of a spectator."[48] Commissioning Van Loo presumably played to Sade's aristocratic circle, insofar as Van Loo was an artist of notable pedigree and popular with courtly circles. He was born in Rivoli, near Turin, to a famous family of Flemish painters who subsequently moved to France. His father, Jean Baptiste Van Loo (1684–1745), was also a respected portrait painter, and his uncle, Carle Van Loo (1705–65), was appointed the *peintre du roi* to Louis XV (1710–74) in 1762. The younger Van Loo became portraitist to the Prussian King Friedrich II and his court in Berlin in 1748 but in 1759 moved to Paris, where he was given a teaching post at the École des Beaux-Arts and a studio at the Louvre, and painted *Portrait allégorique du roi Louis XV réprésenté par les vertus* (*Allegorical Portrait of King Louis XV Represented by the Virtues*, 1762). Later he also painted a series of four tapestry cartoons, *Le costume turc* (*The Turkish Costume*, 1772–75), woven at the Gobelins factory and supposedly commissioned by Louis XV's official mistress, Madame du Barry (1743–93). In the tapestries, Van Loo advanced the vogue for intimate domestic scenes into a series of grand tableaux, presenting an emphatically female, private realm so exotic that one critic claimed the series was capable of "rekindling the desires of the most withered old man."[49] With these credentials, Sade's choice of portraitist would surely have endeared him to courtly society and to his soon-to-be in-laws. This would have been important not least because Sade spent much of his life balancing his noble bloodline and debauched tastes; later in life he would have to elicit the help of his wife's family when running from the law and denying authorship of his infamous novels.

Donatien Alphonse François de Sade was the only surviving child of Jean Baptiste François Joseph, Comte de Sade (1700–1767), who was the French ambassador to Russia (1730) and London (1733), and Marie Eléonore de Maillé de Carman (1712–77), niece of Cardinal Richelieu and lady-in-waiting to the Princess of Condé. But Sade spent most of his formative years away from his home, as his mother left for a nunnery when he was four. From then until he was nine, Sade was educated and raised by his paternal uncle, the Abbé Jacques-François de Sade (1705–78), a friend of the writer Voltaire (1694–1778) and a *grand viveur* who was once arrested in the room of a prostitute, La Léonore, in a Paris bordello in 1762.[50] The Abbé raised the young Sade in his château, the Château de Saumane, a walled fortress surrounded by mountains, about fifteen miles from Sade's family château in Lacoste, in the department of Vaucluse in Provence. In a letter of 1765 to his aunt, the Abbesse of Saint-Benoît de Cavaillon, Sade described his uncle's château as a place of vice: "Priest though he be, he always keeps a few whores at his place. . . . What is his château but a seraglio? No, even better, it is a b[ordello]."[51]

In 1750, when he was ten years old, Sade moved to Paris in the company of his tutor, Jacques-François Amblet, and he enrolled

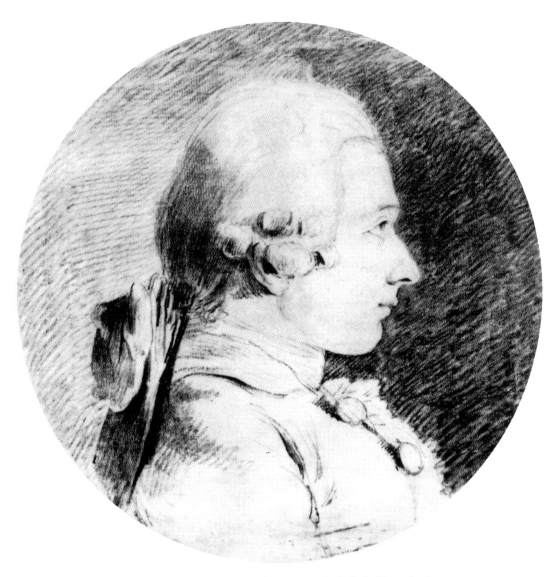

3. Charles Amédée Philippe Van Loo, *Portrait de jeune marquis de Sade* (*Portrait of the Young Marquis de Sade*), **black chalk on paper, ca. 1760–62.**

in the prestigious Lycée Louis-le-Grand, run by the Jesuits on the rue Saint-Jacques, whose ranks of notable alumni included Voltaire, Denis Diderot (1713–84), and Robespierre. Four years later, Sade's father enrolled him in the King's Light Cavalry Regiment, which attracted young men from noble families, and there Sade was schooled in horsemanship, sword fighting, parades, and military tournaments. By 1760–62, when Van Loo drew his portrait, Sade was experienced in battle and still in the elite cavalry regiment, but in many ways he still hovered between childhood and manhood. He was still dependent on his father for financial support, but he was a soldier who enjoyed many sexual affairs, from prostitutes in Paris to a

summer romance with an older woman in the northern French town of Hesdin, where he was garrisoned in the summer of 1762. His portrait, therefore, marks a turning point, as Sade was married off to de Montreuil at the time of his demobilization in 1763. Sade's father had begun looking for a bride for his son in 1759, hoping to find one who could assist with the Sade family's flagging finances and debts, and their marriage contract was approved and signed by Louis XV, the queen, and others in the royal family at Versailles.[52] In sum, Sade's portrait, though not quite a marriage proposal, attempted to fashion a reliable nobleman out of a young man whose sexual tastes and philosophical ideas would quite soon get him into trouble.

In his 1999 biography of Sade, Neil Shaeffer explains that corporal punishment, including flagellation, was frequent at the Lycée Louis-Le-Grand and was based on the Jesuit pursuit of moral absolutism.[53] Shaeffer deduces that this must have had an impact on the young Sade, although, if it did, we cannot see it in the fine pencil lines of his portrait. Rather, all that we see for certain is a handsome young nobleman, soldier, and soon to be husband, with a slightly bemused expression. Only a few months after the portrait was completed, Sade was arrested for harassing a prostitute, and in the following few years he was regularly watched by the police because of his association with other women of ill repute and perverse sexual tastes. About a year after the death of his father, he was accused of imprisoning and torturing a thirty-six-year-old beggar woman, Rose Keller, in a house in Arceuil on Easter Sunday, April 3, 1768. He had stripped and whipped her and then poured molten wax into her flesh wounds. He was arrested and jailed in the royal prison at Saumur before being transferred to the royal prison at Pierre-Encize, near Lyon, but he denied all charges, claiming she was a prostitute and had accepted money for sexual acts (she had stated to Sade that she was prepared to work for a salary of three livres a day when she agreed to accompany him to his house). He was ultimately released, with a settlement of 2,400 livres, which was paid to her.[54]

A few years later, on September 12, 1771, Sade was "executed" in effigy in the Place des Prêcheurs, in Aix, for worse crimes—sodomy (acts of sodomy were punishable by death) and the poisoning of prostitutes in Marseille with the aphrodisiac known as Spanish fly. In 1777, he was arrested again, further to an allegation that he imprisoned and sexually mistreated five girls and a boy at Lacoste. A *lettre de cachet* (a letter signed by the king to authorize imprisonment), obtained by his wealthy mother-in-law, Madame de Montreuil, helped save him from the death sentence. He remained imprisoned without a trial but safe from "the escapades in which he has so often compromised himself," as she wrote in a letter to his lawyer in 1778.[55] Throughout this period, as he ran from the law, Sade wrote and directed plays, even building a theater to seat over one hundred people at his château in Lacoste, where he happily staged plays that addressed the decline of the

nobility, the family, and morality: these included Philippe Néricault Destouches's *Le glorieux* (*The Conceited Count*, 1732), Diderot's *Le père de famille* (*The Family Picture*, 1758), and Bernard-Joseph Saurin's *Les moeurs du temps* (The morals of the time, 1761).[56] Sade had never championed the life of the royal court, but in his theatrical choices he seemed to rail against his in-laws as *robins* (nobility of the robe who emerged out of the bourgeoisie) and found refuge and release in the world of the imagination.

Sade would spend nearly all of thirteen years in prison from 1777 to 1789, first at Vincennes and then in the Bastille, before being moved, just ten days before the Bastille was stormed, to the Charenton asylum on the southeastern outskirts of Paris. During the Revolution, he lost his title and refashioned himself as a militant in the Section des Piques, joining the largely working-class and petit bourgeois sans-culottes, along with many other "*déclassé* intellectuals and journalists," as Colin Jones has put it.[57] That said, in May 1790, he wrote a letter to his lawyer Reinaud, in which he advised, "[D]o not mistake me for an *enragé*. I tell you I am simply an impartial, annoyed to have lost so much, still more annoyed to see my sovereign in irons."[58] His fiction was published anonymously but attacked all walks of life—clergy, bankers, aristocrats, noble and working-class families, chaste daughters, and pedophile fathers—and he found his place in what was a thriving market for licentious literature, or *la fautromanie* (fuckomania), at a time when he had no family income or lands and his ancestral home was in ruins, having been pillaged during the Revolution. Sade was also adamant that his writings were above common erotica: in 1791, he wrote that his work should not be likened to "miserable brochures, conceived in cafés or bordellos" because "[l]ust, daughter of opulence and superiority, cannot be treated except by people of a certain stamp . . . except by individuals, finally, who, blessed by nature to begin with, are also sufficiently blessed by fortune to have tried themselves what they trace for us with lustful brushes."[59] He was never more proud a *philosophe* than when his work was attacked by critics for its power to subvert. One critic in the *Feuille de correspondence du libraire* in 1791 described Sade's *Justine* as "very dangerous . . . it is for this reason that the title [*Justine*] might lead inexperienced young people astray so that they might consume the poison that the work contains."[60] Another, in *Petites-affiches* in 1792, complained of a "bizarre novel, whose title might attract and deceive sensitive and honest souls. . . . If the imagination that produced such a monstrous work is indeed deranged, it must be conceded that it is rich and brilliant of its kind."[61]

In 1801, Sade was arrested in Paris along with his publisher Nicolas Massé on suspicion that he was reprinting *Justine*, and copies of his books were seized.[62] He denied authorship of them and demanded a trial but instead was imprisoned until appeals by his sons to the prefect of police led to his return to the asylum at Charenton in 1803. There he enjoyed

comparative luxury in terms of his boarding (paid for by his family), the freedom to write and direct plays, and the company of his lover, the actress Marie Constance Quesnet (who moved into a room beside Sade's in 1804 and was referred to as his "niece"). Further, his journal dated 1814 reveals he was paying a seventeen-year-old girl, Madeleine Leclerc, a salary for her sexual favors too, as he refers to her "96th visit" to his room on November 27.[63] He also continued to write, completing the manuscripts of three historical novels in 1812–13: *La Marquise de Gange*; *Adelaïde de Brunswick, Princesse de Saxe, événement du XIe siècle* (*Adelaïde of Brunswick, Princess of Saxony, an Occurrence of the Eleventh Century*); and *Histoire secrète d'Isabelle de Bavière, reine de France* (*The Secret Life of Isabelle of Bavière, Queen of France*). While these books pale in comparison to his libertine novels, their focus on women is telling, and in his description of Charles VI's wife, Isabelle, as "extreme in her pleasures . . . as quick to suspect as to punish, to produce evil deeds as to contemplate them in cold blood" we find his fetish for the libertine female emerging between the lines of the real life character and his condemnation of the monarchy.[64] Sade's memoirs and other accounts reveal the dismal treatment of the inmates at Charenton, which included restraining them for harsh forms of hydrotherapy.[65] Sade remained there until his death from a pulmonary condition at the age of seventy-four on December 2, 1814. He was given a Christian burial in the Charenton cemetery, although he had asked in his will to be buried in a ditch on his property at Malmaison. Later, legends abounded about the exhumation of his skull. When analyzed by Doctor L.-J. Ramon in an autopsy at Charenton, the skull was judged to reveal no obvious flaws of character but to be "in all respects similar to that of a Father of the Church."[66] This intimated that Sade's passions and vices were not those of an insane or especially depraved mind, eventually giving weight to the avant-garde belief that he was an accursed artist, martyred by society under the three regimes of Louis XVI (1774–92), the Revolution (1789–99), and Napoleon Bonaparte (1799–1804, as consul; 1804–14, as emperor).

Sade, the *Philosophe*

Sade the man, the writer, and the figurehead of pure freedom were compounded one upon the other in the evolution of his revolutionary image long after his death. By the end of the twentieth century, he came to be identified with the fundamental (but diverse) issues of love, terror, and freedom of speech, and as a barometer of attitudes toward art and politics in a world that had witnessed two world wars, fascism, the Holocaust, and countless other horrors. As Éric Marty has also observed, where World War I led many poets and artists to canonize Sade as a hero of revolution, after World War II, philosophers also turned to Sade,

judging his world against that of fascism, and later a new Sadean discourse emerged in the sixties, led by writers such as Philippe Sollers.[67] The crucial unifying factor across these generations was the Sadean imagination, which offered a lens through which artists, writers, philosophers, and intellectuals in general could address specific events of popular revolt, religious intolerance, police violence, torture, and capital punishment. For example, the words of philosopher Simone de Beauvoir in "Oeil pour oeil" ("An Eye for an Eye," 1946), remind us that issues of virtue and vice, good and evil were raging as cruelly in the aftermath of World War II as they had in Sade's bloody lifetime:

> Since June 1940 we have learned rage and hate. We have wished humiliation and death on our enemies. And today each time a tribunal condemns a war criminal, an informer, a collaborator, we feel responsible for the verdict. . . . We were pleased at the death of Mussolini, at the hanging of the Nazi executioners at Kharkov, with the tears of [Joseph] Darnand. In so doing we have participated in their condemnation. Their crimes have struck at our own hearts. It is our values, our reasons to live that are affirmed by their punishment.[68]

As I explain in chapter 3, Beauvoir also wrote an important appreciation of Sade and defended what she saw as his moralism and suffering in an earlier time of violence and recrimination in French and world history. This is just one example of the many ways in which Sade's name became transhistorical and transnational, as the politics of the Sadean imagination were played out in multiple contexts by numerous thinkers and artists who reflected on and critiqued such problems as the trauma of trench warfare in World War I; Nazism in Germany; colonial violence in Algeria; censorship in Britain, France, and the United States; and the Vietnam War. In such cases, debates about abuses and atrocities and responses to them in public policy and the law became inseparable from debates about Sade.

In rejecting the ideologies of the Catholic Church and the Enlightenment, Sade forced readers to question official morality, especially the fact that the church framed sexual acts in terms of procreation alone—to indulge in homosexuality, sodomy, incest, masturbation was to sin against nature and God.[69] While a rejection of the teachings of the church was promoted during the Enlightenment, the practice of such sexual "perversions" was known as "le crime des philosophes" (the crime of the philosophers), with homosexuality attracting the death penalty.[70] This sense of a Sadean philosophical "critique" of a godless world drew numerous modern-day philosophers to his writings. For example, in his influential essay "Kant with Sade" (1963), Jacques Lacan brings Sade together with his contemporary, Immanuel Kant, noting that Sade's novel *Philosophy in the Bedroom* (1795) came after Kant's *Critique of Practical Reason* (1788). Lacan argues that Sade

"gives the truth of the Critique," questioning any sense of satisfaction or progress that might come of the moral good that Kant emphasizes.[71] Viewing the two men as opposite sides of a theory of desire—Kant speaking to the repression of desire in the name of morality, where Sade speaks to the desire for, and delight in, evil—Lacan reads Sade's proposal of a "rule for jouissance" as a subversive take on Kant's understanding of universal rule.[72] In the *Critique of Practical Reason*, Kant wrote, "Suppose that someone says his lust is irresistible when the desired object and opportunity are present. Ask him whether he would not control his passions if, in front of the house where he has this opportunity, a gallows were erected on which he would be hanged immediately after gratifying his lust. We do not have to guess very long what his answer may be."[73] In his fiction, Sade not only defied this logic but exposed a duplicity in it that would replace the sadism of the law with the much more powerful sadism of self-interest. While Lacan concedes an element of black humor in his proposal, he also asks that we take Sade's writings seriously, that we ponder how a right to "jouissance," permitted to all who invoke it, might challenge our sense of society, the moral law, and what he calls "the freedom of the Other."[74] Lacan suggests that desire within the Sadean fantasy might be understood as the "will-to-jouissance," given that it challenges and splits the subject.[75]

Lacan's historical framing of Sade's philosophical worldview and his recognition of Sade as a productive voice for *jouissance*—whether in his orgies' human pyramids, tales of the rape and murder of young virgins, or baroque play with Enlightenment logic—informs the larger argument I make in this book for an appreciation of the Sadean imagination as an ultimately meaningful and positive site of resistance and *jouissance* for the avant-garde. In orgy after orgy in Sade's work, we are presented with human nature hurtling toward pleasure, rejecting the law, the church, and the family, without any fear or concern of the consequences. The lack of specificity about *jouissance* as a term, and the fact that its frequent English translation as "sexual pleasure" falls short of its sense of loss of the self, complements the open aesthetic of the Sadean imagination too. In *The Pleasure of the Text* (1973), Roland Barthes translates *jouissance* as "bliss" to attempt to denote the sense of the violent pleasure that shatters the self.[76] In feminist writings that rework Lacanian and Barthesean ideas, notably French feminist theory or *l'écriture féminine*, a practice of what Elaine Showalter has called writing "in the feminine" is aligned with the avant-garde (male and female) and related "to the rhythms of the female body and to sexual pleasure."[77] Showalter emphasizes the sense of *jouir*, or orgasmic "coming," that underpins the term. She also reads the element of fear with the loss of the self as offering a nonphallocentric avenue for the exploration of "coming."[78] Thus the term and concept open up new feminist potential for a radical rethinking of sexual pleasure and fear within the Sadean

imagination.[79] Sade's libertines certainly take *jouissance* to its extreme and embody the idea that the subject can situate him- or herself as sadist or masochist and revel in pleasure and pain as they undermine traditional gender roles and give the imagination free rein. Take, for example, Juliette howling with pleasure as she witnesses the libertine Clairwil brutally thrusting the still-beating heart of a tortured male child into her vagina: "There is nothing like the effect of example upon an imagination such as mine: it suggests, it encourages, it electrifies: I soon have my victim laid wide open and promptly insert its living heart between my labia."[80] This is an explosive scene in a chain of *jouissance* all centered on the female orgasm, an arena in which gender identity and sexual norms are broken down and in which no subject position is stable. To borrow Jean Laplanche and Jean-Bertrand Pontalis's conceptualization of the space of fantasy, we might say that Sade locates the reader at the very syntax of the sexual imagination, thrusting him/her into "the *mise-en-scène* of desire—a *mise-en-scène* in which what is *prohibited* (*l'interdit*) is always present in the actual formation of the wish."[81]

This immersive strategy also reminds us that Sade's libertine literature "overturns the classical relationship between the reader and the book; Sade has left breaches allowing the reader's body to invade the textual fortress," as Philippe Roger argues in *Sade: La philosophie dans le pressoir* (Sade: Philosophy in the press, 1976).[82] Sade's first-person narratives frequently act as "emotives"—that is, as speech acts that navigate both individual and collective emotions and the disjuncture between them.[83] In focusing on terror and the reader as textual invader within this world of *jouissance*, Sade's oeuvre not only tests society's moral boundaries but also the boundaries of aesthetics and representation, again helping us appreciate why the avant-garde turned to him to explore the politics of representation. Where the libertine in Sade's writings rejects political, religious, social, and moral norms, he or she also, paradoxically, insists on the pervasiveness of institutional power. The Sadean body—from the masterful libertine to the enslaved, terrorized, victim—thus offers a form with which to explore not just sexual and political terror, but dominant and countercultural ideology. Where the ideal beauty of the classical body traditionally elevates culture and the spirit in Western art and literature (even when erotic, it is controlled), the base, unruly, Sadean body represents its opposite—the obscene. I have argued along these lines in my previous books—*Eroticism and Art* (2005) and *Surrealism and the Politics of Eros, 1938–1968* (2005), but here I develop the argument with a specific focus on the Sadean body and its influence on the international avant-garde.

In early modern France, the term "obscene" was employed in law only in relation to visual culture, especially in the eighteenth century, when printing gave rise to a burgeoning market in forbidden books, many of

them graphically illustrated. The late eighteenth century was a golden age of the sexual underworld, in which Sade's work gradually became available in Paris, London, and other European cities, which were then enjoying an active metropolitan print culture of obscenity. Joan DeJean notes in *The Reinvention of Obscenity: Sex, Lies, and Tabloids in Early Modern France* (2002) that by 1734 there were arrests for the production of *gravures obscènes*, and that term was introduced to French law on July 19, 1791, in order to ban the sale of "obscene images," though prosecution was far from systematic.[84] Equally significant is DeJean's explanation of how modern, secular notions of obscenity centered on the flagrant display of "female body parts," typically with a heterosexual audience in mind.[85] The focus of the twentieth century avant-garde on the female body spoke to this established sense of the obscene, as avant-garde writers, painters, photographers, performance artists, and dramatists employed the obscene female body as a means of defying dominant culture. Moreover, the dominant culture they sought to subvert included the enclosed erotic encounter typical of high art tradition, and the values and morals of classical beauty and propriety it cherished. In the image of the obscene body, spectatorship is politicized, desire is interrogated, and the dynamic of the dominator and dominated is willingly explored. Hence, we find avant-garde artists and writers reveling in the libidinal, terrorized, and fragmented body while creating *embodied* readers, whose awareness of their own bodies and values was heightened and enriched the more they entered into the affective space of avant-garde praxis.

The Pornographic Imagination

In my understanding of the Sadean imagination I seek to build upon the stance set out by Susan Sontag in her 1967 essay "The Pornographic Imagination": it is an imagination that allows the artist or writer to become "a freelance explorer of spiritual dangers," someone who advances "one step further in the dialectic of outrage."[86] Sontag takes her cue from Georges Bataille's *Histoire de l'oeil* (*Story of the Eye*, 1928) and Dominique Aury's *Histoire d'O* (*Story of O*, 1954, published under the pseudonym Pauline Réage), but she also considers Sade's *The 120 Days of Sodom*. She focuses on the ways in which literary pornography philosophizes desire, standing against mass culture and its numbing of the consumer. The pornographic draws our attention to oversaturation and the danger of passivity before an image of suffering. The element of outrage identified by Sontag is crucial, as it refutes one of the accusations brought against many images of sexual violence and terror today—that their production not only encourages voyeurism but numbs the reader/viewer. Sade's libertine writings and the Sadean imagination that followed him went far beyond a sexual,

masturbatory stimulus, as pornography is traditionally understood. While relentless in abject detail, they could never be said to anesthetize the reader. Sade's novels are excessive in their accounts and details, but they do not "freeze discussion" nor lead to the "exhaustion of empathy" in the way that both pornography and mass media images of terror might today.[87] This perspective, from which one perceives pornography and, specifically, the genre of Sadean pornography, as a "vanguard form of artistry," as Susan Gubar has put it—is not intended to sanitize Sade or distract from the sexual brutality of his work, but again to contextualize the turn of modern artists and writers to his oeuvre to explore and deplore dehumanization and terror.[88] In employing the word "Sadean" rather than "pornographic," I take inspiration from Sontag's socially and historically sensitive analysis, in which she argues that "some pornographic books are interesting and important works of art."[89] As she rightly observed, Sade offered artists and intellectuals after 1945 "an inexhaustible point of departure for radical thinking about the human condition."[90] I call this "radical thinking" the Sadean imagination, although in my view it was also widespread prior to World War II. I view it as a powerful means for artists and writers to interrogate systems of patriarchal, governmental, institutional, and imperial power through sexual relations in modern culture.[91] I also base my use of the term on similar terminology developed by the avant-garde itself—for example, the figure of Juliette as "the pinnacle of the divinized Marquis's imagination," as André Masson wrote in "Notes on the Sadistic Imagination" (1947), which I discuss in chapter 2.[92]

Robert Darnton has explained that "pure pornography" did not exist until well into the nineteenth century and that philosophy in the eighteenth century included "both theoretical treatises and general works, which criticized all sorts of abuses without being predominantly religious or political or pornographic in nature . . . scatter[ing] its shot across a wide spectrum of subjects."[93] By the time Walter Kendrick published his 1987 study *The Secret Museum: Pornography in Modern Culture*, he could easily assert that "[f]rom the start, 'pornography' names a battlefield, a place where no assertion could be made without at once summoning up its denial. . . . '[P]ornography' names an argument, not a thing."[94] The evolution of the term is crucial to our appreciation of Sade's characters, plots, and legacy. The word "pornography" appears in the reform text by French printer and libertine author Nicolas-Edme Rétif de la Bretonne (1734–1806), titled *Le pornographe* (The pornographer), in 1769. A sentimental treatise in the form of an epistolary essay, he used the word very much to denote the social issue of prostitution or " A Gentleman's Ideas for a Project for the Regulation of Prostitutes, Suited to the Prevention of the Misfortunes Caused by the Public Circulation of Women," as the subtitle made clear.[95] It thus continued the Greek understanding of the term as "the writing about prostitutes,"

from the ancient Greek *pornē* (a lower-class whore) and *graphos* (writing, etching, or drawing).[96] Rétif de la Bretonne proposed a way of orchestrating the sexual workforce and ensuring it did not contaminate society, the institution of the family, or women's subservience to male authority. He acknowledged that prostitution is a necessary evil in society but effectively molded it into a regime that limited its infectious (physical and moral) potential. His promotion of state-run brothels, presented in a fictional case study around the libertine D'Alzan, and his *pornognomie*, or set of rules by which a brothel should be run, sheds light on the era's stance on sexuality and its control: in this "antidote" to Sade's *Justine*, the desirable but syphilitic character Conillette is sliced with a scalpel and eaten by a priest named Foutamort, her sexual objecthood made viscerally literal as cannibalism removes the problem of sexual immorality and disease in one fell blow.[97] The act allows the libertine to return to the "good" female character, whose virtue is preserved, Conquette-Ingénue.

During Sade's lifetime, the trade in pornography both cultivated a subversive (predominantly male) school of readers and challenged the ideals of domesticity that were developing and would soon become entrenched in society.[98] Etienne-Gabriel Peignot's *Dictionnaire critique, littéraire et bibliographique des principaux livres condamnés au feu, supprimés ou censurés* (Critical, literary and bibliographical dictionary of the main books condemned to be burned, suppressed or censured; Paris, 1806) was one of the first dictionaries to use the term "pornographic" (*pornographique*) to justify the censorship of certain immoral texts.[99] But it was not until the middle of the nineteenth century that "pornography" emerged as a term to define the explicit representation of sexual organs and practices and as a regulatory category, as reflected in the *Oxford English Dictionary*'s 1857 definition of the word: "a description of prostitutes or of prostitution, as a matter of public hygiene."[100] Alongside this production and policing of pornography lay a growing distinction between the definitions of the erotic and pornographic—the former aligned with desire and love and the latter, by the 1830s, with "obscene things."[101] The discovery of "pornographic" Pompeiian frescoes helped clarify the definition further and the *Littré Dictionary* of 1866, as with the *Oxford English Dictionary*, would extend the term to define pornography "in connection with public hygiene," suggesting that the modern definition of pornography was predicated on a view that the explicit sexual body was something dangerous to the public and needed to be controlled. Enlightened man recognized that society's sexual codes indicated society's strength both metaphorically (the biological vigor of a nation) and literally (the man force). As Michel Foucault recounts in *The History of Sexuality* (1976), "sex was a means of access both to the life of the body and the life of the species."[102]

Revolution was not an abstract concept either—it had to rage within every man's body to succeed. As an anonymous article in the radical

newspaper *Les Révolutions de Paris* declared in 1802, "liberty, reason, truth . . . are not gods . . . they are *part of ourselves*."[103] The heightened spirit and brutal desires of the crowd turned the peaceful individual into a violent savage, a phenomenon that artists and writers continued to reflect on in the decades and centuries after the French Revolution. In *Psychologie des foules* (*The Crowd: A Study of the Popular Mind*, 1895), Gustave le Bon (1841–1931) wrote, "Taken separately, the men of the Convention were enlightened citizens of peaceful habits. United in a crowd, they did not hesitate to give their adhesion to the most savage proposals, to guillotine individuals most clearly innocent, and, contrary to their interests, to renounce their inviolability and to decimate themselves."[104] The dynamics and desires of the individual and the crowd were emphatically gendered, too—a fact that made the conflation of sexuality and power in Sade's fiction all the more meaningful for the avant-garde writer and artist.

Sade and Feminism: "The first fairy tale narrated by the fairy herself"

Beatrice Didier has argued that while "feminists do not like Sade," he does present female characters who command bodies and language alike, from Durand with her phallic clitoris in *Juliette* to the four storytellers in *The 120 Days of Sodom*.[105] Sade places female emancipation and equality firmly between pleasure and money and creates a utopian system of sexual equality with his account of the libertine group "Les Amis du Crime" (Society of the friends of crime). In the tale of *Juliette*, she happily asserts, "I like to use [the lash] and have it used upon me," when initiated into the Society, a sodality with a specific set of rules for women in which she is advised to never confuse sex and love.[106] Annie Le Brun's view of Juliette as a Sadean heroine—"[s]he is aided only by her imagination, which returns continually to her body, then transports her continually beyond it"— reminds us of the dynamic of excess that underpins her tale and the potential for her appropriation by the avant-garde.[107] Her description of Juliette's story as "the first fairy tale narrated by the fairy herself" also demands that Sade remain within the realm of literature and not be weighed down by debate about feminism or fascism.[108] In *Soudain un bloc d'abîme, Sade* (*Sade: A Sudden Abyss*, 1986), which originated as Le Brun's introduction to Jean-Jacques Pauvert's 1986 edition of the *Oeuvres complètes de Marquis de Sade*, Le Brun defies any critic or artist to read Sade in the light of totalitarian ideology or theology and also defies feminist calls for his censorship.[109] Instead, she claims, "Sade hurls us into the abyss we naïvely thought existed between the real and the imaginary, but which turns out to be the unbearable infinity of freedom."[110] Le Brun's stance underpinned her exhibition *Sade: Attaquer le soleil* (Musée d'Orsay, Paris, 2014) in which she

presented Sade as a "prism" from which to appreciate a huge range of artworks that engage with sexual desire and violence, from Eugène Delacroix to Francis Bacon. What Georges Bataille called Sade's "use value" for ideological and political debate and action must not be lost within any broad, passionate defense, however.[111] This book is concerned with offering close readings of selected case studies to offer very precise explorations of the Sadean imagination at work in specific historical moments. The Sadean imagination goes beyond a convulsive spirit of freedom—its radical sociopolitical, humanist, and feminist use for the modern day artist must be fully documented and recognized too.[112]

Le Brun's stance differs radically from many of her generation. The pro-ordinance, anti-pornography school led by Andrea Dworkin and Catherine MacKinnon has argued with considerable effectiveness that pornography violates women's rights and enacts their social subordination through sex and so must be stopped. For that school of thought, artists and intellectuals who laud Sade are only perpetuating the degradation of woman in society and creating "high-class pornography" as Dworkin calls it in *Pornography: Men Possessing Women* (1979).[113] This stands in marked contrast to the liberal feminist school of thought which argues that pornography is a genre and mode of representation that not only reveals systems of production and consumption of sexual desire but opens up the politics of seeing and culture, no matter how perverse the terrain. The latter school of thought would also argue that the censorship of pornography infringes on the right to freedom of speech, and that much anti-pornography feminism continues to view male sexuality as phallic, violent, and carnal and female sexuality as passive, inherently lesbian, or even asexual. As Linda Williams writes in *Hard Core: Power, Pleasure, and the "Frenzy of the Visible"* (1989), "[Dworkin's] argument suggests, erroneously I believe, that if female sexuality were ever to get free of its patriarchal contaminations it would express no violence, would have no relations of power, and would produce no transgressive sexual fantasies."[114] In my reading of Sade and the legacy of the Sadean imagination, I aim to explore the critical issue of how females might experience and invite danger and the death drive, both internally in terms of the psyche and externally in terms of society's expectations. Also pertinent to my analysis is Jacqueline's Rose's challenge in "Where Does the Misery Come From?" (1989), in which she invites reflection on Freud's phallocentric concept of the death drive. She contemplates "how we [feminists] can begin to think the question of violence and fantasy as something that implicates us as women, how indeed we can begin to dare to think it at all."[115] A leading argument in this book is that the Sadean imagination opens up violence for the male *and* female artist, author and reader, and questions any straightforward sense of causality. Such questioning is the first step toward

the Sadean imagination's liberating potential, followed by the refusal to restrict sadism and masochism, violence and suffering, to strict sexual and gender or libidinal and destructive divides. It refutes simple dichotomies and acts as a critical process and mode of expression with which to better understand subjectivity, sexuality, and the imagination and the role they play in our experience of society and politics. To my mind, this remains a crucial task and mode of intervention for our times.

Beyond the Pleasure Principle

In "Beyond the Pleasure Principle" (1920), Freud wrote that the boundaries between the libidinal and destructive, or life and death, drives are permeable. Eros constantly battles with Thanatos: "We have always acknowledged a sadistic component in the sexual drive; as we know, this component can develop a life of its own and turn into a perversion that dominates a person's entire sexual life"; furthermore, the death drive is "ousted from the ego at the insistence of the narcissistic libido."[116] In *Civilization and Its Discontents* (1930), Freud continued to view this battle of drives as underpinning civilization's attempts to police itself, as humans' "aggressive drives" are constantly countered by state- and law-enforced aggression.[117] He insists such aggressive impulses begin "in the nursery," where affection and destruction emerge in the child's dynamic with the mother and father and where sexuality and aggression are restricted and repressed for the good of civilization.[118] The "psychological misery of the mass" ensures that modern civilization functions.[119] In contrast, "the sadistic drive . . . so utterly devoid of love" has no collective or libidinal purpose; it simply replaces tenderness with cruelty, happiness with suffering and allows the ego to triumph over the mass general good.[120] Further, Eros speaks to the gathering together of people, "libidinally bound to one another," where its counterpart, Thanatos, speaks to "man's natural aggressive drive, the hostility of each against all and all against each."[121] It is the struggle between these drives that defines civilization and human existence, and crucially that struggle begins in childhood, when caregivers try to inculcate a sense of greater good through lullabies and example.

Sade's novels frequently begin with the child and the education of the child, especially the young female. Freud's theories on the child's sexuality are thus pertinent, as is his reading of the libido as constantly battling between procreative and destructive forces. Freud employed an emphatically gendered view of sadism and masochism, claiming the male is naturally sadistic and the female masochistic (not least in heterosexual copulation). While he had no copies of Sade's work in his private collection, Freud's view of the connection between sadism and masochism, aggression and the libido offers a useful framework through which to understand the

avant-garde subversion of gender binaries.[122] Freud also reminds us that while art offers "illusions that contrast with reality," it still can be "effective psychically, thanks to the role that the imagination has assumed in mental life."[123] Art can intoxicate or terrify us; aesthetic experiences inform our lives, senses, and judgments; and when we discuss aesthetic pleasure (notably beauty), we effectively return to "the sphere of sexual feeling."[124]

The Marquis de Sade and the Avant-Garde: An Overview

This book explores Sade's oeuvre and legacy not only historically, through its chapters and case studies arranged chronologically, but with a specific emphasis on how the avant-garde returned to an eighteenth-century use of sex and terror to criticize religious and political authorities and to force debate on freedom of expression. I do not attempt an exhaustive analysis of everything pertaining to Sade in art, literature, and philosophy in the twentieth century, and I concentrate primarily on the case of France (with significant reference to Germany, Britain, and the United States). In interweaving images and texts from the 1900s to the 1970s, my terrain might be said to be that of the now "canonical" avant-garde, but there was nothing canonical at all about the ideas and art in question in their day. Their recourse to the Sadean imagination was neither romantic nor timeless—rather it was always situated in and engaged with specific political issues and events in specific moments in time as it explored sexual terror. It is my contention that Sade's oeuvre, and the legacy of the Sadean imagination, must be appreciated as "open"—eliciting rather than prescribing experience. I elaborate on this contention, for example, in chapter 4, where I read 1960s happenings and avant-garde theater inspired by Sade in light of Umberto Eco's idea of the "open work."[125] There is no "one" Sadean imagination that appears decade after decade, like the return of the repressed; rather it takes on new forms and battles depending on sociohistorical circumstance. That said, "the" Sadean imagination as presented here in a series of specific works remains yoked to the figure of Sade and his counter-Enlightenment stance. From Apollinaire's claim in 1909 that Sade was "[t]he freest spirit who ever lived" to Pasolini's translation of the Sadean universe into Italian fascism in his film *Salò* (1975), the excesses of his narratives and their style allowed for a radical reflection on both revolution and terror, metaphysical and real.

While my chosen case studies show a shared passion for Sade's work, the various artists, writers, dramatists, photographers, and filmmakers involved interpret that work and build on it in very different ways, as we shall see. Their common ground remains the explicit sexual body, in keeping with Sade's "philosophy in the bedroom" in which the libertine and

the victim, rhetoric and storytelling, constantly force the reader into a theater of the flesh. By extension, it will become apparent that all of the case studies share another Sadean trait: they all enact a *dialogue* with the reader, demanding an active response to the Sadean universe through recourse to abject sex and terror. The aptitude of Sade's writings for multiple but always *unprescribed* readings makes them a very rich a source for ideological and aesthetic debate, allowing a wide variety of interpretations of his oeuvre—from antihumanist and anticolonialist to Christian, totalitarian, and libertarian.

In the first chapter, I outline the key works by Sade that my study draws on to map out the traits and legacy of the Sadean imagination. I closely analyze the first illustrations produced for certain volumes, notably for *La nouvelle Justine, ou Les malheurs de la vertu, suivi de L'histoire de Juliette, sa soeur* (1797). I contextualize Sade's libertinism in light of popular philosophical treatises such as Jean-Jacques Rousseau's *Émile, ou De l'éducation* (*Émile, or Treatise on Education*, 1762), and I examine the sexualized representation of the French Revolution in the form of both virtuous and debauched women: the young Marianne, the figurehead of the French Republic from 1792, who was depicted in popular iconography with flowing hair, bare breasts, and working-class garb; popular pornographic imagery of Marie Antoinette, Louis XVI's queen, as a flat-chested and cruel libertine; the pious mother Madame de Mistival in Sade's *Philosophy in the Bedroom* and her fifteen-year-old daughter Eugénie, educated in torture by monstrous libertines; and Charlotte Corday (1768–93), the enigmatic assassin of the politician and radical journalist Jean-Paul Marat (1743–93), whose image was widely circulated in paintings, prints, and publications where she was associated with the supposedly fairer sex.

The second chapter of the book brings the Marquis de Sade into the twentieth century, to the year 1904, when his scroll *The 120 Days of Sodom* was rediscovered. For the writers Apollinaire, Robert Desnos, and André Breton (1896–1966), Sade was a revolutionary hero of love and a liberator of desire, in keeping with the emancipatory etymology of the word "libertine." I detail the vital role played by Sade's biographers Maurice Heine (1884–1940) and Gilbert Lely (born Pierre-Raphaël-Gilbert Lévy, 1904–85) in bringing Sade's life and oeuvre to new avant-garde audiences, the Sadean imagery of American surrealist Man Ray (1890–1976), and the surrealists' philosophical worldview that "[w]e really live by our fantasies when we give free rein to them."[126] The second half of the chapter focuses on the French painter André Masson, for whom Sade offered a means to extend the "problem of desire" to its imaginary extreme, but also to confront burgeoning fascism in the 1930s.[127]

The third chapter continues to document the pioneering role of those who battled to bring Sade's writings to public attention. I analyze the 1956

trial of Jean-Jacques Pauvert (1926–2014) for publishing Sade's works, which mobilized some of the most influential intellectuals of the day in his defense. These included André Breton, Georges Bataille, Jean Cocteau, and Jean Paulhan. I examine the Sadean novel *Story of O* (1954), also published by Pauvert, which was assumed by most readers and critics to be the work of a man because of its scandalous eroticism but was actually written by a woman, Dominique Aury, who came to Sade with a humanist view that "prison itself can open the gates to freedom."[128] This was at a time when the French were evaluating their recent experience of fascism while creating increased opportunities for women's rights and feminism. I also compare Aury's stance to that of Simone de Beauvoir, who argued that Sade was a moralist in her essay "Faut-il brûler Sade?" ("Must We Burn Sade?," 1951), and I analyze the illustrations of luxury editions of *Story of O* by the surrealist artists Hans Bellmer (1902–75) and Leonor Fini (1907–96).

The fourth and last chapter focuses on the 1960s, considering the performative turn then made by the Sadean imagination, as art, theater, and film looked to Sade against the backdrop of—and as mean of response to—wars, civil rights struggles, sexual revolution, and youth counterculture. Four Sadean works are discussed in detail: Guy Debord's short film *Hurlements en faveur de Sade* (Howls for Sade, 1952), Jean Benoît's performance *Exécution du testament du Marquis de Sade* (Execution of the testament of the Marquis de Sade, 1959), Jean-Jacques Lebel's happening *120 minutes dediées au divin Marquis* (120 minutes dedicated to the divine Marquis, 1966), and Peter Weiss's play *The Persecution and Assassination of Jean-Paul Marat as Performed by the Inmates of the Asylum of Charenton under the Direction of the Marquis de Sade* (1964), directed by Peter Brook for the stage and for film in 1965–67. These works are compared in light of the idea of the "open work," which was then widely influential, and a generational turn to the performative "theater of cruelty" of Antonin Artaud (1896–1948) in the pursuit of the Sadean imagination. These artists pushed their respective media to extremes through an emphasis on the material body, the libertine drive, and their sociopolitical relevance to dissent from what Debord called "the society of the spectacle," as well as the brutality of the Algerian War (1954–62) and the Vietnam War (1954–75).

I end the book by reflecting on the Sadean imagination after the progressive mass protests of 1968 when Sade's name was scrawled in graffiti on the walls of the Sorbonne in Paris: on the one hand, Sade was invoked as a means to reflect on real atrocities through imagined terror, as in Pier Paolo Pasolini's film *Salò* (1975), an allegory of the last days of Mussolini's fascist regime; on the other hand, Sade was profoundly influential in cultural theory, where Foucault, for example, saw him as a "rallying point for the counterattack against the deployment of sexuality . . . by the grips of power," while Michel Camus appreciated his exploration of the "abyss" of

language.[129] I bring this reflection on Sade's legacy up to recent times by discussing the "sadism" of US military police in the Abu Ghraib prison in Iraq, depicted in infamous trophy photographs during the so-called War on Terror that followed the terrorist attacks of September 11, 2001. But the systematic and state-sponsored use of torture in a facility that housed over seven thousand Iraqi prisoners was far from the life and fiction of Sade, who viewed state violence as the worst kind of terrorism. Although this book is more concerned with the twentieth than the twenty-first century, the terrifying and terrorizing imagined universe of Sade remains a crucial cultural and political barometer.

CHAPTER ONE

The Marquis de Sade and the Fairer Sex

O charming sex, you will be free: as do men, you will enjoy all the pleasures of which Nature makes a duty, from not one will you be withheld. Must the diviner half of humankind be laden with irons by the other? Ah, break those irons; Nature wills it. For a bridle, have nothing but your inclinations, for laws only your desires, for morality Nature's alone.

MARQUIS DE SADE, *Philosophy in the Bedroom*, 1795

In this chapter, I focus on the Marquis de Sade and his libertine philosophy in the last decades of the eighteenth century. I begin with his novels and their contribution to our appreciation of the "fairer sex" in Enlightenment life and culture, and I end with an example of that same fairer sex turned monstrous in the guise of Charlotte Corday, the young woman who assassinated Jean-Paul Marat in his home in Paris on July 13, 1793. Between Sade's fictional female libertines and his speech as "Citizen Sade" at Marat's funeral in 1793, my interest lies in Sade's emphatically gendered discourse in obscene and political text alike. As Lynn Hunt has put it, the political culture of the French Revolution was "made up of symbolic practices, such as language, imagery and gestures."[1] The exemplar of the fairer sex in the eighteenth century was not only light-skinned, beautiful, and virtuous, but her inner and outer body, self and society, were deemed synonymous. The Sadean heroine, by contrast, occupied the intimate and dangerous space of the boudoir, and Sade's fiction interwove high and low culture, virtue and vice, and the beautiful and monstrous at once. This was perfectly in keeping with the ambitions of his "philosophy in the bedroom," a set of ideas that he elaborated in his 1795 novel of the same name as a philosophical engagement with the erotic and the political. This was in contrast to the much more formal, classical, and decorous approach to staging and narration that was prevalent in art, literature, and theater from the 1750s. Sade rejected that approach in his oeuvre and its obscene tableaux: he immersed and affected his beholder. In contrast to the absorbing naturalistic aesthetic promoted by his peers, including what Roland Barthes called Diderot's "frigid" texts, in Sade we find texts of *jouissance*, or "bliss," that discomfort the reader.[2] My interpretation of Sade's writings as texts of *jouissance* affords a more open, intertextual, appreciation of his novels' gender and social politics.

Many scholars have discussed Sade's representation of woman, and by extension the institution of the family and the home with which she was identified, but it is his monstrous female characters and their role in subverting the space of intimacy and domesticity that concerns me. His female protagonists are torn from the traditional family and undergo pornographic pilgrimages in a succession of closed, private spaces—the house, convent, brothel, or monastery. His libertine novels document a world of sexual terror during a time of political terror, but Sade tempered his texts, and their sexual codes, for his audiences. The libertine novels were all published anonymously—even the much less graphic *Aline et Valcour* (*Aline and Valcour*, 1793) was published with the subtitle "Écrit à la Bastille un an avant La Révolution de France" ("written in the Bastille a year before the French Revolution") and "Par le Citoyen S***" ("By Citizen S***"), while *The 120 Days of Sodom* remained unpublished in his lifetime.[3] Those works Sade published after 1790, when he was a free man trying to make a living as well as a name for himself as an author, indicate a concern to produce the

perfect libertine novel, not least as his prison-time novel *Justine* underwent several rewrites. It was first written as a story *Les infortunes de la vertu* (*The Misfortunes of Virtue*) in fifteen days in 1787 while Sade was imprisoned in the Bastille.[4] He expanded it into a novel in 1791 after his release from the asylum at Charenton to become *Justine, ou Les malheurs de la vertu* (*Justine, or the Misfortunes of Virtue*), and he then developed it into a much more graphic tale that proved a best seller—five further editions were printed by the turn of the nineteenth century. A contemporary critic praised its "rich and brilliant" imagination, warned young people to avoid "this dangerous book," yet advocated that "more mature" men read it "in order to see to what insanities human imagination can lead" but to then "throw it in the fire."[5]

It seems the novel did not earn Sade much money, so he expanded it yet again to the ten-volume 1797 edition titled *La nouvelle Justine, ou Les malheurs de la vertu, suivi de L'histoire de Juliette, sa soeur* (*The New Justine, or the Misfortunes of Virtue, Followed by the Story of Juliette, Her Sister*). Now including the tale of Juliette, that edition also contained one hundred "carefully wrought engravings" that added visual titillation to his imaginings. A commentary in the August 23, 1800, edition of the *Courrier des spectacles* noted the luxury of a publication in which a third of the pages had been given over to illustrations.[6] When Sade was arrested with his publisher Nicolas Massé the following year, he was charged with penning "dangerous" and "detestable" books.[7] He was taken to his residence at Saint-Ouen, where his house and papers were searched, and a few pamphlets, three paintings, and a tapestry from his bedroom were confiscated, apparently because they represented "the principal obscenities of the novel *Justine*."[8] Although Sade claimed under interrogation to be only the copyist of the manuscripts, his defense fell on deaf ears. Some one thousand copies of the clandestine book were confiscated, and he was denied a trial and soon jailed again—in the prison of Sainte-Pélagie (1801–3), then in the Bicêtre hospital for six weeks, and then in the Charenton asylum, where he spent eleven years until his death in 1814, his family paying his expenses of three thousand francs every year.[9]

In those works that he did write and publish under his name—such as *The Misfortunes of Virtue*, described by John Phillips as a "snappy novella [that] could safely be recommended nowadays to most maiden aunts," or the later *Crimes of Love* (1800)—Sade still advocated a libertine philosophy, but in less visceral terms.[10] *The Misfortunes of Virtue* opens with, "The ultimate triumph of philosophy would be to cast light upon the mysterious ways in which Providence moves to achieve the designs it has for man."[11] And the preface to *The Crimes of Love*, titled "Idée sur le roman" (Notes on the Novel), advises fellow novelists, "Avoid the affectation which comes with pointing out morals; this is not what one looks for in a novel."[12] His female characters enable his philosophy in promoting a godless universe, ruled by nature and the sensate body, and unfettered by virtue. They are not merely

the vessels for his philosophy, they enact it and threaten to contaminate the rest of the world with their libertinism, either by enacting a libertine life and philosophy or in demonstrating how futile it is to deny it. Sade aims to unveil what he sees as the cruelty of nature and be true to it. He claims in "Notes on the Novel" that his art would reveal man's true, inner self: "The paintbrush of the novel . . . gets at the inner man, catches him when the mask is down, and gives a more interesting and simultaneously a truer sketch of him."[13]

Given that our understanding of modernity derives so greatly from the principle of freedom defined by the French Revolution, Sade's characterization of liberty and self-knowledge in radically sexual terms is crucial to our appreciation of his gender politics and his legacy. The theatrical plots and philosophical dialogues, as well as the detailed, explicit illustrations produced for particular editions of Sade's libertine novels, should be considered within the frame of eighteenth-century cultural debates on woman's role in society and alongside the high art arena in which the neoclassical images of heroism by Jacques-Louis David (1748–1825) reigned supreme. As Juliette states at the very end of her epic tale, "Why dread publishing it . . . when the truth itself, and the truth alone, lays bare the secrets of Nature, however mankind may tremble before those revelations. Philosophy must never shrink from speaking out."[14] Sade made a name for himself as a man who roared from the turrets of the Bastille. But to quote another Sadean heroine, Eugénie, in *Philosophy in the Bedroom* (1795), he accorded the imagination "the freedom to overstep those ultimate boundaries religion, decency, humaneness, virtue . . . would like to prescribe it."[15] Sade pushed Enlightenment ideals and philosophy to an absurd extreme and especially in his monstrous portrayal of the fairer sex as naturally wicked, her imagination and body reveling in every libertine fantasy and initiation, once freed. By extension, he staged his tableaux in the private, libertine space of the closed institution but made clear the ambition to corrupt the public place. As Madame de Lorsange explains to Clairwil in *Juliette*, "[O]ne libertine can easily, in the course of a year, corrupt three hundred children; at the end of thirty years he will have corrupted nine thousand; and if each child he has corrupted only matches him in only one-fourth of his corruptions, and we can hardly expect less, and if each succeeding year's batch of corrupted children follows suit, as must very probably happen, by the time those thirty years have elapsed the libertine will have seen this corruption flower in two whole generations, will be able to number nearly nine million persons corrupted either by himself or by the doctrines and examples he has disseminated."[16]

This apocryphal vision of libertinage must not be confused with organized terror. For Juliette, like her inventor Sade, refuses to participate in a nationwide scheme of terror when it is proposed by her murderous lover Saint-Fond. A minister, he outlines to Juliette a "cruel scheme he had

devised for the devastation of France," including plans to destroy charitable institutions and poorhouses, close all grammar schools, and cause a famine "by the total monopolization of corn."[17] He returns to the scheme later in the tale, with plans to starve two-thirds of France to death, and proposes Juliette herself for a principal role in executing the plan. Here Juliette falters: "I—yes, I confess it—corrupt to the core though I was, before the idea I shuddered."[18] This brief moment of virtue in Juliette's tale ensures that the theme of education continues throughout her narrative and life story; she learns from it and becomes all the more libertine. She momentarily turns her back on vice and flees Paris for Angers and later for Italy to avoid her own annihilation by Saint-Fond.

The Fairer Sex in the Eighteenth Century

Sade's obsessive focus on the female body allowed the sexual question to supplant the social question in his vision of absolute freedom over some fifteen years, in the lead-up to the fall of the Bastille and then after, under Napoleon. Despite the radical political upheaval of this period, woman's role in society and in political discourse changed little. She was inevitably aligned with nature and destined to a reproductive identity alone; the control of her sexual body ensured that "natural" society was not corrupted. In *Julie, ou La nouvelle Héloïse* (*Julie, or the New Heloise*, 1761), Jean-Jacques Rousseau denounced the low-cut bodices and rouged cheeks that were in vogue in Paris and emphasized that his heroine, Julie, was virtuous in appearance and disposition, while insisting that the path to happiness was through virtue alone. She is described as "[b]londe; a sweet, tender, modest" girl with "little finery, always tasteful; the bust covered in the manner of a modest maiden."[19] In *Émile, or Treatise on Education* (1762), Rousseau wrote of woman's duty to fulfill the laws of nature, to focus on her children, and to nurse them herself ("for the little creature [to have] the right to the maternal bosom").[20] The writer and botanist Jacques-Henri Bernardin de St. Pierre (1737–1814), author of *Paul et Virginie* (*Paul and Virginia*, 1788), went further again, stating: "Women lay down the first foundations of natural laws. The first founder of human society was a mother of a family. They are scattered among men to remind them that above all they are men, and to uphold, despite politics and laws, the fundamental law of nature. Not only do women bind men together by the bonds of nature, but also by those of society."[21]

Even in Sade's comparatively tame short story "Florville and Courval" (1800), published under his name and without attack from the censors, he debunked such ideas. The female protagonist, Florville, appears to represent the fairer, more virtuous sex but is soon unveiled as the embodiment of incestuous passion. When first described to Courval, who is seeking a wife, she seems the perfect example of the fairer sex: "thirty-six, but she looks no

more than twenty-eight. . . . Her features are soft and delicate, her skin the whiteness of a lily . . . and she leads a secluded life. . . . In short she is an angel on earth."[22] But as the plot unfolds, she ends up defying all family duty and ruins three generations: she (unwittingly) commits incest with her son and his father, who ends up being her brother, kills her son, and causes her mother's execution. As she realizes before shooting herself at the end of the tale, she is nothing more than "the most vicious monster."[23] Sade thus crafted a monstrous castrating female creature who took Sophocles's story even further in the tale's bloody finale. As Pierre Klossowski (1905–2001) acknowledged in his essay "The Father and the Mother in Sade's Work" (1947), Sade subverted the traditional Oedipal role and sacredness of motherhood.[24] The family and network of incest in "Florville and Courval" goes beyond the sexual act and allows Sade to address social relations and forms of representation of the world amidst his characterization of Florville as the "most abominable monster that nature could create" and "a soul that was guilty before it had acted."[25]

The female body has traditionally been employed in Western culture to denote all that is natural, maternal, and sensual, and to teach the difference between virtue and vice as well as nature and reason. It gained new symbolic import during the French Revolution and the periods immediately preceding and following it, as an aristocratic world of indulgence, manners, and taste gave way to a demand for equality and the violence of the masses. In *The Body and the French Revolution* (1989), Dorinda Outram notes that the 1790s witnessed the creation of a "new public world of the Revolution, and hence influenced the sort of state it created," wherein the stoic body stood firm against the bloody terror of the guillotine, the cold face of the new state apparatus.[26] A slow, but increasingly political, new role for woman developed within this time, given its focus on the rights of man, yet simultaneously definitions of the feminine continued to fashion a specific divide in popular and political culture between nature and nurture and between public and private space. Notably, the figure of the young girl "coming of age" emerged as a dominant trope in literature and art—whether as an innocent girl (*jeune fille*) or younger child-woman (*femme-enfant*) on the cusp of puberty. She is the subject of Rousseau's *Julie, or the New Heloise*, in which Julie chooses her father over her preceptor Saint-Preux in a novel that warns its reader, "The child who has no rule but love chooses badly, the father who has no rule but opinion chooses even worse."[27] She appears again as the young illegitimate Suzanne Simonin in Diderot's *La religieuse* (*The Nun*, 1796) in which she is doomed from birth: the product of her mother's affair, she is rejected by her family and sacrificed to the convent of Sainte-Marie, where a Mother Superior and a team of corrupt nuns takes over her education. She tells a sympathetic lawyer, "I learnt to obey," but it is the interlacing of the sacred and the profane in those words, and the series of titillating

tableaux that map her journey as a novitiate that aimed to seduce the reader.[28] Unlike Sade's heroines, Suzanne never gains knowledge en route; rather, she trembles and tremors in a manner that suggests the hysterical body more than the sexual or sensate one. Toward the end of the tale, she pitifully admits to the Mother Superior at Arpajon, "I don't know what the language of the senses is"; and when the older woman asks, "Would you like to learn it?" only responds, "No, dear Mother. What use would it be to me?"[29] She has none of the burning curiosity or questioning nature of Sade's *jeunes filles*; she never appears to gain any self-knowledge.

The illustrations for editions of *The Nun* remind us that visual culture in eighteenth-century and early-nineteenth-century France promoted a very clear iconography of virtue. The first illustrated edition of 1796, with engravings by an anonymous artist, is true to Diderot's anticlericalism but reserved in terms of erotic detail. The first engraving ("Quelle grace faut-il que je demande à Dieu?" [What grace must I ask of God?]), depicts Suzanne kneeling and imploring with raised hands before her initiators, Soeur Sainte Christine and three other nuns, who hold holy water, a rope, and a crucifix to reinforce the theme of martyrdom. The second illustration ("Me voilà sur le chemin de Paris avec un jeune Bénédictin" [Here I am on the way to Paris with a young Benedictine]), depicts Suzanne escaping the convent walls only to land in the hands of the debauched Benedictine monk Dom Morel (fig. 4). It is almost comical but nonetheless shows the power of the church in and outside the convent walls. The reader is encouraged to sympathize with the victim as evidenced by the witness in the scene: a young coachman who assists the nun in holding the ladder.

The five illustrations by Jean-Jacques-François Le Barbier (1738–1826), who exhibited regularly at the Salon between 1781 and 1814, published in editions of *The Nun* between 1799 and 1804, are more directive and serve as a contrast to the illustrations for Sade's *The New Justine*. For in Le Barbier's illustrations, the figures and their gestures are staged in a manner that explicitly encourages the viewer to follow the signs for virtue and vice in each. Síofra Pierse argues that the artist does this to draw our attention away from the erotic and to lend a sense of decorum to the reading experience, but I see the wooden gestures as a rhetorical means to encourage readers to imagine more than they can see.[30] The third illustration by Le Barbier, for example, shows Suzanne in an empty cell in the convent at Longchamp, with Soeur Sainte Christine, two clergymen, and an archdeacon. In the novel, she tells readers that she got up from prayer when the archdeacon entered the room, and relayed to him her torment at the hands of the sadistic nuns, but the artist portrays her still on her knees, still in a position of subservience. He thereby emphasizes her realization that her hope lies in human rather than divine intervention and makes the reader complicit in this realization.[31]

Tome 2.ᵉ Page 160.

Me voilà sur le chemin de Paris avec
un jeune Bénédictin.

Elle joue et chante comme un ange.

Le Barbier del.
Giraud J.ᵉⁿᵉ Sculp.

4. Anonymous engraving, second plate in Denis Diderot, *La religieuse* (Paris: Chez
Gueffier jeune et Knapen fils, 1796).

5. Jean-Jacques François Le Barbier, drawing in Denis Diderot, *La religieuse*,
engraved by Jean Baptiste Michel Duprée (Paris: Chez Rousseau, Mme Devaux et
Bertin Frères, 1804), vol. 2.

The fourth image by Le Barbier depicts a scene at the convent Saint-
Eutrope near Arpajon where the Mother Superior, "Madame ***,"
demands Suzanne entertain the nuns with something "more cheerful" than
the Psalms (fig. 5).[32] This scene seems staged quite matter-of-factly to reflect
the statement "elle joue et chante comme un ange" ("she plays and sings
like an angel"), until the viewer notices the Mother Superior's hands
dancing above her lap and her parted thighs, and the rather prominent
bowl of fruit from which one piece of fruit has fallen. These details,
enhanced by a dramatic use of shadow and the framing of the composition
between an open door behind the group and a draped curtain in the
foreground, encourage a sense of entrapment, voyeurism, and even lesbian
pleasure to reign over the musical performance. The reader-viewer may be

kept at a safe, moralizing, distance, but the engraver alludes to the more scandalous sexual plot in the details—especially as fruit is not mentioned in this scene in the novel.[33] Suzanne learns to use her body to appease the Mother Superior, but while we read of her innocent "favors"—described as "a kiss, either on the forehead, or on the neck, or on the eyes, or on the cheeks, or on the mouth, or on the hands, or on the breast, or on the arms, but most often on the mouth"—we get no sense that Suzanne's own desires are enflamed.[34]

One could argue that the plight of the naive *jeune fille* in *The Nun* reflects Diderot's own conflicted position on female sexuality. In his earlier article, "Sur les femmes" (1772), he shows little empathy for womankind or women's ability to make sense of the world. He writes that a woman is ruled by the womb, "an organ prone to terrible spasms, governing her, and producing in her imagination specters of all kinds." Consequently, women are destined to be second-class citizens: "What then is a woman? Neglected by her husband, deserted by her children, worthless in society, religious devotion is her only and last resort. In nearly every country, the cruelty of civil laws against women joins with the cruelties of nature: they have been treated like imbecile children."[35] And yet—and more important for my purposes in this chapter— Diderot also describes womankind in threatening, almost monstrous terms: "cruel in vengeance, constant in their planning, unscrupulous. . . . Naturally curious, they want to know, either to use or to abuse everything; in a time of revolution, curiosity prostitutes them to their masters."[36] Women's hysterical bodies and desires, their curiosity, and their disloyalty and deception are here all intertwined, so that their flesh and morality both appear to need tutoring if they are not to get out of hand. The young girl must be cultivated as the wife and mother to come; her modesty will determine the future of the fairer "timid sex" (*sexe timide*).[37] Here, again, we are reminded of the social contract underpinning women's lives and representation.

The words and actions of the *jeune fille* (and, by extension, her morals) in the novel reflected her parenting by society, the church, and family; even with the Revolution, her status was enshrined in the family. Patricia Main-ardi explains:

> Family law was a combination of royal law, canon law, and local custom. . . . [W]hatever personal freedom a woman enjoyed was held on sufferance and not on legal rights. A woman remained under the legal authority of her father or husband, or even her brother or uncle if they were her closest male rela-tives. Under the Old Regime, children did not reach the legal age of majority until they were twenty-five (women) or thirty (men). Until that age they could not marry without parental consent, and their wages and property were held in usufruct by their father. He could also betroth them from the age of seven, although the legal age of marriage was twelve for girls and fourteen for boys.[38]

Women were denied their citizenship in Diderot and d'Alembert's *Encyclopédie* (published between 1751 and 1772), as they were aligned with children and servants. The reader was instructed that the nature and moral purpose of "woman" (*femme*) in society was biologically determined and that the happy woman is the obedient one: "Her happiness consists of being unaware of that which the world calls *pleasure*, her glory is to live in obscurity. Caught up in the duties of *wife* and mother, she devotes her days to the practice of unobtrusive virtues; occupied with the governing of her family, she rules over her husband through kindness, over her children through sweetness, over her domestics through goodness: her house is the abode of religious sentiment, filial piety, conjugal love, maternal tenderness, order, interior peace, gentle sleep and of health."[39] Entries on the shelling of peas and lace-making in the *Encyclopédie*, and their attendant plates, depict women busy at work, happy in their domestic labor and skill.

This gender hierarchy is equally transparent in *Treatise on the Power of Husbands over the Person and Property of Their Wives* (1768), penned by Robert-Joseph Pothier (1699–1792), which asserts in its very first sentence: "Marriage, by establishing a community of husband and wife, where the husband is the head, gives to the husband, in his role as head of this community, a right of domination over the body of his wife that extends to her property as well."[40] Family and marriage disputes were divided between civil and religious courts but could also be resolved via *lettres de cachet* (letters signed by the king). This practice evaded public attention and scandal, and convents were often used to banish unruly daughters and wives. This social contract was challenged with the Revolution, not least because the power of the father/husband became equated with that of the monarchy. And while revolutionaries wished to abolish the rule of fathers' paternalism, they still relegated women to an inferior status and were keen to continue with patriarchal norms. The royal family of king and queen was replaced with a new model of "fraternity," which allowed for the rise of new models of the individual in politics and fiction alike, though it must be noted that few tracts or novels promoted the freedom of women in this new order.[41] Sade fictionalized these debates in his philosophical novels, in recognition of this cultural and political shift. He gave a voice to a new model of woman who took Diderot's suffering Suzanne to a whole new level of self-knowledge through the characters Justine and Juliette and their journeys in *jouissance*.

Virtue and Vice: Justine and Juliette

Where Rousseau and Diderot dealt with the subject of female virtue and sexual lust in veiled terms, Sade's females are saturated in sexual knowingness. They respond actively to each libertine scenario, whether they chose to follow it (Eugénie, Juliette) or fall victim to it (Justine). Crucially, in Sade's

fictional world of atheism, sodomy, and aggressive phallic *virility*, he entrusts his seminal philosophical ideas to *female* characters but also places the reader/spectator not in the wings or hidden behind a door or curtain, but within the arena of vice and lust. In this way, Sade's female characters brought the family into the philosophical arena but also challenged the paternal reader courted in most erotic novels of the era. The sisters Justine and Juliette are not unlike Suzanne in being forced to enter a nunnery— they become orphans and enter a convent at the tender age of twelve and fifteen, respectively, but their command over the storytelling and the sheer excess of the sexual torment they endure or inflict, takes the theme of the sacred and profane to new heights. Justine echoes the typical virginal type of eighteenth-century fiction and art but as a result must bear the brunt of every libertine's wrath. She is described in *The Misfortunes of Virtue* as the quintessential young lady whose moral purity is reflected in her fair coloring: "A virginal air, large, engaging blue eyes, dazzling skin, a slender, well-shaped figure, a voice to move the heart, teeth of ivory, and beautiful fair hair."[42] Indeed, Sade sets her against her sister, who is described as "all artifice, cunning and coquetry."[43]

The frontispiece for the 1791 first edition of Sade's *Justine* by French historical painter Philippe Chéry (1759–1838) typifies what Robert Rosenblum calls the "Neoclassical Erotic," in which the antique and the sensual merged as artists turned with renewed vigor to antique love stories in the latter half of the eighteenth century (fig. 6).[44] Chéry portrays a nubile and statuesque Justine in billowing, transparent clothes that allow the spectator to read and enjoy her body, though her pained expression and awkward arms, displayed to accentuate her curves, might recall the baroque style of Chéry's master, Joseph-Marie Vien. Certainly Justine's heavy gestures and fleshy limbs recall the statuary poses of Roman frescoes and sculptures. Equally, the violent, dark landscape behind her serves to bring the low composition further into the reader's space, accentuating its ominous eroticism. A dark and dangerous femme-fatale figure stands in marked contrast to her side. She stands on the Bible and the cross to indicate her libertine sorcery and stance as Irreligion, where Justine treads on a serpent, symbol of temptation. Despite the classical pose and torso of the nude male figure on Justine's other side, he symbolizes Self-Indulgence as he stands defiantly in his own nakedness and unveils her for the viewer. In his "Notes on the Novel," Sade wrote of how he wanted people to see crime "stripped bare, so that they may fear it, so that they may hate it."[45] Staged in nature, with thundery clouds overhead, the reader is visually forewarned that Justine's fate is doomed. Despite surviving one sexual terror after another, she is struck by lightning during a storm at the very end of the plot: "The bolt had entered her right breast, had blasted her thorax and come out again through her mouth."[46] This cruel finale is magnified by its effect on

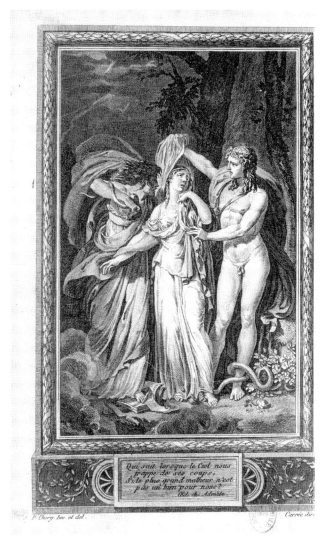

6. Philippe Chèry, engraving, frontispiece of the first edition of Sade's _Justine, ou Les malheurs de la vertu_ (Paris: J. V. Girouard, 1791).

the other two protagonists: it leads Juliette to reenter a nunnery, morphing into "its model and example," while her libertine ally Corville becomes "a man deserving of the highest offices in his native land."[47] Sade's final words have a classical moralizing tone that the frontispiece certainly complements, if only to add to the hypocrisy of the advice: "May you [reader], like her, be persuaded that true happiness lies in virtue alone and that, though God allows goodness to be persecuted on earth, it is with no other end than to prepare for us a better reward in heaven."[48]

Where the 1791 edition of _Justine, ou Les malheurs de la vertu_ only had a frontispiece, the subsequent book, _La nouvelle Justine, ou Les malheurs de la vertu,_

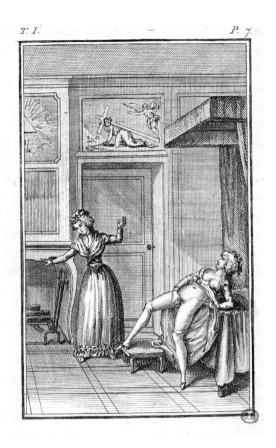

7. First plate in vol. 1 of D.A.F. de Sade, *La nouvelle
Justine, ou Les malheurs de la vertu, suivie de
L'histoire de Juliette* **(Holland, 1797).**

suivie de L'histoire de Juliette, sa soeur (1797), had one hundred illustrations, ten
for each of its ten volumes.[49] Whilst the title page declared the volumes were
printed "en Hollande" (in Holland), they were actually published in Paris by
Bertrandet for Nicolas Massé, and their publication most likely dated
between 1799 and 1801.[50] The engraver was not credited but it is probable
that the artist was the painter and miniaturist Claude Bornet (1733–1804)
who worked in Paris from 1774 to 1801.[51] Lely notes that Rétif de la Bret-
onne claimed it was on sale publicly at the Palais Royal bookstore, quickly
becoming a best seller and not seized by the police until a year later.[52] The
1797 edition narrated the same tale in greater obscene detail in text and
image so that one volume, let alone all ten volumes, was a markedly explicit
and sensational experience. Several illustrations in the first volume of the
series marked this shift, as marmoreal forms gave way to the now canonical
fashionable, domestic interiors and costumes of the late eighteenth century.
The tension between Justine and Juliette remains, but their adventures are
portrayed with graphic if not medical accuracy rather than biblical

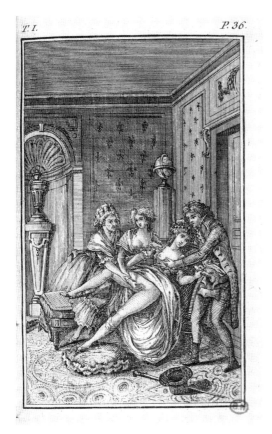
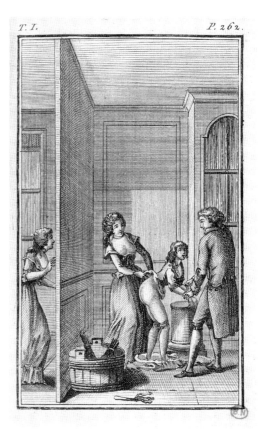

8. Second plate in vol. 1 of *La nouvelle Justine* (Holland, 1797).

9. Third plate in vol. 1 of *La nouvelle Justine* (Holland, 1797).

symbolism: Justine looks appalled and turns away from the boudoir, toward the light of the window, while her sister leans back on a bed and masturbates (fig. 7). The religious image visible in the door panel, depicting Christ stumbling under the weight of his cross on the road to Calvary, reinforces Justine's plight in a more subtle way, reinforcing her trials to stay true to her religion and virtue. The corresponding text details the older Juliette explaining the ways of the world to her sister, how they must use their youthful bodies to prevent hunger, and how she is able to dispel sadness by masturbating, stating, "Justine, when I feel grief I masturbate . . . I discharge . . . and it consoles me."[53] But it is a lecture and demonstration in which Justine wants no part.

The next illustration features the other "bad mother" figure in Justine's tale: her landlady, Madame Desroches, who tries to lure her into prostitution and schools her in libertine whoredom (fig. 8). This is clear in the illustration: the old lady literally guides Justine's hand to the genitals of a Madame Delmonse, another whore who manages to hide her profession

from her husband, who still believes in her virtue. Delmonse demonstrates her skill through example, as we see her arouse the member of a young male behind her in a chain of masturbatory instruction and pleasure that is all the more sensationalist given the "civilized" domestic room in which it occurs, complete with rich wood paneling, an alcove with classical urn, and a globe. Women here promote the reeducation of woman through word and act alike, emphasizing their growth as individuals in the process. Madame Delmonse realizes that the more she indulges in sex, the more libertine she becomes: "Desroches, said Madame Delmonse, after a few minutes reflection, the more I am fucked the more libertine I become, an action determines an idea and this new idea a further action."[54] This is a world driven by sensation, developing the materialist idea of feeling as living into a more extreme concept of fucking as living. Reflecting and thinking—like the dialogue that underpins the storytelling throughout Justine's tale—simply help explain the sensations and actions that beget more sensations and actions. The material libertine female body is the perfect instrument for this radical philosophy: while the female body is traditionally aligned with nature and the senses, it is also aligned with the passive; here that nature is presented as active and desiring.

The war of the sexes, the privileging of the senses, and the centrality of the stage to the Sadean imagination are all revealed in the third illustration depicting Justine witnessing the acts of the sadistic doctor Rodin, seen from a secret vantage point in his house at Saint-Marcel (fig. 9). The scene in the novel recounts how Rosalie explains that her father's house is far from a normal school; it is a school for libertinage, with male and female students routinely tortured by him and his colleague Rombeau. Justine witnesses the stripping and binding of a young pupil, the "charming" Agnès, whose "voluptuous" little body is described at length. That Rodin will soon turn her fair skin a shade of bloody red, assisted by his bare-breasted sister, is intimated by the cat-o'-nine-tails visible in the foreground of this "correction room."[55] The illustration draws the reader into the scene of torture in a manner that magnifies the text, for as readers witness the assault, they also witness Justine witnessing the assault, and her realization of her own impotence becomes the reader's too. As Rodin torments and tortures in the plot, he repeatedly stands back from the tableaux he has created, so that readers are conscious of a scene within a scene ("Rodin considers the scene, he wets his mouth, he brushes that of his victim. . . . [H]e doesn't dare to kiss her, he doesn't dare to devour the tears which electrify his bloodlust").[56]

The subsequent scene in which Rodin castrates his daughter Rosalie by slicing her hymen out of her pinioned body is the engraver's next choice for illustration.[57] If a traditional father's role is to protect his daughter and her virtue, this gruesome act literally destroys that role. The illustrator chose not to depict the excision itself but instead the bloody *jouissance* that it elicits: in the text,

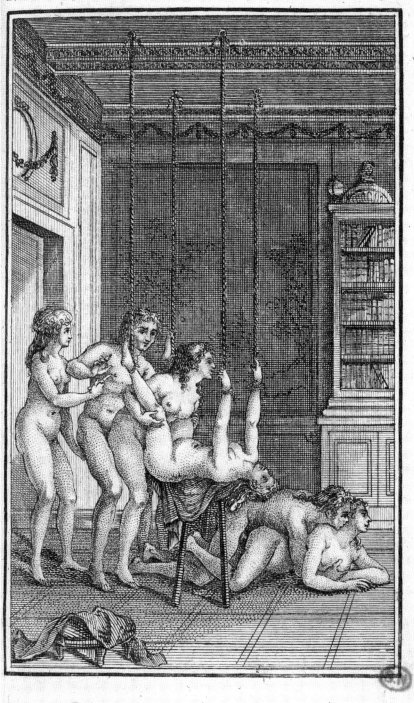

10. Fourth plate in vol. 1 of *La nouvelle Justine* (Holland, 1797).

the men luxuriate in Rosalie's wounded sex and even force Justine to drink her friend's vaginal blood, but here we find a frieze of pleasure and fear: Rosalie suspended by four cords for surgery and the other figures in the scene—Rodin, Rombeau, Justine, Marthe, and Célestine—enjoying her terror (fig. 10).

The sequel to *Justine*, in volume 5 of the same series, presents her sister Juliette's story, but as it presents the world through the eyes of vice, it helps to expand the reader's understanding of Justine and the choices she makes in the name of virtue. Juliette's story opens with the assertion that the convent Panthemont, where she and Justine were sent, produced "the prettiest and most libertine women gracing Paris."[58] She learns the art of libertinism from women too: first from the Abbess Delbène, who is "nearing her thirtieth year" and has "the stature of the Graces."[59] Juliette first meets her at the impressionable age of thirteen, and then from a brothel owner named Madame Duvergier. Juliette makes clear that the community of women in a convent or whorehouse is not bonded through virtue "but by fucking: one is pleased by her who makes you wet, one becomes the intimate of her by whom one is frigged."[60] The libertinism such women share is explained in emphatically corporeal terms, almost as a menstruating threat to the status quo. Delbène explains, "Oh Juliette, Juliette, my libertinage is an epidemic; it must corrupt anyone who comes near me."[61] This sense of a threatening fluidity comes across in the obsessive recourse to the tableaux in the novel's plot and is magnified in the accompanying illustrations to *La nouvelle Justine, ou Les malheurs de la vertu, suivie de L'histoire de Juliette, sa soeur*. The first four volumes having depicted Justine, the remaining six volumes take the reader into even more graphic illustrations of debauchery, with a greater sense of revelry in the obscene. The first illustration for Juliette's tale depicts a boudoir with Delbène identifiable in her dark habit (fig. 11). She is effectively encircled by her pupils, their interpenetrating bodies making her "epidemic" threat to others literal. While the decor is standard, the position of Juliette reinforces the chain of command, her role as the novice, described by Delbène as "still very new."[62] In the text, she tells the reader that her role was necessary to "complete the group," but the detailed bacchanal is clearly for the reader's initiation and instruction too.[63]

The second illustration follows a scene described by Juliette, involving Father Télème, a Recollet friar ("a handsome dark man of thirty-six, confessor to the novices and the residents"), the Abbé Ducroz ("chief vicar to the Archbishop of Paris, a thirty-year-old man, with a very nice figure") and Delbène and her four nubile pupils—Laurette, Volmar, Flavie, and Juliette.[64] These libertines proceed to arrange themselves again into a pornographic tableau described by our narrator Juliette: "Télème, who'd just fucked my cunt, placed himself in my ass; he was a bit bigger than his confrere, but, though I was a novice, nature had crafted me so well for these pleasures that the difference did not cause me any suffering."[65] The artist

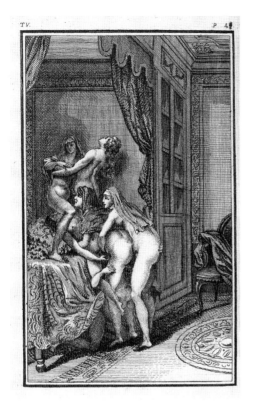 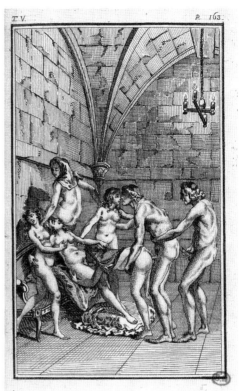

11. First plate in vol. 5 of *La nouvelle Justine* (Holland, 1797).

12. Second plate in vol. 5 of *La nouvelle Justine* (Holland, 1797).

captures Sade's emphasis on bodies plunging into each other's orifices as well as his insistent celebration of sodomy as the best act for men and women alike (fig. 12). Thus, while still being "frigged by Delbène and tonguing Ducroz," Volmar asserts that sodomy is a question of philosophy—"although a woman . . . were I a man, I'd only ever fuck an asshole"—and she proceeds to discharge as if again the thought and act must be one.[66] The illustrator stages this orgy in the dark cell underneath a chapel, in keeping with Sade's description of "the sanctuary of the dead . . . a place where we gather only for fuckery."[67] Delbène explains to Juliette and the reader alike: "When one is so libertine, so depraved and so villainous, one wants to be in the bowels of the earth so as to better to escape the interference of men and their ridiculous laws."[68]

Delbène advocates the rejection of "the concept of this vain and ludicrous God" and instead embraces the pantheistic philosophy of Spinoza (1632–77) and Lucilio Vanini (1585–1619). Her debt to both emerges as she teaches that virtue is a convention and contrary to nature. In reply to Juliette's question "if there be neither God nor religion, what is it runs the universe,"

Delbène confidently replies, "[T]he universe is propelled by its own force, and the eternal laws of nature are inherent to it, without the need for any prime mover, to produce all that we can see: the perpetual movement of matter explains everything: why would we need to provide a motor to that which is always in motion?"[69] She also defines the whore-libertine as the evolution of the new, modern woman who is true to Mother Nature: "The whore is the cherished child of nature, the wise girl is nature's execration; the whore deserves altars, and the vestal the stake."[70] This model of a new female challenges the dominant pattern of gender difference in eighteenth-century France, to say the least. As Juliette masters the art of libertinism, she not only subverts the cult of virtuous womanhood but manipulates the infusion of philosophical and licentious texts in her storytelling. Kathyrn Norberg rightly proposes that Juliette is trained to debunk sexual difference: "The prostitute texts preach an older, materialistic doctrine that leaves little room for biological and temperamental differences between the sexes. . . . [T]hey regard sex as its own reward and pursue it in a ruthlessly instrumental way."[71] Further, because prostitutes were featured in official legal and medical texts as well as in fiction, the sense of Sade offering his readers an argument in favor of legalized, orchestrated prostitution, interlaced with libertine orgies and the bawdy language of the brothel, which was age-old and laced with black humor, must not be overlooked. Norberg notes the shared language between these three types of writings (official, fiction, comic) and that that some forty almanacs of prostitutes appeared between 1779 and 1792 in which a woman's physical and sexual attributes were listed in terms that could easily be mistaken for a pornographic novel—whether for a woman's "fiery cunt" or the tongue-in-cheek description of whores as "very active *citoyennes*," who "know all the Rights of Man."[72]

The description of the house of Croesus in the first volume of *Juliette* (1797) exemplifies this dynamic between the inner and outer world, Sade's universe and the real streets of Paris, as it concerns a brothel owned by libertine-whore Madame Duvergier and her pimping of girls to wealthy debauched men in thriving brothels or "maisons de plaisir." Juliette and six of Duvergier's *protégées* are sent to the house of Croesus to satisfy the needs of an elderly client named Mondor.[73] The setting for the series of tableaux that follows in the novel is crucial for their sensorial and scandalous success. The orgy occurs in a chamber "hung in brown satin, a color adopted, no doubt, to emphasize the radiance of the skin of the sultanas who were received there"; Juliette likewise is dressed "in gold and black gauze which made her stand from [her] companions."[74] These then are detailed in three scenes, the first involving "Sapphic poses" by the girls while still continually moving (as if to ensure the voyeur's eye is constantly energized, much like the reader's mind). The next describes the whipping of Mondor until his "blood flowed," and then the final scene in which each lady takes turns to

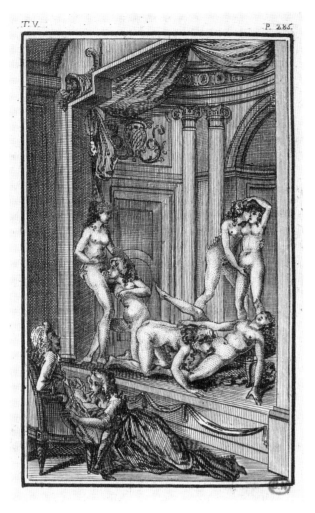

13. Sixth plate in vol. 5 of *La nouvelle Justine* **(Holland, 1797).**

"slap his honor's face, then spit upon it, and finally fart thereupon" while Juliette performs fellatio.[75] The orientalist setting reaches a climax in terms of detail, sound, and discharge as Juliette notes the veritable orchestra of corporeal slaps, spittle, farts, and her own self choking on an increasingly engorged member, before the scene is brought full circle with a final "crapulous episode" in which two girls defecate on Mondor, one into his mouth and the other on his forehead.[76]

The illustration of these successive, fabulously orchestrated tableaux is a more timid version of the text. It involves an almost filmic repetition of sexual imagery in the multiple engravings that punctuate the printed pages with dynamic and explicit arrangements of bodies. These cleverly position the reader-spectator as an extension of the elderly character Mondor, who can only reach a climax once every detail and scene has been enjoyed in

turn. We see Mondor seated, Juliette on her knees before him, and the six other women on stage, the curtain framing their carefully rehearsed Sapphic acts (fig. 13). Sade's plot may be a little censored, but it is presented as theater, as the imagination runs riot. Furthermore, both text and illustration might be viewed as a mockery of contemporary aesthetics of art and theater. In *Entretiens sur le fils naturel* (Conversations about the natural son, 1757) and *De la poésie dramatique* (On dramatic poetry, 1758), Diderot called for a unified tableau in which all gestures act as a unit. In *Entretiens sur le fils naturel* he wrote of an aesthetic built on the "natural and true arrangement of . . . characters on the stage," which was to give as much passive pleasure as a painter would craft on his canvas.[77] Sade and his illustrator seem to take these instructions to carnivalesque ends.

The Sadean Family "Romance"

In Sade's *The 120 Days of Sodom*, the libertines and the storytellers are old, but all other victims are young and represent the next generation. The tales of the four female storytellers enflame and inspire the four libertines, who represent the bastions of society: the aristocratic Duc de Blangis, the bishop of Duclos, the duke's brother the Magistrate Curval, and the banker Durcet. Their stories also get increasingly depraved in a Dantesque fashion, from the first month of November, which is devoted to "simple passions," to more "complex passions" in December, "criminal passions" in January, and then "homicidal" passions in February. It is the last month that sees the good mother mocked, tortured, and killed in a series of horrendous tableaux that defile the natural bond between mother and child. We read of newborn babies being tied by their umbilical cords to their mothers' necks, the mothers left without food for days to see if they would devour their own offspring; of a libertine who liked to trample on a pregnant woman until she aborts; and a torture wheel on which a pregnant woman is suspended and flogged while her mother is forced to sit underneath and eat any discharge that comes from her tortured child—blood, urine, feces, or the destroyed fetus. Such torture recalls the iconography of female martyrs—the spiked breaking wheel that was associated with Saint Catherine of Alexandria, or the slicing off of the breasts of Saint Agatha of Sicily, as Sade rivals the Bible in his terrifying descriptions of atrocities and silent suffering, lending argument to his belief that God, the Supreme Being, only helped justify terror.

Sade's *Philosophy in the Bedroom* was produced later, in 1795, and thus in the aftermath of Robespierre's alignment of atheism and aristocracy and his promotion of the Cult of the Supreme Being to the Convention (May 7, 1794). In it, Sade's view on religion and its hijacking for political ends is even clearer, as Dolmancé deplores religion and a "horrible God, this God of yours, a monster!" to the fifteen-year-old Eugénie.[78] In *The 120 Days of*

Sodom, it is specifically the virtuous *pregnant* woman and the reproductive sexual act that are punished and eradicated from the realm of libertinism. For Andrea Dworkin, the scenes are images of butchery "in illegal abortions."[79] For Timo Airaksinen, the château at Silling presents a slaughterhouse, wherein victims "are not persons and they cannot fight back."[80] Airaksinen claims the reader feels no sympathy for such victims, unlike Sade's Justine, and is left with a sense of the château as "only a show; it makes sense for a while, but then must be dissolved."[81]

Contrary to Dworkin and Airaksinen, I would argue that these tortures against the mother figure ensure the effectiveness of Sade's attack on the family romance and woman's role within it. As the pregnant and damned Constance states to the onetime judge and libertine Curval in *The 120 Days of Sodom*, "Oh, all the world knows your horror of pregnant women."[82] Sade's destruction of the young, fertile female brings his libertine world of non-procreative sex and *jouissance* to its logical end. The Duc de Blangis states to the libertine-whore and storyteller Madame Duclos, who has just recounted the loss of her own mother, "It is a madness to suppose that one owes something to one's mother."[83] The duke poisoned his own mother. He also marries and impregnates Constance, the daughter of fellow libertine Durcet, and he takes great pleasure in torturing his pregnant wife, who is described as a "luckless" girl accustomed to "daily torture."[84] This involves bleeding her veins, having her eat Curval's turds from the floor like a dog, and savagely killing her and her unborn son. But she is not a faceless victim, without personality. Sade ensures her character is developed so that we feel her torture all the more brutally. He introduces her to the reader as about twenty-two years of age, with dark black hair, and with a wit and spirit that allow her to sense the horror of her own fate. Her path to Silling is also explained: she had been imprisoned in her father's house all her life and was initiated into the libertine way from the age of twelve—the age between childhood and womanhood that libertines like for their female victims. Comparable to the virtuous Justine, she manages to survive and heal from her many tortures—including the savage and irreparable damage of her rectum by the duke—but only to find worse tortures then thrust upon her. Constance's name predicts her constant suffering; Justine's name predicts her blind pursuit of justice. Both are doomed, because they do not follow libertinism.

Constance ought to have willingly aborted her own child by the duke, as the Sadean heroine Juliette does with the child she conceives by her father Bernole (whose name, derived from *berner*, meaning "fooled," intimates how gullible he is). With typically cruel accuracy Juliette recounts to her sister (and the reader) that she aborted her fetus at about four months: "I consulted a renowned midwife who, hampered by no scruples in this matter, deftly inserted a long and well-sharpened needle into my matrix, found the embryo, and pierced it. I evacuated it two hours later,

14. Jean-Baptiste-Siméon Chardin, *La bonne education* (*The Good Education*)**, oil on canvas, ca. 1753.**

experiencing no pain at all: this remedy, surer and better than juniper which upsets the digestion, is the one I recommend to every woman who, like me, is courageous enough to grant greater importance to her figure and her health than to some molecules of organized fuck."[85] She also happily killed her father prior to this, with the assistance of Saint-Fond, Clairwil, and Norceuil: "Bernole is tied to a chair fixed by spikes on the floor; I take up my position ten feet from him. Saint-Fond stretches out upon a divan and fits his member in my anus, Norceuil supervising the introduction with one hand, stroking his own instrument with the other; to my right Clairwil is tonguing Saint-Fond's mouth and tickling my clitoris. I take aim . . . I fire. The ball enters Bernole's brow; he expires; and with wild screams we all four discharge."[86]

Infanticide is an extension of parricide and matricide for Sade's regime and the ultimate attack on the family romance. Juliette's roasting of her own

daughter, whom she bore by Monsieur de Lorsange, reinforces this point with satirical punch—her name is Marianne, the allegorical name given to the French Republic by the *conventionnels* in September 1792 and monumentalized in numerous paintings as well as on the official state seal. Juliette's act of infanticide may be interpreted as a critique of that new regime and the cruel principle of the Terror where self-destruction took on an epic scale.[87] Unlike the wretched Constance and Justine, Juliette has none of the virtuous pity of the fairer sex, none of the traditional bonds of daughter or mother.

Sade's *Philosophy in the Bedroom* (1795) continues the theme of reeducation of the *jeune fille* and the family as stage and space for obscenity. The novel is set in 1789–93 and was published anonymously as a "posthumous work by the author of *Justine*," with an allegorical frontispiece and four engravings, in the summer of 1795.[88] The monstrosity of Eugénie is cultivated by her educators—Madame de Saint-Ange; her brother, Le Chevalier de Mirval; and his friend Dolmancé—and by the abuse of her pious mother, Madame de Mistival. Eugénie joins them in an assault on her mother that suggests a wider assault on the new "maternal" nation-state and its republican virtues turned bloodthirsty. The epigraph to *Philosophy in the Bedroom* calls for a new generation of womenfolk that looks to nature as a new "bad," amoral mother: "Mothers will prescribe the reading of this work for their daughters" ("La mère en *préscrira* la lecture à sa fille"). Sade's epigraph knowingly alluded to an antimonarchist and pornographic pamphlet of 1791 titled *Fureurs utérines de Marie-Antoinette, femme de Louis XVI, au manège*, which advised, "Mothers will proscribe the reading of this work to their daughters" ("La mère en *proscrira* la lecture à sa fille").[89] Sade thus presented his own educational treatise for women within a French revolutionary tradition while satirizing the revolution's excesses.

A belief in the use of literature to inculcate "good" morality among womenfolk is reflected in the many contemporary French paintings of young girls reading, notably in the art of Jean-Baptiste-Siméon Chardin (1643–1779) and Jean-Baptiste Greuze (1725–1810). Both artists typically isolate the figure in the composition, encouraging the spectator to "enter" the scene, while also ensuring he/she is offered a number of symbolic details with which to form a narrative around that figure, such as a broken mirror, a dead bird, or an open book. Chardin's painting *The Good Education* (ca. 1753) (fig. 14) presents two women, an older governess and the young girl who learns from her good example, and it stages the open book that the governess holds as the symbolic key to the young woman's moral progression. The girl is reciting her gospels, while her governess is staged as morally superior and enlightened, again symbolized by her fair complexion and the light streaming through the open window onto their faces, as Mary Sheriff has pointed out.[90]

On the other hand, Greuze's staging of timid creatures in intimate domestic settings teased out male voyeurism, especially a cloaked paternal

15. Jean-Baptiste Greuze, *Jeune fille avec un canari mort*
(*A Girl with a Dead Canary*), **oil on canvas, 1765.**

desire for the emphatically innocent female. This is evident in his 1765 painting *A Girl with a Dead Canary* (fig. 15) in which the composition draws the spectator tantalizingly close and allows the juxtaposition of her fair skin and that of her dead canary to take on erotic hues. As Emma Barker has observed, it led Diderot to fantasize, "I wouldn't mind being the cause of her troubles" in his Salon critique.[91] Greuze's art again exemplifies the "closed" work of art of the period, when the depicted object/figure/actor was seemingly oblivious to the spectator and demonstrated what Michael Fried describes as a state of being intended to "screen the audience out, to deny its existence, or at least to refuse to allow the fact of its existence to impinge upon the absorbed consciousness of his figures."[92] Even within this closed scenario and the seeming promotion of virtue, thoughts of lust and vice could enter. Greuze's painting raises the specter of taboo, even as it emphatically represses it, as evidenced by Diderot's pontification on the loss of innocence.

With the character of Eugénie, we are warned that a new breed of child is afoot: she is not forced into a convent but begins her libertine adventure as a means of rejecting the expectations of her family and following the debauched ways of her father. She asserts, "I love my father to distraction, and I feel a loathing for my mother."[93] These emotions lead her to naturally follow Dolmancé's instructions and to willingly assault her mother as an act of libertine liberty, as we shall see below. Her aggression

toward her mother is an action against the female body that her mother represents, in an age when a mother's biological role in the family was undergoing significant change. For in the late eighteenth century the model of mothering by a wet-nurse under the Old Regime gave way to the revolutionary insistence that women of all classes take responsibility for their own infants. Hence, the emphasis on a new mother is as significant as the new daughter in Sade's fictional world. Eugénie's swift reeducation could lead the reader to reflect on whether nature is determined, whether it operates according to moral and scientific laws, or whether it can be refashioned and is thus not predictable. Eugénie moves from the tuition of her pious mother to that of the libertine Madame de Saint-Ange. She quickly opines that we must not "stupidly confuse social institutions for Nature's divine ordinations."[94] This leads Dolmancé to further seduce her with his libertine ethics, as he reasons: "Cruel laws, arbitrary, imperious laws can likewise every century assassinate millions of individuals and we, feeble and wretched creatures, we are not allowed to sacrifice a single being to our vengeance or our caprice! Is there anything so barbarous, so outlandish, so grotesque!"[95] Sade calls on women, as the child's storyteller, to be complicit in the libertine reeducation of young girls. Even where the young girl remains true to virtue, as with Justine, her plight is viscerally detailed, and other male and female characters in the plot are shown to derive even greater pleasure from their cruel punishments.

The possibility for self-knowledge and freedom through libertinism is continually emphasized in Sade's books and is something in which he calls on nature for support. Thus it is significant that Eugénie describes herself as a "submissive scholar" to libertinism and instruction at the hands of Dolmancé and Madame de Saint-Ange.[96] In his "Notes on the Novel," Sade describes nature in a constant state of agitation—"she is like the rim of a volcano from which are ejaculated in turn either the precious stones which serve man's taste for luxury or the balls of fire which annihilate him."[97] Eugénie's repeated articulation of her pleasure in near volcanic terms, calling on God in her joy/agony and describing herself as "on fire," seems to emphasize her turn to her true mother.[98]

The two engravings for volume 1 of the 1795 edition of *Philosophy in the Bedroom* attempt to show this happy student of philosophy but never capture the excessive pleasure she describes: in the first image, we see Eugénie balanced between male and female libertines, her nubile body and garlanded head reminding the reader of her youth (fig. 16). In the text she ejaculates with pleasure between them. The female orgasm is the subject of the second illustration in the volume too, though this time the image reads as a type of instruction manual, the splayed body of Eugénie being aroused by Madame de Saint-Ange, Dolmancé, and Le Chevalier, entwined and climaxing together (fig. 17).

Volume 2 of the 1795 edition contains two more illustrations, both depicting Eugénie enjoying orgies. The instructional nature of volume 1, emphasized in the frontal position of the spectator and almost technical demonstration of masturbation, now gives way to a more titillating boudoir scenario as numerous genitals are visible and engorged in a chain of five naked interpenetrating bodies (fig. 18).

Sade's call for the reeducation of the *jeune fille* is reinforced by his inclusion of a lengthy pamphlet, "Yet Another Effort, Frenchmen, if You Would Become Republicans," in the plot of *Philosophy in the Bedroom*. In the fifth of its seven dialogues that educate the reader and Eugénie alike, Dolmancé reads the pamphlet in a loud voice, employing the language of political theater with aplomb as he calls for a new republic of libertinism free from scepter and censor: "Ah, my fellow citizens, the road we took in '89 has been far more arduous than what still lies ahead of us. We will need to change public opinion much less for what I now propose to you than we did following the storming of the Bastille when everything had to be made anew."[99] All moral standards are questioned in this pamphlet as Sade reasons through the character Dolmancé, "I ask how one will be able to demonstrate that in a state rendered *immoral* by its obligations, it is essential that the individual be *moral*? I will go further: it is a very good thing he is not."[100]

Sade wrote the tract at the height of the Terror and when housed in Picpus, a sanitarium where wealthier prisoners waited for trial or death, and from which he could view the guillotine at work. His text protests the death penalty for its cold attempt to bestow the law with the passion of the libertine, and reasons that this new regime calls for a radical rethinking of crime and punishment, and the new order of things where children are born of the Republic and she alone, "where all must have no other mother than the country."[101] In promoting the reeducation of the young woman, Sade effectively continued an already established erotic tradition evident in the anonymously published *L'école des filles* (The girls' school, 1655) by Michel Millot and Jean l'Ange; *L'académie des dames* (The women's academy, ca. 1660) by Nicolas Chorier; *Thérèse philosophe* (Teresa, the philosopher, 1748), usually attributed to Jean-Baptiste de Boyer, Marquis d'Argens; and *Les liaisons dangereuses* (*Dangerous Liaisons*, 1782) by Pierre Choderlos de Laclos. But as Lynn Hunt argues in her reading of *Philosophy in the Bedroom*, Sade's is a "consistent reduction *ad absurdum* of Enlightenment ideals and revolutionary rhetorical practices," while revealing "the psycho-sexual anxieties of the new republican order."[102] Space is central to this subversive strategy: where women were traditionally banished to the private realm and men were free to think and act in the public one, Sade offers a radically new political and philosophical rethinking. Hunt writes, "[S]ince women cannot be trusted to maintain their private virtues—to control their sexuality—their bodies should be made public, that is, available to all men. The private-public

l'Habitude un mᵉtᵃⁿt caᵘse en nouf quelqu'alarmᵉ
Maif bientôt danf un cœur à la raifon rendu
Le plaifir parle en maître et feul eft entendu

P. 53

**16. Frontispiece to Sade's *La philosophie
dans le boudoir: Ouvrage posthume de
l'auteur de "Justine"* (London, 1795).**

**17. Second plate in vol. 1 of *La philosophie
dans le boudoir* (London, 1795).**

**18. First plate in vol. 2 of *La philosophie
dans le boudoir* (London, 1795).**

tension is thus resolved in a very different way by Sade. This resolution is not one of anarchy. Sade replaces conventional law with a new order that is to be every bit as minutely regulated as the old one."[103] It is Sade's new spatial order that I now want to consider in greater depth.

Staging Public and Private Places: From the Château to the Boudoir

Space was mobilized in radical ways during the French Revolution, from the cruel theatrics of the bloody guillotine to the Fête de la Fédération, celebrated on July 14 each year, the anniversary of the taking of the Bastille in 1789. Festivals were not just a symbol of the Revolution but a pedagogic tool for the fashioning of a new French identity. Many celebrated the family and moral status quo, such as Festivals of Youth, Spouses, Old Age, or Thanksgiving, and are best viewed as "universal exhibitions" during the Revolution, presaging those of the nineteenth century and forging a clear sociopolitical and moralizing consensus.[104] When theater was abolished by the National Assembly in 1791, because it offered a forum for public debate and unorthodox and political ideas, a provision for national festivals (*fêtes nationales*) was, at the same time, written into the Constitution.[105] The promotion of festivals aimed for the unification of public opinion. David Lloyd Dowd has explained that it was also incorporated into the educational plans of such politicians and diplomats as Charles Maurice de Talleyrand, Joseph Lakanal, Joseph Lequinio, and Marie-Joseph Chénier.[106]

The festival was a form of outdoor, communal, ritualized expression that allowed for the public staging of history, often without recourse to any distinguishing spatial features such as monuments, buildings, or grottoes. Mona Ozouf notes that revolutionary space was presented as horizontal and transparent, whereas despotism was staged as vertical and often aligned with "'gothic' haughtiness."[107] Further, revolutionary spaces were presented as a combination of the body and mind, action and emotions, and freedom was staged through the trope of luminosity; in contrast, deception and disguise were emphasized through dark, shadowy recesses.[108]

In his fictional universe, Sade also exploited space for maximum pedagogic effect, turning to architecture, props, torture machines, and voyeuristic tropes in his precise staging of scenes of sexual terror. In so doing, he drew the reader/spectator into the sexual arena and into spaces that were as intimate as they were terrifying. His uncanny staging of the familiar château, convent, or boudoir refutes the traditional divide between private and public, home and forum, and allows him to transgress but also critique the social order. For example, *The 120 Days of Sodom* is set in the time of Louis XIV (1638–1715). It allowed Sade to satirize all who benefited from the king's expansionist wars: the nobility in the figure of the Duc de Blangis, who was

"at eighteen the master of an already colossal fortune which his later speculations much increased"; the church, in the figure of Bishop Duclos, who killed two children for their money; the law, in the magistrate Président de Curval, to whom "all that remained . . . was the depravation and lewd profligacy of libertinage"; and finance, in the banker Durcet, who poisoned his mother, wife, and niece to inherit their fortunes.[109] The château setting is crucial to Sade's exposé of these characters, both in its courtly detail, from textiles to mirrors, and in the overarching theme of exposure.

The main hall in which the storytelling, sexual acts, and "corrections" occur is amphitheatrical and has "four niches whose surfaces were faced with large mirrors, and each was provided with an excellent ottoman; these four recesses were so constructed that each faced the center of the circle"; also in this space was a suspended throne, to allow the storyteller to be "placed like an actor in a theatre."[110] The reader is part of this scenario too, poised ready to observe a spectacle, as the painstaking details of the architectural design, even where the textual syntax itself is excessive, make the sense of an enclosed and all-seeing space palpable. For example, the detailing of the columns on either side of the throne is described by Sade as "designed to support the subject in whom some misconduct might merit correction," and soon their purpose is made "real," as acts involving the smearing of a young girl with honey and excrement, and the burning of her buttocks soon follow.[111] The body and brutal acts on it are reduced to ornamental details in a setting designed for a relentless philosophical schema, but it is the relentless detail and tone that allow the reader no escape. We witness the marriage of architectural design and libertine philosophy as Sade stages a communal experience, but one that is hidden from the public, moralizing eye.

Sade's description of architecture should also be appreciated for its accuracy. In Jean-François de Bastide's libertine novella *La petite maison* (*The Little House*, 1758–62), the decoration and arrangement of rooms are carefully staged for sensual, scenographic effect in the tale of the downfall of the virtuous Mélite at the hands of the Marquis de Trémicour in his house. In Bastide's novella, the boudoir is described as "a place than needs no introduction to the woman who enters, her heart and soul recognizing it at once"; its decoration is very much in keeping with the libertine novel, especially in the penchant for mirrors and atmospheric lighting: "The walls of the boudoir were covered with mirrors whose joinery was concealed by carefully sculpted, leafy tree trunks. The trees, arranged to give the illusion of a quincunx, were heavy with flowers and laden with chandeliers. The light from their many candles receded into the opposite mirrors, which had been purposely veiled with hanging gauze. So magical was this optical effect that the boudoir could have been mistaken for a natural wood, lit with the help of art."[112] This is the domestic space set up by Sade for a "philosophy

19. Jean-Honoré Fragonard, *Les curieuses* (*Curiosity*), oil on panel, ca. 1775–80.

in the bedroom" in which he stages virtue against vice, refashioning the home just as Bastide did through a new "tactility of taste."[113] Sade takes the typical intimate and voyeuristic space of eighteenth-century fiction—which, Darnton demonstrates, extended to political pamphlets that slandered public figures (*libelles*)—to a more open, libertine aesthetic.[114] *Libelles* often took the reader inside the secret recesses of Versailles, but Sade does not stage his reader behind half-closed doors, curtains, or peepholes, as famously visualized by Jean-Honoré Fragonard (1732–1806) in *Les curieuses* (*Curiosity*, 1775–80) (fig. 19).[115] Rather, Sade brings the reader center stage, creating the sensation of terror in the round. In locating sexuality and

power in private space, whether the *petite maison* or royal château, where women had traditionally been confined, Sade refuted the morals of the *ancien régime* and the new revolutionary order alike.

In three designs by Sade that are in the collection of the State Historical Museum in Moscow, and a final design in the collection of Sade's descendant in Paris, Elzéar de Sade, we find his ideas for a libertine's lair. Alexandre Stroev has noted that these sketches reinforce the idea that Sade was intrigued by elaborate structures and systems.[116] One shows a central, oval room at the center of a labyrinth-like form, while his third drawing seems to be his design for a brothel, as it has three focal stages to it, each labeled accordingly: *entrée, Maison d'arrêt, Cimetère* (entrance, prison, cemetery) and supported by the figures "400 + 400 + 400," indicating it may accommodate 1,200 victims (fig. 20).

Rooms in the central hemispherical plan have labels to denote specific sexual purposes: whipping and fucking with all sorts of instruments ("on fouette avec toute sortes d'instrument"), or fucking with the penis ("on fouette avec verges"), or fucking in the ass and mouth ("on fout en con et en bouche"), or fucking fat women specifically ("on fout les femmes grosses"). Curiously, they all are mapped out horizontally—there is no hierarchy to these cells for sexual torture, and their purpose is transparent. The final version of the design increases the number of victims to 1,600.

Sade's designs seem contemporaneous with his equally well-orchestrated *The 120 Days of Sodom*, but they may be compared to architectural treatises and debates of his day. They are contemporaneous with Claude-Nicolas Ledoux's scenographic plan for a "maison de plaisir" for Montmartre in Paris in his 1804 treatise "Architecture Considered with Respect to Art, Customs, and Legislation" (fig. 21). Ledoux's plan had

20. D.A.F. de Sade, unpublished drawing of a brothel, date unknown.

21. **Claude-Nicolas Ledoux, elevation, section, and plans of Oikema [House of Sexual Instruction], from** *L'architecture considérée sous le rapport de l'art, des moeurs et de la législation* **(***Architecture Considered in Relation to Art, Morals and Legislation***) (Paris: H. L. Peronneau, 1804), vol. 1.**

distinct quarters for administration, workers, and factory, which are comparable to Sade's distinct groupings.[117] Both also share a similar metaphoric approach to space—an "architecture parlante" (speaking architecture), as critic Léon Vaudoyer termed it in the nineteenth century.[118] Ledoux's visionary design for the city of Chaux, with a phallic Oikema building intended as a space for pleasure or "Temple Dedicated to Love," made sexual satisfaction a core element in the utopian city's design. Unlike his libertine contemporary, Ledoux envisaged vice as a means to instill virtuous behavior in his utopian project rather than to destroy it; he attempted to re-orchestrate society through a classicizing but also gendered architectural space. Ledoux envisaged sexual spaces as arenas for the purging of passions, allowing men to explore, educate, and unleash their depraved fantasies but not to infiltrate other areas of the city or society.[119]

Such cloistering was not unlike Ledoux's realized project Hôtel Guimard (ca. 1770) in the rue de la Chaussée d'Antin in Paris. This was designed for Mlle Marie-Madeleine Guimard, a dancer at the Académie royale de musique, and her lovers and patrons Benjamin de la Borde, a tax farmer, and the Prince de Soubise, on the Chaussée-d'Antin. It had a theater above its entrance, was large enough to house five hundred people, and was decorated with wall panels by Jean-Honoré Fragonard, as well as elaborate grille-work and red taffeta wall coverings. The architect François Blondel wrote that the design of the rooms "suggest the interior of the Palace of Love, embellished by the Graces."[120] Certainly such design ensured discreet encounters, and the spectator's privacy, and reflected how the theater spoke to pleasure and danger at once. Sade refuses to hide his orgies in the shadows, even if he nods to this culture. In *Philosophy in the Bedroom* (1795) he describes houses of pleasure for women: "houses intended for women's libertinage and like the men's, under the government's protection: in these establishments there will be furnished all the individuals of either sex women could desire, and the more constantly they frequent these places the higher they will be esteemed."[121] This forms part of his revolutionary reeducation of Eugénie in the novel and supports his call for the liberty of womankind quoted in the epigraph at the beginning of this chapter: "O charming sex, you will be free: as do men, you will enjoy all the pleasures of which Nature makes a duty, from not one will you be withheld. Must the diviner half of humankind be laden with irons by the other? Ah, break those irons: Nature wills it."[122] Paradoxically, the exactness of Sade's imaginary architectural spaces sets boundaries on the reader's experience in orchestrating his/her experience of them, while still insisting that there are no boundaries when it comes to the acts being witnessed. They stage the end to an era of decadent, covert pleasure, exploiting the power of spectacle and the body with in it. As Thomas Kavanagh comments, "Militantly materialist, Sade places the pleasure-seeking body at the center of his chronicles of cruelty."[123]

The Spectacle of Sex

The influence of theater on Sade informs how we read his staging of woman, especially as it differed so much from conventional ideas on theater. In "Letter to d'Alembert on the Theatre" (1758), Rousseau lauded the festival as a public art form instead. His proclamation on the merits of the spectacle was often cited during the Revolution: "What! Ought there be no entertainments in a republic? On the contrary, there ought to be many. It is in republics that they were born, it is in their bosom that they are seen to flourish with a truly festive air. . . . It is in the open air, under the sky, that you ought to gather."[124] Rousseau looked back to antiquity—notably the festivals of Sparta, in his faith in their potential for moral education, and the rhetorical tone of his text

22. First plate in Marquis d'Argens,
Thérèse philosophe **(1748), vol. 1.**

reinforced his view that public festivals were the best form of spectacle for the new French Republic, as they were staged in the open air, bring the people together in the light, rather than in a dark theater box. Indeed, the festival need not show things, for it allowed the spectators "become an entertainment to themselves; make them actors themselves."[125] At the same time, Rousseau contended that only military fêtes or those organized by the state would succeed in their moralizing mission; theater must remain subject to the state, just as the citizen must, for the good of the people.

Diderot's stance on the theatrics of the artwork is equally pertinent to our appreciation of Sade's iconoclastic stance on performance and sexuality. Diderot demanded the exclusion of the spectator from the scene, theatrical or painterly. In "Discours sur la poésie dramatique" (1758), he promoted the necessary distance between the work of art and the audience—the willing suspension of belief or use of an imagined curtain, or "fourth wall," as we would now term it, and advised the writer and actor to behave as if no audience were present. He increasingly took on the guise of paternal censor in his writings, insisting on the need for detached aesthetic appreciation. If in his imaginary philosophical dialogue *Le neveu de Rameau* (*The Nephew of Rameau*, written 1761–74, published in French in 1821) we find a man who admits that he liked "to see a pretty woman" and "feel in [his] hand the firmness and roundness of her bosom," in his *Pensées détachées sur la peinture* (*Detached Thoughts on Painting*, 1776), Diderot expressed a suspicion of the erotic work of art: "It

seems to me that I have seen enough of teats and buttocks; these captivating objects thwart the emotion of the soul, by disturbing the senses."[126] Diderot fears the danger of art for the youth of France, as it might "give [his daughter] ideas and be the ruin of her" or "might corrupt his son."[127] Sade was familiar with Diderot's writings on theater and art. As mentioned at the outset of this chapter, in the summer of 1772, he staged Diderot's *Le père de famille* in his personal theater in his château at Lacoste.[128] But in contrast to Diderot and his promotion of a *théâtre à these*, Sade aimed to destroy the fourth wall and to immerse his readers in his world of amoral *jouissance*—especially the young. He makes this clear in the beginning of *The 120 Days of Sodom* when he writes, "[F]riend-reader, you must prepare your heart and your mind for the most impure tale that has ever been told since our world began. . . . Many of the extravagances you are about to see illustrated will doubtless displease you, yes, I am well aware of it, but there are amongst them a few which will warm you to the point of costing you some fuck, and that, reader, is all we ask of you; if we have not said everything, analyzed everything, tax us not with partiality, for you cannot expect us to have guessed what suits you best."[129]

Sade's Female *Philosophes*

In the libertine novels, Sade's females are either the victims or instigators of extreme cruelty, and their variety permits Sade to embody various philosophical arguments. The brutal sexual torment of the virtuous Justine may be read as a parody of Rousseau's Sophie in *Émile* (1762); the story of her debauched sister Juliette may be read as a retort to Aristotle's *Ethics*, as he argued that one becomes virtuous in doing virtuous deeds whereas she becomes all the more evil in doing vice. She follows such heroines as Thérèse in *Thérèse philosophe* (1748), whose free-thinking began in childhood, when at the age of nine or ten she would play with other children, boys and girls. Their games often involved one pretending to be the Master of School, "the slightest fault punished by the whip."[130] A plate in the first edition of *Thérèse philosophe* illustrates this crucial detail in her sexual formation: in it the children's fashionable dress and angelic faces are markedly at odds with their masturbatory play, while the reader's voyeuristic pleasure is emphasized both by their framing in a private attic space and their being seen by a figure from a ladder below (fig. 22).

Thérèse philosophe recounts the challenge set to a young Thérèse by an Abbé T. that she must resist masturbating for fifteen days, and despite the lure of libertine library, in return for the preservation of her virginity. Her fall comes through words not actions, as the literature (the mind) overpowers the flesh (body) in keeping with traditional male-female hierarchies. In contrast, Juliette debunks this system and refuses to be torn in the face of vice. Indeed, she employs quintessentially male and revolutionary imagery

as she claims her libertine way: "Concentrated upon a single point, my passions are like the sun's rays a magnifying glass collects into focus: they straightaway cinder the object in their path."[131]

Such rhetoric spoke powerfully to the age and its concern with the status of woman. This period saw a shift in women's rights: they literally seized their political voice in the streets, marching on Versailles in October 5, 1789, to demand bread and reform and to return the king to Paris, where he could live under the people's surveillance. The representation of women's role in the public sphere was never more political, though its reception varied considerably according to the politics of the writer. For Edmund Burke, women's role in the same "October Days" or "October march" was to be deplored not applauded. In his antirevolutionary *Reflections on the Revolution in France* (1790), Burke describes this challenge by several hundred women to the king in monstrous terms as "all the unutterable abominations of the furies of hell, in the abused shape of the vilest of women."[132] His favor falls instead on Queen Marie Antoinette, whom he describes in the same passage in titillating terms as half-naked as she flees her intruders' bayonets.

Popular iconography of the young revolutionary Marianne in prints, pamphlets, and paintings emphasized her youth and fertility through flowing hair and bare breasts. Richard Sennett has documented her role as a persuasive political metaphor, representing "revolutionary nourishment" that was generous and accessible to all: her image invoked the maternal (the lactating breast) and the virtuous (never displaying any lasciviousness, but rather invoking images of the Virgin Mary).[133] Her sexuality remained emphatically controlled, to emphasize its productive rather than self-satisfying or decadent natures. As the official imago of the new French state, Marianne stood in contrast to the images of Marie Antoinette in *libelles* in the 1780s. The latter was typically presented as flat-chested, and as a negligent mother who encouraged her young son, the dauphin, to masturbate in front of her and her lesbian lover (thus risking her son's mental and physical health, as masturbation supposedly led to loss of sight and strength). The *libelle* titled *Essais historiques sur la vie de Marie Antoinette* (Historical essays on the life of Marie Antoinette), first published in 1781 but republished many times before her execution in October 1793, accused Marie Antoinette of lesbianism; having an affair with Louis's youngest brother, the Count of Artois; and wasteful spending. In a 1789 edition of the same *libelle*, she was accused of poisoning her son the dauphin, who died of tuberculosis that year. Other slanderous and pornographic pamphlets included the sixteen-page pamphlet *Le godmiché royal* (The royal dildo, 1789), in which Louis XVI (1754–93) was described as impotent and homosexual, and *L'autrichienne en goguettes ou L'orgie royale* (The Austrian bitch on the rampage, or The royal orgy, 1789) which depicted him falling asleep after

Ma Constitution.

23. *Ma constitution* (**My Constitution**), print, ca. 1790.

too much champagne, leaving her free to frolic with his "obliging brother."[134] Although written by what Darnton has described as Grub Street–type authors in London, Amsterdam, or Germany, they circulated in large numbers in Paris and proliferated after 1789, reminding us of their very real role as political platform.[135]

These pamphletary fictions pretended to harbor political truths and even leads from real secret political sources, couching the queen's sexual favors in supposedly real political plots.[136] In 1790–91, her relationship with the Marquis de Lafayette (Marie-Josèph du Motier, 1757–1834), the liberal royalist who was made commander of the National Guard in 1789 and fled France with the fall of the monarchy in 1792, fueled further salacious images and texts. This is exemplified in the revolutionary pamphlet *Le bordel patriotique institué pour les plaisirs des députés à la nouvelle legislature* (*The Patriotic Brothel Founded by the Queen of the French for the Pleasure of the Deputies of the New Legislature*, 1791), where the queen, Lafayette, and Jean-Sylvain Bailly (1736–93), the politician who became the mayor of Paris following the fall of the Bastille, enjoy a threesome in which Lafayette moans, "What divine pleasure! What a joy to fuck and be fucked at the same time!," and the Queen urges, "Courage, my friend, don't pull out: thrust ahead!" The text was rumored to have been written by Pierre Choderlos de Laclos, author of *Dangerous Liaisons*, with the support of the Duc d'Orléans, who had his eye on the leadership of Paris.[137]

The print titled *Ma constitution* (My Constitution) was equally slanderous in its fusion of the corrupt erotic body and body politic: the queen perches on

her sofa with splayed legs as Lafayette places one hand on his loyal heart and the other on her pudendum (fig. 23). Her political status is mockingly confirmed by the words under her sex—*res publica*, Latin for "the Republic" and a pun for "public thing," and a cheeky putto to the right who knocks a crown off a royal orb adorned with three fleurs-de-lis. Lafayette's pose indicates his taking of an oath to the queen, but his sexual excitement is also indicated to the right of the vignette as underneath the globe, a bas-relief in the decorative panel depicts an erect penis.[138] Furthermore, the title is both a sexual and political pun: the *con* of the French *constitution* and the French slang for "idiot" and "cunt." Another print, titled *L'âge d'or* (*The Age of Gold*), offered a more explicit staging of the same sexual-political slur: a mounted officer of the National Guard (alluding to Lafayette) holds out a bouquet of roses to a woman (alluding to the queen), but his mount is an erect penis rather than a horse, and one that excitedly spurts ejaculate into the air. The tail and rotund torso of the phallic horse further alludes to the queen in its resemblance to an ostrich, or *autruche* in French, which puns on *Autriche*, "Austria," the queen's native country; Marie Antoinette was often caricatured as "la poule d'autruche."[139] The uniform and excited phallus allude to Lafayette again as protector of the queen and her sexual needs. The excited man-Priapus was frequently employed in pornographic prints between 1790–91 to specifically denote the unsophisticated but ever ambitious Lafayette.[140] To quote Chantal Thomas, Marie Antoinette was nothing less than the "Queen of Vice for the lampoonists of the eighteenth century."[141]

Given this context, the theme of motherhood, which lies at the heart of Sade's *Philosophy in the Bedroom*, becomes all the more politically contentious. In contrast to the nourishing Marianne or Rousseau's good mother Sophie in *Émile*, Sade only terrorizes and tortures the mother in the figure of Madame de Mistival. Her daughter, Eugénie, ecstatically tortures her in the finale of the novel, calling her "an abominable creature I have long wished to see in her grave."[142] The reader witnesses a veritable matriphobia.[143] Eugénie stitches closed her mother's vagina, the very sign and symbol of motherhood, turning the domestic handicraft of sewing, a symbol of virtuous femininity, into a weapon. By contrast, Madame de Saint-Ange, who is twenty-six and the mistress of Eugénie's father, represents Sade's ideal mother: she has only contempt for the bonds of family and ordered this final torture on Madame de Mistival. She also instructs Eugénie at length on how to enjoy a sexual life without the reproductive risk (discussing contraceptive devices and abortion), again implying a new type of liberated woman. For Angela Carter, *Philosophy in the Bedroom* recounts a daughter's "triumph over her mother" and all that sexually repressed women stood for.[144] Carter reads the short novel as an exploration of the Oedipal dynamic between daughter and mother and the liberation of the younger woman from the reproductive function—the mother's torture and death

symbolize Eugénie's own reproductive body too.[145] In this way, Carter proposes, Sade "put pornography in the service of women, or, perhaps, allowed it to be invaded by an ideology not inimical to women."[146]

Sade disfigures the female genitalia again in the story of Justine. This occurs in the castration of Rodin's daughter Rosalie and also when Justine is raped and sewn up and raped again by Saint-Florent in a cruel mimicry of the loss of virginity. Where Eugénie's mother dies from her torture, Justine is constantly resurrected to face further, worse, torture. Nancy Miller argues that this scene reinforces Justine's doomed status as female victim and the "vicious circle" that frames her story of endless violation.[147] It allows Sade to present a universe in which the death of God is reinforced by the cruel torture of those who call on him.[148] Sade's focus on the bad mother and his advice that society must prescribe a new way of being to its daughters, and by extension that daughters must listen and abandon virtue, is certainly taken to its logical conclusion in this finale.

Marat, Man of the People

By the time Sade penned *Justine*, he had undergone a radical change in appearance and status. Far removed from Van Loo's delicate portrait drawing of 1760–62, he had morphed into a corpulent, pallid, and supposedly sexually insatiable ogre. For Sade's biographer Gilbert Lely, his writings became an extension of this abject figure, a purging of his pornographic imaginings, as evidenced in reports of Sade's frantic production of *The 120 Days of Sodom* on a twelve-meter roll of paper in "twenty evenings of work, from seven to ten" in October–November 1785.[149] The lack of fresh air and exercise for prisoners that characterized life in the Bastille adds to this wretched profile. For example, Lely notes that exercise in the Bastille "could be taken either on the top of the towers, or in the first inner quadrangle" but that the towers offered the only chance to breathe fresh air, as the quadrangle was enclosed by walls over one hundred feet high without any opening in them and was either bitterly cold in the winter or like an oven in the summer; Lely supports this fact by citing the prison memoirs of journalist Simon-Nicolas-Henri Linguet (1736–84) written prior to his guillotining on June 27, 1794.[150]

The significance of the architecture of the Bastille, and Sade's limited access to fresh air, lends weight to the revolutionary nature of his rebellious activity there: in the summer of 1789, from the towers of the Bastille, Sade called on passers-by on the rue Saint Antoine to revolt. The Bastille log book of July 2, 1789 states, "A number of times the Comte de Sade shouted from the window that the Bastille prisoners were being slaughtered and would people come and rescue him."[151] This led the governor Bernard René Jourdan de Launay (1740–89) to write a letter of complaint to Lord de

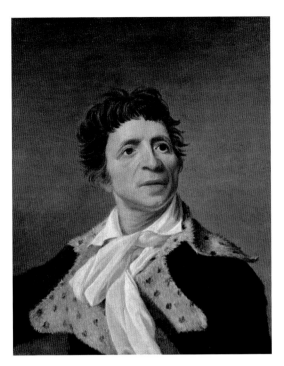

24. Joseph Boze, *Portrait de Jean-Paul Marat*, oil on canvas, ca. 1793.

Villedeuil, minister of state, warning "it seems very dangerous to have this man here, where he will tend to be detrimental to good service. I feel it my duty, Sir, to suggest that it would be most advisable to transfer this prisoner [Sade] to Charenton, or some such establishment, where he could not disturb order, as he constantly does here."[152] Needless to say, Sade's access to the towers for his daily constitutional was soon denied. Indeed, De Launay's letter was presented by Sade to the Committee of General Safety and the Rule of the People in defense of his revolutionary virtues. This was on November 26, 1793, on the eve of his being prosecuted and imprisoned for "moderantism"—that is, for holding political beliefs officially deemed too moderate and wanting to "appeal to the People" as the early optimism of the French Revolution gave way to the extreme violence and ideological rigor of the Terror.[153] As Lely documents, Sade also cited the report of another warden, who claimed that Sade used a "long tin plate pipe at one end of which was a funnel" to amplify his protest to the people. In a statement on June 24, 1794, defending his political conduct, Sade claimed his protest was also to "save" the people; Sade cited a warden named Lossinote who reported theatrically that Sade's handcrafted megaphone allowed him to yell out until "he gathered quite a crowd, then poured out vituperation of the Governor and called on the citizens to come to his aid."[154] Hence in writings and in everyday life, language became Sade's sole revolutionary weapon.

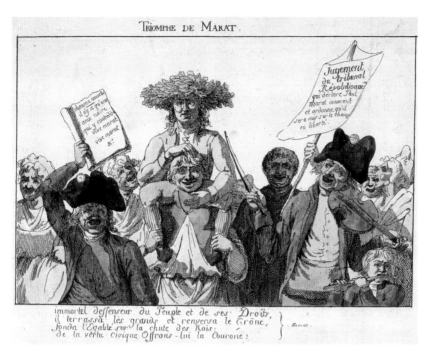

25. *Le triomphe de Marat* (*The Triumph of Marat*), **etching with watercolor, 1793.**

Jean-Paul Marat (fig. 24) was also far from a traditional heroic figure. He was typically painted in tragic terms, and his body was characterized as abject in texts and images documenting his life. His likeness was often presented in passive terms because of his willingness to submit to trial by the Revolutionary Tribunal to save his name as a friend of the people, but also because his poor health contradicted the virile image of revolution and the need to harness violence for Republican ends. Marat was elected a deputy to the National Convention, for Paris, on September 9, 1792, joining Robespierre, David, and Danton, but the Convention was then increasingly split between moderate and radical factions. Marat was accused of using his newspaper *L'ami du peuple* to incite the so-called September massacres of 1792, in which many of the moderates known as Girondins perished, and when he was charged with treason on April 24, 1793, for calling for the guillotining rather than the trial of the king, he was acquitted thanks to the support of the radical Jacobins, Commune, and Cordeliers. Upon his release, he was triumphantly carried on the shoulders of the people from the Palais de Justice to the Jardin des Tuileries, as shown in many contemporary prints (fig. 25). Soon after, the Girondins were suppressed—arrested, imprisoned, and executed or forced to flee Paris, many seeking refuge in Caen.

Marat had a blistering and burning skin condition caused by a rare skin disease that covered his body and scalp and was only relieved by regular baths

26. Brars, *Charlotte Corday*, pastel on paper, 1793.

and dousing with towels soaked in vinegar. This problem explains his physical state when he was murdered and the partially naked image that would characterize his portrait in death by Jacques-Louis David, as I shall explain below. Marat's martyrdom was made all the more splendid by his refusal to let corporeal pain distract him from his writings, his republican duty, and his willingness to meet with the people, as proven by his last and fatal rendezvous. Indeed, his brutal finale became crucial to his cult, allowing for the pathos of death at the hands of the young and pretty Charlotte Corday, whom any fit man could presumably have easily subdued (fig. 26).

Corday, who was a sympathizer of the Girondins from Caen, came to Paris on July 11, 1793, with the intent of assassinating Marat three days later at the Festival of Liberty on the Champs de Mars. Learning he was too unfit to attend, however—Marat's chronic skin disease was particularly painful in the July heat—Corday carried out her plan in his home. In her action, gender and politics, private space and public good came crashing together, a perfect example of the dangers that could ensue when a member of the fairer sex took things into her own hands. Jacques-Louis David visited Marat on July 12, on the instructions of the Jacobins. Like Corday, he found the politician working in his bath: "Beside him was a wooden box on which there was an inkwell and paper, and with his hand out of the bath, he was writing his final thoughts for the deliverance of his people."[155] This description would soon become immortalized in David's painting *La mort de Marat* (*The Death of Marat*, 1793) (fig. 27), which canonized an abject and feminine image of the man as political victim. It merits close attention because in many ways it reinforced the gender divides against which Sade fought.

On October 14, 1793, three months after Marat's death, David declared his painting *The Death of Marat* was finished and ready to be displayed in the courtyard of the Louvre. A month later it would be presented to the

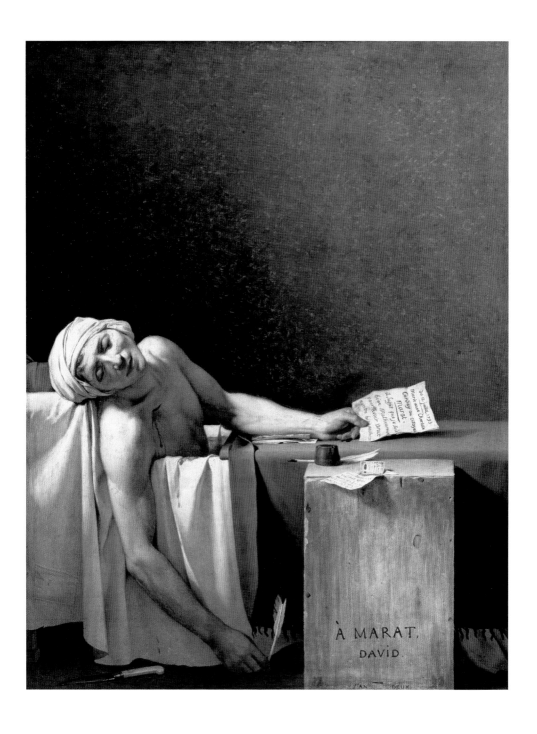

27. Jacques-Louis David, *La mort de Marat* (*The Death of Marat*), oil on canvas, 1793.

Convention. Its immediate reception was positive. The *Journal de Paris* explained, "The expressed horror . . . permeates the whole canvas, which proves that the forceful and skillful touch of the artist would not have been sufficient in itself; it needed the ardent love of country that impassions the artist. . . . [I]t is difficult to look on it for any length of time, its effect is so powerful."[156] It succeeded as a monument not just to Marat but to the Revolution itself, and by extension to David as revolutionary artist par excellence.

David's painting of Marat bears witness to a dialogue between the subject and the artist with great precision. It reflects their fraternity, their shared vision of revolution, and sense of loss. As David proclaimed in his speech to the Convention on November 14, 1793, "The people wanted their friend back, its sad voice could be heard, it prompted me to paint, it wished to see again the features of its faithful friend. . . . I hear the voice of the people, I obeyed."[157] Having become a member of the Jacobin Club early in 1790, David not only orchestrated the revolutionary festivals, he was the most influential member of the Committee of Public Instruction managing revolutionary cultural activities. As Ewa Lajer-Burcharth has persuasively argued, David was thus "almost single-handedly responsible for the invention of the symbolic language of republicanism."[158] She reads the portrait of Marat not only as a form of camaraderie but as an emphatically gendered one: David identified with Marat, who was often caricatured as effeminate and noted for his considerable female following, and saw in him a fellow figure of sociopolitical alterity. This reading is supported by a comparison of David's portrait of Marat with an effeminate self-portrait David painted the following year, after the Thermidorian reaction that marked the end of the Terror, when Robespierre was guillotined but David was spared and imprisoned in the Hôtel des Fermes in Paris between August 3 and early September 1794.[159] Marat was portrayed in popular culture as a castrative woman, reflecting his famous statement that "270 thousand heads still have to fall" to satisfy the bloodthirsty Terror; Lajer-Burcharth thus reads David's *The Death of Marat* as a reinforcement of this gendered imago that staged the journalist as a "woman of the People."[160]

David's portrayal of the dying Marat as Christ-like in his martyrdom makes him not only feminine and castrative but also sacred in his Otherness. As Thomas Crow observes, "Marat's pose, the instruments of violence, the inscriptions, the plain wood of the upright box, the insistently perpendicular compositional order, all evoke Christ's sacrifice without leaving the factual realm of secular history."[161] For Crow, the *Pièta*-like composition thus alludes to the missing female mother, allowing Marat to denote "both Christ and Mother."[162] The attention David gives to the wound on Marat's body, dripping blood onto the pure white sheet to his side further alludes to Christ's stigmata; it also reminds the viewer that the wound was inflicted by a woman who acted unnaturally, assaulting the male body. In mood and

form the painting thus invokes sacrifice at the hands of a female—that is, his calculated, bloody murder by Corday. If the secular cult of Marat demanded a calm, moralizing, neoclassical style, then the highly staged details could still allude to the brutal scenario enacted by the absent murderess. David exploited the double-sided nature of the feminine as both virtuous and an abject threat to the status quo. Arguably, this allowed him to keep interpretation open, to flatter all spectators—especially the radicalized petit bourgeoisie who identified with Marat—and to ensure his own political position was not compromised. It must be remembered that by the end of 1793, David had led the abolition of the French Royal Academy, claiming it was the "last refuge of all aristocracies" and could "no longer survive under the reign of liberty."[163] He had used his role as "dictator of the arts" to decry rococo art and royalist propaganda and to promote a stern neoclassicism on behalf of Jacobin virtues. In January 1794, David, as the president of the Convention, stated, "The arts are going to recover their dignity. They will no longer prostitute themselves celebrating tyrants."[164]

David's revolutionary position became increasingly visible in his shift from the monumental to the metaphysical in his art—notably from a triumphant male heroism, relegation of woman to the domestic space, and translation of civic and moral virtue into emotive narrative in *Les serment des Horaces* (*The Oath of the Horatii*, 1784) to the effeminate representation of sacrifice in *Marat*. If the stylistic direction of his work was indebted, as many have argued, to Johann Joachim Winckelmann's advocacy of neoclassicism in such texts as *Greek Works in Painting and Sculpture* (1755), *History of Art in Antiquity* (1763), and *Unknown Antique Buildings Examined and Illustrated* (1767), then certainly the calm expression of *Marat* resonates with Winckelmann's aesthetics.[165] David's portrait encapsulates the shift in the era of the Revolution from the celebration of religious martyrs to the celebration of political ones. *The Death of Marat* references Caravaggio's *Deposition from the Cross* (1600–1604), notably in his rendition of the limp but muscular right arm of the martyr, which literally gestures to the spectator. The secular martyr has no mourners, as the dead Christ does, but sympathy is elicited through the detailing of the traces of the event that led to his death: the quill and the inscription, on one side, and the bloodstained knife, on the other.

David presents Marat as a familiar friend, in keeping with the rhetoric of the day—"Marat, friend of the people, Marat, consoler of the afflicted, Marat father of the unfortunate, have pity on us!" These words were proclaimed when his ashes were transferred to the Panthéon on September 21, 1794. But the lifelike quality of the face also renders it uncanny, as if it is already cast in wax.[166] David succeeded in answering the Convention's demand to "Return Marat to us whole again."[167] The portrait of Marat was intended to be a pendant piece to a portrait of Louis-Michel Le Peletier de Saint-Fargeau on his deathbed, both to be hung in the hall of

28. **Jacques-Louis David,** *La mort de Joseph Bara* (*The Death of Joseph Bara*), **oil on canvas, 1794.**

the National Convention. Le Peletier de Saint-Fargeau was a member of the nobility who had been assassinated on January 20, 1793, for voting in favor of Louis XVI's execution.[168] This painting is now lost, so we must look to another painting by David of a martyr of the French Revolution for context. One valuable comparison that further elucidates David's notable turn to the feminine for emotive and political effect at this time is *La mort de Joseph Bara* (*The Death of Joseph Bara*, 1794) (fig. 28). This painting, which is unfinished, was produced in homage to the young Joseph Bara, a thirteen-year-old drummer boy who was killed in a battle between republicans and royalists in 1793.

Bara died fighting counterrevolutionary insurgents in a battle in the Vendée. His heroism was not only brought to the attention of the Convention, it was lauded by Robespierre as an example of "filial love" and "love for the country."[169] In David's painting we witness the boy's limp, nude body twisting with pain and his last dying breath. It is a painting devoid of grand narrative, where the historical action occurs only in the wings, to the left of the composition, and where the nude body and parted lips of the boy render him more like an angel than a warrior. His vulnerability is emphasized by the hard ground beneath him, by the manner in which he seems to be within the spectator's grasp and yet not, in the fact that he will die as he was born, naked and with a gasp for air. He is caught by David in a state of metamorphosis, between flesh and spirit.

29. **Henry Fuseli (Johann Heinrich Fussli)**, *The Nightmare*, **oil on canvas, 1781.**

The principle of metamorphosis governed David's oeuvre by the late 1770s, and he was increasingly drawn to the antique for inspiration.[170] Known to be influenced by the writings and ideas of Diderot, David drew from his ideas on the configuration of the body and his definition of gesture as face and body combined in the *Encyclopédie*. In their respective readings, Crow and Alex Potts view Bara's androgynous form as offering a new sense of male heroism. Crow reads David's painting of Bara as an example of "idealized, ecstatic nudity" that has been broken and thus sexually neutered: "His response was to take the boy's body and break it in two, simultaneously to figure its suffering and to downplay its sex. The body of Bara is twisted unnaturally at its center."[171] Potts contends that "the 'manly' phantasies about a heroic public life played a key role in the public politics of the 'radical' Jacobin phase of the French Revolution."[172] He also notes the political reality of the Terror, when no one was safe: for this was the summer of a new law of June 10, 1794, when juries could convict on "moral certainty" alone; this was the beginning of the Great Terror that took 1,376 lives in just under seven weeks.[173] In other words, the lone, vulnerable, child victim speaks to mass arrests, murders, and the call for more boy-martyrs, as well as David's commitment to sacrifice in the name of republicanism. It reflects Robespierre's speech in which he emphasized Bara's innocence and sacrifice, claiming his dying words were "Vive la République" in defiance of his murderers' demand that he say "Vive le roi."[174] But David's image of

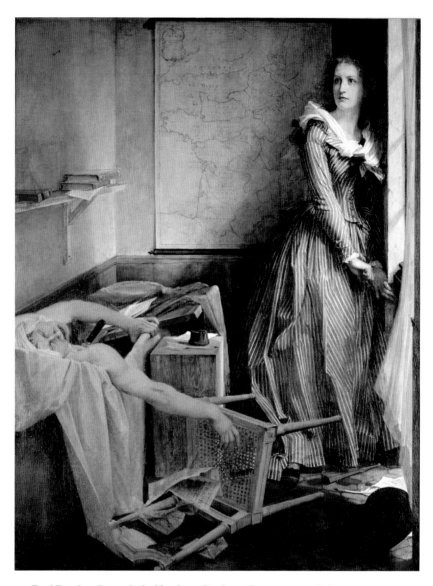

30. Paul Baudry, *Portrait de Charlotte Corday*, oil on canvas, 1858.

Bara's heroism was a feminized one: the heroism of a child remaining loyal to the fair France, or Marianne, rather than the brutal king, or Louis XVI. In his speech to the National Convention calling for the commemoration of Bara and Agricola Viala, on July 11, 1794, David reminded his audience of the role of each in the Republican family. He particularly advised women to "serve the empire that nature had given you" by bearing republican children, and he spoke of Bara, the boy-soldier, as sharing the virtues of Liberté.[175] This reading is supported by Hunt's observation that the Revolution's focus on young heroes supported the rejection of father figures—the child replaced the father, the boy replaced the man.[176]

The shift from a dynamic virility to an effeminate masculinity, reflected the political changes of the era and demonstrates the centrality of gender for political rhetoric and propaganda. It informs the empathically uncorporeal rendition of the male republican martyrs Marat and Bara, and the emphatically corporeal depictions of the fallen female republican, Corday, as I will explain presently. It also speaks to David's refusal to honor Corday's actions in his portrait of the dying Marat, reducing her act of violence to a letter in the composition instead. Helen Weston observes that he did this "to identify Corday with a private dimension of writing, rather than with the public arena of heroic and political action. In eighteenth-century French art a letter most often signified the absent lover."[177] For William Vaughan, her suppression from the scene has psychoanalytical as well as political affect. He reads the posture of Marat's trailing hand not as a nod to Caravaggio but as a nod to the Anglo-Swiss painter Henry Fuseli (1741–1825), whom David met in Rome and who painted a reclining woman in a comparable pose in *The Nightmare* (1781) (fig. 29). As Fuseli's painting was often reproduced in prints, including satirical ones produced by the engraver Jacques-Louis Copia, who would produce prints of *The Death of Marat* for David, Vaughan proposes that the "sadoerotic" element of Fuseli's swooning woman is implied by David.[178] By extension, Fuseli's victim, who writhes in an ecstatic state of pleasure or pain, has become David's perpetrator and "David has had to suppress her."[179]

The *Femme-Homme*: Charlotte Corday

Marat's assassin, Charlotte "Marie" Corday (1768–93) was also staged in emphatically gendered terms in text and image alike.[180] She was typically portrayed as a chaste young woman and a guileless victim of her Republicanism whose mother had died when she was a child and whose father was a playwright. Yet details of Corday's tale embed her act in a particular gender politics. In July 1793, when she set out from Normandy to murder Marat in Paris, she aimed to avenge his threat to guillotine Girondins in her hometown of Caen, and she took with her only her copy of Plutarch's *Parallel Lives*. Finding Marat restricted to his bath at home because of his skin condition, she had to adapt her plan of public murder on July 14 to carry out a private murder on the evening of July 13. Having been twice denied access to Marat's home she "seduced" him with words—a letter promising to betray her fellow Girondins by providing him with a list of names. This letter secured her entry to his apartment. According to her testimony, upon hearing him declare he would ensure those on the list would be guillotined, she stabbed him above the heart, and he uttered his last words: "to me, to me, my dear friend, I am dying!"[181] This testimony begat the image of Corday as "a staunch virago," to cite Jules Michelet's nineteenth-century description of her.[182] Michelet emphasized her youth,

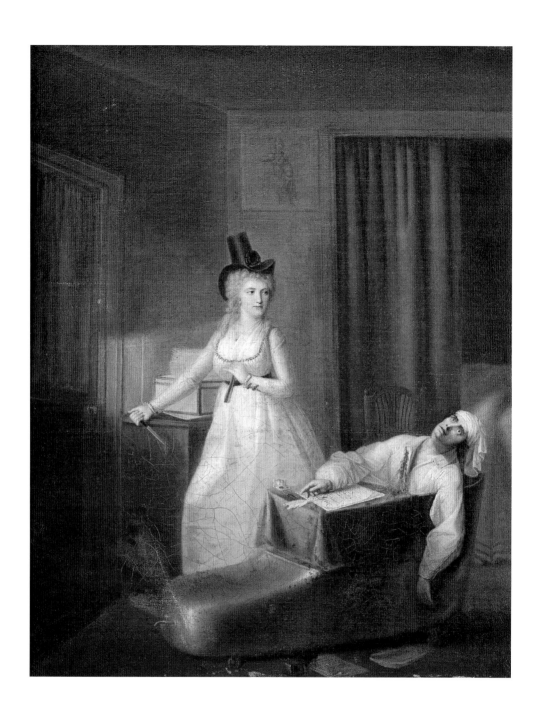

31. Jean-Jacques Hauer, *La mort de Marat, le 13 juillet 1793* (*The Death of Marat, 13 July 1793*), oil on canvas, 1794.

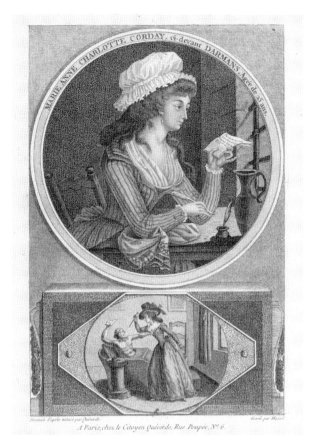

32. François-Marie-Isidore Quèverdo, *Marie Anne Charlotte Corday, ci-devant Darmans, agée de 25 ans* (*Marie Anne Charlotte Corday, before Darmans, Aged 25 Years*)**, drawing engraved by A. B. Massol, Paris, 1795.**

beauty, and noble sentiment and curiously emphasized her fair complexion and hair, in keeping with the stereotypical characteristics of virtue.

But there are elements of the typical Sadean heroine to be found in Corday's story too: when her mother died, she was sent to a convent at the age of thirteen. Michelet suggests that Corday knew she had contravened her convent education, as her letter from prison to her father opened with "Pardonn*ais*-moit, mon papa . . ."[183] The role of books in her radicalism was also emphasized. Indeed, Michelet paints a bestial image of Marat, with his "large amphibian mouth" and dirty sheet draped over his bath, as if Corday is the victim in a lewd tableau.[184] The romantic image of Corday was popular in nineteenth-century paintings and prints. For example, in Paul Baudry's 1858 study of the murder of Marat, Corday is portrayed full height by the window, with natural light illuminating her face and casting a shadow on her victim (fig. 30).

Corday's last hours seem to have ensured her imago would be that of the fallen *jeune fille*: she wrote to her father to ask for forgiveness, asked for her portrait to be made (it was duly done by Jean-Jacques Hauer), cut a lock of her hair to give to her portraitist, and even, in legend, supposedly blushed when her severed head was raised aloft after her execution and slapped on the cheek.[185] Such details suggest the pathos of her death, although other reports portrayed her as vain, claiming that she summoned a hairdresser to her lodgings just before the murder so that she could have her hair lightened and straightened. Hauer's 1793 portrait of Corday, which was exhibited at the Salon of 1794, as well as his 1794 painting of the murder scene itself, appears to give her lighter locks than her passport described, as if at pains to emphasize her vanity and duplicitous ways (fig. 31).[186]

Corday's deeds did not fit the largely passive and decorative role of women in the revolutionary era and won little support among men *or* women. The Society of Revolutionary Republican Women was vehemently against Corday, urging its members to "people the land of liberty with as many Marats as children."[187] A now famous description of Corday was also released in the *Gazette nationale de France* and reprinted for distribution by the General Council of the Department of Paris, which effectively aligned her transgressive sexuality with her political action, stating, "This woman, who they say was very pretty, was not pretty at all; she was a virago, fleshlier than fresh, graceless, unclean like almost all female wits and philosophers. . . . Charlotte Corday was twenty-five—that is, in our mores, almost an old maid—and especially with a mannish demeanor and a boyish stature. . . . This woman absolutely threw herself out of her sex; when nature called her to it, she felt only disgust and boredom; sentimental love and its gentle emotions cannot come near the heart of a woman with pretentions to knowledge, wit, strength of character, the politics of nations."[188] Corday also appeared in many popular prints. In one, engraved by A. B. Massol (17??–1831) after drawings by François-Marie-Isidore Quéverdo (1748–97), Corday is represented in a prison cell at a writing desk, facing the iron bars that entrap her (fig. 32). She holds a quill in one hand, her letter to her father in the other ("Forgive me, my dear papa . . ." visible to the viewer). Below in a vignette she appears in more monstrous terms, stabbing the naked Marat in his bath. Hence, the hand that wields the quill is also the hand that wields the knife. Her roles as political thinker and activist are brought together, both seeming to confirm her guilt.

Soon not only were women's political clubs banned, but other females who were politically active and visibly Girondin supporters met the same fate as Corday. On November 3, 1793, the playwright and political activist Olympe de Gouges (Marie Gouze, 1748–93) became the third woman during the Terror to face the guillotine, having been found guilty of coun-terrevolution. Her "Déclaration des droits de la femme et de la citoyenne"

(A Declaration of the Rights of Woman and Citizenship, 1791), addressed to Marie Antoinette, argued for a national assembly for women and for free education for women, and contended that if "woman has the right to mount the scaffold; she must equally have the right to mount the rostrum."[189] Marie-Jeanne "Manon" Roland (1754–93), who brought together political thinkers in her weekly salon in Paris, was also accused of treason and executed by guillotine five days after de Gouges. Both women, like Corday, were attacked by the patriotic press as bad examples of their sex, their guilt aligned with their ambitions to be female philosophers. The *Feuille du salut public* pilloried de Gouges, in particular, for having "an exalted imagination. . . . She wanted to be a statesman [but she has] forgotten the virtues appropriate to her sex."[190] The French Republic now banished women from the public sphere, working not simply without them but *against* them, as Joan Landes has argued.[191]

David's decision not to put Corday's image in his painting was part of this same attack on female heroism and political activism in pushing her *out* of the frame because she had transgressed her sex. Marat's wound attracts the eye and emphasizes her assault on the male, civic body through her unnatural actions, just as his attention to her letter emphasizes her unnatural position as a woman of letters and ideas. T. J. Clark reads the wounded body of Marat as chilling but abstracted: "the blood coming out of it as impalpable as thread."[192] Peter Brooks goes further in reading the wound on Marat's breast as a gendered political signifier, "a kind of displaced representation of her woman's *sexe*: her sex as wound on the martyred man. . . . The male body has been made to pay for the primal drives of the woman's body."[193] Corday's abject, infectious presence is also reinforced by Marat's dying touch on her letter: Marat has been the victim of her unnatural body and mind. In his eulogy, Sade built on the verbal and visual rhetoric against Corday as only a man of his libertine thinking and precarious political position could. In contrast to David's omission of the vengeful Corday, Sade called on artists to "smash the features of that monster, or show it to us solely amid the demons of Tartary" to keep her *in* the frame.[194] This would ensure that a "monstrosity" veiled her image forever—a monstrosity perfectly in keeping with his libertine heroines and cruel Mother Nature.

The Gendered Rhetoric of Citizen Sade

In Sade's description of Corday in his eulogy—officially titled "Speech to the Shades of Marat and Le Pelletier"—he decries the murder of Marat and Louis-Michel Le Pelletier (1760–93), a Montagnard in the Assembly.[195] His portrait of the young woman as a monstrous creature is perfectly in keeping with her popular vilification. However, by drawing attention to her and her violent act, rather than sidelining her, he manages to bring her

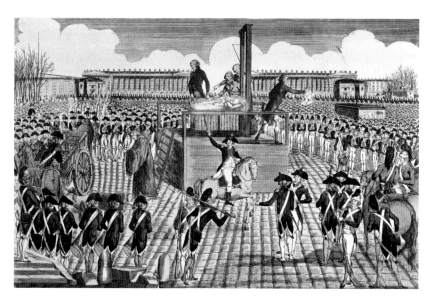

33. *L'exécution de Marie Antoinette sur la place de la Révolution, 16 octobre 1793* (*The Execution of Marie Antoinette at the Place de la Révolution, October 16th, 1793*), **engraving, 1793.**

back *into* the frame. Sade states: "Oh, timid, gentle fair sex, how could it be that your delicate hands could take up that dagger? Ah, but the tomb of that true friend of the people has made us oblivious among you. . . . Let funeral veil hide her memory forever, let nobody ever more depict her, as has been done hitherto, under the seductive sign of loveliness. Too credulous by far, you artists destroy, deface, smash the features of that monster, or show it to us solely amid the demons of Tartary."[196] He portrays Corday as a fiend and emphatically abject, her act, sex, and misery all rolled into one amorphous, if not contaminated, mass. Sade's description of her as an unsexed creature was not dissimilar to the wider rhetoric that surrounded her image and reputation, and was attuned to the views of his audience: "Marat's barbarous assassin, like those mixed beings whose sex is impossible to determine, vomited up from hell to the despair of both sexes, directly belongs to neither."[197] His emphatically monstrous portrayal of Corday was also perfectly in keeping with his libertine philosophy, as she was seen to have broken the mold of the fairer sex. Corday is comparable to his female viragos: she forcefully defies the dominant teachings of church, family, and state as Sade's phrase "vomited up from hell" suggests—the verb "vomit" implying that her person and acts were visceral responses to a sickening regime.

Sade's personal stance vis à vis the Revolution was precarious by 1793, to say the least. On July 1, 1790, he had filled out his citizen card, signing it "Louis Sade" and delivering it to his section in Paris, the Place de Vendôme, which was then renamed the Section des Picques in 1792. His acts were

rewarded by his appointment as secretary of that section in September 1792 and as its president on July 23, 1793.[198] On August 1 that year, Sade ordered landlords and tenants to paint the following statement of allegiance in front of their houses: "Unity, Indivisibility of the Republic, Liberty, Equality, Fraternity or Death."[199] And yet, the previous June, Marat had denounced Sade as a libertine and aristocrat and called for his death.[200] Thus Sade was reasonably successful in fashioning himself as "Citizen Sade" and in continuing to produce his libertine writings behind closed doors, but his eulogy for Marat was far from impartial. It was a form of self-defense as much as of homage, telling his audience what they wanted to hear about Marat and Corday and yet, for those familiar with Sade as the clandestine *philosophe*, revealing the secret Sade too. It was also one of the last eulogies read during Marat's funeral procession, which was officially choreographed with great care by Jacques-Louis David. Sade's address was timed to come just as the procession returned to the Place des Piques, having made a circular journey around the center of Paris, via the Place de la Révolution and Place de la Réunion.[201] Sade described both Marat and Le Pelletier in a fusion of revolutionary and religious imagery as "[s]ublime martyrs of liberty, already lodged in the temple of memory, whence, forever revered by men, you soar above them like the beneficent stars that light their way."[202] Such loyalty to the Revolution and defiance of monstrous femininity seemed further supported by his position on the execution by guillotine of Marie Antoinette on October 16, 1793 (fig. 33). Sade asserted in a letter to the Comité de sureté générale on May 7, 1794: "I was also there when the Austrian submitted to her just punishment," and he reminded them that he had been selected as orator for his Section des Picques for the "fête civique" of Marat.[203]

However, his notes included a jotting about the queen, quoting her as writing in the Concierge Prison, "The savage brutes who surround me daily invent some new humiliation to add to the horror of my fate." He later said about himself, "My detention by the nation, with the guillotine before my eyes, hurt me a hundred times more than all the Bastilles in the world could have done."[204] It goes without saying that Sade had become increasingly vulnerable by this time and feared his own fate as the Jacobins engineered a campaign of persecution against the nobility. As their diatribe against those they perceived as arch enemies of the Republic portrayed them as effeminate, Sade's recourse to emphatically gendered rhetoric in his eulogy for Marat was undoubtedly a careful choice. Equally, Marie Antoinette, who was convicted of high treason by the Revolutionary Tribunal, was typically portrayed in gendered and monstrous terms, not unlike Sade's depiction of Corday. For example, one print from 1791 depicted the queen as a monstrous hybrid creature, its author turning to zoomorphism for political effect as she is portrayed attached to Louis XVI, he bearing goat horns, she a headdress of snakes and peacocks.

Sade must have known his terminology would be approved by the Section des Piques. His status as "Citizen Sade" was secured, if momentarily, when his speech was sent to the National Convention and to all forty-seven other wards and societies of the people. However, Sade's twentieth-century biographers have been less impressed by his eulogy. Gilbert Lely described the speech as "the most disappointing of Sade's little political works. . . . [I]n the gush of revolutionary commonplaces such words as virtue, happiness, patriotism, and liberty are frivolously used, to express falsehood and ignorance. One might even imagine that Sade had intended the thing as a parody, some twisted sort of satire on that ghoul of the Revolution, Marat."[205] Lely reasons that, at best, Sade spoke for his ward. Certainly, Sade's language was perfectly apt for the streets of Paris in October 1793: he attempted to bring political victim and villain into the text, seizing the emotive power of Marat's funeral. Versed in theater, Sade knew how to exploit the immersive experience of public events and crowds. His personal opinion of Marat mattered little, though one cannot help but wonder at the great difference between the two writers. Marat, in his "Discours adressé aux anglais" (Speech to the English) of August 1, 1774, wrote of self-interest as a vice and had bemoaned what he saw as a loss of virtue in society: "[W]e no longer have any enthusiasm for heroism, any admiration for virtue, any love for liberty. . . . Today the art of pleasure is preferred to merit, vain pleasures to useful knowledge. For us a dancer is worth more than a wise man and a joker more than a hero."[206] In his writings, Sade shared Marat's obsession with virtue, but he never aligned it with liberty, merit, or useful knowledge.

Marat's funeral was surrounded with virtue, as his name and memory were canonized in the name of republican idealism. Before the funeral and the final placement of his remains in the Panthéon, other celebratory demonstrations also occurred: a wooden obelisk was erected in Marat's honor on the Place de la Réunion on August 18; "La mort de Marat," a new republican song extended his cult status in word and spirit: "He is our divinity / Alas! / this prodigy of prodigies / Flies to immortality"; and a pamphlet of July 26, 1793, titled *Marat, du séjour des immortels, aux français* (Marat, from the resting place of the immortals, to the French) rhetorically asked, "Could it be true then, citizens, that it takes nature many thousands of years in order to produce men of the stamp of Jesus and Marat?"[207] The streets of Paris were used as a stage in behalf of a new political regime. As David put it, "National festivals are instituted for the people; it is fitting that they participate in them with a common accord and that they play the principal role there."[208] This was emphasized through sculptures that were commissioned to embody new values: Nature was glorified in the guise of a monumental goddess with waters of regeneration flowing from her breasts on the site where the Bastille had previously stood; Liberty stood proudly at the Place de la Révolution,

where symbols of royalty were burned and birds of freedom released. The Nation was represented by a monumental figure of France as Hercules, bearing a club, at the Place des Invalides. And at the Champs de Mars, the president of the Convention brought Marat's funeral to a close in a ceremony in which each departmental delegate presented fasces entwined with tricolored ribbons. As a spectacular pilgrimage through the streets of Paris, from one symbol to the next, the funeral reinforced the iconoclasm and iconography, as well as the participatory impulse, of the new regime.

David's choreography of Marat's funeral thus allowed each section to pay its respects to Marat as if in a series of tableaux. Marat's corpse was carried through the streets, its rotting state camouflaged with white makeup and heavy perfume, until it reached the Church of the Cordeliers some six hours after setting out, where it was put on display as shown in a painting attributed to Fougeat, *Pompes funèbres de Marat, à l'église des Cordeliers, le 16 juillet* (*Funeral of Jean-Paul Marat in the Church of the Cordeliers, July 16* [1794]). In addition to the corpse being paraded on a Roman-style bier, objects that became fetishized in his murder also traveled with him—his bath, the bloody sheet that had covered him, and the knife with which Corday had stabbed him. And every five minutes the torch-lit procession was punctuated by a canon salute.[209] This was the public stage on which Sade's eulogy was delivered, the perfect stage for a man who navigated the dangerous path between citizen and clandestine, particularly enjoyed double meaning, and frequently turned to theater as a refuge in his turbulent life.

But it was not enough to alleviate political suspicion. Sade was declared a "suspect" under the Law of Suspects of September 17, 1793, his home in Paris was searched in December, and he was taken to the Madelonnettes prison. He called on the Section des Piques to come to his assistance and wrote to the Comité de sûreté générale. In his letter to the latter, dated December 29, 1793, he wrote of the Revolution in gendered terms again—calling it "my liberating goddess," and claimed his imprisonment was due to error or vengeance as "[n]one of the articles of the Law [of Suspects] can apply to me; my heart is pure, my blood is ready to be shed if necessary for the good of the Republic."[210] He also claimed that he had "thrown" an incendiary pamphlet into the carriage of the king when "it crossed the Place de la Révolution" following his arrest and forced return to Paris on June 25, 1791.[211]

Sade was moved to the Prison des Carmes and then to Saint-Lazare in January 1794 and by March a "report on the political bearing of Citizen Sade" was issued by the Committee of Surveillance in the Section des Picques that decried him as "a very immoral man, most suspect and unworthy of society."[212] The report cited several sources, including a pamphlet by Jacques-Antoine Dulaure (1755–1835) about the corruption of the nobility in which he compared Sade to the infamous satanist and child

murderer Gilles de Rais (1404–40). In his self-defense, Sade tried to deny his
nobility, claiming his suffering in prison was due to royal despotism, and
even disowning his two counterrevolutionary sons and claiming kinship
instead with his friend Madame Marie-Constance Quesnet, a onetime
actress, and her young son with whom Sade shared a modest home in Paris.
On March 27, 1794, on health grounds, he was transferred to Eugène
Coignard's Maison de Santé in Picpus. This was a refuge for wealthy
prisoners but also an escape from certain death as Sade noted in his last will
and testament when he thanked Quesnet for saving him "from the revolu-
tionary scythe."[213] He narrowly and mysteriously escaped the guillotine on
July 27, only to gain a reprieve the next day when Robespierre himself fell
under the blade at the Place de la Révolution. By October, Sade, along with
all other political prisoners, was freed.

The Divine Sade

Charles Baudelaire wrote that "one must always come back to Sade . . . in
order to explain evil," and he considered David's *The Death of Marat* to be the
painter's masterpiece, a work that was as full of horror as it was of tender-
ness.[214] For the poet, the painting stood as "one of the greatest curiosities of
modern art because . . . a soul is flying in the cold air of this room, on these
cold walls, around this cold funerary tub. . . . This painting was a gift to a
weeping country, and there is nothing dangerous about our tears."[215] Baude-
laire recognized that David's rendition of Marat went beyond the ordinary
portrait or history painting; it offered a political manifesto which insisted that
with the death of God and King, Liberty, Equality, and Fraternity lay in the
hands of man, the citizen, himself. David's image of Marat is an abstraction
of a political and philosophical position.

Sade formulated an embodied politics in his art, notably in his
iconoclastic stance on virtue, which rejected all the *dis*embodied philoso-
phies of his predecessors. If René Descartes (1596–1650) presented the
body as a reactive organism and site of passion in *Les passions de l'âme* (*The
Passions of the Soul*, 1649), disavowing the senses, then Sade insisted we revel
in the senses and allow them to dictate our thoughts and actions alike. In
his libertine writings, Sade rejected the hierarchy of man and beast,
imagining man (and woman alike) reduced to a body-machine. Following
the naturalized and scientific hedonism of Julien Offray de La Mettrie
(1709–51), Sade refused to abstract the flesh and terror itself.[216] Sade's
"philosophy in the bedroom" promoted a body that defied good taste and
all its attendant religious and sociopolitical moral codes and advocated a
radically libertarian society regulated by nature instead. Here government
and law would have a nominal role, and the institutions of family and
church would be banished.

Sade's monstrous portrayal of Corday in his eulogy for Marat further reflected this radical stance as he again substantiated her political act in visceral corporeal imagery. As with his fictional world, he elicited a sensorial response, trying to draw in the crowd so that terror became palpable. His words and tone, and his insistence on bringing the figure of Corday viscerally into his eulogy, might even be said to give a voice to Corday; he undoubtedly brought her back into the picture and scene of the crime. If, as Hunt has written, "[t]alk was the order of the day" from the collapse of the French state in 1786 through the mid-1790s, then Sade's "philosophy in the bedroom" used "talk" to propose a radical new order.[217] His emotive language opposed the previous regime's cold, clinical discourse but also the dominant, acceptable image of the fairer sex.[218] In place of the cult of male heroism and fraternity witnessed in the Revolution, Sade offered the libertine heroine who initiates and inculcates younger women into her world. And in place of the violence of the public forum and crowd he offered the violence of the private boudoir and the named individual.

Sade thus not only staged a subversive assault on the eighteenth century's long obsession with virtue and vice and its attendant gender norms; he offered a radically alternative role for woman as a harbinger of change. His faith in the power of literature to have a central role in challenging attitudes is reflected in *Juliette* in the words he crafts for Saint-Fond, Juliette's ally, who uses his power as a minister to allow libertine philosophy and oppose censorship: "[T]he publication and sale of all libertine books and immoral works [is] instrumental to the progress of philosophy, indispensable to the eradication of prejudices, and in every sense conducive to the increase of human knowledge and understanding."[219] This position, which is also that of Sade himself, clearly challenges Sade's censors and readers alike to be brave and open-minded when it comes to the power of the imagined world.

Surrealist Sade

The Marquis de Sade, the freest spirit that ever lived, had specific ideas on women and wanted them to be as free as men.

GUILLAUME APOLLINAIRE, *L'œuvre du Marquis de Sade*, 1909

Surrealist art invariably oscillated between Eros and Thanatos, the life and death drives. Eros drove the surrealists' constant return to the sensual, convulsive body, and Thanatos to the violated, fragmented body. This movement between *érotisme* and *érotisme noir* was crucial to their understanding and celebration of freedom; it was also crucial to their framing of the Marquis de Sade as an icon of liberty. In the first Surrealist Manifesto of 1924, they wrote, "De Sade is surrealist in sadism,"[1] and throughout the long history of the movement and right up to the late 1960s, they embraced him as part of the movement's pursuit of desire and love, allowing both to expand to extremes.[2]

In this chapter, I focus on the representation and rehabilitation of Sade in the interwar period, when surrealism consciously fashioned its own position as a collective, revolutionary force. In the first half, I examine the crucial role of Guillaume Apollinaire, Robert Desnos, and André Breton (fig. 34) in bringing Sade's life story and work to the avant-garde. I counterpoint Apollinaire and Desnos's heroic vision of the libertine with Breton's more cautious promotion of a "dignified" vision of libertine desire and writing. I also discuss the role of Sade's biographers, Maurice Heine and Gilbert Lely, who were part of the surrealist circle and who presented Sade as a sexologist and avant-garde hero in their analyses. The second half of this chapter focuses on the Sadean imagination in surrealist visual art in the 1930s through the examples of Man Ray and André Masson. Their assault

34. André Breton sitting beside Clovis Trouille's painting *Remembrance* (1930), Paris, ca. 1946.

on the classical body, whether through Man Ray's use of the close-up or Masson's blood-red palette, materialized the Sadean imagination as if answering Sade's call to fellow artists in his "Notes on the Novel," in which he urged, "All the passions and vices must be known."[3]

Sadean Liberty or Love: Apollinaire, Desnos, and Breton

It was perhaps inevitable that Sade and surrealism would be aligned, given that the term "surrealism" was coined by a writer of Sadean texts— Guillaume Apollinaire. He used the word for his nonsensical play *Les mamelles de Tirésias* (*The Breasts of Tiresias*, 1917), aligning the term with a "new spirit."[4] Apollinaire published his own analysis of Sade in *L'œuvre du Marquis de Sade* (1909) as well as novels in homage to Sade's *The 120 Days of Sodom*, which had been published in France in 1904. These novels included *Les exploits d'un jeune Don Juan* (*Memoirs of a Young Don Juan*, 1911), featuring a promiscuous sixteen-year-old protagonist, Roger, and *Les onze mille verges* (*The Eleven Thousand Rods*, 1907), which revolves around an insatiable Romanian prince named Mony Vibescu (fig. 35).

Sade is more evident in the latter book, as its title promises in playing on the pun of the rod or penis (*verge*) and virgin (*vierge*). It alludes to the tale of the fourteenth-century Saint Ursula and the group of virgins who were massacred by the Huns in Cologne for their religion, but it presents the Sadean tale of a Mony Vibescu, "a man in love with 11,000 virgins," as his name makes clear (*mony*, "prick" in Romanian, and *vibescu*, French slang for "Dickfuckass"). In its opening setting in Paris and its narrative of a beautiful female Parisienne, the novel presaged the surrealists' later fashioning of that city as a quintessential space for desire: Vibescu's first encounter is one sunny May morning on the boulevard Malesherbes, where he informs a pretty young woman: "Mademoiselle, no sooner did I set eyes on you than, mad with love, I felt my genital organs drawn towards your sovereign beauty and I found myself hotter than if I'd drank a glass of raki."[5] The nineteen-year-old woman transpires to be Culculine d'Ancône (from *cul*, slang for "ass," and *enconner*, "to put the prick in the cunt"), and her exploits with Mony bring them to Serbia and Siberia during the Russo-Japanese War. Mony's death at the hands of the Japanese, the finale of nine chapters, subjects the reader to graphic tableaux of terror. While awaiting execution in a prison cell in Japan, he is presented with a twelve-year-old female virgin (another prisoner), and once he takes her virginity, he gouges out her eyes and strangles her while she screams. His own fate is worse, however. He begins his tale with the audacious claim, "If I don't make love twenty times running, may the eleven thousand virgins or even eleven thousand rods chastise me," but he dies at the hands of eleven thousand Japanese rods, reduced by successive blows from a

LES

ONZE MILLE VERGES

PAR

G... A...

PARIS

En vente chez tous les Libraires

35. Cover of *Les onze mille verges* by Guillaume Apollinaire, color lithograph, 1907.

throbbing erotic machine to a "tattered relic of humanity . . . a shapeless mass, a sort of sausage meat, none of it any longer recognizable save for the face, which had been sedulously respected and wherein the glassy eyes staring wide seemed to contemplate divine majesty in the world beyond."[6]

Apollinaire conflates the erotic and the political through the Sadean genre in *The Eleven Thousand Rods*, in a way that was foundational to the libertinism of the twentieth-century avant-garde. He presents man's inhumanity to man as bestial, but links it to geopolitics, especially in the novel's finale. The brutal flogging of Mony by Japanese soldiers allows him to allude indirectly to the contemporary scandal in Tsarist Russia of the flogging of peasants by landowners and officers, which he had decried in his articles for the anarchist and socialist Left, *L'intransigeant*, *Paris-Journal*, and *Gil Blas*.[7] He associated Sade with the violent but positive energy of the French Revolution, recounting in "*The Divine Marquis*" how Sade incited the masses to storm the Bastille:

> On July 2nd [1789] he had the idea of using, as a megaphone, a long funnel-shaped tinplate pipe that had been given him to empty his water into the ditch by his window, which opened on to the Rue Saint-Antoine. Through it he shouted several times: "They are butchering the prisoners here! Save them! Save them!" . . . It is possible that it was the shouts of the Marquis de Sade—supplemented by the notes he threw from his window; notes in which he gave details of the tortures the prisoners in the castle had been subjected to—that

36. Robert Desnos (*left*, 1900–1945), with André Masson (*right*, 1896–1987), ca. 1940.

exerted an influence on the already excited minds, provoking the incendiary
mood, and finally inciting the storming of the old fortress.[8]

Through this account, Apollinaire managed to popularize the libertine's
profile while imbuing it with political activism. Moreover, for Apollinaire,
Sade was a universal liberator, calling for the liberty of men *and* women.
Sade's Juliette represented "the new woman that Sade foresaw, a woman
that no one else had any idea of, who frees herself from humanity, who has
wings and who will renew the universe."[9]

Later, when he promoted Sade among younger intellectuals, including
Breton, Apollinaire called for the public dissemination of the writings of
Sade, which were then still mostly locked up in the restricted collection or
"Enfer" in the Bibliothèque nationale. Proclaiming in a 1952 interview with
André Parinaud that Sade was not only a modern author but that he would
dominate the twentieth century, Breton confirmed Apollinaire's immense
influence on his literary and artistic tastes, recalling affectionately Apol-
linaire's garret at 202 Boulevard Saint Germain: "You edged your way in
between bookshelves, rows of African and Oceanian fetishes, paintings of
the most revolutionary kind for the times . . . [Pablo] Picasso, [Giorgio] De
Chirico, [Mikhail] Larionov. . . . It also happened that he would leave me
alone in his home for hours, after having handed me some rare work,

something by Sade or a volume of [Nicolas-Edme Rétif de la Bretonne's] *Monsieur Nicolas*."[10] Apollinaire held up Sade as an admirable exemplar and "the freest spirit that ever lived."[11]

Robert Desnos (fig. 36) continued Apollinaire's appreciation of Sade, writing in 1923, "In essence, all our current aspirations were formulated by Sade, he was the first to posit the integrity of one's sexual being as indispensable to the life both of the senses and of the intellect."[12] His definition of libertinism and obscenity in the same volume also reinforced a peculiarly surrealist view of the Sadean imagination: he defined the former as "liberty of mind and morals in love" and the latter as "anything that contradicts the customs and prejudices in love and modesty."[13] In a 1925 edition of the journal *La Révolution surréaliste*, Desnos celebrated Sade's age of revolution and in his libertine novel *La liberté ou l'amour!* (*Liberty or Love!*, 1927), paid sustained homage to Sade.[14] Desnos's novel was also intrigued with Paris and its revolutionary past, and with urban *flânerie*. The novel adds a surrealist dimension to Sadean syntax in that it defies linear time, insisting on the continuity of past and present, and thereby relying on what Margaret Cohen has described as the "Parisian uncanny . . . haunted by ghosts, above all the ghosts of violent death."[15]

Desnos's novel features the libertine Corsair Sanglot and his accomplice in sexual crime, the beautiful Louise Lame. As with Apollinaire's novel, the protagonists' names intimate their shared free spirits—*sanglot* (from *sangloter*, "to sob"), and *sang* (blood) for the hero, and *lame* (blade) and *larme* (tear) for the heroine—and their adventures are punctuated by proclamations of "La liberté ou l'amour," which hark back to the cries "La liberté ou la mort!" that filled the streets of Paris during and after 1789. Desnos sense of "l'amour" is fashioned as partner-in-crime with "la mort" as well as "la liberté," in keeping with the surrealists' double-edged view of revolutionary desire as born of Eros and Thanatos. Indeed, Desnos frames the narrative as a sort of philosophical treatise, beginning the novel with a declaration of the death of the author and the birth of freedom—"Robert Desnos, Born in Paris, 4 July, 1900. Dies in Paris, 13 December, 1924, the day on which he wrote these lines." He pledges allegiance "To the Revolution / To Love / To she who is their incarnation."[16] As Corsair Sanglot travels from the streets of Paris to the Bois de Boulogne, from the "Sperm Drinkers' Club" to Kent in England, he also travels through time, allowing Desnos to draw the Marquis de Sade and the Terror into the plot.

From beginning to end, Desnos philosophizes on liberty and love. Lame's first sexual encounter with Sanglot leads to the observation: "This wasn't love, the only valid reason for temporary slavery, but adventure itself, with all the obstacles of the flesh and all the odious enmity of matter. . . . Corsair Sanglot had seized her about the waist and thrown her across the bed. He struck her."[17] And, by the end of the novel, the couple's violence

has been eclipsed by national violence, as Sanglot "observes the mass guillotining of the Terror. It is a procession of the admired and the despised. The executioner holds up the severed head again and again with exactly the same gesture every time. Ridiculous heads of aristocrats, heads of lovers full of their love, heads of women heroically sentenced to death. But, love and hate, can they inspire other acts?"[18] Desnos presents his own stance on Sade in the latter passage, describing him as a modern-day hero: "His independence of mind will never be there again, he, the Marquis de Sade, hero of love, of generosity and of liberty. . . . Born into the ranks of aristocrats, Citizen Sade nonetheless suffered much on behalf of liberty!"[19]

Desnos's *Liberty or Love!* not only defies standard literary genres; it repeatedly interweaves elements of both Sade and surrealism in its anticlericalism, as in a passage where Christ's sacrifice is conflated with the sacrifice of rulers in the Revolution: "Christ is finally worthy of his name: he is crucified upon a cross of oak decorated with tricolor pennants resembling a platform on July 14."[20] Desnos also uses Sade to invoke a new type of female "muse," calling on Théroigne de Méricourt (1762–1817), a real heroine of the French Revolution, in his poetic characterization of a "Joan of Arc-of-the-Rainbow": "a pure heroine dedicated by sadism to war, summons to her assistance numerous Théroigne de Méricourt, Russian terrorists in tight, black satin dresses, impassioned criminals."[21] Sexual desire and death are fused in her profile, in keeping with the sperm collected for the Sperm Drinkers Club, which "employs women the whole world over to masturbate the most handsome men," including "the sperm of a condemned man who has been guillotined in France or hanged in England, the manner of death determining the taste of the respective emissions, be it water-lily or walnut."[22]

Toward the end of the novel, Desnos provides an account of the abuse of girls in a boarding school in Kent, England, which indulges the surrealists' penchant for the *femme-enfant*, that is the nubile, pubescent girl who is typically portrayed as curious and sexually uninhibited. The school is run by a thirty-five-year-old libertine headmistress who is introduced in sadistic action, "spanking a sixteen year old girl," the sound of the whip on the child's bare buttocks linked by pathetic fallacy to descriptions of lightning in the dark sky outside, as if nature is delighted by the bruising of soft, white skin.[23] The alignment of nature with sadism, and of night with revolution, is developed further later, in the most violent scene in the novel, in which Sanglot has his way with a chorus of girls in the school garden in the dead of night: "Imagine, then, thirty young girls, night-dresses rolled up above their waists, kneeling on the green lawn. And what does the hero of such a thrilling adventure do? The echoes long reverberated of the punishments inflicted on those excited bodies. The first light of dawn was raising its finger above the forest by the time the Corsair had finished bruising those tender thighs and muscular hips."[24] Sanglot's reeducation of the girls is set as model for all

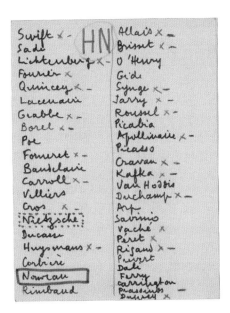

**37. Handwritten list of authors
by André Breton for *Anthologie de
l'humour noir* (Paris: Jean-Jacques
Pauvert, 1966).**

republican lands: "The Republic, from now on relatively secure, will teach its children by his example and welcome his memory to its glorious annals."[25] Unsurprisingly, the episode in the school, coupled with the Sperm Club passages, were censored when the novel came to the attention of the Tribunal Correctional de la Seine soon after its publication in 1927.[26]

Ultimately, Desnos's novel asks the crucial surrealist question: "love and hate, can they inspire other acts?" As in Sade's *Philosophy of the Bedroom* (1795), he called on the citizen for "deliverance from *sceptre* and *censer* alike."[27] In the Second Surrealist Manifesto, released just two years after Desnos's novel, Breton also calls for "total revolt, complete insubordination . . . [to] lay waste to the ideas of family, country, religion . . . [and] laugh like savages in the presence of the French flag, to vomit in disgust in the face of every priest, and to level at the breed of 'basic duties' the long-range weapon of sexual cynicism."[28] Breton's poetry volume *L'air de l'eau* (*The Air of Water*, 1934), describes Sade as a man who pursued "full freedom . . . A freedom / For which the Marquis de Sade defied the centuries with his great abstract trees / Of tragic acrobats / Clinging to the gossamer threads of desire."[29] In February 1937, in the midst of the Spanish Civil War (1936–39) and shortly before the International Exposition in Paris showed the increasing power of totalitarian regimes, Breton cited Sade's "Notes on the Novel" as evidence that a particular "style" always emerges in response to "revolutionary upheaval."[30] Arguing for the value of Sade in troubled times, he describes "the expression of the confused feeling awakened by nostalgia and terror" where the "pleasure principle" avenges itself on "the principle of reality."[31] In this way he managed to steer Sade in a clearer sociopolitical direction.

In the *Anthologie de l'humour noir* (*Anthology of Black Humour*, 1966) Breton describes Sade as "a superior revolt of the mind" and a "mortal enemy of

**38. Callipygian Venus, marble statue, Roman, ca. second–
first century BC.**

sentimentality" (fig. 37). [32] Sade has a "*liberating* element" in this regard and
sat in Breton's pantheon, which also included Edgar Allan Poe (1809–49),
Friedrich Nietzsche (1844–1900), Jonathan Swift (1667–1745), Lewis Caroll
(1832–98), Charles Fourier (1772–1837), and Arthur Rimbaud (1854–91). [33]
Breton writes of Sade's characterization of the monster Minsky in Juliette's
tale as indicative of the libertine's great poetic strength, especially his ability
"to situate the portrait of social inequalities and human perversions in the
light of childhood phantasmagoria and terrors." [34] Sade describes Minsky in
rather vainglorious terms as "a libertine, impious, debauched, bloodthirsty,
and fierce," whose castle is fantastically located in a chasm by a vast lake,
littered with skeletons and echoing with the moaning of victims. (Minsky
kept two harems, one of two hundred girls aged five to twenty, who were to
be used sexually and then literally eaten, and the other consisting of two
hundred sex slaves aged twenty to thirty.) [35] Breton sees Minsky as a sadistic
Bluebeard, but his reading of Sade concentrates less on the children abused
in the tale than on the idea that only a child could dream up such mon-
strous figures; he also includes an excerpt from a letter from Sade to his
wife, in which Sade describes his experience of "signals," or delusions, of

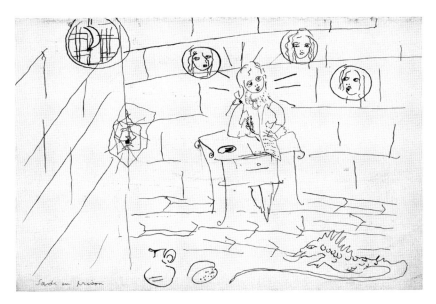

39. *Sade en prison* (*Sade in Prison*), **attributed to André Breton, ink on paper, undated.**

"the utmost beauty."[36] To interpret these, Breton quotes Gilbert Lely, who saw them as "a kind of reaction of [Sade's] psyche, an unconscious struggle against the despair into which his sanity might have collapsed without the help of such a distraction."[37] In citing Lely, and in alluding to the Freudian reading of Sade as a man who found expressive release in his creative acts where his despair might otherwise have driven him insane, Breton again tempers the bloodthirsty account of Minsky and reminds his reader that Sade was a cognoscenti. Sade's letter refers to the pose of the Farnese family's Roman sculpture *The Callipygian Venus*, appreciating how her partial drapery shows off "that part of the body" that he most enjoys (fig. 38).[38]

Breton's framing of Sade reinforced the idea of the libertine as an intelligent *poète maudit*, continuing the stance of the First Surrealist Manifesto of 1924, in which Sade the writer, who delved into "the excesses of imagination to which his natural genius led him," and Sade the man, whose misdeeds "were, by a wide margin, much less horrible than was claimed," were juxtaposed (fig. 39). Breton keeps both personae open and insists the supposed "monster of cruelty" was the same man who "stood up to the death penalty during the Terror and was thrown in jail by the same Revolution that he had enthusiastically served from the first."[39]

Sade's Surrealist Biographers: Heine and Lely

Two of Sade's biographers were especially helpful in bringing his life story and body of works to the surrealist circle: Maurice Heine and Gilbert Lely. Heine worked closely with Apollinaire before the poet's death in 1918, supporting his

ambition to rehabilitate Sade and to analyze his pertinence for the modern world, as well as sharing a taste and skill for erotomania himself.[40] Heine traveled to Berlin in 1929 to buy Sade's *The 120 Days of Sodom* on behalf of Charles de Noailles (1891–1981) and Marie-Laure de Noailles (1902–70), an aristocratic couple who patronized the surrealists. Heine succeeded in securing it, and from 1931 to 1935 he transcribed and edited the text for publication, his dedication to the writer stemming both from an admiration for his novels of terror and his sacrifice of liberty in producing them. In 1926–27, Heine published Sade's *Dialogue entre un prête et un moribund* (*Dialogue between a Priest and a Dying Man*, 1782) and *Historiettes, contes et fabliaux* (Stories, tales, and fables, 1787–88) for the members of the Société du Roman Philosophique—a society that he helped to found in 1923.[41] The twenty articles listed in the statutes for the society make its mission clear: it would publish and edit Sade's manuscripts in its capacity as a private society; it would publish a periodical bulletin in order to keep the "literary public" informed on the subject; and it would serve as a site for the meeting of bibliophiles and researchers of Sade, and be a "purely intellectual" society from which "all religious or political discussion [was] banned."[42] The enrollment fee was 50 francs, the annual membership 325 francs, and members such as Breton and Éluard waited eagerly for every installment. On each anniversary of Sade's birth or death members of the society would also dine out in his honor. The menus for the society's dinners are held in Heine's papers in the Bibliothèque nationale, although they are far from Sadean, often simply listing sole or chicken, pralines, fruit, and a good Beaujolais Saint-Estèphe.[43]

In 1930, Heine released Sade's early novella *The Misfortunes of Virtue*; in February 1933, he published Sade's *Le sujet de Zélonide* (The subject of Zélonide, 1782), a five-act comedy; and between 1931 and 1935, *The 120 Days of Sodom*, in three volumes. He aimed to situate Sade within a literary canon, emphasizing his gothic flair, and also claimed him as one of the first sexologists in his study titled *Receuil de confessions et observations psychosexuelles* (Collection of psychosexual confessions and observations, 1935). In the introduction, he wrote that Sade's was

> the modern approach to the classification of sexual facts on the basis of an ethico-social conception. . . . In *Les 120 Journées de Sodome ou l'Ecole du Libertinage*, a striking work where we encounter the first psychopathia sexualis, Sade admits of four "classes" determined by the degree of passional weight brought to each class: simple, double, criminal, and murderous. From one class to the other, these "tastes" (what today we would call modes of the libido) follow each other and together form a chain of six hundred examples, many of which are prototypes. The similarity between them and modern observations is clear justification of the precursor who broke the pretentious monopoly theologians had established where such matters were concerned.[44]

Heine also corresponded extensively with Breton, providing him with publications by Sade, and he was invited by Breton to publish his ideas on Sade in the surrealist reviews, *Le surréalisme au service de la révolution* (1930–33) and *Minotaure* (1933–39), ensuring the members of the surrealist circle were well versed in Sade's works. Heine's analyses of Sade were informed and original: for example, in a 1936 essay in *Minotaure* titled "Martyres en Taille-Douce" (Martyrdoms in line engraving), Heine relates Sade's oeuvre to the technique of engraving (*taille-douce*) by playing with the Sadean resonance of the ideas of *taille* (cut) and *douce* (soft).[45]

Heine's pioneering work on Sade was continued by Gilbert Lely after Heine's death in 1940.[46] Lely had first heard of Heine in 1928 when he joined the Société d'histoire de la médecine and became secretary for the scientific journal *Hippocrate*, which Heine edited at that time.[47] Lely was drawn to the surrealist circle in 1930–31, and when he met Heine, he immediately felt the greatest "admiration and filial respect" for him.[48] An expert on eighteenth-century poetry, having edited *Les chefs-d'oeuvre des poètes galants du XVIIIe siècle* (The masterpieces of the gallant poets of the eighteenth century, 1921), Lely exhibited a Sadean fervor in his own writings, such as his play *Ne tue ton père qu'à bon escient* (Do not kill your father unless wisely, 1932), in which a daughter kills her own father for forbidding her to wed her lover in a tale full of black humor. After World War II, and following a meeting with Sade's descendant Xavier de Sade in Paris in January 1948, Lely's research on Sade expanded. He edited many volumes of the libertine's correspondence and notebooks: *L'aigle, Mademoiselle* (The eagle, Miss, 1949), *Le carillon de Vincennes* (The carillon of Vincennes, 1953), *Monsieur le 6* (Mister 6, 1956), and *Cahiers personnels, 1803–1804* (Personal notebooks, 1803–1804, 1953), and he produced the major two-volume biography, *Vie du Marquis de Sade* (Life of the Marquis de Sade, 1952 and 1957; augmented in two additional editions of 1962 and 1982). Lely also edited the *Oeuvres complètes du Marquis de Sade*, which amounted to some sixteen volumes, published by the Cercle du Livre Précieux in Paris in 1966–67.[49] As with his surrealist comrades, Lely was attracted by the paroxysm of Sade's language and his subversion of religious, political, and intellectual tyranny in the name of sexual freedom. But his was an almost mystical admiration of Sade. In his poem "Le Château-lyre," written during the Occupation when he made a pilgrimage to Sade's château in Lacoste, he insists "your memory is not effaced," admires the ruined walls in the Luberon sun, and speaks to Sade as a poetic comrade: "You, the space, the mountains, Sade, the future days / The voluptuousness, the word, in a single diamond."[50] Sade served as a vehicle for reflection on autonomy under all regimes in a godless world: "Sade against God is Sade against absolute monarchy, Sade against Robespierre, Sade against Napoleon, is Sade against everything which constitutes, directly or indirectly, any kind of takeover of . . . human subjectivity."[51]

Surrealism and Sadean Desire

Sade seemed to encompass every possible revolutionary spirit for the surrealists, standing as a bastion of freedom. For Georges Bataille, the behavior of the surrealists toward Sade resembled "that of primitive subjects in relation to their king, whom they adore and loathe, and whom they cover with honors and narrowly confine."[52] Many contemporary scholars continue to view the dynamic between Sade and surrealism in this way. In *The Self and Its Pleasures* (1992), Carolyn Dean writes that the surrealists "used [Sade] as an emblem of the affirmative force of the libido and as a tragic symbol of the power of censors and of bourgeois defenders of the state and the family in particular."[53] For Neil Cox, the surrealists viewed Sade "as a presiding deity over their movement . . . built on the knowledge that Sade spent a total of twenty-seven years in prison, and the belief that he did so either as punishment for perverse sexual acts or for writing pornography or for his radical political views, or for all three."[54] However, the surrealists' aim to push love and desire into the public realm, and away from sentimentality and duty, allowed them to direct their interests in Sade in their own peculiar direction. Breton would expand this quest, voiced in the investigations of 1928–32, to a more frenetic sense of love a decade later with his book *L'amour fou* (*Mad Love*, 1937).

They viewed desire as a great impetus for change, forcing onto the world the question "What is desire?"—rather than the conventional Enlightenment question "What is man?," as Annie Le Brun has rightly noted.[55] In the first edition of the journal *La Révolution surréaliste*, Paul Éluard wrote of Sade as a celebrant of "the amatory imagination," while Lely later famously asserted, "Everything on which Sade leaves his seal is love" ("Tout ce que signe Sade est amour").[56] In many ways, both men seized on Sade's claim in a letter to Madame de Sade from prison in 1781, "Though enchained I may be, my heart is yet free and always will be."[57] In their 1929 survey on love, also published in *La Révolution surréaliste*, the surrealists defined their understanding of love, in clear opposition to the bourgeois one, as the "strict and threatening sense of total attachment to another human being, based on the imperative recognition of truth—*our* truth 'in a body and soul,' the body and soul of this human being."[58] This was a stance against traditional, romantic, notions of love or what they viewed as the "corruption" of love into "filial love, divine love, love of the fatherland."[59] When André Parinaud asked Breton in 1952 to qualify the "apparent contradiction between your concept of elective love and the Surrealists' admiration for someone like Sade," he reinforced the dialectic between love and terror, *érotisme* and *érotisme noir*, stating, "the Surrealists elevated to the zenith the meaning of that 'courtly' love that is generally thought to derive from the Cathari tradition, just as often they anxiously studied its nadir, and

it's this dialectical process that made Sade's genius shine for them like a black sun. . . . It's because Surrealism started from this viewpoint that it has made such an effort to lift the taboos that bar us from freely treating the sexual world, and *all* of the sexual world, perversions included."[60]

Sade served as a further exemplar of the power of the imagination to transgress the social order. This was less about a crisis of the self or a reasoning away of Sade's crimes than it was a means of focusing attention on humanity through the body and sexuality rather than the mind and morality. Sade was a marginal figure, but the surrealists glorified him to address the dynamic between the real and surreal terror and through strategies of subversion, parody, and transgression worked "to provoke the manifestation of extraordinary realities drawn from the domains of the erotic, the exotic, and the unconscious," as James Clifford has argued.[61] An exchange between Breton and Jean Duché in 1952 reflects this long-standing position:

> JD: You've spoken of an all-powerful desire, capable of transforming the world. Is it on desire that you base your action?
> AB: *Desire*, yes, *always*. We can rely only on this great key bearer. Just as freedom can't be equated with the impulse to do anything one wants, it goes without saying that I set this desire apart from certain forms of unrestrained bestial appetite, such as have been recently displayed. Even under the frantic guise it wears in Sade, we recognize desire, and duly honor it, as utterly *dignified*.[62]

Breton emphasizes Sade as a writer, and a dignified one at that, rather than a man torn by base instincts or inciting base experiences. This is in keeping with the cautionary portrait of Sade by Jean Desbordes, *Le vrai visage du Marquis de Sade* (The true face of the Marquis de Sade, 1939), a copy of which was in Breton's collection. Desbordes writes, "[S]adism has its degrees. It can be imaginative, and it is as such that it predominates in at least half the human race; and, as the psychoanalysts say, if to imagine a thing is to live it, then the majority of individuals can think of the Marquis de Sade as a sort of unhypocritical fall guy."[63] Given that surrealism's attitude to the human condition was heavily inflected by a faith in psychoanalysis and Freud, Breton's position also reflected his interest in sexology rather than sexual transgression; he argued against close analysis of Sade's sexual life and viewed him as "the most authentic precursor of Freud's work and of modern psychopathology in general."[64]

As we have seen, Freud explains sadism in his "Three Essays on the Theory of Sexuality" (1905), as an active, masculine component of the sexual instinct; in contrast, masochism is a form of inverted sadism and a characteristic of the feminine sexual instinct. They are, however, interchangeable: "A sadist is always at the same time a masochist, although the active or the passive aspect of the perversion may be the more strongly

developed in him and represent his predominant sexual activity."[65] In his essay "A Child Is Being Beaten," Freud also explains that the dynamic between sadism and masochism begins in the Oedipal stage, when the child desires exclusive love from its parents. Adult patients with the fantasy of being beaten tended toward three scenarios: a child being beaten by an adult; the patient as a child being beaten by his/her parent, typically the father; and a group of children being beaten by an adult with authority, such as a teacher. These scenarios reflect a desire for the parent through a desire for the rival child to be beaten, which then leads to guilt and a desire to be punished (crucially linking punishment with sexual desire), and finally associating power over sexual desire with the figure of authority who implements the punishment. Both the sadism of the first scenario and masochism of the second imply that the child learns to repress sadomasochistic tendencies in the Oedipal stage; to indulge in them is taboo. Freud also wrote of a form of "moral masochism" where "morality becomes sexualized," the Oedipal scenario is desexualized, and a dynamic of sadomasochism remains in social relations, as between a pupil and teacher.

Freud's theories on the sexuality of the child and the Oedipal scenario intrigued the surrealists, just as his exploration of the unconscious revealed the amazing capacity of the mind to create alternative realities. The surrealists saw an exemplar of this practice in Sade's writings, especially given the sheer excess of his tableaux. They turned to the Sadean imagination and its iconoclastic force—that is, outside of taste, law, and moral sentiment—as an extreme means of forcing the reader/spectator into an active, feeling, desiring position.

Man Ray's Homage to D.A.F. de Sade

In their "Investigations into Sexuality" of 1928 and 1930–32, the surrealists attempted to explore sexuality and sexology frankly, from discussions on orgasms, sexual positions, "clitorals" and "vaginal-uterines," to sexual "inversion," masturbation, and the use of brothels. Women were vastly outnumbered in these "Investigations," but their voices do lend an important presence to the discussions. Women appeared as "Y" in the Seventh Session (May 6, 1928) in which Sade and coprophilia and the importance of the clitoris for orgasms are discussed; Nusch Éluard, Jeannette Tanguy, Madame Unik, and Simone Vion participated in the Eighth Session (November 1930) in which the women all state that the eyes are their favorite sexual image (as opposed to the breasts, buttocks, or "moist cunt" mentioned by the men); and the dynamic between couples emerged in some exchanges, too, as Madame Léna, Katia Thirion, and Simone Vion speak in the Ninth Session (November 24, 1930), Jeannette Tanguy in the Tenth Session (November 26, 1930). Hence the surrealists aired their own

collective "philosophy in the bedroom" at a time when women were entering into the group as writers and artists as well as wives and lovers and when the surrealist preoccupation with sexuality was viewed with suspicion by the Communist Party.[66] The investigations ran alongside the evolution of Freudian psychoanalysis in France and the discovery and publications of Sade's works, and, as Dawn Ades has noted, they reflect an attempt to establish "how individual determinations could allow for mutuality in the experience of desire and jouissance."[67] Ades also notes that Sade was "in some ways the most important figure in the shadows" behind the investigations.[68] They indicate that the surrealists did not hail Sade simply for all he "suffered" but found in him an example of the untamed Freudian libido, something they constantly tried to wrench out of medical hands and into the everyday.[69] Their focus on the deviant libertine female body offers a further example of this rejection of bourgeois aesthetics and ideology; their assault on that which war-torn society held most dear—woman as daughter, wife, and mother—served as a perfect vehicle for variations on a Sadean homage.

This stance was reflected in Man Ray's explorations of the Sadean text, which arose from his introduction to Sade's works, including Sade's original scroll of *The 120 Days of Sodom*, by Heine, who was his neighbor on the rue Campagne Première in Paris. Two Man Ray photographs with Sadean subjects were published in *Le Surréalisme au service de la Révolution: Hommage à D.A.F. de Sade* (Homage to D.A.F. de Sade, 1930), as a full-page image, in the October 1930 edition; and *Monument à D.A.F. de Sade* (Monument to D.A.F. de Sade, 1933) (fig. 40), in the May 1933 edition.[70] In the former, we see the head of American model Tanja Ramm encased in a bell jar; Ramm was a friend of model and photographer Lee Miller (1907–77), Man Ray's then lover. Ramm's seemingly decapitated head is propped on a book, her eyes closed, as if to suggest the text has led to erotic reverie. Reproduced in an edition of the journal devoted to Sade, Man Ray's homage seems to signify "jouissance at the very edge of reason," to cite Katharine Conley.[71] It certainly was part of a particular obsession with sadomasochism in his work at the time, one which may have been encouraged by his friendship with the American explorer and writer William B. Seabrook, who commissioned Man Ray to take a series of sadomasochistic photographs in 1929–30.[72] Seabrook and his wife, the writer Marjorie Worthington, happily discussed their sexual taste for bondage in their social circles—as Seabrook writes in his autobiography "My propensity for putting chains on ladies was common knowledge."[73]

However, even in the images he produced for Seabrook, with fetish objects of Seabrook's choice (a black mask, leather boots, collars), Man Ray teases out his own aesthetic interests.[74] As evident in the photograph *Blanc et noir* (*Black and White*, 1929), in which a naked woman is fragmented into segments through the placement of a rope and strips of black cloth on her

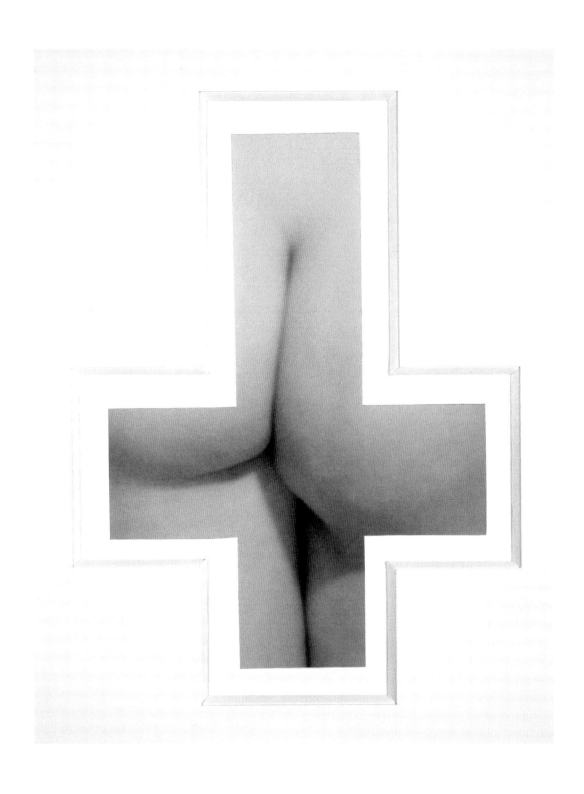

40. Man Ray, *Monument à D.A.F. de Sade* (Monument to D.A.F. de Sade), gelatin silver print, 1933.

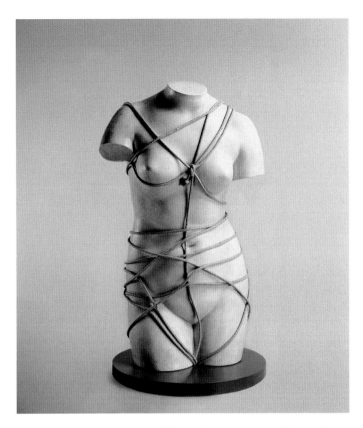

41. Man Ray, *Venus restaurée* (*Venus Restored*), assemblage: plaster cast and rope, 1936, replica 1971.

thighs, breasts, and arms, he distorts classical Venus motifs, plays "primitive" black against "classical" white, and uses materials and light to cast uncanny shadows so as to transgress good form and moral codes at once.[75] In a later painting of 1950 titled *Aline et Valcour* (*Aline and Valcour*), after Sade's novel of the same name, Man Ray returns to this image of the decapitated female in oil paint, now juxtaposing her with a little artist's mannequin propped up between a cone and a sphere—geometric objects drawn from earlier photographs and drawings of chess pieces and mannequins. Both the wooden figure and the real woman are staged as objects, or pawns, in his Sadean narrative but are again manipulated for maximum formal effect.

In *Monument to D.A.F. de Sade*, Man Ray continues to pervert classical motif and genre, again confusing the still life and portrait, the body part and the inanimate object. The work consists of a black and white photograph of soft, pert buttocks, over which is superimposed the outline of a Christian cross, inverted to resemble a sword or phallus. In this photo-montage Man Ray uses the close-up and cropping to place the camera lens and spectator's eyes in proximity so that they must linger on the creases of flesh, like a target, and are open to amorous or predatory thoughts. Jane Livington proposes that

this framing of the anatomy within a cross arouses "simultaneous feelings of tension and resolution," noting that Man Ray provoked the imagination in his photographic works by letting "the main object . . . express its own capacity for self-transformation."[76] However, the image holds a more explicit homage to Sade. The conflation of the sacred and profane in staging the crucifix as a penetrative phallus evokes a very particular and powerful scene of a Black Mass in *Juliette* where a young "maiden" is sacrificed on a table-altar and a crucifix is used to decorate her buttocks, mocking religious mysticism with sadistic ritual. It also alludes to a later scene in which Juliette describes Pope Pius VI and another Black Mass in which the consecrated host is placed on "the tip of the papal prick; the very next moment the bugger claps it into my bum, wafer first. . . . Sodomized by the Pope, the body of Jesus Christ nested in one's ass, oh my friends! what rare delight."[77] In a 1972 interview with Pierre Bourgeade, Man Ray described the cross as "the cross of the Black Mass."[78] His work extends Sade's textual assault on the church and corroborates the surrealists' support of that stance, as the decision to reproduce it as a full-page illustration in their collective journal made clear.

 Monument to D.A.F. de Sade is contemporaneous with Man Ray's *Quatre saisons* (*Four Seasons, 1929)*, photographs, a series of more explicit sexual images published in a book of poems by Benjamin Péret and Louis Aragon titled *1929*. Those photographs harness the Surrealist fascination with the close-up to challenge everyday objects and the spectator's perspective to stage close-up shots of Man Ray and his lover Kiki de Montparnasse having sex, from "Summer" and "Spring" depicting vaginal penetration, "Autumn" represented by fellatio, and "Winter" by anal penetration. Arguably they offer images to the surrealists' investigations; certainly the fact that they show a couple exploring their sexual pleasure through the close-up and cropped image needs to be kept in mind when they are viewed alongside Man Ray's other Sadean works. They replace the image of woman as passive object with woman (Kiki) as active sexual agent. And they are contemporary with Man Ray's subversion of one of the most classical images of female beauty—Venus. In a series of sculptural works and photographs, Man Ray incorporated plaster casts of the Venus de' Medici, the head of Niobe, and the Three Graces, purchasing them in museums or specialist shops and subverting their ideal feminine forms in his own bricolage version of a newly fashioned Sadean heroine. The assisted ready-made *Vénus restaurée* (*Venus Restored* , 1936) (fig. 41) was produced in the year he made a pilgrimage to Lacoste with Paul Éluard, but it draws many of his earlier works into play, as bondage, fetishism, and woman's complicity or activism in sadomasochism are all explored. Binding the cast of an armless, legless, female nude in rope allows him further formal exploration of sexual role play, including his own—early on in his autobiography he asks whether he might be a "budding sadist or masochist."[79]

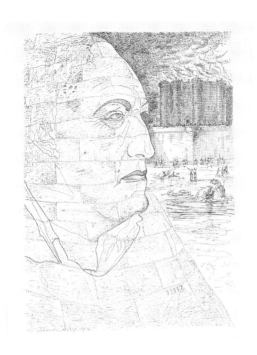

42. Man Ray, *Les mains libres*, paperbound book (Paris: Jeanne Bucher, 1937).

Soon Man Ray moved from images of Sadean bodies to imaginary portraits of Sade. In *Les mains libres* (Free hands, 1937) (fig. 42), a *livre d'artiste* he and Éluard collaborated on as they traveled around the south of France, Sade is hailed as a monument to freedom at a time of burgeoning fascism: "Sade's work seems forever in disgrace and banned. The price that must be paid for its appearance in the light of day is the disappearance of a world where stupidity and cowardice bring with them all our misery."[80] Of the fifty-four drawings Man Ray produced, each accompanied by short poems penned by Éluard, there are two portraits of Sade that bring the collection to an end. They were preparatory drawings for Man Ray's portraits of the libertine for Maurice Heine, finalized in 1938 and 1940, and yet he described the series of drawings as the sum of all his experience in painting and photography.[81] His interest in Sade was attributable to the libertine's "passionate defense of individualism and freedom," and this is reflected in the portraits: the Marquis's pallid flesh becomes the hardened defensive brick of a counter-monument set against the Bastille, the "free hands" or "free play" of the book's title embodied in his gargantuan form. Man Ray was searching for a specifically surrealist expression for such freedom.[82] Later, when living in the United States, Man Ray wrote a short text on Sade, reflecting on his renewed significance for a war-torn world. In it he states that Sade's works are "inextricably tied up with philosophy, psychology, politics and religion. . . . His insights attain at times the propositions of a vast prophecy and anticipation, many of the details of which have already been realized."[83]

André Masson's Sadean Universe

André Masson also long admired the writings of Sade. Joining the surrealist group in Paris in 1924, Masson shared their fascination with the libertine and in *La Révolution surréaliste* in 1926 wrote: "Keep the ghost of liberty inside your walls; I challenge you to put your hand on my shoulder because, I'm telling you, after Saint Just, a revolutionary knows no rest except in the tomb, when, like Sade, he flatters himself to vanish from the memory of men."[84] In December that year, in a letter to Michel Leiris, who had introduced him to Bataille, Masson also wrote of his fascination with "Sade the Sublime in his prisons."[85] He had a preexisting interest in the art of the eighteenth and nineteenth centuries and a particular obsession with violence and terror thanks to a long-standing interest in the writings of Nietzsche and a firsthand experience of war as a French infantryman who joined up in 1915, fought in the Battle of the Somme, and was nearly killed in 1917.[86]

As a young man living in Brussels, Masson enjoyed visiting the Musée Royal des Beaux-Arts, where he developed a taste for painters such as Eugène Delacroix, Jean-Auguste-Dominique Ingres, and Jacques-Louis David, enjoying their fascination with the body and space and especially admiring David's *The Death of Marat*.[87] In his oil painting *Le fauteuil Louis XVI* (*The Louis XVI Armchair*, 1938), he even alluded to David's work by reprising a detail from *The Death of Marat*: where Marat clutches in his hand the note from Charlotte Corday that would lead to his fall, in Masson's painting the battered armchair-king is holding the so-called Veto (a reference to the power of veto, granted him by the 1791 Constitution, with which Louis attempted to protect the power of the Catholic Church and limit the mobilization of civil militia, just before he was deposed, executed, and replaced by the French Republic). We find a fascination with death and life, physically and psychically, constantly informing Masson's oeuvre, no doubt partly as a result of his near-death experience during a military offensive at Chemin des Dames in April 1917, when he was shot in the chest and left on the field throughout an arduous night before being rescued and hospitalized. Otto Hahn wrote of the effect of that event on the artist: "The world around him became something wondrous and he experienced his first complete physical release, while in the sky there appeared before him a torso of light."[88] While Masson refused to speak of the war and his traumatic experience at the front until much later in his life, he obsessively returned to images of sacrifice, massacre, and sexual violence.[89] In a letter of December 1926, Masson explained that he was beginning to think through "this idea which used to seem incomprehensible of being at the same time the sacrificial victim and the sacrifice," an idea he was prompted to reflect on by Éluard's portrayal of Sade as a revolutionary in his 1926

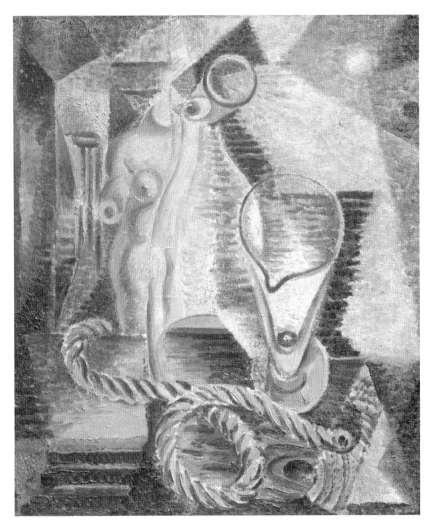

43. André Masson, *La corde* (*The Rope*), oil on canvas, 1924.

essay in *La Révolution surréaliste*.[90] Two years later, on the basis of his reading of Sade, Masson admitted to his art dealer Daniel-Henry Kahnweiler a fascination with the subject of hanging.[91] As he later clarified in an essay of 1947 titled "Notes on the Sadistic Imagination," Sade offered him the opportunity to explore a universe where everything is possible and permissible, where the "problems of desire" lead to imaginary visions that the reader/spectator can also cultivate.[92]

That same year, Leiris asserted in an essay on Masson that he was the only artist capable of properly representing Sade's universe.[93] Leiris insists that Masson's aptitude for Sade was there from the outset of his career and evident in such early works such as *La corde* (*The Rope*, 1924) (fig. 43): "How could we call him obscene, he who has opened dark chasms in woman and traced circles of fire around her orifices? Of course, we can say of certain

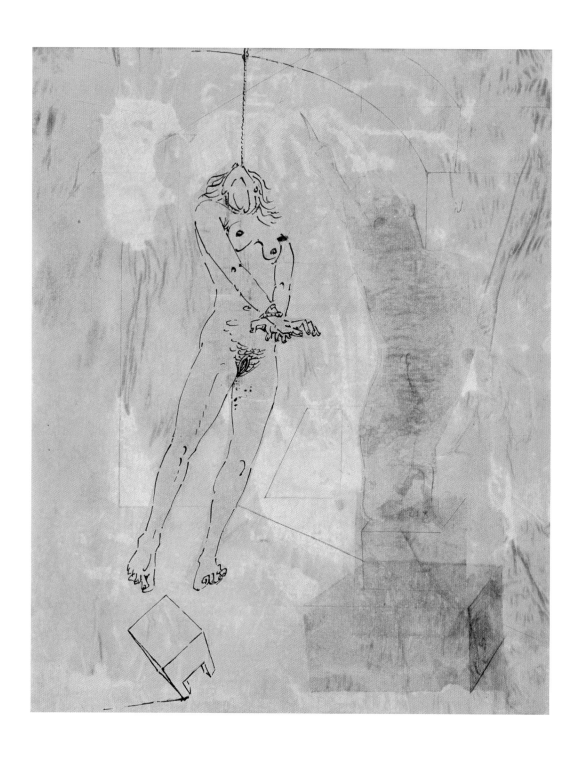

44. André Masson, *Dessin pour Justine* (Drawing for Justine), 1928. Graphite, Indian ink, collage, on paper.

paintings by Masson that he has assembled in them erotic elements, or at least their functions, not in order to be sensual or obscene but to recall the most violent forms of the human nightmare, according to the wishes of the spirit, giving them idealized forms whose hallucinatory character nonetheless reminds us of their monstrous origin."[94] Leiris also finds love in the painting, as he admires "the serpentine, the whipping, and even the mortal dance beside the woman, a beautiful victim who unfolds her curves and her seductive talents on a bed of darkness, revealing by a simple undulation her darkest and ordinarily hidden treasures, all their shadows and lights. A voluptuous dialogue between love and combat."[95]

This painting marks Masson's transition from cubism to surrealism, as the tropes we associate with the later movement emerge powerfully through a limited palette and reduction to form: the headless nude with cubist breasts, a prominent rope that leads the eye back into the composition and yet seems to snake toward the spectator too, and architectural elements, which lend depth through shading and line. For Leiris, the work testifies to Masson's unique potential for a Sadean surrealism: "[T]his painting allows me to understand that the painter is the only one who has so far been able to imagine, for the works of Sade, illustrations which are not servile or shamefully naturalist copies of the scenes described but whose talent is supremely equal to that of the divine marquis himself."[96]

Four years after *The Rope*, Masson's illustrations for Sade's *Justine, ou Les malheurs de la vertu* (1928), which Georges Bataille found "admirable" and planned to include in an "Erotic Almanach" to be published by Pascal Pia (1903–79), reveal this Sadean imagination in much more abject terms.[97] Masson now not only refers specifically to Sade's text but brings the female figure from the background to center stage, the rope of the earlier work now serving as the central motif as death by hanging and the crushing of (her) virtue is made palpable (fig. 44). Her hands are bound, a stool has been kicked out from under her feet, and she dangles from the noose. If the Sadean text is viewed as a "pleasure machine," as Le Brun has described it, this portrait of the sacrificial victim seems to prolong the shock, inciting the lust and excitement of the spectator who is also "suspended."[98] It is Sade's philosophy that God is evil and the misfortunes suffered by Justine are a result of her denial of this truth, so her ritualized and brutal suffering is a key moment in Sade's novel, rightly highlighted by the artist in this scene.[99] Masson observed in 1968 that Sade "reminded us ceaselessly—watchman in flames—that man is the cruelest of all animals."[100]

However, as with Man Ray, the choice of imagery again speaks to a very specific aspect of Sade's philosophical tale of Justine: the figure of the counterfeiter Roland, whose particular penchant is for the "jeu de coupe corde," or the slow hanging to death of women. He is so fascinated by this form of death and the possible pleasure it elicits that he asks Justine to

asphyxiate him in the same cellar in his château that is strewn with the corpses of his female victims, determined to test his belief that "this death is infinitely sweeter than it is cruel," but he also asks her to cut him down once he has ejaculated in blissful terror and before he dies.[101] The shadowy male figure in the illustration is thus as crucial as the suspended female. His right hand and phallus point to the noose, reminding us of the shared contract between the libertine and his victim Justine and how, having bound her arms and tied a black silken noose round her neck, he plays with tightening it before explaining the link between asphyxiation and sexual excitement. It is to "prove" this sexual pleasure that he entrusts her to asphyxiate him, knowing her good conduct means she will not leave him to hang. She duly ties a noose round his neck as he stands on a stool; "his dart soon rises to menace Heaven" when she removes the stool and reproaches him "with all his life's horrors"; and she cuts him loose before he dies, her virtue again proven to the reader.[102] By saving him, they both live to witness her further torment, and Sade again proves that only crime prospers.

Masson's illustration for *Justine* also suggests the terrifying space surrounding her tortured figure. The novel describes a cell that Roland uses for his tortures, but Masson may also have looked to Giovanni Battista Piranesi (1720–78), a printmaker who depicted spatial constraint with powerful sexual and psychic effect. In his studio in Paris, Masson had reproductions of Piranesi's *Les prisons* (*Imaginary Prisons*) series, which he described as "[m]etaphysical prisons, stairs of vertigo. This world is closed: there will be no escape. Wheels, racks, infinite rigging are destined only for 'torture by Hope.'"[103] Piranesi had given visual form to prisons of the mind in two series of fantastic etchings—a series of fourteen in 1749–50, reworked and expanded with a second series of sixteen in 1761. These exaggerate the architectural scale and solidity of prison walls and machinery, with accentuated three-dimensional volume, dark shadowy recesses, and a claustrophobic sense of enclosure. The shadows also lend themselves to interpretation in the light of Freud's 1919 essay "The Uncanny," in which shadows, the "double," and the fear of spirits and death itself are aligned.[104] Though architecturally and perspectivally complex, and charged with meaning, Piranesi's spaces contain no people, so they are disciplinary but far from Sadean.[105] In contrast, in his Sadean universe, Masson's figures are center stage, although he still uses shadow for psychic effect. This continues in another of Masson's illustrations for *Justine* in 1928: a mixed-media drawing of a male libertine, standing tall with an engorged phallus and holding a bloody whip in each hand, as five nude women are arranged in defenseless poses around him. As if reprising Antonio Canova's classical sculpture of *The Three Graces* (1814–17), here female flesh is tortured from every angle.

In "Notes on the Sadistic imagination," Masson elaborates on his vision of Justine, discussing the monks who assault her in the novel as having

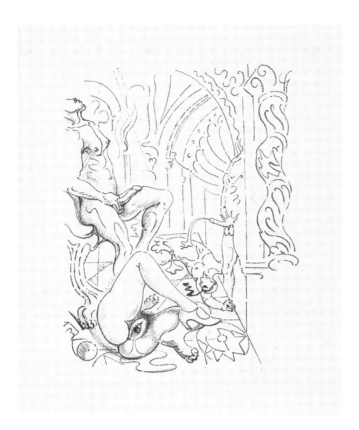

**45. André Masson, lithograph for Lord Auch (Georges Bataille),
Story of the Eye (Paris: [Pascal Pia], 1928).**

"tastes brought to light as monstrous and as frequently occurring in one individual—your neighbor, your brother or yourself."[106] Curiously, he also noted Breton's preference for Justine's sister, Juliette, and his choice of excerpt for his *Anthology of Black Humour*. If Justine leads Masson to reflect on Sade our neighbor, then Juliette leads him to reflect on the excesses of the Sadean imagination: "[I]t is necessary to go to Juliette to find the pinnacle of the divinized Marquis's imagination: a large Italian decoration on blood-soaked armor, which depicts—as it should—an erupting volcano."[107] His visualization of Sade seems to be constantly torn between the suffering of the victim and the pleasure of the libertine in Sade's fiction, though his image of the libertine is in keeping with that of Breton and his circle. Breton published a poem on Sade in his 1934 collection *The Air of Water*, in which he describes Sade as having the force of an "erupting volcano" as well as the "eyes of a young girl."[108]

 If Masson's words on Sade are often Bretonian, his illustrations for *Justine* might be described as Bataillean, that is, as showing a more dissident, materialist surrealism, informed by his friendship with Bataille and his novel *Story of the Eye*, whose protagonist, Simone, is undoubtedly a

46. André Masson, *Abattoir* (*Slaughterhouse*), oil on canvas, 1930.

modern-day Juliette. Bataille's Sadean tale revels in the trauma of the young male spectator/collaborator of Simone, and depicts male victims, whether the matador Granero or the priest who falls victim to her desires. In his eight unsigned lithographs for the book, produced in an edition of 134 copies and with no publisher's name, Masson also enjoys the dynamic between sexual roles, between torturer and victim (fig. 45). He indulges in the same sense of tableau throughout, demanding that the spectator also enter the scene, by his use of a gaping vulva-eye as the visual focal point to ensure an affective experience.

When Masson uses color, this abject affective quality is even more visceral. In 1930, Georges Limbour described Masson as a "universal dismemberer" and wrote of the artist's use of sand as an excellent medium for the absorption of blood-red pigment.[109] Masson liked to emphasize the viscosity of blood by mixing red paint and sand in his paintings to emphasize its texture and abject quality, again ensuring that the sacred and profane were inseparable. That same year Pascal Pia wrote, "murder, love, [and] death. . . . It is a question always to express the revolt of the spirit before the fate that the universe gives him."[110] William Jeffett interprets Masson's obsession with death in terms of his personal history or trauma: "[The degree to which painting opened itself like a fresh wound to the visceral reality of human

47. Eli Lotar, *Aux abattoirs de la Villette* (*At the Villette Abattoirs*), gelatin silver print, 1930.

existence represented the degree to which Masson invested these works with an ontological or existential content. . . . [W]ith these *Abattoirs* Masson embarked on a confrontation between the self and reality."[111] In *Abattoir* (1930) (fig. 46), red paint draws the eye to the cut throat of both a slaughtered horse in the bottom right of the canvas and a sheep in the middle ground; another daub of bright red emerges from the same sheep's weeping eye. Blood as the symbol of life and of death—it is both the red of a mother's procreative blood and the blood of sacrifice. Masson spoke of this painting and two others with the same title as depicting "the world of killers."[112]

Carl Einstein (1885–1940), who was also affiliated with Bataille and his dissident surrealist review *Documents* of 1929–30, read Masson's paintings of *Abattoirs* as a refusal of traditional hierarchies between "psychological values and logic," as an "unfettered projection of an interior drama onto the structure of things, a projection through which opposing forms might be connected with a single function."[113] Indeed, he read this quality as "the drama of transmutation," seeing Masson's paintings as "psychological contractions through which hallucinatory speed is compelled to persevere."[114] It should also be noted that the violently erotic painting *Le jeu lugubre* (*The Lugubrious Game*, 1929) by Salvador Dalí (1904–89) was contemporaneous with Masson's abattoir imagery, a work Bataille celebrated in

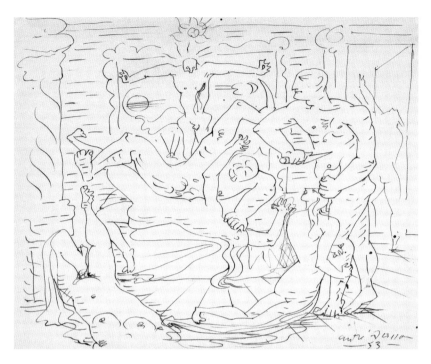

48. André Masson, *Massacre à la Crucifixion* (*Massacre at the Crucifixion*), ink on paper, 1933.

Sadean terms, recounting his desire to "squeal like a pig" before it.[115] The violence and abjection of Masson's version of the abattoir can be underlined by comparison with others, too. Late in 1929 and in 1930, Masson visited slaughterhouses at La Villette and in Vaugirard in Paris with the photographer Eli Lotar (1905–69), who would publish some of his powerful black-and-white images in Bataille's journal *Documents* as illustrations for its short *"Critical Dictionary"* entry for "Abattoir" (fig. 47).[116] In these photographs, Lotar is working photographically with the remains of real animals rather than in Masson's relatively imaginary world of drawings and paintings of women; his images imply a kind of violence, but in the moment of the image, the violence is already in the past; hence, he presents the parts of beasts in quite beautiful, abstract terms, counterpointing the everyday scene of an alleyway with severed hooves or close-ups of entrails and blood, and in an overall atmosphere of calm.

Masson intensified his experimentation with a Sadean aesthetic throughout the 1930s. He produced a series of crucifixion works such as *Massacre à la crucifixion* (*Massacre at the Crucifixion*, 1933) (fig. 48) and *Sacrifices* (1933). Neither of these clusters of images was explicitly discussed in terms of Sade at the time, but they show a continuing repetitive and frenzied sexual violence. Masson's search for the best formal means of portraying the Sadean imagination, where line, color, and compositional grids could do justice not merely to the excessive syntax of Sade's fiction and amoral

universe but to the sense of pure terror, now dominated his oeuvre in the interwar period. Such works could not fit into any sense of traditional iconography or legible style and were not intended to illicit sympathy or empathy from the spectator either; rather, they aimed to craft a sensual rendition of terror, such that lines and color and surface pulsated as a body and mind in horror would.

Masson's drawings for the journal *Acéphale*, published between 1936 and 1939, and edited by Bataille, alongside other members of his Collège du sociologie, including Klossowski and Leiris, took the surrealist engagement with Sade in a new political direction: he fashioned a headless man with labyrinthine entrails, a skull at his phallus, a flame in one hand and a dagger in the other. Masson had moved to Spain and witnessed the October 1934 insurrection in Catalonia and the Asturias. By the summer of 1936, he had fled the country and returned to France, and as Robin Greeley has argued, he may be seen to have opposed it from afar through his role in *Acéphale*.[117] Here, too, Sade became crucial to Masson's revolutionary voice. Whereas his first image of the headless male was produced at the outbreak of the Spanish Civil War, with a Communist hammer and sickle as head, in a landscape of war and ruin and with his right foot crushing a cross and his left a swastika, the later version of the figure, which Masson produced in France to finally illustrate *Acéphale*, was devoid of such specific political and historical detail. He had replaced Communist politics and insignia with Sadean ones, as specific political brutality was coded in a universal, sexual symbolism. For Greeley, the *Barcelona Acéphale* with hammer and sickle—as she names it due to its inscription "Barcelona 1936"—reflects Masson's "longer project to rethink Marxism outside the stalemate to which Stalin and the Popular Front governments had brought it."[118]

And yet as with his illustrations for Sade, we find he turns again to a universal, affective iconography to insist on the need to rethink the constant dynamic between terror and the terrorized. Violence was not to be simply made into a political instrument, whether for fascist or Communist causes, nor was mechanized, politicized violence to be set against intense, erotic violence; he still hoped for a new revolutionary way. In June 1936, Masson reported to Kahnweiler, "I am above all a man for whom the world has more than just a Marxist or nationalist meaning. And in art, I will always remain obstinately revolutionary!"[119] In a letter to Jean Paulhan, Masson said of the Spanish Civil War that "[t]he violence, the fanaticism—so much love and so much hate—surpass anything I could have imagined."[120] The war led him, alongside many artists and writers involved with *Acéphale*, to consider further the radical potential of sadistic desire and terror as political allegory. In turn, his drawings inspired Bataille's essay "Le conjuration sacrée" ("The Sacred Conspiracy"), written in Tossa de Mar in Catalonia on April 29, 1936, a key text in the first

edition of *Acéphale* in which Bataille declared war on fascism on behalf of himself and the journal's contributors but with new focus on sovereignty and an emphatically Nietzschean fervor: "What we are starting is a war. It is time to abandon the world of the civilized and its light."[121] Hence he called for a "free" acephalic hero:

> Man has escaped from his head just as the condemned man has escaped from his prison. He has found beyond himself not God, who is the prohibition against crime, but a being who is unaware of prohibition. Beyond what I am, I meet a being who makes me laugh because he is headless; this fills me with dread because he is made of innocence and crime; he holds a steel weapon in his left hand, flames like those of a sacred heart in his right. . . . He is not me but is more than me: his stomach is the labyrinth in which he has lost himself, loses me with him, and in which I discover myself as him, in other words as a monster.[122]

Masson gave an emphatically masculine form to Bataille's "monster," a creature with the power to make one experience laughter and dread; it is not hard to surmise that Masson drew on his readings of Sade as well as his conversations about Sade with the surrealists and Bataille. Indeed, Masson seems to have experienced a Sadean epiphany in Tossa at the time. Bataille recorded in his text "The Sacred Conspiracy":

> André Masson is happily moving around and singing; at this very moment, as I write, he has just put on the phonograph a recording of the overture to *Don Giovanni*; . . . a few days ago, . . . he suddenly talked of his own death and the death of his family, his eyes fixed, suffering, almost screaming that it was necessary for it to become a tender and passionate death, screaming his hatred for a world that weighs down even on death with its employee's paw.[123]

Mozart's *Don Giovanni*, also titled *The Rake Punished*, is an opera about a licentious young nobleman that opened in Prague in October 1787, during the final years of the reign of the Habsburg Emperor Joseph II and on the eve of the French Revolution.[124] We will recall that these were the dark days of Sade's imprisonment in the Bastille. Mozart's opera opens with Don Giovanni and his manservant, Leporello, at the house of the Commendatore; a masked Don Giovanni chases the Commendatore's young daughter, Donna Anna, and subsequently kills the Commendatore when he tries to seek revenge; it ends with the Commendatore returning, as a statue, whose chorus of demons proceed to surround the unrepentant Don Giovanni and drag him into hell. And in between we learn of the rake's many sexual exploits, including one scene, the "Catalogue Aria," in which Leporello sings of Don Giovanni's sexual tour across Europe in which he took 640 women in Italy, 231 in Germany, 100 in France, 91 in

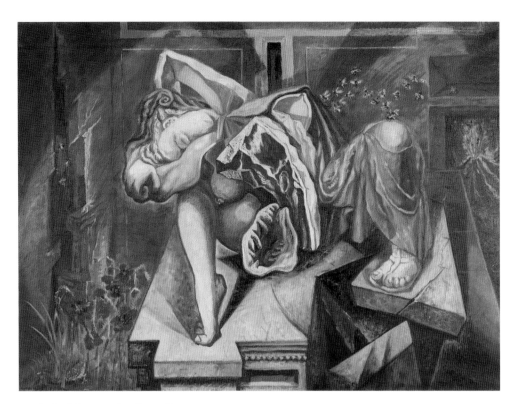

49. André Masson, *Gradiva*, oil on canvas, 1939.

Turkey, and 1,003 in Spain. Such a list would be fitting for any Sadean novel and mocks Enlightenment rationalism and moderation.[125] In the opera, Don Giovanni is deplorable, but the moral of the plot is that he remains defiantly true to himself and to liberty, refusing to submit to social rules and codes. *Acéphale* also promoted a Sadean hero, a man who rejects reason and civilization, who embraces terror and ecstasy. Masson's totemic man symbolized this dialectic of desire and terror, liberty and libertinism.

However, we find a replacement of the Nietzschean male with the monstrous Sadean mother, typically symbolized with a castrative vulva, as Masson's fear of war increased. In the ink and aquarelle drawing *La mère sadique* (*The Sadistic Mother*, 1937), an insectoid, headless figure bears a key as phallus and plunges a knife into a still life with fleshy forms and a lock on a table. The mood is not merely one of agitation but of frenzy—not unlike Bataille's vision of a mass rising, full of "contagious emotion that, from house to house, from suburb to suburb, suddenly turns a hesitating man into a frenzied being."[126]

Masson's painting *Gradiva* (1939) (fig. 49) repeats the motif of the devouring vulva, while alluding to another tale of desire and mythology analyzed in Sigmund Freud's 1906 essay, "Delusions and Dreams in Jensen's

Gradiva," in which Freud examines the story of a young archaeologist, Norbert Hanold, who is obsessed with an antique marble relief depicting a walking girl whom he named "Gradiva."[127] The archaeologist takes inspiration from her and a dream about the eruption of Vesuvius and then decides to visit Pompeii. There he meets a childhood friend, Zoe, and his quest for the woman of his dreams is happily replaced by a recognition that he had repressed his desire for her; their reunion allows his cure, through love.

For the surrealists, Gradiva came to symbolize the power of woman to bring men from the real to the surreal—for example, in 1937, Breton named his own Parisian gallery the Galerie Gradiva, and in an essay explained that her name signified "[s]he who advances. . . . At the border of utopia and truth, that is in the midst of life: GRADIVA."[128] Masson also recognized her importance, but his painting of her is menacing, depicting her idealized, classical beauty in the ancient relief turning abject and Sadean, such that her body both seduces and repulses the viewer. On the one hand, this duality is signified by the honey and bees swarming around her breasts (symbolizing nurture) and on the other hand, by the deep, daggerlike shadow her right foot casts back into her vagina and the raw meat steak nearby (symbolizing birth and death). The eye is inevitably drawn to this blood-red detail. An erupting volcano and the bizarre detail of a raw steak allude to the dénouement and sexual liberation of Hanold in Jensen's tale as his true desire is revealed. Sade is also evoked, as Juliette appreciated the splendor of Italy's volcanic landscapes and was inspired to throw her companion, Olympe Borghèse, into Vesuvius. Breton referred to the image of the volcano orgasmically "vomiting forth flames" as exemplary of "the sublime imagination" of Sade in *Mad Love* (1937).[129]

Masson describes the volcano in *Juliette* as "the summit of the imagination of the divine marquis: grand Italian decors in front of a volcano, in eruption, emblazoned with blood."[130] He breaks from the original text in one significant detail, however—in including the red poppies (or *coquelicots*), whose form and blood-red hue link this work with his earlier automatic works. That flower is an ancient symbol of dream and death, but it also specifically brings to the painting an echo of World War I, so that the sheer horror that faces its female figures is the terror that Europe faced in 1914–18 (and, presumably, Masson would have said, in Spain too). This approach to the creation of meaning is in keeping with Masson's explanation—with reference to another of his paintings, *Le fil d'Ariane* (*Ariane's Thread*, 1938), that he aimed to make each of his paintings a kind of labyrinth, ultimately leading the viewer to "a terrifying Minotaur."[131] Masson brings us close to terrified flesh through the artist's own hand, "which presses down and traces a line, i.e. in the body which throbs (which takes pleasure)" and through color that serves not to delineate shape or fill in background but as "pulsion's entire space," as Roland Barthes wrote admiringly in his analysis of Masson's art in 1973.[132]

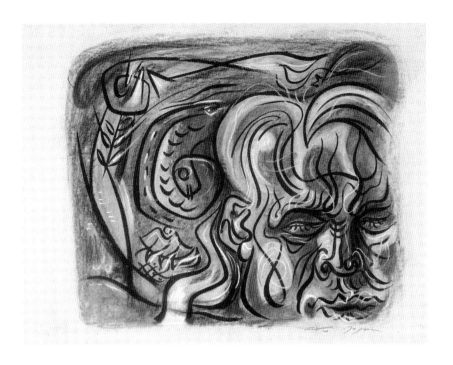

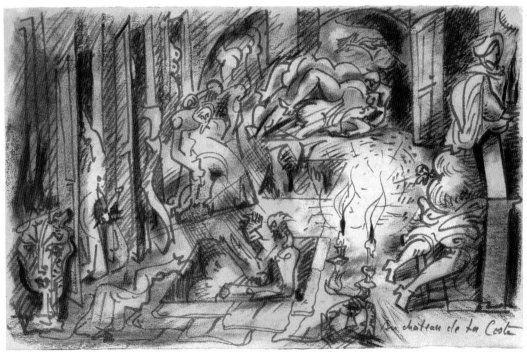

50. André Masson, *Portrait de l'artiste devant un de ses tableaux* (*Portrait of the Artist in Front of One of His Paintings*), ink and chalk on paper, 1943.

51. André Masson, *Au Château de La Coste* (*The La Coste Castle*), wash, pastel on paper, 1969.

Masson did not agree fully with Bataille or Breton—for example, he declined to become involved in Bataille's journal *Documents* and refused to join Breton and Bataille when they tried to forge common ground in *Contre-Attaque* in 1936: these projects were all too Marxist for Masson. On November 8, 1936, he explained in a letter to Bataille, "I am sure that everything based on Marxism will be squalid because this doctrine is based on a false idea of humanity."[133] With the outbreak of World War II, Masson was forced into exile in the United States with his wife, Rose Maklès (1902–86), and their two sons, Diego and Luis, and his thoughts on Sade's relevance to the contemporary world only strengthened. In his self-portraits, he even staged himself as a tormented artist, imprisoned in his ideas, in a Sadean fashion. In his 1943 *Portrait de l'artiste devant un de ses tableaux* (*Portrait of the Artist in Front of One of His Paintings*) (fig. 50), an automatic style emphasizes this sense of creative intensity or purging, and seems to both identify with and call for the *engagé* artist, whose work is not only engaged with the sociopolitical but strives to be a form of philosophy. Masson never wavered from this position, turning to Sade for inspiration again and again, as we see in his loosely drawn wash and pastel *Au Château de La Coste* (*At the Château de La Coste*, 1969) (fig. 51).

Terror as an Ideal, Terror as a Method

In November 1945, six months after the Allies liberated Buchenwald, the writer and onetime surrealist Raymond Queneau (1903–76) described Sade as central to "Surrealist ideology" and claimed Breton felt some embarrassment at having promoted the libertine so much prior to 1939, as his imaginings had proved to be "a hallucinatory precursor of the world ruled by the Gestapo, its tortures and its camps. . . . Disagreeable as it may be, philosophies end in charnel houses."[134] Yet Breton's stance on Sade did not waiver, and Sade's writings continued to offer a powerful means to address terror, all the more so when no artist or writer could escape it in real life. In the aftermath of World War I, during the 1920s and '30s while fascism reared its ugly head, and then during and after World War II, to celebrate and rehabilitate Sade was to acknowledge, lament, and condemn an extended era of brutality and fear. Moreover, this era continued, or even intensified as the Holocaust was publicly confirmed, the atom bomb was deployed, and, in France and other European countries, there was a widespread and violent purging of those who had collaborated with fascists. As Tony Judt has said of the aftermath of World War II, "Terror as an ideal, terror as a method, terror as a regrettable necessity, terror as a metaphor, terror in every shape and form permeated intellectual consciousness."[135] The surrealists' experiment with literary and visual language in this era recalled and extended that of the Marquis de Sade.

Saint-Just acknowledged the political and moral power of words and rhetoric, but also their ineffectiveness, in his plea to the Committee of Public Safety at his trial on July 27, 1794, just two years after he had called for Louis XVI to be deposed and put to death. As Saint-Just faced the guillotine, he conceded the effect of the Reign of Terror on language: "What language shall I speak to you? How can I depict for you terrors of which you have no idea, how can I make you understand the evil that a word reveals, that a word puts right?"[136] Language had been used effectively by Saint-Just, Robespierre, and the Jacobins as a weapon to sway the populace against the king. The rhetoric of the Enlightenment, of good and evil, virtue and terror, with which the monarchy had been overthrown, had been so effective and so emotive that Saint-Just was unable to find new words with which he could mobilize the people at his own public trial. In particular, he could no longer clearly speak of evil—the Terror had drained the word of its significance, language had been exhausted of its moral impact. The challenge then was to be wary of rhetoric but, paradoxically, also to try to find a *new* rhetoric, new languages, to reawaken the moral spirit of the people. The avant-garde faced a similar challenge in the aftermath of the war. In the next chapter, I turn to the case of the woman writer, Dominique Aury, who chose to craft her own modern Sadean heroine named "O" in a 1954 novel Breton would happily claim for surrealism. Her project continued the avant-garde exploration of liberty and love but also offers an important counterpoint to the many male voices I have considered.

Story of O
Slave and Suffragette of the Whip

Sade made me understand that we are all jailers, and all in prison, in that there is always someone within us whom we enchain, whom we imprison, whom we silence. By a curious kind of reverse shock, it can happen that prison itself can open the gates to freedom.

Pauline Réage, "A Girl in Love," 1969

In 1947, in the aftermath of the horrors of World War II, Jean-Paul Sartre (1905–80) wrote that "[p]erhaps never since the eighteenth century [had] so much been expected of the writer."[1] People turned to literature and art for some kind of explanation for, or redemption from, the evils so many had witnessed—not to justify anything but simply to better understand terror in terms of individual instinct and the institutionalized "duty" to inflict pain, or to destroy and kill. That same year, Pierre Klossowski published *Sade My Neighbor*, in which he read Sade's work as an ethics of monstrosity: his fiction presented a godless, perverse universe that, ironically, exposed humanity's need for the spiritual.[2] Klossowski advanced a "theo-pornology," uniting theology and "superior pornography" in his reading of Sade, as Gilles Deleuze (1925–95) described it in 1965.[3]

As we saw in the previous chapter, Klossowski was member of the antifascist *Contre-Attaque* group (1935–36) and the *Acéphale* and Collège de sociologie groups, joining forces with Georges Bataille, Michel Leiris, Roger Caillois, and others. Klossowski's study of Sade advanced some of the ideas in his earlier essay, "Le mal et la negation d'autrui dans la philosophie de D.A.F. de Sade" (Evil and the negation of others in the philosophy of D.A.F. de Sade), published in 1934–35 in *Recherches Philosophiques*, but also drew on his recent life experiences as a curate with the Dominican Order during World War II and his relationship and marriage to Denise Roberte Morin-Sinclaire in 1947, a widow with two children who had fought in the Resistance and survived internment in the Ravensbrück concentration camp.[4] His reading of Sade focused on how the spiritual could be born from the carnal, the edifying from the terrifying. As Klossowski put it, "the act of creation is itself a consequence of the fall."[5] By this logic, Sade could be viewed as a moralist who stages the "torments and bitterness of his own mind" on his female victims, while his virile, aggressive world is an example of how fear can be translated into cruelty and self-interest.[6]

Sartre and Klossowski had access to Sade's writings through their literary circles—notably through the efforts of Heine and Lely and Bataille—whereas common readers did not. In 1947, the young French publisher Jean-Jacques Pauvert (fig. 52) set out to rectify this by publishing the complete works of Sade so that members of the general public could judge his world of terror for themselves. At the time, one could find some of Sade's writings in book stores—*Justine; Historiettes, contes et fabliaux; Zoloé;* and a very inaccurate edition of *Dialogue between a Priest and a Dying Man*—but his more famous works were not available, nor were reliable, scholarly editions. *The 120 Days of Sodom* had been published only in a limited run by Maurice Heine in 1931, as explained in the previous chapter. During the war, Pauvert, who fought in the Resistance as a courier, immersed himself in literature and discovered the Marquis de Sade. He recalled in 1996, "I worked in a bookstore and then in Gaston Gallimard's publishing house

from 1942 on. I was sixteen years old. I hadn't read Sade, of course, but I began to meet writers and they were all talking about Sade—[Jean] Paulhan, [Albert] Camus, [André] Breton was still in America. . . . There was this sense of *érotisme noir* in the air, and it was for that reason that I too began to get interested in Sade."[7]

This chapter considers the pioneering work of Pauvert in bringing Sade to the masses, the 1956 trial of Pauvert for publishing Sade's writings, and the defense of Sade as a great writer that was made by leading intellectuals during the trial. I then focus on Dominique Aury, another author championed by Pauvert, who published a modern Sadean novel titled *Story of O* in 1954. Here the very idea of Sade as a neighbor was taken to an erotic extreme, through the character of a young woman simply named "O," who lives in Paris, works as a photographer, and happily subjects herself to the sadistic desires of her lover René. Through close consideration of the history of the novel's plot, the dynamic between Aury and her real-life circle of intellectuals and lovers, and the controversial reception of the novel, I aim to evaluate the turn to Sade's philosophy in postwar France as it sought to come to terms with its recent brutal past, and specifically for a woman author immersed in a progressive literary circle that included humanist feminists such as Simone de Beauvoir.

Humanist feminism viewed femininity as a social construct underpinned by an oppressive set of practices and prevailing attitudes, notably marriage, motherhood, the Christian doctrine of sin. As Iris Marion Young has argued, for Beauvoir, "women's confinement to femininity stunt the development of their full human potential and makes women passive, dependent and weak."[8] This humanist feminist stance is now viewed as a first-generation feminist perspective that called for women to be freed of the mysteries of the feminine and its attendant "immanence."[9] Beauvoir promoted a move beyond women's issues (sex, reproduction, rights, etc.), to a focus on living, working, and sexual relations as equal "persons," though later feminists would argue that the definition of "human" itself remains male-centered.[10] Debates on women's rights were prominent in Aury's Parisian circles and France's pro-natalist postwar society.[11] Sade's insistence on unlimited human freedom offered a compelling discourse through which to explore a feminism of equality rather than difference. Aury's fictional tale of a modern woman happy in a sadomasochistic relationship would test the boundaries of that position.

Jean-Jacques Pauvert and *l'affaire Sade*

The first book by Sade that Pauvert read was *The 120 Days of Sodom*, when he was sixteen years old, and thereafter he made it his mission to produce a standardized series so as to disseminate the libertine's work beyond the

52. Jean-Jacques Pauvert; photograph by Louis Monier, 1978.

somewhat elite and clandestine circles in which it was known. Each Pauvert volume of Sade's writings would include a preface by a scholar of Sade and a short biographical introduction. This was both a commercial move and a rebellious one, as Pauvert recognized the increased demand for Sade's works among intellectuals and the general public—including many self-exiled Americans, mostly writers, artists, and ex-GIs who had settled in Paris and enjoyed its relatively lenient erotic culture. Between 1947 and 1972, Pauvert succeeded in his mission, producing thirty-one volumes of the *Oeuvres complètes du Marquis de Sade*. These were described as "discreet and severe" and were published without illustrations except when there were title pages in the original editions.[12] He selected writers for the prefaces as each edition progressed, either reprinting an existing essay already published on Sade or asking his contributor to write a piece offering his or her "point of view in general on Sade."[13] By the time he had published all Sade's works, these contributors included Dominique Aury, Georges Bataille, Maurice Blanchot, André Pieyre de Mandiargues (1909–91), Maurice Heine, Pierre Klossowski, Gilbert Lely, and Jean Paulhan. The lack of illustrations kept costs down, as did the scheme for purchase: readers were able to save by buying a subscription to the whole series under the publishing house Cercle du Livre Précieux. The fact that the works were printed for subscribers alone also aimed to evade the law.

Pauvert's devotion to Sade, and his audacity in publishing Sade under his own name at his well-known business address in Paris, did not go unnoticed by the authorities. In 1954 and 1955, the Commission du Livre began to review the new editions, and in December 1956, all the volumes that Pauvert had printed were seized, his publishing house was closed, and he was put on

trial before the XVIIe Chambre Correctionelle de Paris. There Sade's writings were deemed a threat to morality, as they involved "descriptions of scenes of orgies, the most repugnant cruelties, and the most varied perversions."[14] The trial of Pauvert was referred to in the press simply as *l'affaire Sade*, and it forced him and those intellectuals who had championed Sade into the cultural and political limelight—notably André Breton, Georges Bataille, Jean Paulhan, and Jean Cocteau, all of whom agreed appear in behalf of the defendant. All of these men had been published by Pauvert, and they had the necessary intellectual authority to help his case.

Pauvert's only method of defending his publications was, naturally, to defend the writings of the Marquis de Sade as *literature*, however challenging and scandalous it might be. Accordingly, his defense lawyer, Maurice Garçon, who was also a much-respected writer and historian (elected to the Académie française in 1946), took the view that while Sade's writings might embody a threat to public morality, it was a *literary* threat and one from which society would benefit.[15] Garçon also argued for the right to freedom of speech—insisting that the French constitution of September 3, 1791, gave all French citizens the equal right to speak, write, print, and publish their ideas, and adding that aesthetic judgments were relative. He cited Diderot, who had said that law was the expression of the majority, and he pointed out that definitions of the immoral or pornographic are dependent on the politics of the cultural period in which they hold sway.[16] The censorship of numerous great literary masters was offered as a case in point, including Charles Baudelaire's collection of poems *Les fleurs du mal* (*The Flowers of Evil*, 1857). Garçon also insisted on the particular vulnerability of literature before a tribunal, claiming the legal system was always at least thirty years behind the common person's notion of morality. He pointed out that the jury included men of law, representatives of the minister for education, and members of the National Union of the Association of the Family, but that there were no literary figures among them to defend the literary and publishing tradition, or to argue for the relevance and importance of Sade's oeuvre to modern French society.[17]

Garçon's words were perfectly logical and also tempered in acknowledging the sociohistorical relativity of moral codes and censorship alike. Indeed, in 1963 he would publish an elaborated version of the argument he had made in court, *Plaidoyer contre la censure* (Plea against censorship), in which he argued that censorship was particularly severe in the aftermath of World War II, whereas at the time of the law of 1810, one was permitted to make an appeal and hope for a more enlightened response.[18] He again cited the constitution of 1791, contemporaneous with Sade's libertine novels, as a set of legal principles that had to be respected, while insisting that "[f]reedom of speech is granted to every man to speak, shout, print and publish his thoughts without being subject to any censorship of prior inspection."[19]

He noted that article 8 of the Charter of 1830 had also reinforced the claim that "[t]he French have the right to publish or have their opinions printed."[20] As Jeanne Galzy observed in a 1969 article on censorship, Garçon's defense of freedom of expression was part of a wider cultural battle in postwar France, standing against the power of the minister of the interior to devise and censor a "blacklist."[21]

Jean-Jacques Pauvert, for his part, explained his firm belief that the writings of Sade were central to the history of French literature. He noted that in the first half of the twentieth century Sade's works had been translated into numerous foreign languages—a recognition of his literary importance. He insisted that while a charge of obscenity might be leveled against Sade, the threat posed by Pauvert to the general public was minimal, given that he had published only two thousand copies and these had been sold under a subscription system only; furthermore, the majority of copies were bought by philosophers, doctors, and professors who knew exactly what they were purchasing.[22] Pauvert's later testimony in his book *Anthologie historique des lectures érotiques*, vol. 1: *De Sade à Fallières (1789–1914)* (1982) further clarifies this reasoning by arguing that Sade pushed the limits not just of erotic literature but of morality itself, offering "the philosophy of Evil."[23] He cited writer André Pieyre de Mandiargues to support his position that Sadean literature's transgressive values preserved "the essence of poetry."[24] In this fusion of politics and poetry, Pauvert echoed the surrealists—and Mandiargues was friendly with the surrealist circle too, but he also insisted on a peculiarly *French* tradition of revolutionary erotic literature.

The depositions of André Breton, Georges Bataille, Jean Cocteau, and Jean Paulhan were of paramount importance to this line of argument at the trial. Each was called on in person, or through written testimony, as in the case of Breton and Cocteau, to speak for Sade as a great author, whose recognition by all branches of society was long overdue. Breton, who had claimed Sade as "Surrealist in Sadism" in the first Surrealist Manifesto of 1924, described Sade as a master of literature and aligned him with other great writers whose work had been censored, including Baudelaire, Swinburne, Lautréamont, and Apollinaire. He argued that Sade had the greatest insight into the human soul and followed a long, enlightened history of thought, including the Gnostics; and he held that far from being a criminal, Sade was an inspirational writer for representing "the peculiar addictions that inspire the nation."[25] Ideas and culture, like liberty itself, should not be censored, he argued, because they were "one and indivisible."[26] Breton concluded that in publishing Sade's works, Jean-Jacques Pauvert was contributing to the "intellectual radiance" of France.[27]

Jean Cocteau gave his defense in writing, stating that Sade was a fundamental part of a French cultural heritage, a bastion for free expression and moral judgment:

Dear Sir,

Sade is a philosopher and, in his own way, a moralizer.

To attack him would be to attack Jean Jacques [Rousseau] of the *Confessions*. He is troublesome, his style is weak, but he does not deserve our reproach. The merest detective novel from prudish America is more pernicious and more audacious than the pages of Sade. In condemning him, France would be missing his vocation.[28]

Georges Bataille also reinforced the idea of Sade as philosopher in his speech. Indeed, he claimed to speak on behalf of philosophy, proposing it was the one discipline capable of addressing the Sadean imagination and contending that Sade's philosophical power lay in presenting the reader with an abyss of horror.[29] He reasoned that there were two aspects to Sade's *oeuvre* that had to be considered: the descriptions and the demonstrations. He argued that the former could be read as obscene, but the latter could only be judged from a moral point of view, and that people gained by being exposed to Sade's work because it led them to realize the outcome of disobedience to reason.[30] Bataille's faith in the power of the profane to reveal the sacred led his biographer, Michel Surya, to interpret his stance on Sade here as "Jesuit-like."[31] When asked by the court if Sade's *oeuvre* did not entail a "danger" to society, Bataille replied that it did not, stating that he had enough confidence in human nature to believe it could not be corrupted by Sade.[32]

It was the defense of Jean Paulhan that held the greatest weight in the trial, as it made the overarching defense that Sade's literature had to be viewed within a moral frame. As Paulhan put it, "I think there is a danger there, but it is an eminently moral danger."[33] If the other witnesses were aligned with the contentious avant-garde, Paulhan was a major figure in the publishing world, notably with Gallimard. He had joined the *Nouvelle Revue Française* in 1920 as secretary, was editor in chief from 1925 to 1940, and then director from 1953 to 1963. He had been in the Resistance, and in 1949 was made Commandeur de la Légion d'Honneur and in 1951 Lauréat de la Ville de Paris. He too was not without controversy. In January 1952, his pamphlet *Lettre aux directeurs de la Résistance (Letter to the leaders of the Resistance)*, earned him the wrath of many *résistants* as he argued against the purging of collaborators and condemned their mistreatment.[34] Between independent acts of revenge and the Conseil National de la Résistance, the purging of collaborators was a veritable bloodbath: approximately 10,800 executions without trial took place in France during the Liberation—half had occurred before the Allied landing, and the trials of collaborators continued until 1951, when there was an amnesty for collaborators that involved the judicial sentencing to death of some seven thousand people, and the eventual execution of eight hundred.[35] The Comité national des écrivains (CNE;

National Committee of Writers), formed during the Resistance, participated in purging "people of letters," as did the Commission d'épuration de la librairie et de l'édition (Committee for the purging of the publishing industry), which included Jean-Paul Sartre as representative of the CNE.[36] The Catholic novelist and intellectual, François Mauriac deemed the process a "necessary evil" that would become a "running sore."[37] The trial of Robert Brasillach, under article 75 of the French Penal Code, for his anti-Semitic articles while editor in chief of *Je suis partout* (1937–43), for attending the International Congress of Writers in Germany in 1941, and for "intellectual relations" (*rapports intellectuels*) with the Nazis, was held up as an example for artists and authors. He was found guilty of treason and was executed by firing squad on February 6, 1945, though many intellectuals, including Paulhan, petitioned against his death sentence.[38]

Paulhan's position at Pauvert's trial must be viewed through the lens of this recent history and the fact that Vincent Auriol, the president of the Fourth Republic, had written him a four-page letter of objection following the publication of *Lettre aux directeurs de la Résistance*.[39] Paulhan's opposition to the Communist Party's call for retribution against collaborators might be viewed as a declaration for free expression and literature despite politics. It complements Gallimard's decision in 1951 to publish the work of Louis Ferdinand Céline, who was also found guilty of collaboration. Aury herself observed that for Paulhan "no cause was more sacred than that of literature."[40] As he had made clear in his volume *Les fleurs de Tarbes ou La terreur dans les lettres (The Flowers of Tarbes, or Terror in Literature)*, published in 1936 and in a revised edition by Gallimard in 1941, he was particularly concerned with the theme of terror in literature and its power to change the reader. He distinguished between a literature of "terror," which innovated and challenged literary tradition in privileging thought over language, and a literature of "rhetoric," which strove to work within literary conventions by prioritizing language. Thus for Paulhan, there existed an opposition between the form of expression and expression itself, or between sign and meaning. A writer who is a "terrorist," in Paulhan's view, rejects floral language and rhetorical seductions and instead attempts to renew language, using "words that act directly on the mind" and employing "cold calculation."[41] He states that "an idea of language" is central to the terrorist writer, and that he distrusts reason— indeed he adds, "the simplest definition we have of a terrorist is that he is a misologist [*misologue*]."[42] For Paulhan, the writer and artist struggled between terror and rhetoric to find a true image of the real world. Within this opposition, he believed that Sade's texts went beyond erotic metaphor or metamorphosis: they aimed to affect the reader on many levels, or put another way, the reader could not be the same person after having read the text. Literature has the power to reveal if readers open themselves to the experience, and Sade's texts were exemplary in this regard. Paulhan aimed for this in his own writing

too, as indicated by the title he gave his last volume, *Les instants bien employés* (*Moments Put to Good Use*), published in 1966. He explained the title: "[by] talking about those [moments] in a reader's life; I want to 'encourage' the reader and enable him to get through to the heart of the problem, to what is true in literature."[43]

Finally, at the time of *l'affaire Sade*, Paulhan's name was also associated with the very public *petit porno* scandal over the novel *Story of O*, published by Pauvert in 1954, and written by Aury under the pseudonym Pauline Réage. The novel was written in the Sadean genre and included a preface by Paulhan titled "Le bonheur dans l'esclavage," translated in English language editions not as "Happiness in Slavery" but as "A Slave's Revolt."[44] As we shall see, Paulhan's role in the novel went far beyond the preface, but it too buttressed his profile as a champion of Sade and of freedom of expression. Indeed, Paulhan had offered Gallimard his *Lettre aux directeurs de la Résistance* at the same time he offered the publishing house the manuscript of *Story of O* on behalf of its anonymous author—his political and poetic vision were indivisible.[45] When the trial of Pauvert took place, this scandal was still in the air. Indeed the choice of Pauline Réage for the nom de plume of the author of *Story of O* led many of his circle to suspect he was very close to it, reading it as an anagram, *égérie paulan* (Paulhan's muse) and suspecting that the author might be his lover.[46]

During the trial, Paulhan exemplified the power of rhetoric, unsurprisingly. He introduced himself as the author of a "short thesis" on the Marquis de Sade produced at the Sorbonne in 1946—a reference to his much praised preface to Sade's *The Misfortunes of Virtue*, and yet a modest self-portrait given his many publications and associations.[47] Titled "Le Marquis de Sade et sa complice, ou Les revanches de la pudeur" ("The Marquis de Sade and His Accomplice"), Paulhan had argued in that essay that while he conceded that Sade's oeuvre contained "an eminently moral danger," it was a danger that contributed to society's good, as the reader's morality is invariably challenged by Sade's immorality—morality itself was relative, and Sade's work could have different effects on its readers.[48] He thus insisted that morality was part of the social contract and not an inherent quality in humankind.[49] He gave the example of a young girl who, having read Sade's work, fled to a convent.[50] The girl's decision to enter a convent might be read as a positive or negative reaction to Sade's perversity: she may have fled the real world for the safety of the convent, or she may have hoped to experience some of the immorality Justine and Juliette experienced in the convent. In either case, Paulhan argued that evil could only be portrayed within a state of evil, and that the Bible itself was equally terrifying as it recounted many horrific acts.[51]

The various depositions of Breton, Bataille, Cocteau, and Paulhan during Pauvert's trial indicated the high esteem in which Sade was held and

the considerable intellectual reputation and influence he had gained in the intellectual community in postwar Paris. But, more important, they indicated the tempered manner in which Sade's literary universe of terror and sexual violence was reasoned into a morality tale. The prosecution was equally spirited: it argued that Sade's oeuvre enflamed public curiosity about immoral acts and only created a demand and taste for such obscenity; Pauvert and his colleagues were accused of harboring anarchic intentions in their endorsement of such an immoral author, owing to the fact that a selection of Sade's writings had been published in *Le Petit Crapouillot*, a supplement to the satirical review *Le Crapouillot*. Obscenity, described as the "coarse sensual evocation" of sexual acts, was a real threat to the status quo and needed to be curbed.[52] The verdict was announced on January 10, 1957, and Pauvert lost the case. The jury decided that Sade's writings constituted too great a risk to the public's moral health. It was announced that the right to freedom of speech was not limitless; Sade's oeuvre encouraged parricide and was debauched and degrading to humanity. Those editions of Sade's works that had been seized were destroyed, and Pauvert was fined two hundred thousand francs.

According to Pauvert, this was a "hefty fine" but one that he never actually paid.[53] Indeed, he retaliated by publishing *L'affaire Sade*, including all the testimonies and the judgment, and asserting that he had no intention of publishing Sade clandestinely and would appeal. In February 1957, he published two more volumes of Sade—*Historiettes, contes et fabliaux* and *Écrits politiques* (Political writings)—and his defiance was rewarded on March 12, 1958, when the Court of Appeals decreed that writing that posed a threat to the moral status quo need not be destroyed but must be limited in distribution—immoral literature was for adult eyes only. This would solidify the prominent role of the Brigade mondaine, the special vice squad, to ensure that national and foreign works of art, literature, and film were screened (and, by extension, censored) for any possible moral turpitude lest they corrupt the youth of France. It was officially claimed that this policing of culture aimed to pursue violent gangster films and books, but Maurice Girodias, who founded Olympia Press in 1953 to publish "dirty books," wrote in his memoirs that it tended to focus on anything deemed sexual corruption, demonstrating a return to "Gallican puritanism."[54]

For Pauvert, the trial was like a "whirlwind" in which he was at the center; it differed from those of other French editors, who simply played the "game" of censorship, and revealed a great social unease in the French republic.[55] It was symptomatic of a burgeoning cultural conservatism, directed at publishing houses that chose to support *érotisme noir*.[56] Pauvert never wavered in his determination to publish and promote Sade, and for this he became a "hero" among the avant-garde.[57]

The Sadean Woman "O"

In his memoirs, Pauvert paints a picture of the wartime era in which quotations from treasured texts were shared among comrades, whether a passage from Lautréamont or Breton, or the thought-provoking proposition by Sade that "[c]ruelty, fruit of the extreme sensibility of the organs, is known only to extremely delicate beings, and the excesses to which she carries them are only refinements of their delicatessen."[58] Books were precious, thanks to a lack of paper and a lack of free expression, and their importance went far beyond the page. These conditions must be kept in mind as we consider the creation, plot, trial, and reception of *Story of O*, the Sadean novel that Pauvert published in 1954. It was a work that continued the Sadean legacy but brought it manifestly into the mid-twentieth century, and that again risked Pauvert's publishing house. But most important for our understanding of the Sadean imagination, it was written by a woman who was immersed in the Parisian publishing business and whose life story and devotion to freedom of expression were as passionate as Pauvert's. Its radical assault on the status quo was magnified by the fact that it was born out of the development of women's rights during World War II, and it would be the subject of feminist debate up to and after the formation of the Mouvement de libération des femmes in 1970. In many ways, the novel reflected the "new woman," both in the guise of the author and the female reader of eroticism. As Paulhan wrote in his preface to Réage's novel, the novel's gender politics were contentious: "Few are the men who have not dreamt of possessing a Justine. But as best I know no woman has so far dreamt of being Justine."[59] When approached about the book by the Brigade mondaine on August 5, 1955, Paulhan defended it as a modern-day *Lettres de la religieuse portugaise* (*Letters of a Portuguese Nun*, 1669) or *Dangerous Liaisons*, (1782), citing erotic classics of the past to insist on its continuation of an important tradition concerned as much with "form and tone" as eroticism.[60]

Prima facie *Story of O* presents a third-person account of the sexual enslavement of a beautiful young fashion photographer who lives and works in Paris, and is simply called "O." She is taken by her lover René to a private château in Roissy, on the outskirts of Paris, where she undergoes a series of tortures and rituals as a sex slave, from whipping to the insertion of increasingly large shafts into her anus to ensure she is never free of male domination. The reader is most affronted not by the descriptions of these acts as by O's willingness to be a victim, because of her love for René and the fact that her happiness increases the more she suffers under the hands of an older male, Sir Stephen, to whom she is given by René. Written in a calm literary style, lingering over details of costume, whips, rooms, and O's emotions, the novel reveals many of the tropes of the Sadean novel but is

free from Sade's frenzied syntax. There is a curious counterpoint between the erotic engagements that take place in the château outside the city and the modern urban environment, which is a place of personal and professional routine. In the car before O arrives at the château, she is blindfolded, her hands are tied, her underwear removed, and her bag taken. The reader is informed that O accepts this humiliation out of love for René, believing that her love leaves her no choice but to comply with his wishes: "[She believed] that attachment would be the greater, the more her prostitution would humiliate and soil and ruin her. Since she loved him, she had no choice but to love the treatment she got from him."[61] At the château, O is stripped and prepared for initiation by other women, again in keeping with the Sadean genre in which women teach women the ways of libertinism. She is shackled by a leather collar and bracelets, her hands are tied behind her back, and she is presented to four masked men who rape, sodomize, and whip her. She is not allowed to look into their eyes, to speak, to raise her head, or to deny them anything. A "Sir Stephen" is introduced—a friend of René who will become a paternal figure for O and who will take her as his personal sex slave. He brands her and pierces her labia with a ring that is decorated with his own insignia, and this ring is so large that it weighs her body down, impeding her walk. The branding of O recalls Sade's tale of Justine's branding at the hands of Rodin, but whereas Justine is wretched in her torture, O accepts it passively. She follows orders and accepts the fact that she is told she will have to endure such pain "daily."[62]

O's time in Roissy has an impact on her working life because, back in Paris, she now looks at models through new, more sensual eyes or finds she is dressing differently, noting the texture of wool or silk on her skin, or wearing stockings to ease the discomfort of her bruised genitals. In Paris, she is a financially independent professional woman working for a cosmopolitan fashion magazine, and much of the action takes place in the city's streets. For example, in one scene, René, O, and Sir Stephen drive through Paris in a large Buick, making their way to Sir Stephen's apartment in an old hotel where O will have to consent to their joint "ownership" of her and to brutal whippings—although, the narrator informs us, "her body was saying no."[63] The banality of well-known, real locations is in marked contrast to O's increasing apprehension as the car winds through the streets until the description shifts abruptly from the outdoor public world to the indoor, private, forbidden world: "After the Alma circle, the Cours de la Reine was clearly visible through the leafless branches of the trees; and the Place de la Concorde was scintillating and dry, overhung by those dark clouds promising snow which can't make up its mind to fall. O heard a click and felt warm air climb up along her legs: Sir Stephen had switched on the heater."[64] The car finally stops at a "little street, one of those running between the rue de l'Université and the rue de Lille," after which we see Sir

Stephen's apartment "furnished in dark English mahogany and pale silks."[65] But here the reader is again pulled away from the everyday to O's inner philosophizing: "It was then that a memory came to her mind: several years before she had seen a curious print showing a woman kneeling, as she was, before an armchair. In the picture, the floor of the room was tiled, a child and a puppy were playing in a corner, the woman's skirts were raised, and a man was standing nearby brandishing a handful of switches, preparing to beat her. All the figures were wearing late sixteenth-century costumes and the print had a title that struck her as revolting: Family Discipline."[66] This memory, coming to O's mind as she herself is kneeling in a room about to be "disciplined" by two men, questioning her own humiliation, forces the reader into a position of self-consciousness and questioning vis à vis the action being depicted. O recounts a scene of sexual violence almost in the same breath as a scene of Paris life, and a detail about a riding crop can quickly move into a description of a young model, Jacqueline, "in a ski outfit, the sort only movie stars who don't ski ever wear."[67]

O's own violent urges are only directed toward women—notably Jacqueline, who takes on the role of the *jeune fille* in being lured to Roissy, and Anne-Marie, who lives near the Observatoire but is a key figure in Sir Stephen's school of libertinage. She is comparable to the libertine-whore and is introduced to O by Sir Stephen. Anne-Marie has power ("No one possessed Anne Marie"), but little beauty ("a small, thin woman Sir Stephen's age, and her black hair streaked with grey").[68] It is Anne-Marie who will prepare O for her branding, binding O in a black nylon corset that is so tight it leads O to cry out. She also binds O's hands and ankles and ties her to a column before she is branded with the red-hot rod. The cruelty of the scene is strikingly, if calmly, described—"One single abominable pain shrieked through [O] and as though lightning-struck stiffened her and sent her screaming against her bonds"; it ends with O being untied and passing out in Anne-Marie's arms." Sade's Justine is cleverly invoked through the mention of lightning.[69]

O perceives her sexual relations with Jacqueline and Anne-Marie as one of compliance, whereas Sir Stephen is presented as an unrelenting sadist who despises her body as he enjoys it. He repeatedly insults her verbally as well as physically, telling her "You are easy, O."[70] He defines their relationship in contractual terms: "You are going to obey me without loving me and without my loving you."[71] The violation and branding of O are ritualized—by bathing, the application of makeup and costume, the careful use of tools of bondage, and the contrived settings in which her violations take place. The final command that she receives in the novel is issued to her by Sir Stephen and requires her to be removed from the confines of the château, led by a chain affixed to her genital "link" and with an owl mask on her head. She is brought to a "little cloister with Renaissance arcades," where "a dozen couples were dancing on the terrace and in the courtyard"

but where "one could sense curiosity stirring in the shadows."[72] Here, she is presented by Sir Stephen to another man, called "The Commander," and between midnight and dawn, people stare, mutter, and prod her as the ceremony unfolds: "[T]here was even a drunk American who, laughing loudly, put his hand to her belly but, upon realizing that he had taken hold of a handful of flesh and also of steel, he became suddenly sober and O saw the same horror and loathing appear on his face."[73]

This public humiliation completes O's depersonalization and leads O to fully perceive herself, for the first time, as an enslaved object. She realizes that her body and identity have been irretrievably changed and that she cannot be remolded. The final scene in the novel again forces the reader into a sudden sense of self-consciousness: once the dancers have departed, she is unmasked and put on a table and taken by her masters, "now the one, now the other."[74] The last line and image effectively leave the reader him/ herself in the Sadean chain. The next page offers a postscript: "There existed another ending to the story of O. Seeing her about to be left by Sir Stephen, she preferred to die. To which he gave his consent."[75] This is the alternative, romantic end, which insists that we do indeed have a love story.

The novel's message took another turn in 1969, when a sequel appeared, *Retour à Roissy*. In that, it becomes clear that O does not die but returns to the château as a willing sex slave. This sequel was written at the same time as *Story of O*, but its publication was delayed; it was felt by the author to be "the other side to the dream. . . . [I]t was a degradation into reality . . . prostitution, money, force, etc."[76] When it was finally published, it was due to the encouragement of Pauvert, who felt its brutally real message had new relevance in the sixties.[77] It was accompanied by an essay, "Une fille amoureuse" ("A Girl in Love"), which the author penned in 1968. Here she explained that the novel began as a love letter but also that the novel, like the world, had to face squarely "horrors, wonders, dreams, and lies."[78]

A Girl in Love: Anne Desclos

Inevitably, rumors abounded as to the true identity of the pseudonymous author, Pauline Réage. Paulhan was under suspicion, having written the preface and delivered the manuscript to Gallimard in 1951, although Gallimard refused it. When it was therefore published by Pauvert in 1954, it was presumed Pauvert was supporting his friend, Paulhan. In reality, although Albert Camus (1913–60) had declared that *Story of O* could not possibly have been written by a woman, it was Paulhan's colleague and lover, Dominique Aury, who ultimately confessed to its authorship.[79] It was her clandestine project, written by night "without stopping, rewriting, or discarding . . . writing the way one breathes, the way one dreams," and intended originally just for Paulhan's appreciation.[80]

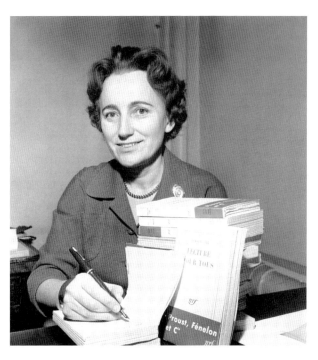

53. Anne Desclos [Dominique Aury, pseud.], 1954.

Aury was born Anne Desclos in Rochefort-sur-Mer, Charente-Maritime, on September 23, 1907 (fig. 53). Her father, Victor Auguste Desclos, was an English professor who had grown up in London and had both French and British nationality, while her French mother, Angèle Louise Anne Auricoste, known as Louise, did not work. An only child, Anne was raised by her paternal, Catholic grandmother in Avranches near Mont-Saint-Michel. According to Aury's biographer, Angie David, her mother "felt a great disgust for the body and sexuality" and did not enjoy pregnancy; this was why she decided to have no more children.[81] Aury always shared her father's passion for English literature, and it was he who introduced her to erotic publications, permitting her to read Laclos's *Dangerous Liaisons* (1782) at the age of fourteen and anything else she wanted from his extensive library.[82] Later in life, Aury recounted how she got into trouble at school when the headmistress found her with a volume of Voltaire that her father had given her, though she avoided punishment because her father came to her defense.[83] She also explained that she not only admired her father but enjoyed a sensual relationship with him; she appreciated that he was a man who loved women, and he influenced her choice of lovers as well as of books.[84] Certainly her literary tastes evolved from his: William Shakespeare, Rudyard Kipling, and Virginia Woolf. When her father secured a post at the Lycée Condorcet in Paris after World War I, Aury was moved

there to live with her parents, studying at that school and at the Lycée Fénelon, followed by a bachelor's degree in English at the Sorbonne.

On March 9, 1929, Aury married a young Catalan journalist, Raymond d'Argila, and on January 26, 1930, their son, Philippe, was born. However, Argila proved a violent and controlling man, and the marriage soon ended in divorce; by 1933, she had entered into a relationship with the writer Thierry Maulnier (Jacques Talagrand, 1908–88), the year before he authored the right-wing tract *Demain la France* (Tomorrow, France) with Jean-Pierre Maxence in February 1934. Maulnier's political leaning could have impacted her ideas—he also wrote a book on Nietzsche in 1935 in which he asserted that "it is necessary to restore to philosophy the taste for blood"; in 1936, he helped found the nationalist journal *Combat* (January 1936–July 1939) and in 1937, the weekly newspaper *L'Insurgé* (January–October 1937), for which Robert Brasillach wrote; and in 1938, he wrote *Au-delà du nationalisme* (Beyond nationalism).[85] It was in the late 1930s and as she engaged with Maulnier's circle that Aury changed her name from Anne Desclos to Dominique Aury, her new name appearing in her first published essays on art and culture in *L'Insurgé*—an emphatically antipatriotic, anticapitalist newspaper that hoped to rally nationalism and whose ambitions for a "new right" came dangerously close to fascism in neighboring countries in its promotion of sovereignty and order. Maulnier was enamored of fascism's mobilization of the young and its emphasis on order, grandeur, and self-sacrifice, but ultimately accepted that totalitarianism, and a rejection of a long tradition of European revolution, would not work for France. His political ambitions within publications and in terms of political mobilization were not successful partly because of his "rather tortured discriminations" between his nationalism and fascism and partly because of his "inner ambivalence" about fascism, as Paul Mazgaj has noted.[86]

Aury's relationship with Maulnier and exposure to his right-wing, protofascist circle, who wrote of national restoration, attacked the bourgeoisie, and courted fascism in literary or explicit political terms, marked a new direction for her life and career. Maulnier called on France to adopt a "minimum fascism" against Nazi Germany, as Mark Antliff has put it, but he never explicitly declared himself a fascist nor followed those who supported the fascist regime with the fall of France in May–June 1940.[87] His political stance is best understood in aesthetic terms, or as a highly spiritual "literary fascism."[88] Aury shared his nationalism but never expressed or demonstrated any anti-Semitic or protofascist position. The outbreak of the war led to the gradual dissolution of their relationship, as she moved to stay with her parents and son in Launoy and Maulnier moved to Lyon; it was over by 1942. Furthermore, she distanced herself from his circle (apart from Maurice Blanchot, who also shifted drastically from a nationalist stance),

and she refused to acknowledge Robert Brasillach, a friend of Maulnier's and fellow contributor to *L'Insurgé*, when their paths crossed in Paris in 1941, the year his collaborationist newspaper *Je suis partout* was relaunched.[89]

She found work writing for the women's journal *Tout et Tout* and later distributed the clandestine magazine *Lettres Françaises*, the voice box for the Comité national des écrivains, which was founded in 1941 by Jean Paulhan and Jacques Decour (1910–42). Ironically, Aury gave a copy of the magazine to Paulhan in 1943 without knowing he was on its editorial board. By then she was working alongside him as an editorial assistant for the *Nouvelle Revue Française* at Éditions Gallimard. Paulhan supported the publication of an anthology she compiled, *Anthologie de la poésie religieuse française* (Anthology of French religious poetry) by Gallimard, in which she selected works over seven centuries from Rutebeuf (1245–85) in the Middle Ages to the contemporary poet Paul Claudel (1868–1955); later Paulhan collaborated with her on a poetry collection, *Poètes d'aujourd'hui* (Poets of today, 1947).[90] After 1944, Aury continued to work in publishing, notably as secretary for the Algerian review *L'Arche*, which had been launched in 1944 by the Algerian writer Jean Amrouche (1906–62) under the patronage of André Gide (1869–1951). She was an increasingly prolific and important figure in Paris publishing, as demonstrated by her many awards, including the Prix Clarouin for translation, the Grand Prix de la Critique and France's Legion d'Honneur, and the Prix des Deux-Magots in 1955, for *Story of O*, albeit under her second pen name, Pauline Réage.

Many in Aury's circle, including Gilbert Lely, suspected she was the author of *Story of O* long before it was confirmed. In the late 1950s, Lely wrote to Aury that having compared the writing in *Story of O* to her essay on the Abbé François de Fénelon (1651–1715), published in 1958 in her volume *Lecture pour tous*, he had deduced she was the author.[91] Lely must also have noted how spiritualism inflected her sadism. In her essay on Fénelon, Aury had explained, "Profane love and sacred love are the same love, or should be. Only the object changes, if one can admit that it is decent to use the word object for God. . . . The pure love in which Fénelon in the exact sense of the word annihilated himself is the single discourse of his *Spiritual Writings*."[92] Aury looked to the lives of Saint Theresa of Ávila and John of the Cross in believing that devotion and prayer were "impudique" (indecent), and comparable to the profane or erotic, which were also driven by the pursuit of absolute love.[93] For Aury, the key to O's tale seems to lie in her insistence that "one is not free when one loves."[94] Loss of one's self to a loved other is crucial; it also explains why rejection by the lover is the ultimate "death" for O—and a powerful spiritual one.

The eroticism of storytelling, so crucial to the Sadean genre, also lies at the heart of Aury's work. She explained that she wrote to seduce Paulhan (fig. 54) and to ensure that her seduction lasted, viewing the writing and

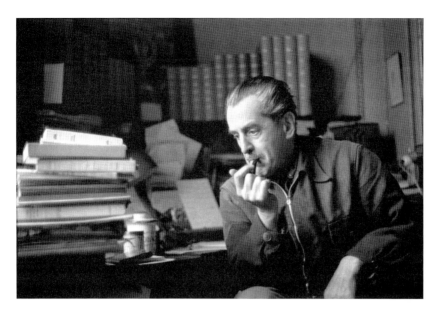

54. Jean Paulhan; photograph by Henri Cartier-Bresson, 1946.

reading of the text together as comparable to "a little Scheherazade."[95] This description of the novel's role is very telling. Scheherazade, the heroine of *The Thousand and One Nights*, is a mistress of literature who escapes death and also masters the Sultan through her knowledge of literature, philosophy, and poetry, as well as her art of storytelling. The Sultan's practice was to bed a virgin and kill her in the morning, so as to ensure only he ever got to enjoy her, but on the first night Scheherazade spends with him, the Sultan spares her life to hear the end of a tale the next day. Soon he is so seduced by her storytelling that his appetite for her is insatiable. At the end of 1,001 nights, and 1,000 stories, when she has no more stories to tell, and by which time she has given birth to three sons, the Sultan admits to having fallen in love with her and makes her his queen. The metaphor tells us something about Aury's fantasy image of her relationship: Scheherazade is not only learned but is described as a woman of "beauty, and modest sensibility," while the Sultan is a man with a "savage heart."[96] In 1995, when Aury first allowed herself to be identified as the author of *Story of O*, she recounted, "I wasn't young, I wasn't pretty. . . . [I]t was necessary to find other weapons. The weapons, alas, were in the head. 'I'm sure you can't do that sort of thing,' he said. 'You think so?' I said. 'Well, I can try.' "[97] It was never intended for publication until Paulhan offered to find a publisher.

Paulhan's presentation of the novel meant that first he, and then his lover Aury, were suspected as its author. Aury denied all involvement and managed to evade further suspicion through the intervention of the minister Édouard Corniglion-Molinier, whose partner was a friend of Aury's and

arranged a lunch where they could meet. Aury recounted in an interview, "Some of the other guests left and I got up to leave as well. I said: 'Monsieur le Ministre, je vous remercie.' He said he would see me to my car. I said good-bye and he kissed my hand: 'Madame,' he said, 'I was very pleased to meet you.' That's all. The next day he issued a decree ending all the proceedings against *Story of O*. Under French law, when a minister does that, no one can ever resume legal action. That was the end of it."[98] The public revelation in the 1990s that O's creator was Dominique Aury and the man she loved was Paulhan, a married colleague, led both the novel and its preface to be read in a new light. The book now went beyond a scandalous love letter; it could be viewed as a dialogue between two respected intellectuals who had been active in the Resistance, were central to the Parisian publishing world, and shared a faith in the pleasure and use value of the Sadean imagination. It also shed further light on Paulhan's stance on Sade.

If Aury ascribed the origins of the story of O, and her fate, to love, Paulhan saw it as rooted in a master-slave dialectic. In his view, the novel was best described by the term "decency"—a term Breton also used to describe Sade, as noted in the previous chapter.[99] As the publishing contract Aury drew up with Pauvert insisted that Paulhan's preface always be published with it, we must assume that she wanted the reader to frame O's tale in terms of his observations on "A Slave's Revolt."[100] His preface lent weight to her erotic story simply by virtue of his status in the literary world, but the fact that he opened the preface by recounting the story of a revolt of freed slaves in Barbados in 1838 undoubtedly located the erotic story in a humanist and sociopolitical frame.

In citing a European colony, Paulhan's preface drew on his own life story. From 1908 to 1911, Paulhan taught at the Collège Européen in Antananarivo in Madagascar, enjoying a retreat from his fiancée Sala Prusak (whom he married in 1911), taking a native mistress, and drawing on his studies in Paris with Émile Durkheim (1858–1917) and Lucien Levy-Bruhl (1857–1939) to research Malagasy proverbs (*hain-tenys*), which he collected during his travels.[101] He also worked as a gold prospector for six months during this period. In 1921, he translated this experience into a short story about a French military convoy charged with escorting three hundred Senegalese women across Madagascar from Amabatomena to Manabo. Through the diary of a colonial sergeant, Aytré, Paulhan presents both the position of the colonial invader and the unruly Africans. The narrative is not written in sympathy with the women—his entries are matter-of-fact, less interested in their hardship and toil than in the potential of the land for growing sugarcane and coffee—but his observations go beyond the keeping a military log. For example, the entry for December 9, 1910, reads: "We have women of three different races: Yoloffs, Bambaras and Toucouleurs. They argue frequently, they are an awful sight, and not easy to please. . . .

The threat of a few blows with the rope is enough to make them get back into line."[102] The women are punished with a rod for stealing, but Aytré becomes increasingly intrigued by their strength and their different beauty. He writes of the women "of the Ambositra region" who dress in white with intricately braided hair "to form a little mound on each side of their ears. . . . Their way of dressing is a bit coquettish, they don't show their legs. . . . Their morals are the most depraved one can imagine: it's probably the country and the customs that make it like that."[103] Aytré delivers the women to their menfolk and brings the tale to an end with the reflection: "It is possible that from their point of view all whites look alike. What idea do they have of us?"[104] The journey allows the narrator to explore his own identity through the foreign land and the foreign Other—the "black beauties" whom he escorts.[105]

Paulhan's writing was influenced by the work on the psychology of colonization in Madagascar of Octave Mannoni (1899–1989), notably Mannoni's thesis of a "dependency complex" among the colonized; this shaped his presentation of slavery in Barbados and perhaps of the sexual slave in the boudoir as "happy" in a state of dependency.[106] Given that November 1954 saw the outbreak of the Algerian War and the accelerating collapse of French imperialism, Paulhan's conflation of colonial and sexual politics is problematic, to say the least. Moreover, Paulhan extends his account of racial difference to a consideration of gender difference, not least as he says that details in *Story of O* gave away that it was the work of a woman. For example, he singles out an observation made by O, in the midst of her torment, that the slippers of her lover René had become scuffed and frayed and needed replacing. Such an observation, according to Paulhan, could only be that of a female author: "Such a thing, such a detail seems almost unimaginable to me—a man would never have fancied such a thing. Would not at any rate have dared mention it."[107] For him, *Story of O* is a novel by a woman who finally admits—for all women—that woman's life is dominated by her sex: "Here we have it at last: a woman who admits it! Admits what? Exactly what women have always—and never more so than today—forbidden themselves to admit. Exactly what men have always accusingly said was true about them: that they never cease slavishly to obey their blood and temper; that, in them, everything, even their minds, even their souls, is dominated by their sex. That they have got incessantly to be fed, incessantly washed and burdened, incessantly beaten."[108] In this respect, Paulhan effectively takes the Freudian position that woman is inherently masochistic and defined by her sex. He also exploits the religious subtext to O's acceptance of her suffering, as she complies with her subservient position—admitting if not avowing to it.[109] And yet he also insists that this is a love story, when he writes, "*Histoire d'O* is surely the most fiercely intense love-letter a man could ever receive."[110]

55. Édith Thomas in the 1930s.

Story of O and Humanist Feminism

Aury's novel raises challenging questions about the relationship between libertinism and feminism and is very much in keeping with the specific historical juncture of the cult of Sade among the avant-garde, on the one hand, and, on the other, a burgeoning feminist movement in postwar France. Aury stated that her choice of pen name paid homage to two formidable women: Pauline Borghèse (1780–1825), the sister of Napoleon Bonaparte, and Pauline Roland (1805–52), the nineteenth-century women's rights activist. She also paid homage to a third woman, the writer Édith Thomas (1909–72), who was her lover in 1946–47 (fig. 55). Thomas's understanding of "humanist feminism"—which she explained in an unpublished anthology containing writings by forty-three women and two collective petitions, the 1789 "Petition of Women of the Third Estate to the King" and the 1848 "Petition to the Provisional Government"—was known to Aury and likely contributed to her own exploration of feminism and the feminine in her writings and fiction. In the anthology, Thomas defined humanist feminism as "[giving] to each human being, man or woman, the possibility of developing fully and harmoniously," and provided examples of those who articulated such a stance, from the fifteenth-century writer Christine de Pisan to her own contemporaries, in the person of Simone de Beauvoir.[111] In *The Women Incendiaries* (1963), her study of women who were involved in the Paris Commune of 1871, Thomas also explained that "feminism" was "merely the nineteenth-century avatar" of "feminine

humanism" and that her concern in her historical study of female revolutionaries was to review the stories of women and their role in revolution as human beings first and foremost.[112] Her work grew "out of the nature of things," reminding us again of this generation's turn to history and literature to shed light on its own circumstances, and from the vantage point of a revolutionary woman herself—with experience as a member of the coordinating committee of the Union des femmes françaises in the Resistance.[113]

56. Cover of *Femmes françaises*, featuring article by Édith Thomas, "J'ai visité le maquis," September 28, 1944.

When Aury met Thomas, she was already a recognized journalist, historian, and novelist. Thomas had trained in paleography at the École des Chartes, gaining a diploma there in 1931 with a thesis on "Les relations de Louis XI avec la Savoie"; in 1933, she won a prize for her first novel, *La mort de Marie* (Marie's death), which was published in 1934; and subsequent publications included *L'homme criminel* (The criminal man, 1934), *Sept-sorts* (Seven fates, 1935), and *Le refus* (The refusal, 1936).[114] In 1933, she joined the Association des écrivains et artistes révolutionnaires, which was founded by writers who were members of the French Communist Party in March 1932 (as part of the French section of the International Union of Revolutionary Writers established in 1930 in the Soviet Union), and which met until 1939. Although Thomas contributed to the association's journal, *Commune*, she quit the group in 1934, feeling too constrained by its Stalinist orthodoxy. Beginning in 1935, she founded and wrote for the weekly paper *Vendredi*, alongside Andrée Viollis, André Ghamson, Jean Guéhenno, and Louis Martin-Chauffier, and until the outbreak of World War II she also wrote for other antifascist publications, including *Europe*, *Regards*, and *Ce Soir*. Thomas reported from the front, traveling to Spain to report on the Civil War in 1936 and 1938, and with the outbreak of world war she became active in the Resistance and in the clandestine Comité national des écrivains, also contributing to the clandestine journals *Les Étoiles* and *Les Lettres françaises*. In fact, the Comité met in Thomas's apartment at 15 rue Pierre-Nicole, in Paris's fifth arrondissement, from 1943 until the Liberation.[115]

Thomas provided a distinctive perspective on war from a female point of view, as her reportage brought readers very close to its everyday reality, as evidenced in her two-part article "J'ai visité le Maquis" in *Femmes françaises*, the weekly newspaper of the Union des femmes françaises, founded during the Occupation and produced by the Communist-led Resistance movement, Front National (fig. 56). These articles addressed Thomas's time with the maquis (guerrilla fighters in the Resistance) in May 1944, and although it appeared in *Femmes françaises* in September, part of it had appeared clandestinely in *Lettres françaises* too. The article recounts her meeting with a young woman, describing her experience of living by subterfuge, the daily fear and hardship of having to leave her child with her mother in order to fight, seeing her husband imprisoned, and the worry of now bring pregnant with another child while risking arrest and death.[116]

Thomas met Aury just after the Liberation of Paris in August 1944, when Paulhan recommended Aury as a new writer for *Femmes françaises*. A friendship between the three developed, although Thomas stopped all communications with him when Paulhan published his treatise against the purge, *Lettre aux directeurs de la Résistance*. They only renewed contact in 1967, the year before his death. In 1946, the two women began a love affair, when,

according to Thomas's biographer Dorothy Kauffman, "Dominique had considerable experience with men and episodically with women—in contrast to Édith, who had little sexual experience with men and none with women."[117] Books, writing, and publishing brought them together, just as they had Aury and Paulhan. Thomas was the more prolific writer of the two, however: in 1945, she published *Études de femmes* (Studies of women) and *Le champ libre (The open field)*; in 1947, a biography of Jeanne d'Arc; and in 1948, *Les femmes de 1848 (The women of 1848)*. Her publications continued right up until her death, including *Eve et les autres* (*Eve and the Others*, 1952), *Pauline Roland: Socialisme et féminisme au XIXe siècle* (Pauline Roland: Socialism and feminism in the nineteenth century, 1956), *George Sand* (1960), *Les pétroleuses* (*The Women Incendiaries*, 1963), and *Le jeu d'échecs* (The game of chess, 1970). She also remained politically active, as a member of the French Communist Party from 1942 to 1949 and, later, on the committee Vérité et Liberté during the Algerian War.[118]

Thomas's novel *Études de femmes* is the story of three young women and their shared quest for happiness—a teacher, a lawyer, and an unfulfilled young wife who has put love before a possible career in biology. Aury reviewed the book in *Femmes françaises*, revealing her admiration for the author between the lines of her critical analysis of the three characters and Thomas's overarching stoic theme of a woman's destiny, which need not be prescribed by her "civil status or profession" (fig. 57).[119] The evolution of the modern woman was reflected in the design of the newspaper itself, which reflected wartime austerity and the aspiration to postwar recovery: alongside Aury's review we find a column called "Sur la table," with two recipes using egg powder, "croquettes paysannes," and "bouchées bonne femme," and an advertising feature titled "Brises d'automne" (Autumn breezes) with drawings of women in smart fashion styles.

Thomas's diaries reveal the couple's struggles to name their own lesbian relationship:

> This morning D. said to me: "Édith, I've drawn you into a trap." She was pale, ill, agitated. "I love you the way a man loves a woman." What to do? My God (who doesn't exist), what to do? I feel friendship, respect, deep affection for her. We agree on what is essential; we experience things, people, books in the same way. I love her delicacy, her intelligence, her exceptional quality of being. If she were a man, I would be infinitely happy about her love for me. If I were a man, I would love her. But she is a woman and I am a woman. What to do?[120]

Thomas also notes: "I never thought that homosexuals and lesbians could be in love outside their closed network. And here I discover the love of one of them for a physically normal being. And it happens that this woman is beautiful, intelligent, delicate and that I love her (as much as I can love a

57. Dominique Aury, review of Édith Thomas's *Études de femmes* in *Femmes françaises*, September 7, 1945.

woman). One moral rule remains for me: not to make her suffer as I have suffered."[121] Given that Aury's protagonist O loves both men and women and finds her own desires becoming increasingly experimental through her sexual relations with Jacqueline and Anne-Marie, we can surmise that both Thomas and Aury were as interested in equality in the boudoir as in the workplace and in moving away from rigid conventions of gender.

A year later, Paulhan replaced Thomas as Aury's main love interest, but the relationship between the women continued, especially in their fiction. Aury's presence may be found in Thomas's story "The End of Gomorrah" in *Eve and the Others*, a collection in which Thomas restages biblical stories. There, Lot's wife is named Edith and chooses to stay in Gomorrah with her close friend Deborah rather than leave the city with her husband. Further, Aury's choice of pseudonym in *Story of O* nods to Pauline Roland, the subject of Thomas's major study *Pauline Roland: Socialisme et feminisme au XIXe siècle*; Thomas was researching the book at the same time Aury was writing her erotic novel.[122] In an interview in the 1970s, Aury alluded to the possible role of Thomas in O's story, stating, "One of my friends (whom I respect, and I don't respect people easily) could well be Anne-Marie, if she weren't

purity and honor itself: I mean that from her Anne-Marie could have derived her resolve and her rigor, and her clean and upright way of exercising her profession."[123] There are very real similarities between the real and fictional women: in the novel, Anne-Marie lives near the Observatoire, as Thomas did, and she is rather manly and slim, as Thomas was. Anne-Marie observes the relationship between O and Sir Stephen, much as Thomas might be said to have observed the affair between Aury and Paulhan. Without doubt, there was complicity between the real and fictional women behind O's story and in their shared interest in humanist feminism as the best path for the modern woman. Aury's exploration of woman as a happy Sadean slave might be read as promoting "equality in inequality," offering a diversity and multiplicity of sexed subjects, as explained by Simone de Beauvoir in *The Second Sex*.[124] Beauvoir insists on the need for economic as well as sexual independence for women while also exploring the complexity of love and its challenges to the pursuit of liberty: "[The woman in love] abandons herself to love first of all to *save herself*; but the paradox of idolatrous love is that in trying to save herself she *denies herself* utterly in the end."[125] In her writings, Thomas also explored the subject of the feminine, biology, and the role of the couple in a woman's life, as well as women's role in literature and history; although her manuscript remained unpublished, she began writing it in 1947, two years before *The Second Sex* was published and as her affair with Aury was ending. She later added Beauvoir's book to the draft of the table of contents, and deemed Beauvoir's study to be a flawed but "courageous effort of elucidation."[126] With her death and the publication of her last novel, *Le jeu d'échecs*, in 1970, Thomas was often compared to Beauvoir for her exploration of the modern woman, though she never won the same international critical attention.

Slave or Suffragette of the Whip

Story of O received considerable critical attention from the public and critics alike. Paulhan received many letters from the public including one from a woman, Andrée Delamain, who introduced herself as a Catholic and the wife of editor Maurice Delamain, before proceeding to give a lengthy analysis of the novel, framing it within the context of Paulhan's earlier essay "Le Marquis de Sade and His Accomplice." She explained that the religious subtext to the plot greatly appealed to her: she read Sir Stephen as Christ, and O's journey as one of total sacrifice, in keeping with the total sacrifice of the self for the love of God. As a result, "O is an absolute that cannot possibly exist because the god she serves . . . is not an absolute either."[127] In a review in *Critique*, André Pieyre de Mandiargues also wrote of the novel in quasi-religious terms. He compared O's story to that of a pilgrim, involving a "complete spiritual transformation" and a "blossoming" (*épanouissement*)

that results from the destruction of the flesh and delivery of the spirit.[128] This aligned it with the novels of Sade, as both went well beyond the sensual, while its fetishism for the mystical distinguished it from other erotic publications: O's total descent into hell and the destruction of her body underpin her happiness and "transfiguration by a current that comes from the soul rather than the body."[129]

In contrast, in November 1954 in *L'Express*, François Mauriac wrote a most condemnatory article on Paulhan and *Story of O* (without actually naming it). He described the novel in terms of "literary morals that make me vomit."[130] While Paulhan did not publicly reply to Mauriac's article, he did write to Mauriac directly, criticizing his comments, which he said were delivered with "such violence!"[131] Mauriac's letter in response, dated July 15, 1958, further attacked the novel, calling those who would defend it "fools" and asserting that eroticism was a literary "cul-de-sac."[132] Sade is "unreadable," Mauriac claimed; he and Paulhan differed fundamentally on the representation of the flesh: he did not approve of flesh treated in crude, anatomical terms; for him, it was "the heart of flesh" that counted, a term he underlined in his letter.[133] Even when Mauriac returned to the subject of eroticism in an essay in *Le Figaro littéraire* in 1963, he repeated that he found *Story of O* "atrocious" and "intolerable."[134]

Although very few copies of *Story of O* were actually sold, even when the novel won the Prix des Deux Magots in 1955, it did not take long for it to attract the attention of the censor.[135] In testimony he gave to the Brigade mondaine (vice squad), Paulhan refused to disclose the real identity of "Madame Réage" but described her as an academic who was afraid of shocking or offending her family and hence wished to retain her anonymity. Pauvert also refused to name the author, so prosecution was difficult. Indeed, the novel became more notorious and popular as people speculated about the author, gossiping that it might be André Malraux (1901–76), Henri de Montherlant (1895–1972), Raymond Queneau, or a further Sadean novel by André Pieyre de Mandiargues, given that he had written the tale of a sadistic Monsieur de Montcul, formerly the English diplomat Sir Horatio Mountarse, and his château of perversion in *L'anglais décrit dans le château fermé* (*Portrait of an Englishman in His Château*) in 1953.[136] It was also strongly suspected that the novel was the work of someone from the surrealist circle, not least because Breton included the title in a surrealist calendar of activities in 1955. One could describe the novel as a story of surrealist-like *amour fou* (mad love) in that O's love for René consumes her so much that she abandons all reason and pursues desire despite the costs. Equally, one could read it as the story of the potentially iberating power of "sadism" for a woman, extending the interwar avant-garde's interests in Sadean heroines—O is freed from the roles of wife and mother, and confronts the abyss unflinchingly as a lover, liberated from every taboo,

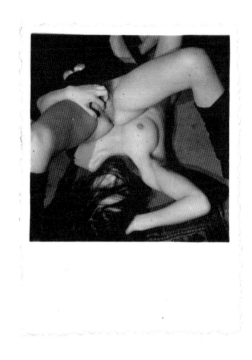

58. Hans Bellmer, *Untitled*, **gelatin silver print, 1946.**

every social and moral code. When the novel was reviewed in February 1954 by Jean-Louis Bedouin, in the surrealist journal, *Medium, Communication Surréaliste*, he deemed it "dangerous," echoing Paulhan in his preface, for its depiction of enslavement to love.[137] Bedouin read the book less as a story of masochism than as one of the "bright reality of desire."[138] The sacred in all its Christian forms was anathema to surrealism, so his conclusion that it might be read as "a mystical work" allows it to remain in the surrealist lexicon, with O's story taking carnal desire into a mystical escape from all spiritual and social dogma.[139]

André Berry, writing in *Combat* in March 1955, described the literary qualities of *Story of O* in glowing terms, admiring its "somber and powerful images, precise tableaux, subtle observations" and noting that eroticism was staged with "dignity."[140] A few months later, Georges Bataille joined in the celebration. In a review in the *Nouvelle Nouvelle Revue Française*, he praised the manner in which the novel staged the dynamic between torturer and tortured, differentiated between it and "mechanical pornography," and admired its exploration of "desire of the impossible," as exemplified by the fact that O is "[a] visionary who died from not dying"—her final solitude and introspection at the end of the novel being read by Bataille as a more profound loss of the self.[141]

The interpretation of *Story of O* by the writer Nora Mitrani (1921–61) offers an insight into the novel's particular appeal for women of the

avant-garde. Mitrani, a Jewish poet from Bulgaria who was raised in Paris and studied at the Sorbonne, was a member of the surrealist circle in wartime Paris and the lover of Hans Bellmer from 1946 to 1948. Mitrani explored Sadean desire in a series of anagrams collectively titled *Rose au coeur violet* (Rose with a violet heart), which she wrote with Bellmer in 1947–48. The title of the collection was taken from a line in Gérard de Nerval's poem "Artémis," one of his sonnets in *Chimères*, in which he wrote, "Rose au coeur violet, fleur de Sainte Gudule," playing with the erotic potential of the word violation (*violé*) and the female vulva (*rose*).[142] For Bellmer, Nerval's romantic poem was "too florid, too sweet," but as he explained in an interview with Bernard Noël, "One or the other suggested we make anagrams with the line from Nerval. Yes, it was like a fever. Anagrams are better with two, a man and a woman."[143] Mitrani, for her part, explained the work as an enactment of the "mortal gravity of love," which causes vertigo, madness, and fear.[144] They also collaborated in a series of photographs that Bellmer would describe as "obscene" and as "sodomising the Me [*Moi*] in the You [*Toi*]."[145] Bellmer wrote of these photographs as an intense experiment, carried out while they holidayed together, and how he saved them for his drawings and portraits, notably for his engravings for a luxury edition of Bataille's *Story of the Eye* that year.[146]

A series of untitled photographs, dated 1946, depicts two women in various explicit sexual poses—possibly Mitrani with prostitutes or just prostitutes—and gives a sense of Bellmer's experimentation with the camera to explore Bataillean motifs in his art (fig. 58). In *Story of the Eye*, the sixteen-year-old protagonist Simone is first encountered lowering herself to sit in a saucer of milk for the cat, and she reaches erotic ecstasy in the story in Madrid where she thrusts bull testicles from a bullfight, and later the eyeball of a priest she sacrifices in a church, into her vagina, constantly needing the thrill of violence to reach her orgasm.

Mitrani's intense relationship with Bellmer—who produced the first frontispiece for *Story of O* in 1954, as discussed below—makes her an especially interesting reviewer of Aury's novel. In 1956–57, she published two essays on *Story of O* for the surrealist review *Le Surréalisme même*, describing O as a modern woman in one, and as a slave and a suffragette of desire in the other. In her first article, Mitrani referred to the superficial portrayal of women in popular advertising to argue that women had to wield "feminine arms" if they were to regain their autonomy; she also noted O's silk Orientalist garments as a type of femininity that was very "fashionable" for French women in postwar society.[147] Mitrani reads *Story of O* as a kind of masquerade—that is, the deliberate flaunting of femininity as a cultural mask, echoing psychoanalyst Joan Riviere's analysis of gender play in her influential essay "Womanliness as Masquerade" (1929).[148] The surrealists' choice of the Czech surrealist Jindrich Heisler's 1943 frontispiece for an

edition of Sade's *Philosophy in the Bedroom* as the illustration for Mitrani's article gave a Sadean visual force to her argument. In choosing this particular photomontage, which depicts a woman facing a mirror with her eyes bound by chains, the surrealists remind the reader of their long-standing celebration of Sade and his subversive sexual potential. Heisler's representation of woman may be read as a parody of the traditional *vanitas* portrayal of the desirable woman—that is, before her mirror, preening herself for the delight of the voyeuristic male spectator. In addition, the image illustrates Sade's *Philosophy in the Bedroom*, in which the young Eugénie is desocialized as part of her sexual education, liberated from her inherited patriarchal notions of femininity as passive and virtuous.

The idea of emancipation through libertinism is continued in Mitrani's second essay on *Story of O*, titled "Des esclaves, des suffragettes, du fouet."[149] There she argued that women needed to show that they were no longer slaves of the whip—be it in life, love, or literature—and she praised Simone de Beauvoir for freeing women from the confines of patriarchy (Mitrani does not mention *The Second Sex* of 1949, but she was surely thinking of it). Likewise, the case of "Mme O," who feels "fulfilled" despite her debasement, challenges the patriarchal female ideal. It presents the reader with a somewhat grotesque image of woman, liberated from patriarchy, home, and family, but subversively taking the passive role demanded of her by society to its logical, masochistic extreme. O is a suffragette of the whip, in abandoning socially prescribed female norms, but a slave of the whip in subjecting herself to every man's desire for her body. Interestingly, in 1959 Mitrani further reflected on O in an essay titled "Une solitude enchantée," which was published in the exhibition catalog for the 1959 International Surrealist Exhibition in Paris, dedicated to the theme of Eros.[150] There Mitrani makes the very astute observation that O, despite being an obedient sex slave, is unable to masturbate even when Sir Stephen demands she do so; hence, Mitrani sees the novel as only a *step* toward female emancipation.

Paulhan had alluded to the allegorical role of the body in his preface to *Story of O*, when he stated that it staged "[a]n idea, a mode of ideas, an opinion which in this book finds itself put to torture."[151] O's savage sexual experiences are juxtaposed with the everyday occurrences of contemporary France as if to emphasize this dynamic between the real and the fantasy, the body and the idea of its torture and final death. The interruption of the real in O's story ensures that readers never remove themselves from the everyday, as in the bizarre scene where O becomes so depersonalized that she no longer comprehends why a beautician in "the Beauty Institute" is "scandalized and horrified" by her abused body.[152] This detail lends a very particular female perspective to the story too, specifically a vogue for the erotic narrated through the female victim's perspective.

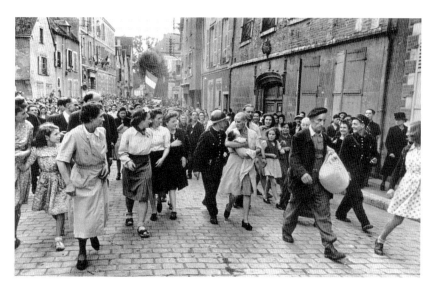

59. *Femmes tondues* (**Shorn Women**), **rue Collin-d'Harleville, Chartres,
August 16, 1944, photograph by Robert Capa.**

In 1981, before Aury publicly admitted authorship, the feminist literary
critic Anne-Marie Dardigna read *Story of O* as symptomatic of a postwar
trend in erotic literature exploring the *jouissance* of the female victim.[153]
Dardigna emphasizes how O is treated like horse meat, bartered over, her
body having "value" only in terms of exchange.[154] She concludes that the
novel is symptomatic of patriarchal practice in its branding of women
(literally or metaphorically), but she also makes the observation that, in
doing so, it allegorizes another aspect of patriarchal society—that is, its
history of torture and conquest at a time when France was using torture in
the Algerian War.[155] The word "confession," used in *Story of O* and by
Paulhan in his preface, was akin to the discourse of the *épuration* and of
Stalinist propaganda, both of which were ubiquitous in France by 1954.

The novel also echoes the experiences of the Occupation during World
War II. For example, one figure in the Resistance, Marie-Antoinette Morat,
described the Nazi invasion of France in sexual terms: "[T]he invasion was
like a rape. To this day when I read about a rape trial, I am reminded of the
Occupation. This was real violation—violation of my country."[156] Certainly,
the final parading of O seems reminiscent of the public and cruel displays
of female collaborators after the Liberation. Alain Brossat has described the
terrifying "carnival" in which they were typically stripped, marked, shaved,
mocked, and dragged along public streets (fig. 59).[157] The description of a
tondue by one woman whose father was executed by the Germans captures
the moral dilemma that faced the French, and French women in particular,
when it came to this ritualized parading:

The war was not finished, but in Paris it assumed another form—more perverse, more degrading. At least, that is how I viewed it. This was the *épuration*. The "shorn woman" of rue Petit-Musc was a large young woman with a nacreous, rosy complexion. She walked along with her wedge-soled shoes tied around her neck, stiff like those undergoing a major initiation. Her face was frozen like a Buddha, her carriage tense and superb in the midst of a shouting, screeching mob of faces contorted by hatred, groping and opportunistic hands, eyes congested by excitement: festivity, sexuality, Sadism.[158]

While O's abused body may not intentionally have stood for France's abuse at the hands of the Nazis or the sadistic treatment of collaborators after the war, Aury had witnessed both and in 1975 spoke of humiliation as the "most profound form of destruction."[159] The humiliation of the individual reduces the individual to a body, to a mass, a shape, and eventually a no-thing. This nullity of the human is the worst form of death, as O's wretched finale makes clear. If the novel is read as a love letter to Paulhan, it certainly draws out his favored topics for debate—art and ethics, resistance and retribution, rhetoric and terror—but from a feminist point of view, it also engages in debates on humanism, existentialism, and essentialism.

The Story of the Second Sex

Jean Paulhan wrote in the preface to *Story of O* that O represented an "ideal" womanhood that is "virile, or at least masculine. . . . That, in a word, one must have a whip in hand when one goes to visit them (that is, women)."[160] This seems at odds with the ideal of the modern French woman at a time when she had only recently been granted the vote (August 25, 1944) and was striving for financial and sexual independence in an economy still recovering from war.[161] French political parties recognized women as a new electorate—for example, the Communist Party courted the female vote in magazines and papers such as *Femme françaises*. Traditional attitudes toward women were slow to change. A 1947 study showed that nearly three-fifths of women did not read newspapers of their own choosing but rather the paper of their husband's choice.[162] The first women's magazines, *Marie-France* and *Elle*, preached domesticity and advised women on household management, fashion, and beauty, and such publications became powerful tools of influence, printing about sixteen million copies per month for about fifty million readers.[163] In 1953, Robert Prigent, the minister of population and health, was still insisting that woman's place was naturally in the home.[164] A book titled *Les carrières féminines* (Womens' careers), in the same year, took the same position, presenting the home as a place that was "difficult" to run but "magnificent" in its rewards.[165] Only advertising companies promised to

"liberate" women, by providing them with labor-saving domestic appliances, but theirs was a narrow, consumerist idea of liberation.

Aury was writing her novel at a time when female psychologists and philosophers were increasingly urging women to realize their own complicity in patriarchal tradition and mythmaking, and to engage in political life irrespective of their gendered repression.[166] The psychoanalyst and translator of Sigmund Freud, Marie Bonaparte (1882–1962), had argued in *De la sexualité de la femme* (*Female Sexuality*, 1951) that women were incapable of erotic function separate from the biological function of childbearing; hence, they suffered from sexual repression, and by extension, social repression. She claimed that women who could stimulate themselves sexually could be liberated from their biological role and thereby could harness their libidinous-aggressive feelings for socially and politically progressive ends.[167] The three obstacles to woman's autoerotic liberation were, according to Bonaparte: her femininity; her virility, which had to be repressed given the traditional passive role of woman; and her socially enforced virtue, which forced woman into a subservient position morally and sexually and perpetuated man's superiority. Arguing that the language of sexuality also presented women as passive, Bonaparte held that if women were to act more like men, society would be free of frigidity, sexual unease, and taboo. The surrealists were very familiar with Bonaparte's ideas: they had published her translation of Freud's "The Question of Lay Analysis" in *La Révolution surréaliste* in 1927; they had discussed "clitorals" in their sexology discussions in 1928; and the surrealist poet and psychoanalyst Andreas Embirikos (1901–75) had founded the Greek Psychoanalytic Society with her in Paris in 1946.[168] Further, Bonaparte's ideas on female frigidity and especially on the female clitoris caused considerable debate among male and female intellectuals in inter- and postwar Paris. She controversially advocated surgery in an essay of 1924, and again in her book, claiming it could improve clitoral sensation.[169] It is tempting to read O's failure to bring herself to orgasm through masturbation, when Sir Stephen demands it of her, as an example of Bonaparte's "teleclitoridian" problem.

Of course, Beauvoir's *The Second Sex* had a huge impact on postwar France shortly before *Story of O*—twenty-two thousand copies were sold in the first week of its publication in 1949. Its analysis of woman as "Other" effectively offers a feminist frame for the reading of O: "When man makes of woman the *Other*, he may, then, expect to manifest deep-seated tendencies toward complicity. Thus, woman may fail to lay claim to the status of subject because she lacks definite resources, because she feels the necessary bond that ties her to man regardless of reciprocity, and because she is often very well pleased with her role as the *Other*."[170] Beauvoir exposed the dominant feminine ideal as a patriarchal one, whereby woman was chained to her biology and was forced to deny her aspiration to independence; but

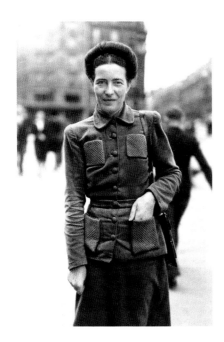

60. Simone de Beauvoir at Saint Germain des Près, Paris, ca. 1946.

she also identified a particular French chauvinism that she and Aury, as female authors in literary circles dominated by men, would surely have found especially resonant: "[I]n France a man feels himself economically threatened by feminine competition; to maintain, or to assert the maintenance of a superiority no longer guaranteed by the customs of the country, the simplest method is to vilify woman."[171]

Aury wrote about existentialism and interviewed Beauvoir for *Les Lettres françaises* in December 1945, introducing her as "an existentialist writer and philosopher" (fig. 60).[172] In the December 1950 edition of *Contemporains*, she reviewed Beauvoir's *The Second Sex* and lauded its "freedom of spirt" as a woman author takes on gender and sexuality:

> If a woman discusses the physicality of love at length and in terms considered scientific, she assaults the gravest of all taboos, and she violates the rules of modesty and of good education in one fell swoop. To a certain extent she exposes herself, compromises herself and in doing so compromises other women, who are quite ready to wish this on her. Hence the laughter because the detours of philosophical language sometimes give rise to comic effects, but primarily because this very language is generally straightforward and because the one who uses it is a woman. Clarity is for those whom professional secrecy obliges to remain silent: doctors and confessors. From the pen of a woman and on this subject, clear language is a usurpation, a scandal. This is why Simone de Beauvoir's book will go down in history, less due to its content than to its tone of freedom.[173]

Aury notes that Beauvoir exposes the sad truth that woman is the second sex, from birth and by nature, whether in marriage or in the workplace, and she praises her for calling for an end to this injustice. Beauvoir in turn refers to Aury in her memoirs, describing conversations they had as part of the *Temps modernes* editorial team: "There were moments of gaiety, mostly when Paulhan carefully tore a book to pieces and concluded 'of course, we must publish it.'"[174]

It is clear that both women were conscious of their status and responsibility as women of letters. Like that of *Story of O*, the reception of *The Second Sex* was very heated and often because it was ostensibly the work of a woman. Réage was attacked by both Catholics and Communists—the former deeming her book immoral and putting it on the pope's black list; the latter deeming it *petit bourgeois* and irrelevant to working-class women and insisting that women's subordination was only a part of the larger subordination of the proletariat. Beauvoir described the response to her book as: "[V]ery violent! perhaps we made a mistake in publishing the chapter on sexuality in *Les Temps modernes* before the book actually came out. That was the beginning of the storm. And the vulgarity. . . . Mauriac, for example, immediately wrote to one of our friends who was working with us at *Les Temps modernes* at the time: 'Oh, I have just learned a lot about your employer's vagina . . .'"[175]

Albert Camus, Beauvoir noted, felt she had made a laughing-stock of the French male, although he too had become obsessed with Sade—as his play *Caligula* (1944), his book-length essay *L'homme revolté* (*The Rebel*, 1951), and his shorter essay "Reflections on the Guillotine" (1957) all attest. In *Caligula*, we find that cruelty becomes the logic of pure freedom, with the protagonist explaining, "One is always free at someone else's expense. Absurd perhaps, but so it is."[176] In *The Rebel*, he writes appreciatively of Sade's exposure of "the presumptuous alliance of freedom with virtue. . . . [H]is hatred for the death penalty is at first no more than a hatred for the men who are sufficiently convinced of their own virtue to dare to inflict capital punishment, when they themselves are criminals."[177] He also points to Sade's philosophy as a source of the rise of fascism and dictators: "Two centuries ahead of his time and on a reduced scale, Sade extolled totalitarian societies in the name of unbridled freedom. . . . With him really begin the history and tragedy of our times."[178] Camus emphasizes the libertine's world as one of imprisonment and despair, where man, as "nature's executioner," is led on a path of destruction "to universal annihilation."[179] In his later essay "Reflections on the Guillotine," Camus is as damning of this supposedly legitimate mode of crime as Sade was before him. He writes that capital punishment is a "penalty the imagination could not endure" that "besmirches our society, and its upholders cannot reasonably defend it."[180]

Beauvoir was also offering her views on Sade at this time. Two years after *The Second Sex*, she published an essay titled "Faut-il brûler Sade?"

("Must We Burn Sade?") in *Les Temps modernes*.[181] Sade's union of the sexual with the ethical attracted her and led her to defend his "human signification" for society for its important realization that sexual practice was socially nurtured.[182] Beauvoir depicted Sade as a historical barometer, indicating the degree of individualism and alienation within society, and claimed that Sade's originality was his decision to pursue his own cause, sacrificing his social existence and responsibility and choosing, instead, "the imaginary."[183] She is close to André Breton's view in describing Sade as a man who "by means of his imagination . . . escaped from space, time, prison, the police, the void of absence, opaque presences, the conflicts of existence, death, life and all contradictions."[184] She points out that Sade had enough material stability to be able to praise Republicanism and had a château to which he could safely retreat when the bloody reality of the Revolution was unfolding. She also observed that while Sade loved to inflict sexual pain and loved blood, he could not inflict torture or death for a purely political agenda, as was demanded of him as Commissaire du peuple en province. In Sade's imaginary world, the torturer and the tortured are constantly aware of each other. This consciousness of subjectivity and objectivity, the interdependence of sadism and masochism, led Beauvoir to describe the Sadean world as "rational" and Sade's actions as "moral." She also suggests that Sade attempted to explore culpability. In classifying Sade's activities as crimes, society delineated what was good and what was evil. Tracing the development of Sade's personal disposition, from his cold father to his harsh mother-in-law, she reads his increasing perversity as a symptom of society's increasing attempts to control him. She interprets Sade's philosophy as an assertion that "in a criminal society, one must be a criminal," a stance that resonated powerfully in a postwar world where many called for an "eye for an eye" in the punishment of fascists and fascist collaborators.[185] Further, Sade offers a case for reflection on the dynamic between sadist and masochist in the heterosexual couple. She analyzes woman's relationship to man in Hegelian terms, writing of it in light of the master-slave dynamic: "Certain passages in the argument employed by Hegel in defining the relation of master to slave apply much better to the relation of man to woman. . . . Hegel's definition would seem to apply especially well to her. He says: 'The other consciousness is the dependent consciousness for whom the essential reality is the animal type of life; that is to say, a mode of living bestowed by another entity.' "[186] O might be viewed as the paragon of such objectification—she is a sexual tool, mastered and crafted by Sir Stephen so that her identity becomes absorbed in his.

In 1975, Aury's description of patriarchal society resounds with the feminism of Beauvoir: Aury stated that in society man needed to vilify woman; in the "universe of men," the body of woman had been reduced to an instrument for childbirth and pleasure.[187] Hence, O's story might be

read as an effort to put into fiction Beauvoir's understanding of the body as sexuate. Beauvoir insisted that the body is not a thing but a situation, thus combining existentialism and phenomenology, and in her analysis of Sade in *The Second Sex* she asserted that Juliette and Eugénie should not be viewed as masochists, because they "give themselves to the male in every possible way for their own pleasure."[188] Their sense of freedom—even if it involves submission—marks them above masochism. She also notes that woman is often complicit in the master-slave dialectic, desiring enslavement to the extent that it seems to her an expression of liberty and transforming her prison "into a heaven of glory, her servitude into sovereign liberty."[189]

O's story may be read as engaging with many of Beauvoir's ideas in light of a burgeoning feminist humanism in the postwar era. Notably, O is complicit in her own rationalization of her enslavement. Her character is that of a modern career woman, and economically independent. Yet she becomes engulfed in a masochism that leads her to rationalize to herself that defiance is useless and that her worth is defined only in terms of men. Beauvoir's evocation of woman's paradoxical state of slavery (a state she could theoretically escape but in which she chooses to remain) is similar to that reverential mentality displayed by O toward her male masters. Beauvoir states that for the typical female "victim," what exalts her is not the idea of her beaten and enslaved person, it is rather the strength and authority, the supremacy of the male, upon whom she is dependent. O is so tyrannized by the male world that she believes she is "a creature of some other world." She is so scared at the thought of losing her master that she feels death would be easier.

Finally and tellingly, given their roughly similar ages and shared Catholic upbringing, both Beauvoir and Aury turn to mysticism in their analyses and descriptions of desire.[190] Beauvoir writes that women frequently turn to religion as a mystical escape from the world men have delineated, replacing the masculinist with the divine. Religion and desire are linked for woman: she denies herself, renouncing her flesh, or punishing herself for indulging her flesh. The act of love is depicted by Beauvoir as one of annihilation, of total sacrifice, and the abolition of a woman's ego: "Abandon becomes sacred ecstasy. When she receives her beloved, woman is dwelt in, visited, as was the Virgin by the Holy Ghost, as is the believer by the Host."[191] Aury's attitude toward the divine and its eroticism was similarly Catholic in inspiration, and O's sexual pilgrimage evokes the iconography of Saint Theresa and other female martyrs. Aury's spoken analysis of the female psyche drew on the teachings of Catholicism and the belief that women had one of two vocations—marriage or the convent. She stated that women want to be possessed, possessed to death and to be martyrs to love as a martyr to God would be.[192] Her analysis of love is also similar to Beauvoir's. Aury interprets O's story as one of self-sacrifice intended to prove her

self-abandonment, her nearing the "absolute."[193] The experience of love seems most comparable to the experience of war: time and passion take on a new meaning, often resulting in sacrifice.

Judith Butler's reading of Beauvoir on Sade reminds us of the pertinence of the Sadean imagination to the postwar epoch and its humanism: "To try to understand Sade is to recognize that if nothing human is foreign to us, even Sade will have to cease to be unimaginable. By imagining him, Beauvoir is exemplifying a task of (a postwar) humanism, making a choice of her own, establishing as well, and in a timely way, what it takes to overcome the difficulty of imagining others who are disgusting or difficult to apprehend. 'To sympathize with Sade too readily is to betray him.'"[194] Aury's O forces the reader into the same position of trying to imagine the Other.

Imagining O

Artists' representations of O lend a final crucial aspect to this chapter's analysis of the Sadean imagination. The first print run of *Story of O* was six hundred copies, which were numbered, and many had a medallion-sized engraving by Hans Bellmer on the title page, in red ink (fig. 61).[195] Pauvert, who befriended Bellmer after the war, invited him to produce the illustration, having worked with Bellmer before. In 1950, Bellmer had produced the frontispiece for a luxury edition of *Justine*, with a preface by Georges Bataille, and in 1952, he had done drawings for a luxury edition of Louis Aragon's *Le con d'Irène* (*Irene's Cunt*).[196] In 1954, Pauvert organized a small exhibition of Bellmer's work at a gallery on the rue de Ciseaux in Paris. Bellmer explained his appreciation of Sade in an interview in 1971 in terms not dissimilar to Aury's, emphasizing that desire underpins terror: "I admire Sade very much, especially his idea that violence towards the loved one can tell us more about the anatomy of desire than the simple act of love."[197] His frontispiece for *Story of O* shows a doll-like girl with long curls and high heels, toppling in her contorted, multiple pose but bearing none of the collars, rings, whips, or the eighteenth-century costume of O. Rather, it draws on Bellmer's well-known and controversial photographic images and drawings of *poupées*, a series of erotically pliable doll sculptures made of wood and plaster and metal rods (first doll, 1933–34) as well as plaster and ball joints (second doll, 1935), which he produced throughout the 1930s. In his illustration, as with his dolls, Bellmer defies—if not defiles—the *jeune fille* as innocent, twisting her limbs like a toy so that we see her breasts, anus, and face at once. His approach is anagrammatical, extending his erotic play with the female as rose/Eros, witnessed in his collaboration with Mitrani, as discussed above.

In contrast, Argentinian-born surrealist Leonor Fini offered a much more personal, pensive exploration of *Story of O* in her twelve color

**61. Hans Bellmer, frontispiece for Pauline Réage, *Histoire d'O*
(Paris: Jean-Jacques Pauvert, 1954).**

lithographs and black-and-white drawings for an edition of the novel in
1962. This was a special, limited printing published by Pauvert's Cercle du
Livre Précieux subscription scheme, limited to 352 copies.[198] The collabora-
tion was undoubtedly thanks to Fini's close friendship with those whom had
championed Aury's novel, notably Mandiargues and Lely, as well as her
long-standing interest in Sade. Fini illustrated a special edition of Sade's
Juliette in 1944, while living in Rome with her Italian lover Count Stanislao
Lepri (1905–80), and relished the fact that it was printed in the Vatican, as
she often recounted in interviews.[199] Her twenty-two black-and-white
etchings for *Juliette* revel in the tale's violence—from images of female
libertines bearing whips and flaying babies to orgies and languorous

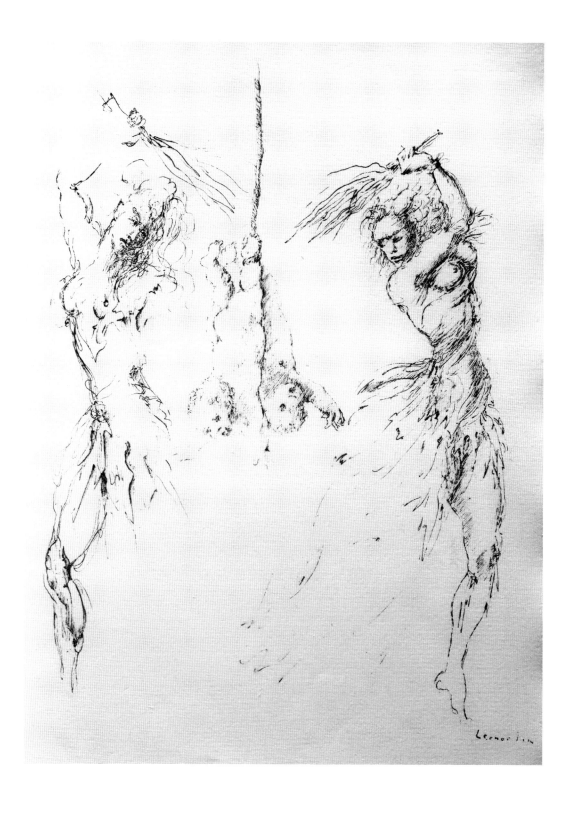

62. **Leonor Fini, plate from D.A.F. de Sade,** *Juliette*, **etching made from photo-lithograph (Rome: Colophon, 1944).**

postcoital harems (figs. 62 and 63).[200] In one illustration, for example, we see two naked women holding whips alongside their victims—two cherubic babies who are suspended on a rope by their feet like lambs for slaughter. The calm cruelty of the scene recalls the scene in the novel where Juliette howls with orgasmic pleasure as she witnesses the libertine Clairwil brutally torturing a male child. Juliette describes Clairwil thrusting the mutilated child's still-beating heart into her vagina and how she takes excited inspiration from her amoral example: "There is nothing like the effect of example upon an imagination such as mine: it suggests, it encourages, it electrifies: I soon have my victim laid wide open and promptly insert its living heart between my labia."[201] Her circle at this time included Georges Bataille and the writer Jean Genet (1910–86), who described her art in a 1950 essay as harboring a "'pestilential' smell. . . . If I fasten on the olfactory sense to speak about them, it is not because your drawings immediately evoke the smell . . . , but their complexity and their architecture seem to me comparable to the complex architecture of swamp odors. Your work hesitates between vegetable and animal—mosses, lichens, as well as the most ancient animal representations following the most ancient method: the Fable."[202] Her two 1950 oil paintings of Genet show him as a transgressive "saint" with soulful rather than criminal eyes, reminding us of their shared ambition to defy heteronormative expectations.[203]

Fini had befriended Genet at a masquerade ball (the Bal Nègre) in Paris in 1947 and designed costumes and stage sets for his plays *Les bonnes* (*The Maids*, written in 1945, first performed in 1947) and *Le balcon* (*The Balcony*, written in 1956, first performed in 1957); later she produced six illustrations for a collector's edition of Genet's *La galère* (*The Galley*), a long, homoerotic poem recounting the life of criminals aboard a galley ship destined for one of France's penal colonies, which would lead to the charge of "public indecency" in 1954.[204] Genet dedicated the poem to "Nico (the Greco-Ethiopian god)," namely, Nico Papatakis, the half-Greek, half-Ethiopian man who had been the subject of numerous paintings by Fini in the early 1940s, including *L'alcôve* (*The Alcove*, 1941) and *Nu* (*Male Nude*, 1942), where his naked body is displayed for the spectator to enjoy, reversing traditional gender roles. Just as Genet's writings exposed "a world of crime and sexual perversion: he is warning us of what lies just beyond us . . . his real subject is the world, politics, ethics, freedom . . . and love and murder!" as one American critic wrote appreciatively in 1951, so Fini's Sadean and erotic works should also be viewed as going beyond the personal to the sociopolitical.[205]

Fini's stance extended into her lifestyle too, as she preferred to live in a "community" of friends and lovers, and enjoyed a thirty-year relationship with Lepri and Constantin Jelenski (born Konstanty Jeleński, 1922–87), whom she described, respectively, as "a man who was rather a lover and another who was rather a friend."[206] She met the former, an Italian

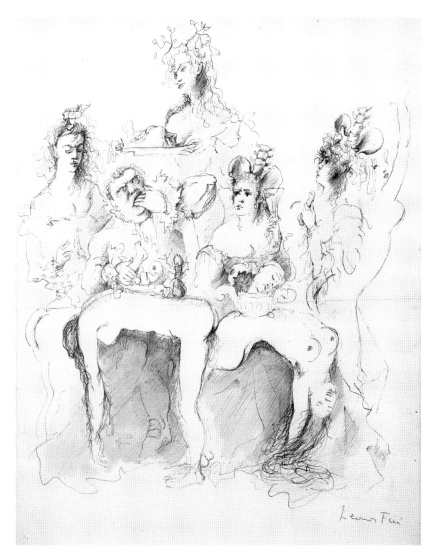

63. Leonor Fini, plate from D.A.F. de Sade, *Juliette*, etching made from photo-lithograph (Rome: Colophon, 1944).

diplomat and painter, while living in Monaco in 1941 and the latter, a Polish writer, in 1952. They lived as a threesome until the death of Lepri in 1980; Jelenski died in 1987. Fini's art frequently addressed the sexual struggle between male and female, notably in her revision of the mythology of Oedipus and the sphinx, her staging of men as sleeping beauties (as with her portraits of Nico), and her choice to illustrate Sade's dominatrix Juliette rather than his more virtuous Justine, whom male surrealists preferred.[207] The Italian novelist Alberto Moravia (1907–90) praised Fini's illustrations for *Juliette* enthusiastically: "Not only has she recaptured the mixture of eighteenth-century grace and fury, of systematic cruelty and elegance, of reason and dream, that are proper to the author of *Juliette*, but she has also

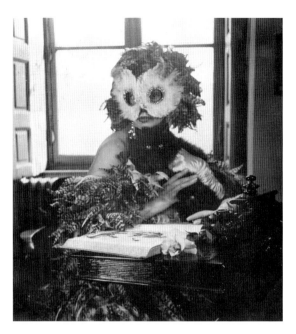

64. Leonor Fini in costume for Bal des Oiseaux (Ball of Birds), photograph by André Ostier, Paris, 1948.

given the text an interpretation of her own, complete and free. The desperation and the sadness, the macabre pleasure and the unhealthy monotony of the mechanics of eroticism are represented with real force in these insatiable nudes, in these faces with their veils of black melancholy."[208]

Fini was no stranger to publicity or self-fashioning, but it was a sense of art as a form of theater or "porte-parole" (spokesperson) that she shared with Genet.[209] She once stated that her paintings were theatrical scenes that "impose[d] themselves" on her mind.[210] Fini often featured in the glamorous social pages of newspapers, her dramatic dresses and masks for society balls capturing journalists' and photographers' attention—whether in a feature in *Life* magazine (July 12, 1948) where a photograph of her in a mask was titled "French Devil-Cat," or posing for André Ostier (1906–94), who photographed her in a headpiece constructed from a fox skull and tulle for the Bal du Panache in Paris in June 1947, a cat mask for the Bal de Voilette (Ball of Veils) in June 1948, and an owl mask for the Bal des Oiseaux (Ball of Birds) in 1948 (fig. 64).

It was this owl mask that inspired Aury in her account of O's final pilgrimage in *Story of O*, when Sir Stephen orders her public humiliation in front of a dozen dancing couples. Aury studied the history of eighteenth-century costume using the Louvre collection and admitted to a particular fascination with long dresses with corselettes to support the bust but admitted to taking inspiration specifically from Fini.[211] Aury could have seen Fini in her

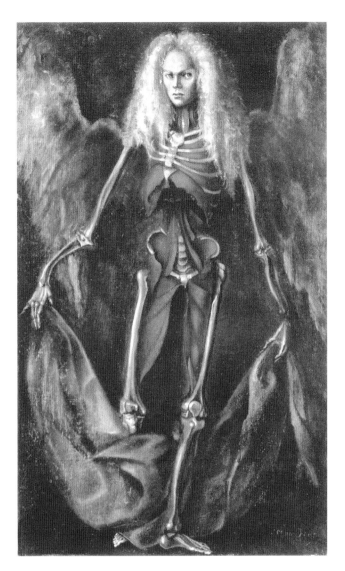

65. Leonor Fini, *L'ange de l'anatomie* (*Angel of Anatomy*), oil on canvas, 1949.

66. Jacques-Fabien Gautier-Dagoty, *L'ange anatomique* (*The Flayed Angel*), varnished color mezzotint, ca. 1745.

splendid masks in many press photographs or in the book about her masks by André Pieyre de Mandiargues, published in Paris in 1951.[212] In a 1955 article in *Le Jardin des Arts*, Armand Lanoux emphasized the theme of sorcery in Fini's art, illustrating it with a photo of Fini wearing an owl mask while holding one of her cats; when asked why she wore such masks, Fini replied that it was a disguise that allowed her to be Other.[213] However, the owl often appeared in her art as a symbol of female creativity or insight—as in the early *Autoportrait avec hibou* (*Self-Portrait with Owl*, 1936)—in keeping with the association of the owl with the Greek mythological figure of Athena. O too arguably takes on a mythological or mystical air, striving for "the impossible aspect of eroticism," as Bataille noted in his 1955 review of the novel.[214] O's torture and terror deliver her from herself and allow her to explore her Otherness, using René and Sir Stephen for her own erotic dream of death. A series of poems that Aury published in the *Nouvelle Revue Française* in 1960 further reflect this exploration of Self and Other. Aury writes in one verse, "When you advance into my night you are not you, I am other. This other knows not who I am."[215] Susan Sontag notes the "othering" aspect of Aury's tale in "The Pornographic Imagination": "In the vision of the world presented by *Story of O*, the highest good is the transcendence of personality. The plot's movement is not horizontal, but a kind of ascent through degradation."[216] Fini, too, seems to linger on this aspect in her illustrations.

Fini frequently drew on sacred and mythological symbolism, infusing it with eroticism, a combination that meant her art was frequently compared to that of symbolist painters Gustav Klimt (1862–1918) and Franz van Stuck (1863–1928). This was evident in a variety of her works, including her series of images of erotically charged female guardians in apocalyptic landscapes, such as *Le bout du monde* (*The Ends of the Earth*, 1948) and *La gardienne des phénix* (*The Guardian of the Phoenix*, 1954). Her painting *L'ange de l'anatomie* (*The Angel of Anatomy*, 1949) (fig. 65), exemplifies a particularly Sadean reworking of earlier male artists' works—namely, a painting of the same title from 1745 by Jacques-Fabien Gautier-Dagoty (1716–85) (fig. 66). In both the paintings by Fini and Gautier-Dagoty, the traditional female angel is flayed so that her anatomy is shockingly visible to the spectator, flesh and musculature juxtaposed with anatomical precision. A further variation on woman as deathly guide appears in *Dans la tour* (*In the Tower*), which Fini painted while staying with Lepri and Jelenski in Tor San Lorenzo, an Italian coastal village, in the summer of 1952. The image features a self-portrait of the forty-five-year-old Fini—dressed in a voluminous black gown—guiding the thirty-year-old Jelenski, nude save for a bright red cloak round his shoulders, toward an illuminated opening in the Renaissance tower. Jelenski is almost somnambulistic in his expression, while Fini appears as part femme-fatale, part guardian, keeping their sexual role-play open. As she wrote in 1975, she painted tableaux that did not already exist because she wanted to see them.[217]

67. Leonor Fini, illustrations for deluxe edition of Pauline Réage, *Histoire d'O*,
pen, ink, and wash (Paris: Éditions Cercle du livre, 1962).

Fini closely read *Story of O* before deciding on the precise scenes, costumes, and details she would focus on in her illustrations (fig. 67). Her personal copy of the book, in her archive in Paris, is marked accordingly: she drew a line alongside many passages through the novel, but those from the opening pages most influence her final images for the book. These are the passages describing the two women who first prepare O for her initiation; O wearing eighteenth-century dresses whose tight bodices emphasize her breasts; the account of the room they bring her to with its three-faced mirror and fourth mirror on the wall; the detailed description of the man with whips wearing a long, trailing, violet robe and stockings that leave his sex exposed; O nearly falling as her body is twisted while being examined by four male libertines and then taken by each in turn; O being shown a riding crop, with her hands bound behind her back; and finally the description of a series of whips that would also be used for her torture that have been marked out.

All of these scenes were given visual form in fine ink lines to create a sense of twisting movement and physical strain. Fini surrounded her figures with black washes that evoke a bleak dungeonlike atmosphere as O progresses from one confrontation to the next, while Sir Stephen appears in magisterial purple robes. Fini's cover for the luxury edition of the book depicts O naked, with her legs spread, her hands behind her back, and her head bent—her first initiation position. Its combination of clean lines, explicit sex, and physical contortion recalls Bellmer's earlier frontispiece. O is given the outline of a skirt while her genitalia bleed red into the foreground, picking up the red of the title page itself. Her whipping and near strangulation are captured in other illustrations, the torturer's engorged penis dominating the image. The male figure in these lithographs is archetypal: statuesque, strong, and phallic. The female figure has a nubile body, elongated legs, and waifish expression. Fini's portrait of O's face is reminiscent of her pen and ink study of *Medusa* (1950) as well as her self-portraits in ink, which she produced throughout her career: O's mouth acts as symbol for her being, wailing in a black wash, reduced to an orifice. Her eyes are also pools of light, while her facial contours have been smeared with ochre, a color Fini uses to emphasize bodily fluids and pain. Where Fini portrays O full frontally, she is still represented as a shape, a grotesque of the female body. Apart from her sadomasochistic attire—pink stockings and a bodice that thrusts her breasts up—it is the faint outline of male figures stepping forth from a murky background that dominate the compositions. O's collar, the symbol of her final enslavement, is especially striking in the last illustration, where her white body is set in contrast to a dark male torso. She is on her knees; he stands majestically, twice her size. We see her back and buttocks as her head faces his groin, a sense of motion emphasized through a frenzied black daub of ink.

Fini's plumed mask features in her preparatory drawings and final images for *Story of O*: it covers O's face like a headdress and yet allows her to

68. Leonor Fini, *La peine capitale* (*Capital Punishment*), **oil on canvas, 1969.**

gaze back at the viewer. In one drawing, O wears the mask while seated, naked; in another, she is standing, costumed, but attention is drawn to her black eyes emerging from the mask. In contrast to the images of Masson and Bellmer, Fini seems at pains to give the Sadean heroine a character, paying attention to the facial expression, and not simply reducing her to a sexualized form. That is not to say she identifies with the victim. In 1970, Fini explained that Aury's novel struck her as a "cold" book, but that it appealed to her because it "possesses the virtue of describing things that are painful and strange. . . . *Story of O* is certainly a book with elements of female masochism but my own tendencies are rather the opposite. I identify with the men in the book."[218]

Fini's illustrations also reflect the "automatism" of her artistic style, trying to suppress conscious control of the medium and composition, but in their abject strokes and mood they also complement her long-standing fascination with the femme-fatale, or anti-Eve figure.[219] She had little interest in the maternal in art or literature.[220] She sought out new iconographies for woman, notably ones that showed her as dominant and primordial, and she recognized the power of the Sadean heroine in this regard. Max Ernst, writing for a 1960 exhibition catalog, made her paintings sound like dangerous spells for libertine seduction, though he emphasized her mythical rather than her masochistic images: "Her paintings are made up of vertigo. Canvases which, at first, seem to be evil, full of corpse-like dissolution. . . . After the first dizziness, those who are bold enough let themselves be drawn by the inverted vacuum, and for their exorbitant reward, they discover that this abyss, which seems dark (glutinous), is inhabited by the most astounding collection of legendary beings . . . the pulsating pearly colors of this chimerical flesh, that resembles the bifid love-making of sphinxes."[221] Fini emphasized the open nature of her artworks, once explaining they went far beyond biography: "In my paintings I never say *I*, and it is vain to believe that one can find, in a painting or a poem, a glimpse of a phase of life."[222] In an interview in 1993, she said of the woman in a Stygian landscape in her painting *Le bout du monde* (*The End of the World*, 1949), "She is woman, symbol of beauty and deep knowledge . . . the essential element of life, the primeval material, because she knows how to survive the cataclysm."[223] Sade presented Fini with a world that complemented her search for a new iconography, and a world she claimed she found easy to illustrate. Indeed, she emphasized that the book did not alarm or embarrass her in any way: "It is easy to illustrate twisted and entwined bodies, as in *Story of O*. And I was not embarrassed by the book: I'm so used to being free, that I wasn't overcome with pride to have illustrated *Story of O*."[224] Fini chose to portray O as a willing victim, and yet her palette and loose brushstrokes also evoke a sense of repressed rage, desire, or the scream. In so doing, she allows the imagery of O to hover between the two roles identified by Mitrani: slave and suffragette of the whip.

69. O (Corinne Cléry) in her photography studio in Paris in _Histoire d'O_ (Just Jaeckin, 1975).

70. O at the masked ball in _Histoire d'O_ (Just Jaeckin, 1975).

A few years later, in a canvas titled _La peine capitale_ (_Capital Punishment_, 1969) (fig. 68) such ritualized violence in explored in more meticulous brushwork. A red-haired young woman sits naked, apart from a pair of stockings, alongside two females, one of whom holds a goose, the other a large knife. The bird's drooping neck is both strategically near the red-haired woman's exposed sex and under the knife blade, suggesting both a beheading and phallic castration at once, as the artist once explained.[225] She might be said to take _The Goose Girl_ of the Brothers Grimm's collection (1815) or the celebrated painting _La gardeuse d'oies_ (_The Goose Girl_, 1891) by Adolphe William Bouguereau (1825–1905) in a sadistic direction here, while at the same time reversing traditional gender roles so that the animal no longer denotes female sexual innocence, but male sacrifice at the hands of _jeunes filles_. Fini twists tales and expectations to her own erotic ends; as she stated in an unpublished interview, "Of course, [the girls] play. Under their games there is always an erotic substrata."[226] Jelenski wrote in 1968 that Fini's work had "no feminism" in it, but many of her females can still be viewed as militants or _guérillères_; hers is undoubtedly a "revolutionary vision of women" in the late 1960s.[227] Although she resisted labels, Fini called for women to find alternative "glories" for themselves, to go beyond a battle for "equality"—a word she "detested," believing that men and women could never be pure equals—and to reject what she described as canonical, male role models, or what she called the "academy."[228] Her erotic

ideal was an androgynous one, a world "without this space of divergence, without this space of hostility" between the sexes.[229]

Just Jaeckin's *Story of O* (1975)

While the critical debate surrounding *Story of O* was mostly concentrated in the half-dozen years immediately after its publication in 1954, its influence was long-lasting, and, as I have explained, further editions were released in the 1960s. Then, it enjoyed a renewed controversy thanks to the release of a film adaptation of the novel by the French director Just Jaeckin in August 1975, starring Corinne Cléry as O and Udo Kier as René.[230] Jaeckin (b. 1940) had been a photographer for *Elle, Vogue*, and other French fashion magazines but in the 1970s moved into filmmaking with *Emmanuelle* (1974), *Madame Claude* (1975), *Story of O* (1975), and *Girls* (1980), which blended erotica, art cinema, and commercial marketability.[231]

In an interview thirty years after he shot the film, Jaeckin emphasized that *Story of O* was a "wonderful love story" and that he wanted his film adaptation to reflect it as a "fantasy" that explores "a tremendous communion between two people [O and her lover René] sharing the same fantasy . . . we must not judge."[232] Aspects of the story posed challenges for him and for his actors, from O's branding to her repeated whipping, but he decided to make it in the style of Alice in Wonderland—"did she like her dream, did she hate it, it's a fantasy." He also used eight different castles as locations to ensure the architecture of the film replicated the lavish architecture of the novel, from winding stone staircases to mirrored rooms, marble bathrooms, and giant fireplaces.[233] Mixing the voice of a female narrator with dialogue, the film moved seamlessly from poetic images of O walking in a trench coat in the rain or seated in a rowboat in the sunshine in Paris with Sir Stephen (Anthony Steel) to dark castle rooms in which she is blindfolded, gagged, and whipped. Hence, the film hovers between melodrama and horror, but it also has the trappings of 1970s *Playboy*-style kitsch, with countless furs on beds and leather sofas, chandeliers, and soft lighting, all enhanced by the eerie soundtrack created by Pierre Bachelet (1944–2005), which combines easy-listening piano, guitar, and a haunting high-pitched female voice.[234] Like the novel, therefore, Jaeckin's film is structured in shifts of register and narrative space that keep reminding us that O is a modern and fashionable woman. Jaeckin undoubtedly draws on his own experience here, especially in the scenes in which O returns to Paris to photograph models in her studio. In the novel, thanks to her secret life, O begins to take these photo shoots in a heightened sexual direction, but the film gives her a distinctly phallic role, as she lingers suggestively over one model's hair and lips and demands that another gyrate with a large lightbulb (fig. 69).

71. O and Sir Stephen in the final scene of *Histoire d'O* (Just Jaeckin, 1975).

Three color schemes dominate the mise en scène of the film to ensure that the surreal is interlaced with the Sadean: a brown-gold scheme in the château to emphasize naked flesh; green for the world of nature outside the château; and a bright white for the streets and interiors of Paris. Each reflects aspects of O's story of initiation, though there is a very clear sense of the evolution of her personality in the film—from obedient girlfriend of René to sexually assured lover of Sir Stephen. Indeed, the constant use of soft focus for erotic and sentimental scenes seems to insist that the spectator should not divorce flesh from love. Jaeckin is careful to stage her story as a dream, so that the spectator wonders at the flights of her fantasy rather than her masochism at the hands of her sadistic lovers.

Thus the crucial scene in which O wears a magnificent owl mask for her final initiation is also staged in glamorous terms and shot in soft focus to emphasize its dreamlike nature (fig. 70). In the novel, O is driven to a cloister in the woods where she finds couples dancing in ball gowns and white dinner jackets who touch her and stare at her as if she were an object rather than human; in the film, O is brought to a beautiful garden in a speedboat, the waves crashing suggestively around her, and when she arrives, the dancing couples are all in formal evening attire, as if for a television commercial, and the camera lingers over her plumage and exchange of glances with Sir Stephen, so that she stands like a queen before her king, rather than a victim before her last trial.

The very last scene in the film arguably aims to complicate sex and love further, and certainly to update O's story for a 1970s audience. Jaeckin adds a coda to the original plot that changes its ending considerably to suggest sadism and masochism are fluid, and roles for sexual fantasy. It is staged in domestic terms, with O and Sir Stephen in a seated embrace and in 1970s clothing, thus returning the spectator to the "real" to reinforce the idea that Roissy has been an elaborate dream. Sir Stephen tells O that he loves her, and O asks him if he would bear the same suffering she has borne out of love from him. He says he would, and she then quickly acts on his words and "brands" his hand with his own hot cigar, which she has taken and smoked. The camera lens zooms in on the neat "O" now burnt onto his flesh and the ring she wears on her finger (which also suggests the ring pierced through her labia in her Roissy life). The couple are united in this simple visual but highly symbolic juxtaposition (fig. 71).

When *L'Express* chose to devote two editions to Aury's novel and its film adaptation in September 1975, *Story of O* was brought to a largely new audience and a new generation who had come to enjoy greater sexual liberty than Aury's own generation had known when the book was first published. In the first edition, the magazine daringly printed an image from Jaeckin's film on its cover: a close up of the bare-breasted Cléry as O from a central scene in which she is whipped in front of René (fig. 72). In so doing *L'Express* again reflected a new sexual freedom for the media, popular press, and audiences alike—a very different perspective from that of Mauriac in the same weekly back in 1954. Inside the magazine, Paulhan's original essay, "A Slave's Revolt," was reprinted, as well as an essay by novelist and founding member of the magazine, Madeleine Chapsal (b. 1925), titled "Le choc d'*Histoire d'O*", in which Chapsal wrote of the novel's pertinence to France in the 1970s.[235]

The subsequent edition reiterated the magazine's editorial line that the novel spoke to "the liberation of sexuality in France."[236] The editors insisted that there was no conflict between the journal's condemnation of the use of torture in the Algerian War when the weekly was first founded in 1953 and their decision to explore the theme of sexual torture in *Story of O* in 1975. They framed their inclusion of an interview with Pauline Réage, by author and publisher Régine Deforges (1935–2014), within the context of women's liberation, though the article's opening discussion on the immorality of war, in contrast to the immorality of a novel, further reinforced the magazine's political stance that real obscenity lay in war, not sexual practice.[237] Aury, under the pseudonym Réage, made the same point in the interview: "Concentration camps offend good morals, and the atomic bomb, and torture . . . not specifically the different ways of making love."[238] The creator of O was also pressed by Deforges on her feminism, to which Aury categorically stated that she did not feel the solution for feminism lay in the

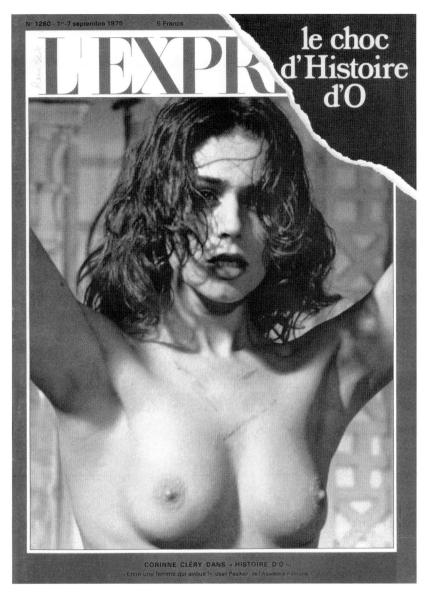

N° 1260 · 1ᵉʳ-7 septembre 1975 5 Francs

le choc
d'Histoire
d'O

L'EXPR

CORINNE CLÉRY DANS « HISTOIRE D'O »
« Enfin une femme qui avoue !» (Jean Paulhan, de l'Académie française)

72. Front cover of *L'Express*, September 1–7, 1975, using a production still from *Histoire d'O* (Just Jaeckin, 1975).

Mouvement de libération des femmes, the largest French feminist organization, founded in 1970: "I have never been part of a feminist movement, but I have always been a feminist."[239] Her position on the symbolism of O reinforces this position: she named her protagonist "O" to ensure anonymity, to emphasize the private fantasy world, not to symbolize the shape of the female sex or issue any universal feminist message.[240]

The novel's reception was clearly a complex function of the very particular historical moment in which it was produced: a time when the

French were weighing up the atrocities and terror of World War II, and searching for retribution, purging, forgiveness, and a sense of the absolute. When the luxury illustrated editions of *Story of O* were printed in the 1960s and again in the 1970s, when the film adaptation was released, it was read in much less existentialist terms. Moving beyond its origins in postwar Paris, it came into contact with the international phenomenon of second-wave feminism, in which women authors and readers engaged with the writing of their own erotic lives much more routinely than before. Odile Hellier, founder and owner of the Village Voice Bookshop in Paris, conveyed the historically specific pertinence of *Story of O* to women's liberation when she admitted that the novel was the antithesis of the stereotypical passive role ascribed to woman in society and fiction: "I read the book in the 1960s between the sexual (the Pill) and the feminist revolutions. Today, with 'political correctness' the novel is viewed by hardcore feminists as a work of female masochism verging on pornography. At the time, however, I and my women friends saw the book differently. What impressed us was that the heroine, O, was not a passive lover or a victim. . . . O was the initiator, the one who controlled the imagination, enacting her own fantasies."[241]

Story of O, despite its mystical and masochistic portrait of a woman in love, presented a female perspective on sexual power more than a decade before sexual liberation, let alone the Sadean imagination, began to permeate popular film, television, and culture in general. Roger Vadim (1928–2000) acknowledged as much in relation to his sexually adventurous and controversial film *Et Dieu créa la femme* (*And God Created Woman*, 1956), which was released two years after *Story of O* was first published.[242] His film famously starred Brigitte Bardot as a reckless young girl, Juliette, who follows her desires unimpeded by her foster parents, her new husband, and gossip. Sexuality and morality were unbound in the film, making it a crucial milestone in the French (indeed, the international) history of screen sexuality and movie censorship. Vadim explained, "Before, a girl who slept around was regarded as either a prostitute or someone who was sick. I wanted to show a modern girl who likes to laugh, who is sentimental, and yet who does . . . that. . . . She is not sick. . . . But the morals of our society are so strict a woman cannot live like that without distress."[243] Indeed, Beauvoir recognized that Vadim had launched a new type of modern eroticism in Bardot, a barefooted temptress who fused the child-woman with the femme fatale for an emerging generation of youth, and that for France Bardot was "an export product as important as Renault automobiles."[244] Beauvoir stated that she approved of Vadim "trying to bring eroticism down to earth," and she alluded to the rejection of the traditional sublimation of female sexuality in novels and films of the 1950s, which unleashed a more real and animalistic desire instead.[245]

Aury's provocative recuperation of the Sadean imagination led to many reiterations in fiction and critique, but its most important legacy was to further the belief that provocative and shocking texts and images could play a crucial, progressive role in society. The next and final chapter turns to the counterculture of the 1950s and '60s, which explored the Sadean imagination for deliberately political effect in experimental and art film, theater, and happenings.

Screaming for Sade

For me the last word can never be spoken. I am left with a question that is always open.

The Marquis de Sade in Peter Weiss's *Marat/Sade*, 1964

If social change in the long 1960s demonstrated the existence of a kind of "global village," to use Marshall McLuhan's famous phrase, then the performative potential of the Sadean imagination was played out on many "tribal drums."[1] A new generation of artists, from the mid-1950s to the mid-1970s, turned to Sade to liberate the senses and drive self-awareness, both sexual and political. They staged Sadean tableaux as a means of exploring the experience of art collectively and emphasizing the need for participatory social life. Their emphasis on the embodied artwork, whether in experimental film or theater, performance art or improvised happenings, energized the spectators, turning them into fellow performers, as did the use of new, often unregulated, spaces. This avant-garde aimed at nothing less than a total revolt against the status quo, although, as Susan Sontag observed in "The Pornographic Imagination"—published in 1967, as the Vietnam War reached full intensity—too many people continued to find dirty books "dirty in a way that a genocide screened nightly on TV, apparently, is not."[2]

This chapter looks at four examples of artworks that turned to the name of Sade and explored the Sadean imagination in a radically performative manner: *Hurlements en faveur de Sade* (Howls for Sade, 1952), an early film by the situationist Guy Debord (1931–94); *Exécution du testament du Marquis de Sade* (Execution of the testament of the Marquis de Sade, 1959), a performance by Canadian surrealist Jean Benoît (1922–2010); *120 Minutes dediées au divin Marquis* (120 minutes dedicated to the divine Marquis, 1966), a happening by Jean-Jacques Lebel; and the play *Marat/Sade* (1964) by the German writer Peter Weiss (1916–82), its production in London and New York in 1964–65, and its film release in 1967, all directed by the English theater and film director Peter Brook (b. 1925). These works came into being outside of mainstream culture, transgressing conventional ideas and values by assaulting the traditional art object, museum space, and relationship between artist and spectator. It is often their very materiality—the blank screen, the stripping and painting of the body, the scream, and the sexual gesture—that conveys the libertine drive, but this drive was always aligned with particular sociopolitical agendas. The Sadean imagination was harnessed not only for new libidinous experiences for their own sake, but as a means to expose the fragility and corruption of the body politic too.

Throughout this period, Sade's writings were increasingly available thanks to Jean-Jacques Pauvert's long-running project to publish his complete works and thanks to Grove Press, New York's equally maverick publishing house, which released English translations of *The Complete Justine, Philosophy in the Bedroom, and Other Writings* (1965), *The 120 Days of Sodom and Other Writings* (1966), and *Juliette* (1968). The increasing availability of Sade facilitated an increasing appreciation of his work, prompting Georges Bataille in *La littérature et le mal* (*Literature and Evil*, 1957) to praise the

then-recent readings of Sade by Klossowski, Paulhan, and Blanchot: "Never before have such splendid homages contributed to the slow but sure establishment of Sade's reputation."[3] Indeed, a veritable literary and artistic deification of Sade occurred as younger generations discovered him too, seizing on the libertine to address issues of freedom and censorship, recent political terror, and the utopian aspirations of the 1960s.

Sadean Dialectics

In *Dialectic of Enlightenment* (1947), Theodor Adorno and Max Horkheimer argued that the Enlightenment paved the way for an instrumental rationalism wherein "pure reason becomes unreason."[4] They explained sadism through Kant's notion of the Enlightenment as "the bourgeois subject freed from all tutelage," and they read the death of religion as the birth of a regime of "utmost terror" built on systems of organization and penal laws of great severity to replace a fear of hell and damnation.[5] In this light, Sade's Juliette, for example, is not a radically new kind of subject but the daughter of the Enlightenment: she is the embodiment of "intellectual pleasure in regression, *amor intellectualis diaboli*, the joy of defeating civilization with its own weapons."[6] Adorno and Horkheimer insisted on Sade's pertinence to a world traumatized by war and man's cruel inhumanity to man, but in doing so, they came dangerously close to a vulgar equation of Sadism with Nazism. They wrote of the female sex as "a minority even when she is numerically superior to men," comparing woman to "the indigenous population of colonies" and "the Jews amongst Aryans," a subject whose "defenselessness legitimizes her oppression."[7] They traced a direct path from Sade to the Holocaust, in which the libertine's exploration of "private vices" gave way to "public virtues in the totalitarian era."[8] This line of reasoning—whereby instrumental rationality, as the key tool of the Enlightenment, had facilitated the oppression of the weaker and marginal in society—fails to address the politics of Juliette's own monstrosity and defiance of virtue, though it does rightly acknowledge the role of the female body, or the feminine Other, in mapping out ideologies of the body politic. In fascist fantasies and dogma, all those who were to be erased from society—communists, Jews, homosexuals, the mentally and physically disabled—were frequently described in feminized terms, with sex, menstruation, and death readily aligned, as Klaus Theweleit has convincingly argued in his study of the rise of Nazism.[9] Adorno and Horkheimer turned to Sade to expose the Enlightenment's treatment of nature and man (as objects) as the path to the barbarity of twentieth-century war and persecution. As Martin Jay writes, "De Sade's blatant brutality was merely the most obvious example of what was a far more pervasive phenomenon. In fact, the Enlightenment's sadism towards the 'weaker sex' anticipated the later

destruction of the Jews—both women and Jews were identified with nature as objects of domination."[10]

In his 1961 book *Les larmes d'Eros* (*The Tears of Eros*), Bataille looked to earlier historical cases of cruelty. He presented three châteaux where children were subject to cruelty: the French feudal lord Gilles de Rais's château in Mâchecoul, the Marquis de Sade's château in Lacoste, and the château of the Slovakian "bloody countess" Erzsébet (Elizabeth) Bathory. These examples allowed Bataille to indulge in his penchant for the medieval period (he had studied medieval paleography and numismatics at the École de Chartes in Paris) and to contribute to a normalization of a long Western tradition of cruelty and terror built on the dialectic between the sacred and the profane. Bataille ended his book with a particularly macabre chapter on voodoo sacrifice and on the Chinese torture of the hundred cuts, or "cent morceaux," wherein a criminal was doped with opium to extend his capacity for torture, which had a particularly profound effect on him. He includes a photograph of the torture in the book, an image he hoped would remain with the reader, just as it had remained with him since he first saw the picture in 1928.[11] It is also a form of torture to which Sade refers in the adventures of Juliette: in one scene with Saint-Fond, she witnesses Delcour, an especially bloodthirsty libertine with surgical tastes whose father was once a hangman in Nantes, subject a sixteen-year-old girl named Louise to "that Chinese torture which consists of being chopped up alive."[12]

Bataille was in his sixties when he wrote his study, and given that his sight was failing as he wrote and that he would die from a long-term illness, cerebral arteriosclerosis, in 1962, the book may also be read as Bataille's last testimony to the generation of the 1960s. Theirs was a generation that lived through the collapse of French imperialism in Indochina and Algeria and its wide-ranging effects. Bataille's readers would have been well aware of the Gestapo, SS, and torture in Nazi death camps in the then-recent past, but in the midst of the Algerian War (1954–62), known as the *sale guerre* (dirty war), his readers would also have been increasingly sensitive to the pertinence of his discussion of ritualized, politicized terror at a time when summary execution and torture were being used on an ongoing basis by the French military against the Algerian nationalist movement (Front de libération nationale, or FLN) by the French military. When Bataille's book was published, Henri Alleg, a journalist for *Alger Républicain*, who was arrested by French paratroopers on June 12, 1957, had recently published *La question* (*The Question*, 1958), in which he recounted his month-long torture (electrocution, waterboarding, burning) in the El Biar detention center in Algiers. The memoir was banned by the French government, but not before over six thousand copies had been sold.[13]

Simone de Beauvoir, who had argued in defense of Sade in her essay "Must We Burn Sade?," also addressed the torture of the young Algerian

woman Djamila Boupacha (b. 1938) in *Le Monde* in 1960. In both texts, she argued against censorship, for freedom of speech, and against indifference in the face of inhumanity and torture. In the former essay, she wrote that Sade succeeded in disturbing his readers, refusing to allow them a passive or indifferent response to violence: "Sade's merit lies not only in his having proclaimed aloud what everyone admits with shame to himself, but in the fact that he did not simply resign himself. He chose cruelty rather than indifference. This is probably why he finds so many echoes today, when the individual knows he is more the victim of men's good consciences than of their wickedness."[14] In her support of Boupacha, Beauvoir draws attention to the masculine excess of war, torture, and rape, arguing that "when the government of a country allows crimes to be committed in its name, every citizen thereby becomes a member of a collective criminal nation."[15] Her memoirs make clear that she could not tolerate this hypocrisy: "this indifference, this country, my own self were no longer bearable to me. . . . I felt that I was suffering from one of those diseases where the most serious symptom is the lack of pain."[16] Beauvoir would later sign the 1960 "Manifesto of 121," properly known as the "Déclaration sur le droit à l'insoumission dans la guerre d'Algérie" (Declaration on the right of insubordination in the Algerian War). This was an open letter against the war signed by 121 intellectuals and published in the magazine *Vérité-Liberté* on September 6, 1960. In it, nearly ten years after her defense of Sade, but consistent with it, she calls on her fellow citizens to revolt against state-sponsored atrocities, insisting on the urgent need for a collective voice of opposition.

The Open Sadean Work

In their turn to Sade, the artists that I focus on in this chapter—Debord, Benoît, Lebel, Weiss, and Brook—refused any suggestion that there was a division between art and society. They created critiques of dominant constructions of gender and race, they engaged in collective action, and they explored the affective power of the senses in protest against repression. In many ways, their art continued and expanded on the concerns of the interwar and immediately postwar avant-garde and its focus on the Sadean novel and canvas. Their Sadean artworks relied on a principle of "openness" that was both literal—as in not closed, rendering a sense of proximity, sensual closeness, moral implication even—and emphatically performative, as in a "work in movement," to borrow from Umberto Eco's *Opera aperta* (*The Open Work*, 1962).[17] While Eco recognized all art as having a certain openness, he insisted that the open work in the twentieth century was "intentional, explicit, and extreme—that is, based not merely on the nature of the aesthetic object and on its composition but on the very elements that are combined in it."[18] Such openness demands an active role for the

spectator: "Every reception of a work of art is both an interpretation and a performance of it, because in every reception the work takes on a fresh perspective for itself."[19] The element of unpredictability and interaction that Eco describes worked against conventional views of the world and tended to lead to a sense of "alienation," forcing viewers/readers to "accept our involvement in things other than ourselves, and at the same time assert our selfhood in the face of the world by actively seeking to understand it and transform it."[20]

Artists working with a Sadean aesthetic and pursuing this sense of openness looked especially to the "theater of cruelty" of Antonin Artaud, who broke from the surrealist group in 1926 to focus on a new theater and language "that wakes us up, nerves and heart."[21] Artaud founded the Théâtre Alfred Jarry with playwright Roger Vitrac (1899–1952) in 1927 and later advanced his ideas in essays on the theater and cruelty written between 1931 and 1935 and published in book form as *Le théâtre et son double* (*The Theater and Its Double*, 1938). In "The Theater of Cruelty—First Manifesto" (1932), Artaud explains that the key question for worthwhile theater was "whether it makes us think."[22] Sade was to be part of the program for a new form of theater: Artaud describes one of his proposed pieces as a "tale by the Marquis de Sade, in which the eroticism will be transposed, allegorically mounted and figured, to create a violent exteriorization of cruelty, and a dissimulation of the remainder."[23] For Artaud, the theater, like dreams and eroticism, should be bloodthirsty and even inhuman. The figure of Sade denoted the collapse of traditional art and civilization, the overthrowing of morality and repression, and his writings reveled in the triumph of the passions, all evoked in cataclysmic and monstrous terms. Artaud's 1947 radio play, *Finir avec le jugement de dieu* (*To Have Done with the Judgment of God*), which he explained as "providing a small-scale model for what I want to do in the Theater of Cruelty," also aimed to materialize the senses. It called for man's emancipation by stripping him bare, emasculating him, so as to free him from his civilized values and beliefs:

Man is sick because he is badly constructed.
We must make up our minds to strip him bare in order to scrape off that
 animalcule that itches him mortally,
god,
and with god
his organs.
For you can tie me up if you wish,
but there is nothing more useless than an organ.
When you will have made him a body without organs,
then you will have delivered him from all his automatic reactions
and restored him to his true freedom.[24]

Artaud called for a new becoming; Debord would speak of situations; Benoît of derision; Lebel of tribal workshops and festivals; Weiss of resistance; and Brook of experiments. Though coming to Sade from different directions, they all saw in Sade's writings and life story a radically iconoclastic approach to morality, sex, and the obscene body, which could force the reader/viewer into an active, performative role. Such performativity is always demanded of the reader in the Sadean text—as Marcel Hénaff writes, "To read [Sade] is already to conspire. . . . To read is already to be among the elect."[25] But these artists explored that sense of performativity in new ways, collapsing the distinction between actor and audience, text and image, word and meaning, and united in their defense of free expression, as they defied traditional aesthetic values. The Artaud-like scream unites them, whether as a protest or a mode of uninhibited expression. A scream might denote intense physical pleasure or pain, a state of happiness or grief, but it always also suggested a loss of reason and control with an immediacy and intimacy that invariably affected those around. Debord, Benoît, Lebel, Weiss, and Brook did not "instruct" the spectator to scream; rather, in turning to Sade, they created artworks and spaces that willed that physical and/or psychic response.

Howls for Sade

Guy Debord's first film, *Hurlements en faveur de Sade* (Howls for Sade, 1952, black and white, 124 minutes), was released the year after the publication of Beauvoir's essay "Must We Burn Sade?" and Camus's *The Rebel*. Debord was only twenty-three years old, and in many ways his filmic intervention on the Sadean imagination was that of an angry young man in search of his own new mode of expression—Camus's words in his novel, "I *rebel*, therefore we *exist*," might be applied to Debord.[26] The film opens with a caustic statement on love:

> Voice 1: Love is only worthwhile in a pre-revolutionary period.
> Voice 2: None of them love you, you liar! Art begins, grows and / disappears because frustrated men bypass the world of official / expression and the festivals of its poverty.[27]

In form and content, the film's dialogue then proceeds to attack romance, traditional communication, and the screen itself, calling for the death of cinema and leaving the screen blank throughout—either white or black— until a final twenty-four minutes of total silence. *Hurlements en faveur de Sade* was one of six films that Debord produced between 1952 and 1978, and, in the script, he asserts the film lineage he hoped to continue in his art by listing various key works in the history of cinematic experimentation (early

73. *Traité de bave et d'éternité*, Isidore Isou, 1951.

cinema, slapstick, dada, surrealism, Soviet montage, Lettrism) and including his own birth in the list: "1902: *Voyage dans la lune*. 1920: *The Cabinet of Doctor Caligari*. 1924: *Entr'acte*. 1926: *Battleship Potemkin*. 1928: *Un chien andalou*. 1931: *City Lights*. Birth of Guy-Ernest Debord. 1951: *Traité de bave et d'éternité*. 1952: *L'anticoncept. Howls for Sade*."[28]

Debord's attack on mainstream cinema complemented that of Romanian artist Isidore Isou (Ioan-Isidore Goldstein, 1925–2007), who asserts in his film-manifesto *Traité de bave et d'éternité* (*Treatise on Venom and Eternity*, 1951) that "the cinema is too rich, it is obese . . . this pig stuffed with fat will rip apart in a thousand pieces. I announce the destruction of cinema, the first apocalyptic sign of disjunction, of the rupture of the pot-bellied organism called film."[29] Isou had formed the Lettrist group in Paris in 1946, along with Gabriel Pomerand (1925–72), as a multidisciplinary movement that hoped to change society through creative methods and analysis of the science of knowledge itself. Isou's concept of violent destruction was central to its radical aesthetic, which was to be achieved through a rupture between sound and image and what he termed "discrepant editing" (*montage discrepant*). Isou reiterated this position in his books *Mémoires sur les forces futures des arts plastiques et sur leur mort* (Memoir on the future forces of the visual arts and their death, 1946) and *Esthétique du cinema* (Aesthetic of cinema, 1953), in which he explained that the destruction of cinema could be achieved by "chiseling" (*ciselante*) and by the invocation of Sade.[30] In his *Treatise*, Isou explains Sade's "perversion" through the interior thoughts of his own protagonist, Daniel, as he wanders the streets of Paris (fig. 73). He speaks of Sade's infatuation with any type of woman, however ugly, admiring his penchant for eating his lover's fecal matter and aligning this act with the film's own devouring of consumer, capitalist excrement, as Daniel asserts, "I know that the cinema will feed on the excrement of its own photos or become frozen in the academic pretentiousness called Hollywood, the U.S.S.R. or Italy."[31] In image, form, and text, Isou's film exemplifies Daniel's call for a "sadism of the photo" and for a "film that hurts your eyes," as Isou

uses discrepant editing (radically nonsynchronous sound and image) and manipulates the film stock by scraping its surface, as seen around Daniel's face in one still. This assault on the image and medium invokes the slicing of a young woman's eye with a razor blade in the opening of the surrealist short film *Un chien andalou* (An Andalusian dog, 1928, black and white, 16 minutes, silent) by Luis Buñuel (1900–1983) and Salvador Dalí. In both films, the eye—the traditional sign and symbol of the mind, reason, or soul—is viscerally assaulted. Fittingly, Daniel defends Sade against the accusation of decadence in a crucial passage in the film, insisting that "Sade produced his works during the French Revolution: it had nothing to do with a moment of decadence but of the birth of a people."[32]

Debord left the Lettrist movement in 1952 to form the Lettriste Internationale, and then the Situationniste Internationale in 1957, but he extends Isou's thinking in *Hurlements en faveur de Sade* as he crafts a film that refuses visual pleasure and is confrontational. This attitude is clear in the last assertion of "Voice 1," which states, "I've nothing more to say to you."[33] Debord's film also presages his strategy of *détournement*, which he described in 1956 as "the mutual interference of two worlds of feeling, or the bringing together of independent expressions" to produce "a synthetic organization of greater efficacy."[34] An early version of the script of *Hurlements en faveur de Sade*, published in *Ion* in April 1952, suggested the film would include newsreel footage of a boxing match, people killed in the streets of Athens, and the Indian army; images of Debord, Isou, and another Lettrist, Marc'o (Marc-Gilbert Guillaumin, born 1927); sequences of painted filmstrip; and words on the screen broken down phonetically ("T,e,l,l,e,m,e,n,t,v,i,d,e,à,h,u, r,l,e,r,à,h,u,r,l,e,r," translatable as "so empty one could scream, one could scream"). When the film came to be made, it contained no such representation, however, nor did it include other details that Debord initially planned and that might be called Sadean—for example, a reference to Gilles de Rais, to perversions "disdained by the public at large," and to the sound of a Lettrist gasping.[35]

The title of Debord's film alludes to the intense experience of pain or pleasure. In the Sadean universe, the scream of the victim usually leads the torturer to ejaculate, the traumatized body becoming, as Roland Barthes put it, "a sonorous fetish" for the libertine.[36] Debord leaves the spectator to wonder about the cause of the scream and which voice utters it, as the dialogue is delivered in dull monotonous tones by Gil Wolman (voice 1), Debord (voice 2), Serge Berna (voice 3), Barbara Rosenthal (voice 4), and Isou (voice 5). Many sentences are articulated in a disconnected way, whether referring to "childhood love" (voice 1) or death as "a steak tartare" (voice 2), asking the banal question "Would you like an orange?" (voice 4), or citing excerpts from James Joyce, the Civil Code, Isou's *Esthétique du cinema*, and John Ford's film *Rio Grande* (1950). Throughout the film's many

74. **Antonin Artaud, ca. 1945.**

seemingly nonsensical exchanges, everything is reduced to the speaking mouth, and yet the scream is never heard. In other words, Sade is present in Debord's film even though "no-one's talking about Sade in this film," as the female voice (voice 4) observes; her voice is described as that of a "young girl" in the script and elsewhere she states, "I will tell you some stories from my country which are very frightening, but they have to be told at night in order to be frightening."[37] Her voice stands in contrast to the male "Voice 3," which repeatedly alludes to the revolutionary era by citing the Civil Code in a matter-of-fact tone: "Article 1793. When an architect or a businessman is given a contract for the construction of a building according to a plan agreed by the landowner . . . and the price agreed with the landowner."[38] It is Debord's own voice (Voice 2) that has the most Sadean tone, observing that "Jack the Ripper was never caught" and later speaking as the persona of Jack the Ripper himself, "So close, so gently, I lose myself in the meaninglessness of language. I push into you, you're wide open, it's easy. It's like a hot stream. It's as smooth as a sea of oil. It's like a forest fire."[39] The fact that these utterances lead nowhere in terms of a coherent narrative, and that the film ends in blankness, ensures that the film's *détournement* of text and image extends to a *détournement* of Sade's name too. Debord's radical transformations of the film and the experience of the filmgoer are inseparable—nothingness defies the spectacle that he was determined to subvert. The blank screen is the inverse of the howl, and of the orifice of the mouth, to which the film's title alludes. Debord's film elevates the base mouth above the eye, the instrument of knowledge and sight. In refusing images, he opens up the cinematic space to pure sound, whether that produced by the film's dialogue or by the audience in the auditorium when

the screen is silent. As the fifth voice in the film's five-person dialogue explains, "Just as the film was about to start, Guy-Ernest Debord would / climb on stage to say a few words by way of introduction. / He'd say simply: 'There's no film. Cinema is dead. / There can't be film any more. If you want, let's have a discussion.'"[40]

Artaud's (fig. 74) surrealist influence is also found here, which is unsurprising given the Lettrists' interest in his work. Serge Berna published some manuscripts by Artaud in 1953, which he had found in an attic on the rue Visconti in Paris the previous year, while another Lettrist, Ivan Chtcheglov (1933–98), with whom Debord would develop "metagraphic" writings and compositions, was equally passionate about Artaud.[41] Debord's film did not involve any recorded screams, as Artaud had included in his radio play *To Have Done with the Judgment of God*, which was banned by the French government just before it was scheduled to go on air on February 2, 1948. However, a performative howl was part of the experience of Debord's film, as the blank screen and silence at the end drew the audience in, encouraging them to scream in frustration, response, or excitement.[42] As Kaira Cabañas has noted, eyewitness accounts indicate *Hurlements en faveur de Sade* did prompt visceral, and often erotic, responses, and these were encouraged by Debord at the first full screening of the film in the Ciné-club du Quartier Latin on October 13, 1952. For that screening, Berna pretended to be a professor from the "Ciné-mathèque of Lausanne," introducing the film as one full of "erotic tension."[43] Michèle Bernstein, Debord's fellow situationist and later his wife, duly screamed into the space when encouraged by him. She later explained, "I was to howl when people began to make noise, when they began to complain—I was to make a greater noise. And I did. . . . Serge Berna tried to keep people from leaving. 'Don't go!' he said. 'At the end there's something really dirty!'"[44] Despite this potentially ludic element, Debord's was an emphatically corporeal approach to filmic expression, relying in a Sadean fashion on the creation of an uncomfortably intimate situation.[45]

In 1957, Debord formed a new situationist movement, made up of the International Lettrist group; the Mouvement pour un Bauhaus imaginaire (MBI), a descendant of the avant-garde painting movement known as CoBrA, led by Asger Jorn (1914–73); and the Psychogeographical Committee of London.[46] Their journal, *Internationale Situationniste*, was published irregularly between 1958 and 1969, with Debord as its director. They often included soft porn and pin-up images to explore alienation in consumer society. For example, in *Internationale Situationniste* no. 1, we see a woman in a bikini on page five and a nude in a trench coat on page seven, both serving as extensions of ideas rather than illustrations of the surrounding articles, including one, "Le bruit et le fureur," which discusses youth and popular culture in relation to Roger Vadim and Alain Robbe-Grillet (1922–2008). A later issue (*IS*, no. 8, January 1963) juxtaposes a photograph of Marilyn

« Je me suis mise de bonne heure au-dessus des chimères de la religion, parfaitement convaincue que l'existence du créateur est une absurdité révoltante que les enfants ne croient même plus. » Sade

75. Photograph captioned with a quotation from Sade, accompanying the "Notes editoriales" (Editorial) in *Internationale Situationniste* 2 (December 1958): 7.

76. René Dazy, Violette Nozière after her arrest in August 1933.

Monroe with the caption "Marilyn Monroe, August 5, 1962: the specialization of the mass spectacle constitutes, in the society of the spectacle, the epicenter of separation and non-communication."[47] Kelly Baum argues that in such arrangements the situationists turned to the sexual, objectified female not merely to denote alienation but to suggest she was the instigator of alienation.[48] In this image, marked with the date of Monroe's actual death, the situationists are "exploiting the full extent of Monroe's social and cultural currency to craft a succinct allegory of the pernicious effects of the spectacle on human subjectivity."[49] Baum reads their use of the pin-up, Hollywoodian or otherwise, as an attack on commodity fetishism and conventional morality. She rightly concludes that Debord and the situationists recognized that "the expression of embodied desire constituted a revolutionary act in itself."[50] At the same time, I would add that their idea of desire was deeply shaped by the Sadean imagination, seeking to move the sexual *and* political situation in new directions. For example, in *Internationale Situationniste* no. 2 (December 1958), Debord referred to his own *Hurlements en faveur de Sade* in an editorial titled "Absence and Its Costumers" and opposed its twenty-four minutes of blank film screen to the contemporary trends of the avant-garde as led by Yves Klein and his monochrome paintings. Debord describe these as a "fascist wave," and then cited Sade beneath a

Indépendance de l'Algérie

« Un jour il n'y aura plus de pères
Dans les jardins de la jeunesse...
Violette rêvait de défaire
A défait
L'affreux noeud de serpents des liens du sang. »
Eluard (« Violette Nozières »).

77. Press photograph of Djamila
Bouhired with the caption
"Indépendance de l'Algérie," accom-
panying the article "Nouvelles
de l'Internationale" (News from
the International), *Internationale
Situationniste* 2 (December 1958): 33.

press photograph of a young woman spinning hula hoops. The quote from
Sade reads: "I rose early above the chimeras of religion, perfectly convinced
that the existence of the creator is a revolting absurdity in which not even
children believe (Sade)" (fig. 75).[51]

In the *Internationale Situationniste* we also find a quote from Paul Éluard
from the 1933 surrealist publication on Violette Nozière (1915–66), an
eighteen-year-old who tried to kill her parents and succeeded in poisoning her
father with a lethal dose of barbiturates (fig. 76). In a volume of eight poems
and eight drawings published by E.L.T. Messens's Éditions Nicolas Flamel in
Brussels in 1933, the surrealists supported Nozière's argument, in her much-
publicized trial, that she acted in self-defense because her father had been
raping her for years. They emphasized the theme of rape in punning on her
name (*viol*/rape) and in presenting a broken letter "N" on crumpled violets in
the journal's cover photograph by Man Ray.[52] In the *Internationale Situationniste*
twenty-five years later, this was juxtaposed with a press photograph, cap-
tioned "Indépendance de l'Algérie," of the militant Algerian nationalist
Djamila Bouhired (b. 1935), who was accused of bombing a café in Algiers
and tortured by French paratroopers in April 1957 (fig. 77).[53] Frantz Fanon
(1925–61) described her as "a conscious Algerian patriot," not to be mistaken
for "a poor girl who is the victim of wickedness."[54]

The situationists' use of a well-known image of Bouhired, like their
citation of Nozière, reveals their imaginative Sadean thinking. They
respected Sade as a figure opposed to the Father and strove to present a new
theater of desire. Debord titled an essay "One More Try if You Want to Be

Situationists (The SI in and against Decomposition)" in recognition of Sade's "Yet Another Effort, Frenchmen, if You Would Become Republicans," and in it he announces that "the collective task we [the situationists] have set ourselves is the creation of a new cultural theater of operations, placed hypothetically at the level of an eventual general construction of its surroundings through the preparation, depending on circumstances, of the terms of the environment/behavior dialectic."[55] Debord's aesthetics of visceral assault were Sadean in their intended subversion of the institutions of family, church, academy, and art, and they were well represented by the situationists' matricidal tract, "The Avant-Garde Is Undesirable," of January 1961: "European culture is a sick, pregnant, old hag who is going to die. Should we try to save the mother or the child? Some would try to rescue the mother, even if it meant killing the child. The avant-garde has decided: the mother must die so that the child may live!"[56] Greil Marcus rightly describes such declarations as an "intellectual terrorism" enacted by the situationists on low and high culture alike.[57] Moreover, their "terrorism" frequently focused on woman, whom they viewed as subordinated in consumer society, and they subversively re-deployed her mass-produced image in a form of *détournement*. Indeed, they called for the "extensive participation of women in all aspects of struggle" as a key aspect of their revolutionary assault on art and life.[58]

A Surrealist Testament to the Marquis de Sade

The Marquis de Sade wrote in his last will and testament of January 30, 1806, that he was to be buried without ceremony in a simple coffin in the woods at his estate of Malmaison. Once buried, the soil was to be "sown with acorns, so that . . . the traces of my tomb will disappear from the surface of the earth as I flatter myself that my memory will vanish from the mind of mankind."[59] For the Quebecois surrealist Jean Benoît, the fact that Sade's will was not followed when he died eight years later in 1814, and that he was given a Christian burial in the grounds of Charenton instead, demanded intervention. For him, Sade was his surrealist "soul-mate."[60] On December 2, 1959, at 10:00 p.m., Benoît staged a performance for his fellow surrealists and friends in the private apartment of the Egyptian-born surrealist Joyce Mansour (1928–86), whose writings were often indebted to Sade—from her collection of poems *Cris* (*Screams*, 1953) to her writings *Les gisants satisfaits* (The satisfied effigies, 1958).[61] Before an audience of some one hundred people, he demanded that the world "STAND ASIDE to let the Marquis de Sade pass 'in his own likeness'" so that the libertine could be reinvested with his subversive and atheistic powers.[62] A testimony to free expression, Benoît proceeded to perform a ritualistic striptease, explaining and then discarding each element of his Sadean costume against the

backdrop of a soundtrack of traffic and city noises, composed for the event by the Croatian writer Radovan Ivsic (1921–2009).[63]

As I have documented at length elsewhere, Benoît's costume for the performance was quite distinctive—made of paper, felt, wood, metal, black dye, an old nylon stocking, and a headdress resembling the tribal masks of either the West African Dogon people or the Native American Kwakiutl (fig. 78).[64] He also carried wooden panels, a large medallion (inscribed with the names Breton, Heine, and Lely, who had "resurrected" Sade's writings), and a phallic branding iron inscribed with the letters S-A-D-E. As each piece of his elaborate costume was removed—with the assistance of his wife, the surrealist painter Mimi Parent (1924–2005), who was dressed all in black—an accompanying explanatory text was recorded. This was made up of Sade's last will, read by Breton, and Benoît's own explanation of each detail of his costume, read by Jean-René Major, a fellow Quebecois artist. Benoît's text also explained how the costume symbolized the imprisonment of Sade, and man's repression in general, as was made clear by the large medallion, which carried an image of the silhouette of a man behind bars. By the end of the striptease, Benoît stood naked, dressed only in body paint and a large wooden phallus strapped to his groin—his "membre viril" with which he simulated an erection and which he described as having the proportions of two well-endowed young men or "fuckers" from Sade's *The 120 Days of Sodom*: Brise-cul (Bum-Cleaver) and Bande-au-ciel (Invictus).[65] In Benoît's preparatory drawings, the phallus was adorned with a bouquet of five flowers, each inscribed with a letter: A-M-O-U-R, recalling Lely's oft-cited phrase that Sade signaled love.[66] The black arrows painted on Benoît's flesh also all led to the heart, and he finished the performance by raising a hot branding iron—heated by Parent—and burning the letters S-A-D-E onto his bare chest. During this action, Benoît cited Beauvoir's question, "Must We Burn Sade?," and answered "Oui, sur la fesse" (Yes, on the buttock).[67] According to Benoît, *all* critics of Sade were to be branded with hot iron—his notes for the performance listed not only Beauvoir but also authors Paul Bourdin, Jean Desbordes, Louis Parrot, and Paul Claudel, whom he labeled as "detractors."[68]

Benoît's *Exécution du testament du Marquis de Sade* took surrealist texts and ideas into the realm of performance art and energized a younger generation that had come to join the movement in Paris. It would also lend a gothic element to the Exposition InteRnatiOnale du Surréalisme [EROS], held in the Galerie Daniel Cordier from December 15th, 1959 to January 29th, 1960. Benoît's costume was housed in that exhibition behind bars in a dark, fetishistic crypt designed by Parent, as if drawing the public into the bowels of a Sadean château. Benoît's performance also presaged the new directions that Sade would take in the 1960s—into explicit body art that explored sadism, masochism, and took a stand against the repressed body and reactionary calls for censorship.

78. Photograph of Jean Benoît in costume for his performance *Exécution du testament du Marquis de Sade*, 1959.

79. Hans Bellmer, *La poupée* (*The Doll*), gelatin silver print, 1934.

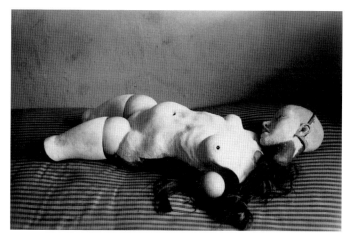

The whole surrealist circle followed Benoît in championing Sade in their EROS exhibition, which a critic in *Finance* described as pushing the boundaries of public decency: "Surrealism or pornography, it's the same difference. But this exhibition, what a pretty challenge to its neighbor, the Minister of the Interior of Public Decency."[69] It was the most powerful evidence of their great collective turn to Sade as the 1960s dawned.[70] In one gallery space, the public found a life-size pubescent doll sculpture by Hans Bellmer suspended from the ceiling above the gallery entrance, her naked limbs twisted into a kind of praying mantis form with two sets of legs, each fashioned with Mary Jane shoes and ankle socks. Underneath her were

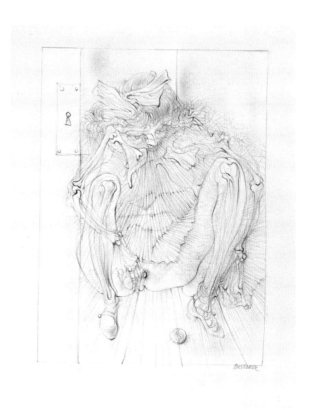

80. Hans Bellmer, *À Sade* (*To Sade*), pencil on paper, 1961.

mirrors embedded in a sand-covered floor while orgasmic moans recorded by Ivsic emanated from the walls.[71] According to Rosalind Krauss, Bellmer "casts the doll again and again as phallic. . . . This doll's body, coded female but figuring forth the male organ within a setting of dismemberment, carries with it the threat of castration."[72]

Krauss does not refer to Sade, but Bellmer's repeated staging of the doll, versions of which he produced in photography or installations over several decades, undoubtedly alludes to Sade's work, where the flesh and mechanics of the female body were tested to the extreme (fig. 79). As we saw in the previous chapter, Bellmer was selected by Jean-Jacques Pauvert to create a frontispiece for Aury's *Story of O*; he also illustrated Sade's *Justine, ou Les malheurs de la vertu* (1950) and books by many other authors whose fiction followed Sade, including luxury editions of Georges Bataille's *Story of the Eye* (1947) and Louis Aragon's *Irene's Cunt* (1953).

In 1959, Bellmer also illustrated a limited edition of Sade's *Mon arrestation du 26 aout: Lettre inédite* (My arrest of August 26: Unpublished letter), published by Jean Hugues.[73] As in his *Poupée* installation for the EROS exhibition, his signed, double-page engraving also teases out the phallic in the feminine, but not merely to uncanny ends; he exploits the Sadean

imagination with surgical accuracy to craft new monstrous forms that merge sadistic and masochistic impulses. The outline on the left page presents an orifice and phallus at once, while the female nude on the right is penetrated by a gargantuan phallus and yet seems one with it, as if it grew in her womb. His 1961 series of ten engravings titled *À Sade* (*To Sade*), published by Éditions Anonyme [Alain Mazo], again explore the interpenetration of male and female, interior and exterior forms. In a pencil drawing for one image, a little girl is portrayed crouched on floorboards, her bare sex visible between her squatting legs, as she plays with a ball (fig. 80). In playing with the ball-vulva motif, this image recalls his illustrations for Bataille's *Story of the Eye*, and yet the prominent keyhole in the girl's side also teases out the themes of prohibition and incarceration, as well as the romantic trope of virtue as something to be kept under lock and key. This image is not as explicit as Bellmer's later etchings in *Le petit traité de morale* (Little treatise on morals, 1968), in which one of the ten etchings depicts a female performing fellatio as well as two erect penises penetrating a womb with a baby inside, but it typifies Bellmer's manner of depicting the female/vagina/womb as the space of both excessive pleasure and death. The viewer is challenged by the precision of the technique, with its delicate and sinuous lines, on the one hand, and by the cruelty of the aggressive penetration, on the other.

That many of Bellmer's works also show a childish face or body again recalls the obsession of many of Sade's libertines with sexual initiation, matricide, filicide, and infanticide. Throughout the volumes of *Juliette*, for example, bodies are constantly hung for flogging, dismemberment, and rape, whether a young girl hanged by Saint-Fond in return for giving money to her father or an eight-month pregnant Venus type called Cornelia, who is beaten, hoisted on a *strappado* by Monsignor Chigi, head of the Rome police, and Count Bracciani, a physician, and dropped from a height ten times until the fetus falls from her body into Chigi's lap and the woman's tormented body disintegrates. As with the killing of the beautiful, pregnant Constance, daughter of the libertine Durcet and "wife" of the libertine Duc de Blangis, and the tearing out of her unborn son from her womb in the final tableau of the 26th Day in *The 120 Days of Sodom*, Sade revels in the gruesome killing of life and future life simultaneously.

In the tale of *Juliette*, we also encounter a Venetian aristocrat named Signor Cornaro who has a comparable penchant for blades and slow torture. He argues that virtue can have no bearing on the practices of government and insists those in power should take action against moral citizens, not corrupt ones: "Crime is necessary to Nature's right functioning, her laws expect it."[74] Then, when a poor, pregnant woman knocks on his door to ask for help and unwisely brings her four starving children into his chamber, he not only whips and beats her but whips and sodomizes her children. The voracity of this attack epitomizes Sade's obsessive destruction of the bonds of

family. Furthermore, the chamber leads to a room "decorated to represent one of those temples where the Saturnalia were celebrated in the Rome of olden days"; there nine tableaux depicted further acts of sexual violence with children or beasts (for example, a mother flogging her daughter and being flogged by a man in a chain of familial victimization). Finally, the impoverished mother is suspended by her feet from the ceiling, as her children are tortured and cut into pieces around her, so that she suffocates from the pressure of her bloated belly on her lungs.[75] While the reader attempts to absorb the degree of suffering, Juliette chides Signor Cornaro when his energy flags, giving him broth and encouraging him to continue, to destroy his victims—her voyeurism is as insatiable as his cruelty.

In his focus on the child, notably the child-woman, Bellmer also reveled in the obscenity of violence done to the innocent. He exercised such power in artworks involving his lovers too, producing a series of sadomasochistic photographs of the writer and artist Unica Zürn (1916–70), with whom he lived from 1953 until her death by suicide in 1970. In her writings, she seemed to take on a masochistic role not unlike Bellmer's doll, saying once, "It is my fate to be an eternal victim."[76] In *Céphalopode à deux (autoportrait avec Unica)* (*Double Cephalopod, Self-Portrait with Unica*; oil and collage, 1955), Bellmer may be seen to exploit this dynamic: we see his menacing self-portrait, her fragile, absent gaze, their forms entwined by female limbs and feminine lace—the collaged cloth at Unica's hair especially suggesting the doll. However their photographic collaboration also draws on her contemporary drawings and their recurrent obsessive motifs of the articulated body: eyes, limbs, bizarre animals, and breasts. As with Nora Mitrani, Zürn was also fascinated with the anagram and excelled at it in her writings, notably *Hextentexte—Zeichnungen und Anagramme* (*Oracles and Spectacles*, 1954).[77] The anagram advanced the surrealist tradition of the *cadavre exquis* in new psychosexual directions. In 1958, Bellmer took a series of photographs known as *Unica ligotée* (*Unica Tied Up*) (fig. 81), showing Zürn bound with string so that her naked flesh is manipulated into a sculptural anagram.

Her bare body appears mutilated and multiple at once, based on Bellmer's Cephalopod drawings—*Céphalopode irisé* (*Irridescent Cephalopod*, 1939), *Céphalopode à la rose* (*Cephalopod with Rose*, 1946)—and obsession with the multibreasted Diane of Ephesus, but he stages this "cutting up" of Zürn's body in a disturbingly contemporary, even homely, setting. One photograph, in which her torso is bound like a leg of lamb, appeared on the cover of *Le Surréalisme, même* (no. 4, Spring 1958), with a caption inside the cover: "Tenir au frais" (Keep cool). The female form is almost abstracted, but the sense of the artist as Sadean surgeon remains. In Bellmer's contemporary text, *Petite anatomie de l'inconscient physique ou L'anatomie de l'image* (Little anatomy of the physical unconscious, or The anatomy of the image, 1957), he wrote of a "criminal artisan" and an image of "multiple breasts in

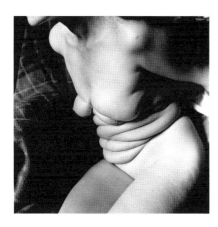

81. Hans Bellmer, *Untitled* [*Unica ligotée* (*Unica Tied Up*)], gelatin silver print, 1958; printed posthumously by Roger Vulliez, 1983.

82. Unica Zürn, *Château d'Eros* (*The Château of Eros*), oil and gouache on board, 1956.

unspeakable settings"; in these photographs, he made a version of such a tableau.[78] As in his collaboration with Nora Mitrani, Bellmer enjoyed collaborating with Zürn, whose painting *Château d'Eros* (1956) (fig. 82), also staged in the EROS show, reminds us of her interest in Sade too, as its sinewy lines trace eye- and breastlike motifs and the ghostly outline of a château. Zürn's exploration of the Sadean imagination also appears in her novella *Dunkler Frühling* (*Dark Spring*, 1969), which recounts the tale of sexual

initiation and insanity of a sixteen-year-old girl who ultimately commits suicide by jumping from her bedroom window. In 1970, Zürn's fate was equally tragic: she leapt to her death from the window of the sixth-floor apartment she shared with Bellmer on the rue de la Plaine in Paris.

A red velvet–lined room in the EROS exhibition space staged a different type of Sadean challenge: in place of Bellmer's doll suspended from the air as if about to be initiated into some bizarre game, the public discovered a cannibalistic feast being acted out on the gold-painted body of a real female model, lying on a table and thereby serving as the platter for the meal. Dressed only in food (seafood, chicken, fresh fruit, and *petits fours* between her bare breasts and on her stomach); she was surrounded by a group of people sitting around her, eating and drinking champagne, caged off from the crowd by iron railings. This was the *Le festin* (*Cannibal Feast*) tableau by Meret Oppenheim (1913–85), which was originally conceived as a festive fertility celebration, or "Spring Banquet," in Bern in April 1959, but which Breton invited Oppenheim to adapt for the Cordier gallery space.[79]

In its cavernous staging in a dark, velvety room and in its use of a breathing model as table, it undoubtedly evoked Sade's character Minski, a beastly cannibal who explains to Juliette, "I eat what I fuck."[80] Minski enjoys virgin-blood sausages and testicle pastries for breakfast, and he insists on a theatrical staging of the body, as he proudly recounts to Juliette, "[Y]ou notice this table, these chandeliers, those chairs are each made up of a group of girls cunningly arranged; my meal will be served upon the backs of these creatures; my candles are stuck into their cunts; and our behinds, yours as well as mine, settling into these chairs—they are comfortable—will rest upon the soft faces and elastic breasts of these maidens."[81] Oppenheim's banquet explored the interdependence of sadism and masochism, the artist-performer and the spectator-witness, a tension she herself addressed in distinguishing between her original formulation and its re-staging for the EROS exhibition: "[T]he original intention was misunderstood. Instead of a simple Spring festival, it was yet another woman taken as a source of male pleasure [in the EROS exhibition]. There's always a gap between aims and public comprehension."[82] Yet it won her considerable critical attention, especially among reviewers. For example, the Franco-American critic Patrick Waldberg (1913–85) wrote: "On the day of the opening, shrimp were eaten on the bare belly of a dancer rented for the occasion, which seems a curious way to honor Woman! The padded Labyrinth through which the audience flowed evoked, less charmingly, the "Mysterious River" of Luna Park or the "Tunnel of Love" of Coney Island. Hidden microphones exhaled amorous sighs into the passage."[83] In his 1965 book *Érotique du surréalisme* (Eroticism of surrealism), the Moroccan literary and film critic Robert Benayoun (1926–96) who, like Waldberg, was linked to the surrealist circle, also noted the emphatically penetrative entryway leading into the gallery space and the cannibalism of Oppenheim's installation: "[A]

'vaginal' beaded door opens onto a labyrinth filled with sighs and swoons, toward a fetish room and a red room where a provocative cannibal feast was taking place."[84] In his review in the *Tribune de Lausanne*, journalist Pierre Descargues describes the space as "speleological" because of its sandy, grotto-like character, though his description also echoes the prison and dungeons, the underground world, where Sade's imagination had festered.[85] The unwitting gallery goers had no choice but to weave through the dark and cavernous exhibition, its interactive geography exposing them to sadistic play and fear.

"He was pure fire": Jean-Jacques Lebel and the Marquis de Sade

Jean-Jacques Lebel, who was a member of the surrealist group from 1956 to 1959, turned to the happening to expand the surrealist imagination in new, immersive directions in the sixties. For Lebel, the happening offered people "something to do, something to participate in and create with. We are giving [people] a language for their hallucinations, desires and myths."[86] In an era of increasing political turmoil, he turned to Sade as a figurehead for a revolt led by desire and as a means of translating avant-garde ideas into new collective or tribal experiences. One of those artists he most admired was Artaud, the recording of whose aforementioned play *To Have Done with the Judgment of God* was discovered by a friend of Lebel's in the vaults of the French national broadcaster RTF in Paris.[87] This discovery allowed Lebel to help propagate what he termed the "Artaud virus" in Europe and the United States.[88] Another seminal influence was Breton, whom he knew from childhood through his father, Robert Lebel, and who inspired Lebel's sense of the artist as an "anthropological researcher."[89]

Allan Kaprow (1927–2006) first coined the term "happening" in the title of his work *18 Happenings in 6 Parts* at the Reuben Gallery, New York, October 4–10, 1959, and explained it as a kind of painting beyond the canvas: "the entire painting comes out at us (we are participants rather than observers), right into the room."[90] Lebel saw the happening in more libidinous and political terms, expanding the role of Sade as an energizing and disruptive force in the process. Two especially important happenings, *L'enterrement de la chose de Tinguely* (The burial of the Thing of Tinguely), staged in association with the so-called *Anti-Procès* (*Anti-Trial*) exhibition in Venice in 1960, and *120 minutes dediées au divin Marquis*, staged in Paris in 1965 as part of an international "Festival de la libre expression" (Festival of Free Expression) that he organized between 1964 and 1967. He cited Sade's name and writings in both as a kind of call to arms, later explaining, "Sade was the black flag we held high as an emblem of subversive thought and of this freedom that our enemies denied us. He was pure fire."[91] Lebel used the term "festival" to denote the system by which his happenings would be part of a larger

collective movement: it was public, improvisational, experimental, and it offered a plurality of activities by artists and responses by audiences. It was also Sadean in opposing the form and technique of classical and realist theater and allowing "everything to interpenetrate and interchange."[92]

L'enterrement de la chose de Tinguely happened in the Palazzo Contarini-Corfu and the Grand Canal in Venice on Bastille Day, July 14, 1960. The title alluded to Sade's pagan burial, the date recalled the storming of the Bastille, and the "thing" was a mechanical sculpture with wheels, made by Swiss sculptor Jean Tinguely (1925–91), which had been exhibited in an *Anti-Procès* exhibition (June 18–July 8, 1960) at the Galerie Il Canale, near the Palazzo. The exhibition was orchestrated by Lebel and was part of a larger itinerant show that toured in Paris, Venice, and Milan in 1960–61, bringing together around sixty artists to protest the Algerian War and the use of torture against the FLN by the French military. The "burial" of Tinguely's kinetic work began in more traditional funereal terms, with candles and three keeners, including the Mexican film actress Pilar Pellicer (b. 1938) and artist Nikky (Nicola) Amey (1921–2009). Guests also heard tapes of dada sounds described in a handout distributed at the event as "leaves falling and people crying, screaming in pain AND ecstasy, ritual voodoo trance by priestesses," and electronic music composed by the pianist Frank Amey (b.1922), who had moved from the United States to Venice in 1956 with Nikky, to whom he was married.[93]

Two readings immediately aligned the event with Sade. First was an excerpt from Sade's *Juliette*, read by Lebel, in which Saint-Fond lists a six-point plan for a new way of living according to libertine principles as a means of assaulting good taste. It opened with the announcement: "The Christian religion will be strictly excluded from government; there will never be any celebration of a festival other than that of debauchery."[94] Second was an excerpt from Joris-Karl Huysmans's *Là-bas* (*Down There* or *The Damned*, 1891), which recounted Gilles de Rais's pleasure in torturing little boys. This was read by the American beatnik writer Alan Ansen (1922–2006), and both readings were delivered in a *mélange* of languages (French, English, and Italian), reflecting the international range of artists involved while also confronting the audience with a deliberately confusing montage of sound and images, bloodthirsty descriptions, and sacred ceremony. A masked man in black then attacked Tinguely's sculpture, with rose petals falling about to suggest violation but also, according to Lebel, to mock the "tears of roses" of the French Carmelite nun Saint Teresa of Lisieux (1873–97).[95] The happening then moved in procession from the Palazzo to the Grand Canal, where the participants and Tinguely's sculpture traveled on three gondolas provided by surrealist collector and gallerist Peggy Guggenheim (1898–1979) (fig. 83). At the end, the sculpture was laid to rest when Lebel unceremoniously threw it in the water.

The stretch of water navigated by the procession and into which the artwork was thrown, between the island of San Giorgio Maggiore and the

83. **Procession of gondolas in Jean-Jacques Lebel,** *L'enterrement de la chose de Tinguely***, Venice, July 14, 1960.**

Doges Palace, alluded to Sade's insistence in his will on a non-Christian burial in nature. The happening had personal and political aspects as well: it was a symbolic burial of the artists' friend Nina Thoeren (1939–60), a student of anthropology who had been raped and murdered a few days earlier in Los Angeles—her death was announced at the start of the happening. Through the Sadean imagination, a revolt against colonialism, against the culture industry, and against the murder of a loved one were celebrated together on a date that honored the French Revolution.

Alongside Enrico Baj, Roberto Crippa, Gianni Dova, Erró and Antonio Recalcati, Lebel also produced the large protest work *Grand tableau antifasciste collectif* (*Large Collective Antifascist Painting*, 1960) (fig. 84). Painted collectively in Milan, it was part of Lebel's *Anti-Procès* exhibition, the third stage of which took place in Milan in the summer of 1961. The collective painting decried the Algerian War at a time when police brutality was increasingly evident even on the streets of Paris—on October 17, 1961, police chief Maurice Papon ordered his men to attack a demonstration of some thirty thousand pro-FLN marchers, leading to the deaths of at least forty people. As Baj explained, the artists came together to work on the painting in Crippa's studio in Milan "to protest against violence, against fascism, against the war."[96] Lebel, who was responsible for the upper-left section of the canvas, brought a distinctively Sadean eye to the composition: he portrays the Algerian woman Djamila Boupacha as an abstracted nude with splayed legs, being raped by a machine gun. Boupacha was arrested in Algiers in 1960,

84. Jean-Jacques Lebel, Enrico Baj, Roberto Crippa, Gianni Dova, Erró and Antonio Recalcati, *Grand tableau antifasciste collectif* (*Large Collective Antifascist Painting*), paint and collage on canvas, 400.5 × 497 cm., 1960.

detained and subjected to torture by French police officers as a form of interrogation. In her testimony against the French militia—documented by Simone de Beauvoir in an article in *Le Monde* on June 2, 1960, and then in a book-length account published in 1962, Boupacha stated that she had been subjected to torture with electrodes (which were affixed to her nipples, vagina, and anus), waterboarding, and rape. Beauvoir uses Boupacha's own words in describing her rape or the "bottle treatment": "they rammed the neck of a bottle into my belly. I screamed and fainted"; in parentheses Beauvoir notes, "She was a virgin."[97] Torture was a common weapon in the colonial war, but this brutal rape and taking of a Muslim woman's virginity exploited the association between purity and terror and demanded a questioning of police action and ethics. In Lebel's part of the canvas, he painted a barrel of a gun exploding into Boupacha's body and the hand-painted word *liberté* emerging from her head, while in the lower-right portion of the painting the "Manifesto of 121" was pasted on to the work.

Lebel signed the manifesto and was a member of the Comité des intellectuels contre la poursuite de la guerre d'Algérie; he also published the manifesto in the journal *Front Unique*, which he founded in 1956 with the writer and gallerist Arturo Schwarz (b. 1924).[98] The explicitly political nature of the *Grand tableau* meant it was quickly confiscated by the Milan police, possibly at the request of the French government.[99] As Lebel later recounted, it was "one more 'exhibit' for an obscenity trial that ultimately did not take place."[100]

By the time Lebel founded the Festival of Free Expression in Paris in 1964, his sense of art as an intervention and his use of sexual "obscenity" to expose political injustice was even more pronounced: "There was a state of specific and precise oppression. That's why we called it 'Festival de la Libre Expression.' " That has to be understood in a political sense, not only in an artistic sense, and in a social sense too."[101] To evoke and encourage the opening of the mind, Lebel emphasized the role of improvisation by performers and audience alike, and of hallucination, the ne plus ultra of expressive and sensory freedom. In the statement he issued to launch the festival in the summer of 1964, he wrote: "What about free art? Where are our hallucinatory experiences? What do the terms 'spectacle,' 'creation,' 'image,' 'perception,' 'language' mean today? In what respect has poetry touched the contemporary world? Where is revolutionary art in relation to

85. **Poster for the 3ème festival de la libre expression (Third Festival of Free Expression), Théâtre de la Chimère, Paris, April 4–May 3, 1966.**

mass culture, everyday life, the state?"[102] There was an element of threat in this experimental project, but it was a threat of communication rather than of violence: "This festival aims to establish a contact and dialogue between the avant-garde and the public—one that today's society renders difficult and dangerous. We have to take steps to ensure this communication takes place."[103] The festival ran from 1964 to 1967, the first in the series being held May 25–30, 1964, at the American Center in Paris; the second, May 17–25, 1965, also at the American Center; the third from April 4 to May 3, 1965, at the Théâtre de la Chimère in Paris; and the fourth, titled "Sun Love," in Gassin near Saint-Tropez on August 8, 1967.

The third festival took the Sadean imagination to exceptional heights (fig. 85). It took place at the Théâtre de la Chimère, which was on the first floor of the building that André Breton lived in—42, rue Fontaine, in the ninth arrondissement of Paris. The ideas voiced in *L'enterrement de la chose de Tinguely* were here explored in more visceral, orgiastic directions, surrounding the public with the Sadean imagination for two hours. The audience entered the theater space through the stage door only to be greeted by two bloody meat carcasses described by Lebel as "like the walls of the vagina," an image that recalls the surrealists' 1959 EROS show.[104] This abject introduction led to a noisy and confusing space comprising free jazz, strobe lights (arranged by light artist Jean-Claude Bailly), and film clips by or about avant-garde artists (Allen Ginsberg, Taylor Mead, Piotr Kowalski, Marta Minujin, Merce Cunningham, Man Ray). Lebel and his friends offered people LSD-laced sugar cubes for a heightened experience. This happening consisted of twelve scenarios organized across two hours, loosely arranged, and relying on a high degree of improvisation from both artists and spectators. There was no stage, plot, or script—just a forum for free expression with Sade's *The 120 Days of Sodom* as inspiration. Lebel used the concept of "philosophy in the bedroom" as a means of shedding light on recent political memory, invoking World War II, the Holocaust, state power, and censorship. Thus the central space in the theater included a pile of old shoes (a reference to the collection of thousands of shoes from prisoners arriving at the Nazi death camps), and a naked woman invited members of the audience to sign a collective artwork with a thumbprint (a reference to police control). Lebel and the artist Bob Benamou spanked the naked bottoms of two women across their knees, simultaneously to the rhythm of "La Marseillaise," before the roles of spanker and spanked were reversed.

Later, Lebel, dressed in a blue wig and priest's chasuble smeared in excrement, sprayed the naked artist Shirley Goldfarb (1925–80), with Chantilly cream (fig. 86). In explaining his aim to stage a crazy, erotic mass in this happening, Lebel has cited as inspiration *Le sacré* (1939), a collection of poems and fragments on mysticism and eroticism by Laure (Colette Peignot, 1903–38).[105] She had been involved in the *Contre-Attaque* and *Acéphale*

86. Shirley Goldfarb in Jean-Jacques Lebel, *120 min-utes dédiées au divin Marquis*, **Third Festival of Free Expression, Paris, 1966.**

groups in the 1930s. Like her lover Bataille, she explored in her writings the theme of sacrifice, both as something that marks a threshold in life and something that celebrates the body as it violates it.[106] In *Le sacré*, Laure fuses her own fantasies with emphatically Sadean philosophical observations; for example, she writes that the "permanence of the threat of death is the intoxicating absolute that carries life away, lifts it outside of itself, hurls forth the depths of my being like a volcano's eruption, a meteor's fall."[107] The homage to Sade using Goldfarb's naked body was playfully absurdist, and may have nodded to her own tachiste art practice too, but it alluded to the sacred in details, notably the use of props: Goldfarb first gave her own improvised soprano version of the ninth day of *The 120 Days of Sodom* before lying on an altar where Lebel then sprayed her with the cream; the collective rite of this mass was then further mocked as members of the audience were welcomed to lick the cream off her body. Meanwhile, in another part of the venue, another woman, dressed as a little girl and mimicking the voice of a child, called out extracts from Sade's text and also went up to individuals to whisper Sade's words in their ears. Hence, no one could

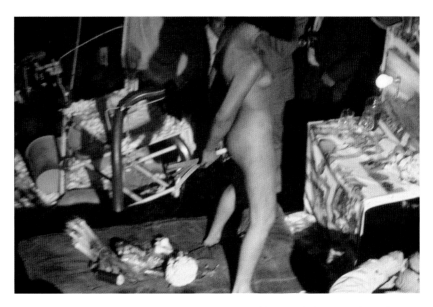

87. Cynthia in Jean-Jacques Lebel, *120 minutes dédiées au divin Marquis*, Third Festival of Free Expression, Paris, 1966.

escape the Marquis's presence. Lebel wanted to assault the senses—as he stated in a 1996 interview, "I'd read *The 120 Days of Sodom* and I knew that the 'revolutionization of desire' wasn't going to happen because of anything like mini-skirts, going topless, or Timothy Leary's psychedelic bacchanalia."[108]

Two other aspects of Lebel's *120 Minutes dediées au divin Marquis* identify it as a specifically Sadean activism within the larger counterculture's assault on sexual taboo. First, it was a celebration of sexual difference and libertine freedom in featuring Cynthia, a transsexual prostitute who worked at La Nouvelle Ève, a striptease cabaret at the Place Pigalle. Dressed as a nun, Cynthia proceeded to undress, teasing out a fantasy of the convent girl as Sadean heroine by autosodomizing herself with leeks and carrots before turning to the audience to show her breasts and penis (fig. 87). This was a tableau that took the Sadean imagination out of the château or convent and into a public forum. When Cynthia revealed herself indeed, the sociologist and philosopher Lucien Goldmann (author of important studies of Kant, Pascal, and Racine), collapsed with a heart attack, to great consternation.[109] Cynthia's role continued, however, as Lebel and the artist Frédéric Pardo (1944–2005) put her on a type of throne, before Lebel and Jean-Claude Bailly powdered her with sugar laced with LSD.

Second, Lebel's happening was meant as an attack on the censorship of Jacques Rivette's film *La religieuse* (The nun, 1966) (fig. 88), an adaptation of Diderot's novel of 1760, which had been banned in March 1966 because of protests by Catholic groups and an accusation of blasphemy made against it

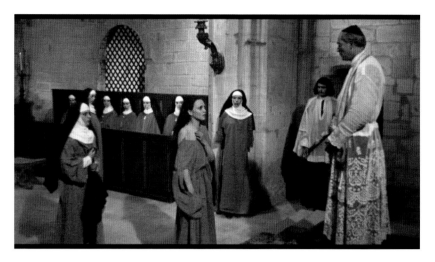

88. Anna Karina as the young nun, Suzanne Simonin, in *La religieuse* (Jacques Rivette, 1966).

89. Production still showing Veronique (Anne Wiazemsky) reading Sade's *Les infortunes de la vertu*, with Guillaume (Jean-Pierre Léaud), in *La chinoise* (Jean-Luc Godard, 1967).

by Minister of Information Alain Peyrefitte. Denise de Casabianca (b. 1931), who performed as a nun in Lebel's happening, had been the editor of Rivette's film, which starred the highly acclaimed Anna Karina as the tormented Suzanne Simonin. Rivette's film used a highly theatrical mise en scène, counterpointing the austere stone of the convent with elements of bright color (blue, gold, pink), to emphasize the oppression of Suzanne and a tension between the sacred and the profane, advancing the original text into a modern, psychological, study of sexual repression.[110] Fellow New Wave director Jean-Luc Godard condemned the film's censors as a "Gestapo of the spirit," and, the following year in his own film *La chinoise* (1967), he portrayed the Maoist student revolutionaries Guillaume (Jean-Pierre Léaud) and Véronique (Anne Wiazemsky) reading Mao's *Little Red Book* and Sade's *The Misfortunes of Virtue* side by side (fig. 89).[111]

Lebel's happening was dominated by the image and idea of the Sadean body, especially the Sadean heroine, who was shown to be active, libidinous, and threatening.[112] Lebel remained defiant, believing that "it was fundamental to be antipatriotic—to shit, literally, on France," though soon he was arrested.[113] The owner of the Théâtre de la Chimère, Madame Martini, claimed that Lebel had gone too far and called the police. Soon the press was reporting that Lebel's new art form was a "total art, a merciless bulldozer intent on ridding the world of its cultural ruins."[114] Jean-Paul Sartre later observed that Lebel exercised "a certain sadism toward the public: the latter is stunned by flashing lights, unbearable noises, sprayed with diverse objects that are usually filthy, you have to go to these happenings in old clothes."[115] However Sartre was one of many who signed a declaration protesting Lebel's detention, along with André Breton, Maurice Nadeau, Gérard Legrand, Joyce Mansour, José and Nicole Pierre, Alain Joubert, and Patrick Waldberg, as well as Marcel Duchamp, Simone de Beauvoir, Edgar Morin, Eugène Ionesco, Michel Leiris, Jacques Prévert, Eric Rohmer, Jacques Rivette, and Jean-Jacques Pauvert. Their declaration challenged the official accusation that Lebel's happening was an affront to "common decency" (*bonnes moeurs*) and "offensive to the Head of State," and it asserted that the policing of such events constituted a "clear and intolerable attack on freedom of thought."[116]

The protest against Lebel's arrest can be said to have typified the artistic and intellectual activism that Lebel implicitly called for when he celebrated Sade in these works as a kind of direct action of expression— what he termed a "poésie directe."[117] As *Life* magazine reported in February 1967, he saw the artist in extreme—if not Sadean—terms, "on the verge of physical extinction, like a suicide or a criminal."[118] Sexual obscenity was harnessed to expose political obscenity, as Lebel himself subsequently put it: "Obscenity today is no longer sexual, it is political."[119] Sade's role was crucial to the spirit of this radical assault and to Lebel's call for a "radical

subjectivity . . . the opposite of the submission to norms that prevails today in the world of art and in society as a whole."[120]

"We're citizens of a new enlightened age"

Peter Weiss's play *The Persecution and Assassination of Jean-Paul Marat as Performed by the Inmates of the Asylum of Charenton under the Direction of the Marquis de Sade* (1964) is a play about a play.[121] Generally known by the shorter title *Marat/Sade*, its preparations began in 1963, and it premiered at the Schiller Theater, West Berlin, in April the following year. The spectator was informed at the outset that Sade wrote his play in 1808 in a French asylum for "the socially impossible," and that it was acted out by the inmates (although the play by Sade that Weiss's play claims to be reenacting never actually existed).[122] Sade's fictional play allows Weiss to stage the libertine's rhetoric against the revolutionary rhetoric of Marat, with a focus on the fatal day Marat was killed by Charlotte Corday—July 13, 1793. Weiss's play is set four years into the Revolution and allows him to explore a double opposition—of passion versus principles and of libertinism versus liberty—by reflecting on the Thermidor and the execution of Danton, as well as dictatorial power. Weiss indulges in none of the graphic sexual cruelties of Sade's fiction. Instead, his play returns us to the "fairer sex" of Corday, discussed in Sade's eulogy at Marat's funeral. She takes on an emphatically phallic, castrating role vis à vis both Sade and Marat, in keeping with the libertine Sadean heroine, but she also offers the most humane perspective on the bloody Terror amidst their rhetorical positions and the bedlam of an asylum. In this way she hovers between Juliette and Justine and refuses the traditional dichotomy between vice and virtue. In contrast, Sade and Marat stand as two opposite poles in their political stances on liberty and terror. Sade announces to Marat "For you just as for me / only the most extreme actions matter"; he explains that his universe is internal ("the world inside myself") and that he is "seeking a personal annihilation."[123] Marat insists the pen is not enough, that violence is necessary for revolutionary success; he disputes Sade's faith in the imagination and written word as he asserts, "Imagination can't break down / any real barriers. / I write, but I never believed the pen alone / could destroy institutions."[124] His words repeatedly turn the inmates into an angry mob, further underlining his status as a man of the people.

The inmates at the asylum who play various parts in Sade's play include a female patient acting the part of Simonne Evrard, Marat's mistress, who stands in contrast to the mechanistic Corday in constantly fussing over Marat. Corday is played by a somnambulist who frequently needs the assistance of two nurses because of her entranced state, and she must fend off the advances of a Girondin deputy, Duperret, played by a patient suffering from erotomania who wears the "smooth tight trousers of an 'Incroyable.'"[125] He lusts after

Corday in a way that makes a mockery of Girondin ambition and acquisitiveness. Meanwhile, the "radical Socialist" ex-priest, Jacques Roux (1752–94), who called for the redistribution of feudal lands alongside his fellow revolutionaries Robespierre, Danton, and Marat, is played by a patient bound in a straitjacket throughout the play, while the four singers who represent the sans-culottes (the Third Estate)—Kokol, Polpoch, Cucurucu, Rossignol—taunt Marat, shouting, "We want our revolution NOW." Through the figure of Sade, Weiss attacks the rise of a patriotic bourgeoisie, as when Sade mockingly says, "my patriotism's bigger than yours."[126] And yet Weiss often defends Marat—for example, when we are told that his idealism is ahead of his time, a comment that links him to later revolutions, presumably including the October Revolution. Further, through the figure of the director of the asylum hospital, Monsieur Coulmier, and his wife and daughter, there is a call for the healing power of art and a reminder that the artist is all too often society's outcast; Coulmier instituted theater entertainment as part of the treatment of patients at Charenton from 1797 to 1811. Equally, through the rantings and violent silencing of Roux, Weiss magnifies the battle between free expression and censorship. Overall, the play is effectively a layered but still calculated and epic piece of theater (with scenes introduced in turn by the Herald and carefully posed tableaux) and emotive physical theater (with cries, shrieks, and great physicality lending angst and tension to the performance despite the rationality of much of the dialogue). The play sets the calculated, humanist, individualist Sade against the bloodthirsty rationalist populist Marat, and Corday's bodily movements, from sleepy collapse to aggressive attack, ensure the audience remains on edge. She is presented as a "phenomenally pulchritudinous" young woman of twenty-four with long hair, wearing "pink leather boots," a "ribboned hat," and a "thin white blouse of Empire cut. The blouse does not conceal the bosom, but she wears a flimsy white cloth over it."[127] Weiss's image of her is very much in keeping with her portrayal in late-eighteenth-century and nineteenth-century art where, as we saw in chapter 1, her flimsy white dress and long hair were emphasized to expose her duplicitous nature. In the play she hides her knife under her blouse while speaking of her passionate desire to kill Marat and the Revolution in one fatal blow: "I shall take the dagger in both hands / and push it through his flesh."[128] The costumes for the original German performances were designed by Weiss's wife, the Swiss stage-designer Gunilla Palmstierna-Weiss (b. 1928), who had researched them in Paris, and they so impressed Brook in the first Berlin production that he retained them for his London and New York stagings.[129]

Corday's pretty clothing jars with her hysterical nature, ensuring that she appears as a frenzied femme fatale who is not in charge of her actions.[130] It also allows Weiss to stage her as both monstrous and seductive in persuading Marat to let her into his home only to deal a "single blow" that kills him, recalling the biblical tale of the beheading of Holofernes by Judith.[131] Corday

offers a voice to the thoughts of the audience too, as she speaks of Paris as a "slaughterhouse," predicting her own execution and blushing guillotined head: "They say / that the head / held high in the executioner's hand / still lives."[132] Dr. Gullotin famously claimed that the condemned did not feel anything once the blade hit the neck, the science of the machine making it the perfect tool of justice, but Corday's words reinforce contemporary accounts of bodies still writhing after the blow, and the sheer horror and excitement of the public spectacle of execution. In Weiss's play, the character Sade states that the greatest acts in history have followed nature rather than law, conflating the Terror with Nazism as he reasons, "Nature tells a man to fight for his own happiness and if he must kill to gain it / why then the murder is natural. . . . Haven't we experimented in our laboratories / before applying the final solution? / Man is a destroyer."[133]

While there has been much critical debate on the most important influences on Weiss's play, it is usually interpreted as a work indebted to Brecht's theater of alienation. When Weiss was a young man in Berlin, his friend Uli Rothe introduced him to Brecht's *The Rise and Fall of the City of Mahagonny* (1927) and *The Threepenny Opera* (1928); Weiss later met Brecht in 1950.[134] Given that Weiss's career began in painting and that he was exposed to surrealist ideas in 1937–38 when he was an art student at the Art Academy in Prague, it is tempting to say he also brought a touch of surrealism to the play's exploration of the Sadean imagination.[135] Prague enjoyed a dynamic surrealist scene in the 1930s, and later Weiss visited Paris in 1947–48, 1952, 1958, and again in 1960. In 1958, he met Breton, Roberto Matta (1911–2002), and Gilles Ehrmann (1928–2005), who took a series of photographs of Benoît in his costume for *Exécution du testament du Marquis de Sade*. Weiss also attended surrealist exhibitions.[136] In his Paris notebooks, he mentions Salvador Dalí, Giorgio de Chirico, Marcel Duchamp, Max Ernst, René Magritte, Man Ray, and Yves Tanguy, but laments that works once felt to be "high-explosive bombs" had been reduced to "meditations" and "dream material"; for him, surrealism was unable to address the recent horrors of war.[137]

Weiss described his aesthetic process as "hermetic" and emphasized his practice of writing in blocks, without paragraphs, which he compared to the practice of painting. In this respect and others, he was attuned to new directions in art, especially in turning from surrealism to performance art, becoming interested in the younger artists Jean Tinguely and Daniel Spoerri (1930–), whose work he saw in Paris in 1958 and 1960 and that aimed to bring art into the street and the street, or the everyday, into art. In his notebooks, Weiss describes witnessing Tinguely's action piece *Le transport* (Transport, 1960), in which he paraded six large sculpture-machines through the streets of Paris in a circus that was brought to an end only when the police arrested Tinguely.[138] In further entries, Weiss describes another unidentified happening as having had "charged moments" and "orgiastic

90. Patrick Magee as Sade, Glenda Jackson as Charlotte Corday, and director Peter Brook, rehearsing *Marat/Sade*, photograph by Dennis Stock, London, 1966.

beginnings" though he doubts that the "separation between art and life" can be "overcome."[139]

Political circumstances also impacted Weiss's ideas on Sade and his interest in the era of the French Revolution: the building of the Berlin Wall in August 1961; trips he made to East Berlin, where he experienced censorship of the arts under the German Democratic Republic; and his visit to Frankfurt in March 1964 to attend the Auschwitz trials (which ran from December 20, 1963, to August 19, 1965).[140] Weiss's exposure to these environments and events anticipated Peter Brook's reading of Weiss's play *Marat/Sade*, expressed in his 1964 introduction to the English translation of the play: "It is firmly on the side of revolutionary change. But it is painfully aware of all the elements in a violent human situation and it presents these to the audience in the form of a painful question [posed by Marat in the play]: 'The important thing is to pull yourself up by your own hair / To turn yourself inside out and see the whole world with fresh eyes.' How? Someone is bound to ask. Weiss wisely refuses to tell."[141]

Brook's experimentation was driven by a respect for Weiss's creation of a kind of "total theater"—a highly immersive theatrical experience, going beyond the dominant realist tradition and reliant on directness and immediacy in staging, a heightened physicality in performance, and examination of emotional extremes (fig. 90).[142] As he wrote, "[Weiss's] force is not only in the quantity of instruments he uses; it is above all in the jangle produced by the clash of styles. Everything is put in its place by its neighbor—the serious by the comic, the noble by the popular, the literary

by the crude, the intellectual by the physical: the abstraction is vivified by the stage image, the violence illuminated by the cool flow of thought."[143] He describes the experimental troupe he orchestrated with the Royal Shakespeare Company to bring the play to London (and later New York) as "our avant-garde."[144] In setting up that group to advance his experimental practices, Brook took inspiration from Jerzy Grotowski, founder of the Laboratory Theater in Poland in 1959, who was known for his emphasis on spirituality, anti-rationalism, anti-illusionistic staging, and physically authentic performance.[145] Brook, like Weiss, was also influenced by Brecht, whom he met in Berlin in 1950 and named as one of three key influences on his work in his memoir *The Shifting Point* (1987): "For Artaud, theatre is fire; for Brecht, theatre is clear vision; for Stanislavsky, theatre is humanity. Why must we choose among them?"[146] Brook had transatlantic influences too, given that he was assisted by the iconoclastic New York theater director Charles Marowitz (1932–2014), who had moved to London in 1956 and who worked with Brook to bring what was billed as a "Theater of Cruelty" season to the Royal Shakespeare Company in 1964, with *Marat/Sade* as its highlight. Together they selected a team of twelve actors, including Glenda Jackson, who would play Corday. She struck both directors as having exceptional potential for their project—indeed, Marowitz's description of her in audition for the Royal Shakespeare Company experimental troupe is almost indistinguishable from the way she played Corday: "behind her studied stillness was a cobra ready to spring or a hysteric ready to break down."[147]

His staging of Weiss's play ensured the audience was constantly overwhelmed by noise, dialogue, and chaos. In keeping with Weiss's focus on the character Corday, Glenda Jackson dominates Brook's production, notably in two powerful scenes in which her actions make Sade and Marat appear vulnerable. In one, Corday (Jackson) whips Sade with her hair, following the play's script, "let her beat me / while I talk about the Revolution," as Sade (Patrick Magee) offers his naked back to her while he stands facing the audience.[148] This is reinforced by the ritualistic moaning of the inmates, which coincides with each blow of Corday's hair on Sade's shoulders.[149] In the second of her central scenes, Corday attacks Marat (Clive Revill in the London production, Ian Richardson for the New York and film productions), pulling her dagger from her dress as the patients let out "one single scream."[150] Brook emphasizes the complicity of Corday and Sade in both scenes, between their sadomasochistic pleasure in the former and her passing of the dagger to him in the latter.

Brook's infusion of the program of the Royal Shakespeare Company with a Sadean imagination was not popular, however, and led Emile Littler, president of the Society of West End Theatre Managers and a member of the executive council of the Royal Shakespeare Company, to attack the

Aldwych Theatre's season of "dirty plays" in the *Daily Telegraph* on August 25, 1964.[151] Despite this, Brook insisted that "violence is the natural artistic language of the times. . . . It's our reality, there's no way round it."[152] In a discussion in London, Brook again related the play to the contemporary political situation, specifically to the right-wing US presidential candidate of 1964, Barry Goldwater. Brook stated that "many people at the time [of the French Revolution] would have seen the political necessity of assassinating Marat, just as some would today justify the assassination of Goldwater, on purely political grounds. But Weiss asks us to take this apparently purely idealistic act and judge the degree of erotic drive that provoked it."[153]

Brook knew the play would do nothing if not assault the audience, explaining, "Starting with its title, everything about this play is designed to crack the spectator on the jaw, then douse him with ice-cold water, then force him to assess intelligently what has happened to him, then give him a kick in the balls, then bring him back to his senses again."[154] In preparation for the London performance, he insisted that all of the actors "find the madmen in themselves," and he advised them to consult nineteenth-century medical textbooks and the art of William Hogarth and Francísco Goya, as well as to pay visits to asylums. For Brook, a good play was one in which "the intelligence, the feelings, the memory, the imagination are all stirred."[155] Susan Sontag wrote in her review in *Partisan Review* in the spring of 1965 that his production of Weiss's play brought "theatricality" and "insanity" together with brilliance, exemplifying "a theatre of dialogue (of language) in which the text is primary" and a "theater of the senses" extending Artaud's theater of cruelty.[156] She emphasized the successful fusion of spectacle and sound in Brook's staging of insanity, her words reflecting how the play took the visualization of the Sadean imagination to new heights: "Insanity establishes the inflection, the intensity of *Marat/Sade*, from the opening image of the ghostly inmates who are to act in Sade's play, crouching in fetal postures or in a catatonic stupor or trembling or performing some obsessive ritual, then stumbling forward."[157]

The set designs of Sally Jacobs (b. 1932) for Brook's production were also crucial to this immersive edge: twelve cells in the floor alternately suggested graves, cells, and bloody sewers, evoking metaphorically the underbelly of society, the twisted mind, and the rancid prisons of Sade's time, which excluded light and air. The mise en scène lent a mood of the uncanny, expressing the working of the mind and dreams rather than any recognizable prison or camp.[158] In the United States, the play was discussed explicitly in terms of political dissent. In a forum at the St. Marks Playhouse in Manhattan in January 1965, Brook and the actor Ian Richardson (then playing Marat in the New York run of the play), together with several important figures in off-Broadway theater and prominent theater and cultural critics, recognized the great political potential of Sade's name at a time of intense political

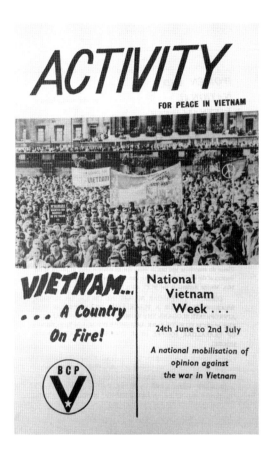

91. British Communist Party magazine, June 24–July 2, 1967, announcing National Vietnam Week in protest against the Vietnam War.

unrest, racial violence, student activism, and early opposition to the Vietnam War. These included Harry Baum, the director of the Playhouse; Geraldine Lust, the director of the Living Theater's Artaud Workshop; Leslie Fiedler, the literary critic and novelist; Gordon Rogoff, of the Yale Drama School and the *Drama Review*; and Norman Podhoretz, the editor of the influential journal *Commentary*.[159] The heated political environment of 1964–65 led audiences to see the play as a battle between possible radical forms of revolt, though a schism was evident among the discussants with regard to their assessment of the play.[160] For Podhoretz, the politics of terror was the play's most emotive element, but it exposed the dangers of ongoing leftist extremism in particular: "The play is largely about politics: it is the dark night of the soul of a Marxist, or possibly a Communist, or of a revolutionist at least. The arguments about terror, the effort to update the whole business, are clearly related to present-day events. It's not a question of sanity or madness, but of whether or not you believe in this kind of terror based on ideology, whether you think it can clean up the world."[161] On the other hand, Lust expressed the view that the play invited comment on a wide range of urgent issues, including "consciousness expansion, the resurgence of the irrational, national loyalties, the revolutions in education, sex, and technology, religious disenchantment and contrasting

ecumenical movements. Also political revolutions and the Negro Freedom Movement. The play touches on all of these."[162] Brook acknowledged that the play was more "interesting" in New York as "there is a more complicated and dangerous shifting between the two protagonists: the play and the audience" because of Vietnam (fig. 91).[163] And Richardson emphasized that the play's ending was left open to chance and improvisation, which sometimes led to actual violence—"there's been real blood up there, fractured teeth, unconscious people."[164] The discussion ended without agreement but clearly demonstrated the success of both Weiss and Brook in creating an environment for reflection of personal and political change for actors and audience alike, against the conventions of traditional and commercial theater.

At the same time, Brook's *Marat/Sade* was still theater, albeit an outrageous and Artaud-like form. In this sense, it was both like and unlike Lebel's *120 minutes dediées au divin Marquis*. Brook met Lebel in London on June 8, 1964, when Lebel's second Festival of Free Expression traveled to perform in Denison Hall at the invitation of theater producer Michael White (1936–2016). There Brook would have seen several action works by Lebel and other artists, including *Nets* by Jocelyn de Noblet (b. 1934), *Gold Water* by Erró (Guðmundur Guðmundsson, b. 1932), and *Meat Joy* by Carolee Schneemann (1939–2019).[165] At an ensuing party in White's home, Brook and Lebel enjoyed a heated discussion on happenings, theater, and free expression, in which Lebel recalls explaining to Brook, "No, we're not trying to do theater. For us, this is not theater. There may be some theatrical elements in what we're doing, but it would be as silly to call it 'theater' as it would be to call it 'painting' or 'music.'"[166] For his own part, Brook took the play beyond the theater, and toward a larger, mainstream public in directing a filmed version of *Marat/Sade* over seventeen days in May 1966. Brook aimed to stay close to the stage version, which the company had by then been performing for eighteen months, but he also aimed "to see if a purely cinematic language could be found that would take us away from the deadliness of the filmed play and capture a purely cinematic excitement."[167] He found that the medium of film could never replace the live play, as film engulfs the viewer so that "one can neither think, nor feel, nor imagine anything else" whereas the live play "permits one to experience something in an incredibly powerful way and at the same time to retain certain freedom."[168] This was the spirit of freedom he felt photographer Max Waldman (1919–81) had successfully captured in his series of black-and-white photographs of the play in New York that year, finding them to be "very beautiful" and to "capture the spirit of the play with utmost freedom" (fig. 92).[169] Above all, he wanted a sense of performative openness, and this informed his later treatise *The Empty Space* (1968), in which he writes of the potential of theater to scorch a memory or picture on the spectator's mind: "It is the play's central image that remains, its silhouette."[170] Herein also lies the political potential of Brook's aesthetic.

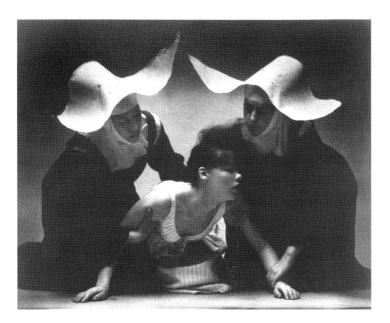

92. Charlotte Corday (Glenda Jackson) being restrained by nuns in
Peter Brook's production of Peter Weiss's *Marat/Sade*, photograph by
Max Waldman, 1966.

93. Cover of *Life* magazine, "Mad New World of Batman,
Superman, and the Marquis de Sade," March 11, 1966.

In the March 11, 1966, edition of *Life* magazine, Brook's version of *Marat/Sade* was hailed as proof of a "MAD NEW WORLD of Batman, Superman and the Marquis de Sade," and his stage production was described as a "sensational drama of lunacy" (fig. 93).[171] Brook insisted that the madness of the play should resonate powerfully with contemporary politics, and Sontag's reading of the play's Artaud-like qualities positioned it within a longer history of avant-garde celebration of Sade as a true revolutionary. As David Roberts has observed, the anarchic revolutionary tone of the play can now also be viewed as "the answer pre-1968 to questions posed only in the wake of 1968."[172]

"This time we must not be afraid of our dream"

In 1965, in recognition of the topicality of the Marquis de Sade, and largely as a result of the Marat/Sade play, *Yale French Studies* devoted an edition to him ("The House of Sade"), in which Michel Beaujour argued that the insane were "the only true heroes" of Weiss's play and, by implication, of society. Through them, Weiss forced the public to experience the overwhelming disorder of madness—indeed, Beaujour notably likened the play to a happening: "Weiss attempts to deliver an experience of unheard-of violence, of frantic aggression which is similar to the impact of 'happenings.'"[173] Beaujour lauded Brook's production for powerfully depicting the mad inmates of Charenton taking over the real, as well as the staged, audience. The transformation of the innocent spectator into an object in the play was the key to its potential to awaken the senses and the spirit. Beaujour took his interpretation further in reflecting on the play's implied critique of Western society, referring not only to an exposé of the "Western intelligentsia," "Western society," and "Western spirit" but to the "cries of the 'damned of the earth,'" an allusion to Frantz Fanon's book of the same title (in English, *The Wretched of the Earth*) and to "Lumumba"—that is, the Congolese independence leader Patrice Lumumba who was assassinated in 1961.[174] Hence, Beaujour recognized in the Sadean imagination a potential for the critique of colonial war and its dehumanizing effect on individuals and nations alike. This surely resonated for the audience too, especially in the last words roared in the play by the character Jacques Roux in a straitjacket—"When will you learn to see? When will you learn to take sides?"

The editors of *Yale French Studies* claimed Sade as "one of the dominating influences in this century" and asserted, "Sade's voice was rarely serene; sometimes it was silly; frequently it was strident. But it was a singularly human noise."[175] In April 1966, the *Nouvelle Revue Française* included an essay in which the Chilean surrealist Roberto Matta wrote that the lives of Sade and Breton were marked by "a battle for liberty" above all else.[176] In winter 1967, *Tel Quel* published a special

edition dedicated to Sade, drawing on the papers of a conference the group held on May 12, 1966, on the theme of "Signe et perversion chez Sade" with essays on Sade by Klossowski, Blanchot, Philippe Sollers, and others.[177] The following year, Sade's name would be cited in word and graffiti in the events of May '68 in Paris with protestations to "enjoy without restraints" and "seize your desires as realities." Indeed, the slogan "The more I make revolution, the more I want to make love; the more I make love, the more I want to make the revolution" recalled the "Revolution/Copulation" chant of the singers in *Marat/Sade*, just as the spontaneity of the events recalled the happening's assault on political repression and consumer culture.

In an essay titled "What's to Be Done about Art?" of August 1968, the writer Alain Jouffroy also described May '68 as an irruption that was built on the "French materialists of the eighteenth century . . . Marat and Sade."[178] The "death of the work of art" heralded in the sixties brought with it the "death of the ideology of *moral, esthetic* and *mercantile* 'values.'"[179] In its place again a radical sense of the imagination had been born: "The only art that still remains to be invented is the art of making a revolution; that can begin with a book, a picture, or a film, perhaps also by not hesitating to dream at the top of our voices. . . . This time we must not be afraid of our dream."[180] For Lebel, who was on the barricades on the night of May 10 participating in what he called "a spontaneous explosion" against de Gaulle and his administration, the student and worker uprisings of that month were fueled by a faith in the power of the imagination.[181] In 1969, he described it as "a gigantic fiesta, a revelatory and sensuous explosion outside the 'normal' pattern of politics. . . . Desire was no longer negated but openly expressed in its wildest and most radical forms. Slavery was abolished in its greatest stronghold: people's heads."[182]

The romantic image of Sade shouting from the tower in the Bastille undoubtedly enflamed these visions of art as revolution and revolution as a new form of art. But the considered use of Sade's writings and "philosophy in the bedroom" by the artists discussed in this chapter makes clear that his name and legacy deeply informed the idea of art as free expression and participatory political discussion in the 1960s. In 2003, Daniel Cohn-Bendit, the prominent activist in May '68 and major instigator of the Mouvement du 22 mars, would describe his generation's sense of revolt as a way of *being*, stating, "Traditional analysts, of the left and right, have a traditional idea of revolution—the American revolution, the French revolution, the Russian revolution—there has to be blood, death, atrocities committed by both the old and the new powers. Not for us. In May '68, a new way of making things move was set in action, a way that affected how you should be, freedom."[183]

Conclusion

We're all in danger.

Pier Paolo Pasolini, interview with Furio Colombo, 1975

In *The Sadeian Woman* (1979) Angela Carter describes the Marquis de Sade's *The 120 Days of Sodom* in almost glamorous terms: "four libertines take four of the most brilliant and distinguished prostitutes in Paris off for a holiday to the remote and isolated Castle of Silling, besides a numerous complement of wives, servants and victims."[1] She notes that these four women will survive what turns out to be an "ensuing holocaust" as "they know how to utilize the power of the word" to save their lives. Carter's reading of the libertine whore as a storyteller who masters both sex and language as instruments of terror and emancipation reinstates her view of pornography in the service of women. It also appears to bring full circle Apollinaire's 1909 view of Sade's heroines as the "New Woman." However, Carter emphasizes that Juliette and her kind do not "renew" womanhood so much as remove "a repressive and authoritarian superstructure that has prevented a good deal of the work of renewal."[2] Her celebration of Sade in the 1970s thus speaks both to the real atrocities of current and historical political and patriarchal regimes, and to Sade as a powerful literary voice— that could forge a new intellectual and linguistic order with exciting, feminist, if not utopian, potential.

The film *Salò or The 120 Days of Sodom* (written and directed by Pier Paolo Pasolini, 1975) also revels in the figures of the four female storytellers from Sade's original text but uses them to narrate a dystopian view of terror and oppression. In Sade's original novel, four female storytellers inspire the events that take place in the castle in Silling, their narratives bringing each day to a close in a semicircular theater in a grand hall where they perch on a raised chair. Roland Barthes describes them as "priestesses of speech," emphasizing their role in reiterating speech as act and word as crime.[3] In Pasolini's film, these characters appear in a more maternal light as they reign over the villa, three of them recounting tales that might be described as nightmarish bedtime stories to the four libertines, collaborators, and victims, while the fourth accompanies their tales on a piano. Pasolini's penchant for Greek myth, evident in his staging of the Great Mother in murderous and incestuous plots in his earlier films *Edipo Re* (Oedipus Rex, 1967) and *Medea* (1969), takes a more terrifying turn in *Salò*, adapting Sade to the very specific historical frame of Benito Mussolini's Italy and presenting these libertine whores as the aging face of those who collaborated in and survived that cruel fascist regime. The film was also a critique of the postwar Italy of the "economic miracle" and emerged in a period of time, 1974–75, when Pasolini wrote a regular column in the weekly newspaper *Il corriere della sera*, as well as for the magazine *Il mondo*.[4] Giuliana Bruno notes that he used these platforms to present polemical ideas on Italian culture and politics, and was "never tired of fighting his own famous battle against petit bourgeois values."[5] The film thus engages in two historical moments through its Sadean and intergenerational plot. As his title makes clear, the

film is set in the Republic of Salò, the northern Italian region that served as Mussolini's headquarters from 1943 to 1945, but it also speaks to current politics—the so-called *anni di piombo* (years of lead), which were characterized by economic collapse and widespread political violence beginning in 1969 and continuing through the following decade.[6]

The spectator is alerted to the centrality of fascism to the film from the outset, as the opening credits indicate "1944–45, northern Italy during the Nazi-Fascist Occupation." Within this historical window and through a series of exquisitely framed tableaux, we find a series of females dominating the film's coded message: from the mother who loses her son to the regime at the outset, to the four storytellers who enflame the sadism of the château, to the young blonde protagonist, Renata, who seizes the spectators' imagination as the quintessential Sadean *jeune fille*. These figures represent the mother, the bad mother, and the future mother, and thus might symbolically denote the decline and fall of Italy, as Pasolini adapts the eighteenth-century French source to the specific context of wartime Italy. Moreover, his film ends in a narratively open-ended way, such that its meaning and implications are implicitly relevant to the present (that is, the mid-1970s).

The structure of the film, as with Sade's original novel, is Dantesque: it leads from the "Ante-Inferno" where the victims are assembled, to the "Circle of Manias," "Circle of Excrement," and "Circle of Blood," where the total destruction of victims is recounted by Signora Castella (Caterina Boratto), dressed in white and furs, who sometimes slips into German, and whose name denotes the castle wherein the Republic of Terror began and will soon end.[7] Through this epic structure, which looks to Artaud and Brecht for influence—for example, in terms of Pasolini's understanding of the film as a "rite" and use of words such as "hieratic" and "solemn" when instructing the actors—the spectator is invited to witness how powerful men can create a Sadean despotism by putting themselves above the law.[8] Pasolini gives a central role not just to women but specifically to the young female in this exposé, and her image allows me to bring full circle my exploration of the Sadean imagination and the role of the fairer sex within it.

Of the sixteen victims in the film (eight young men, eight young women, all nonprofessional actors), we find the female archetype in the figure of Renata (Renata Moar). Pasolini ensures that the film begins and ends with her as the epitome of virtue and sacrifice—opening with the report of the death of Renata's mother and closing with the death of Renata herself. She is introduced as a fourteen-year-old girl whose mother tried to save her from the debauchery of the libertines and was thrown into a river, where she drowned before her daughter's eyes. Renata's childlike role is perversely magnified in one of the most confrontational scenes in the film, where the Duc de Blangis (Paolo Bonacelli) defecates in the central storytelling room, inviting the naked Renata to come and eat his feces in a

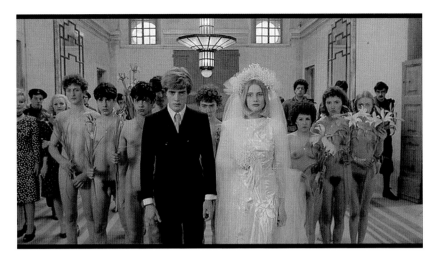

94. Renata and Sergio's wedding ceremony in *Salò, or The 120 Days of Sodom* **(Pier Paolo Pasolini, 1975).**

dialogue that parodies the mother feeding her toddler: "Come over, little one. It is ready." ("*Vieni avanti, piccolo. E' pronto.*") When Renata does not readily oblige, his tone becomes more commanding, and she is forced to eat by the instruction "Eat!" ("*Mangia!*"). The scene recalls Sade's luckless Constance, who is forced to eat Curval's feces in *The 120 Days of Sodom*. Armando Maggi reads this familial exchange as a mockery of traditional "paternal" roles and Renata as a key element of a wider staging of a land of Sodom—a land of total, near-biblical destruction, whose ideological symbol is the turd.[9] However, Renata also speaks to the maternal and the education of the virtuous woman into the libertine whore: the film's "philosophy in the bedroom" promotes sodomy and annihilates the vagina, destroying family romance and virtue, both of which are embodied in the virginal and feminine.

Renata plays a crucial role in the film's mockery of the heterosexual couple and the ideology that supports the institution of marriage. She is forced to "marry" another victim—the blonde youth Sergio (Sergio Fascetti)—and to participate in a procession in a traditional bridal gown (fig. 94). Renata is presented in a lavish white dress with a long gauze train carried by a naked girl, followed by other naked females carrying white lilies, who are flanked by fascist blackshirts. The scene mocks Christian iconography in which such flowers denote chastity and innocence and are usually associated with the Virgin Mary.

Their forced union and the symbolism of the flower are both further mocked when they are left alone, they begin to have sex, but the libertines break in on their privacy and pull Sergio away, shouting that Renata's virginity is for them to take, not him ("that flower is reserved for us!"). Sergio and the libertines then proceed to form a chain of masturbation and

sodomy to the sound of bomber planes overhead as sexual and political power are literally, and somewhat crudely, aligned. The Duke's speech that follows this scene ensures Renata's powerlessness and reinforces the idea of the Sadean brutality of the fascist regime: "We are the real anarchists. . . . [T]he only real anarchy is the anarchy of power." This echoes Pasolini's description of Sade in August 1975: "Sade was the great poet of the anarchy of power."[10] Pasolini continues to attack the family romance in the characters Ezio (Ezio Manni) and the black maidservant (Ines Pellegrin), both of whom are shot when they are found guilty of copulation together. Prior to being riddled with bullets, Ezio defiantly holds his left hand aloft in a Communist salute. The raised fist may refer to the filmmaker's expulsion from the Italian Communist Party for his homosexuality—an event that had a defining effect on his life, as he once explained: "In 1948, several Communists thought I should be expelled from the Party; I had to leave what I loved, it was a death in my soul."[11]

The homosexual couple is also mocked when Sergio becomes the "bride" of Magistrate or President Curval (Aldo Valletti) and a banquet of feces is enjoyed. Sergio is told to "eat shit" in preparation for his wedding night. Such abjection recalls Luis Buñuel and Salvador Dalí's earlier exploration of coprophilia in their film *L'âge d'or* (1930, 60 mins), notably the scene in which a man and woman are forcibly separated from their erotic wrestling and the man fantasizes about the same woman sitting on a toilet before the image of a toilet alone, and then molten lava erupting from a volcano fills the screen, accompanied by the sound of a flushing toilet. However, in Pasolini's film there is little visible pleasure in the destruction of the nation, religion, and family, and where acts of violence and coprophilia occur, the libertines do not discharge profusely in cosmic pleasure, as they do over and over again in Sade's novel. Rather, Pasolini's selection of details and scenes from Sade and his manipulation of the camera-eye to celebrate the abject ensure that the theme of the destruction of the virtuous female is at the forefront of his film. In *Salò*, eating and excrement are analogous with capitalism or pure wasteful expenditure, and the scene of people eating their own and their neighbors' feces evokes a world of toxic consumption and consumerism.[12] This is evident when a girl at the banquet advises another, who is gagging on her meal, to "offer it to the Madonna," or when the storyteller Signora Maggi recounts the tale of a client who paid her to secure the tasty stools of a condemned woman.[13] Both references allude to the Last Supper too, reminding us of Pasolini's own words, "The sacred was not found in a celestial heaven, but in terrestrial shit" (fig. 95).[14] Excrement as heterogeneous matter denotes the formless and the body itself, and by extension Christ's body, which is "eaten" in the sacrament of communion. Indeed, as Sam Rohdie has explained, the motif of the Last Supper appears in many of Pasolini's films, including *Accattone* (1961), *Mamma Roma* (1962), *La*

95. The motif of the Last Supper in *Salò* (Pier Paolo Pasolini, 1975).

ricotta (1963), *Il vangelo secondo Matteo* (The gospel according to St. Matthew, 1964), as well as *Salò*.[15]

Pasolini described "all the sex in *Salò*" as a "metaphor for the relationship between power and those subjected to it."[16] The torture of Renata and Sergio at the very end of the film, in the grounds of the castle, brings its litany of atrocities to a hellish finale. The libertines use binoculars one at a time (Blangis, Durcet, and Curval) to view the spectacle of terror in the château's courtyard in a way that draws the spectator intimately into the idea and visualization of terror (fig. 96). The device of the binoculars limits the spectator's and the camera's peripheral vision to mostly medium shots and close-ups that foreground the victims with their eyes and mouths wide open in terror. The reduced distance between the voyeur and the victim reminds us of the distinctive perspective of Sade, who wrote *The 120 Days of Sodom* in the heart of Paris but locked within the walls of the Bastille, looking out at the world on the cusp of revolution. The binoculars create the effect of a screen within a screen, which ensures that the spectator remains highly self-aware. Even the shake of the camera, which is notable in several shots, contributes to the sense of a cold, cruel documentation of trembling in excitement and fear. Indeed, footage of the making of the film shows Pasolini repeatedly instructing his actors not just to look toward the camera but to open their eyes as wide as possible.

By the end of *Salò*, it seems as if the spectators themselves are summoned to scream. Indeed, it is important to note that Pasolini was strongly influenced by Artaud's theater of cruelty, which he described in 1968 as a kind of "Scream theatre" and "the product of bourgeois anti-culture."[17] Later, he called *Salò* a "cruel" film.[18] The brutal voyeurism and terror of *Salò* is augmented by the film's score: the victims' real (acted) screams are muted,

96. The Duc de Blangis (Paolo Bonacelli) watching a final spectacle of torture in *Salò* (Pier Paolo Pasolini, 1975).

and the only sound is the "Primo vere" movement from Carl Orff's 1937 monumental cantata, *Carmina Burana*. This is played on the radio inside the villa, entering from the outside "real" world and so allowing Pasolini to allude not just to the aesthetics of fascism but to the rise of neo-fascism in 1970s Europe. The radio introduces the subject of propaganda, orchestrated politics, and those passive to neo-fascism's burgeoning voice. It also reinforces the idea of the aesthetic orientation of fascism. The film was shot in Salò (exteriors) and Mantua (interiors), and this civilized musical score, along with the villa's art deco furnishings and paintings (including copies of works by dadaist Marcel Duchamp, expressionist Lyonel Feininger, cubist Fernand Léger, and futurist Gino Severini), clashes brutally with the torture and terror being witnessed.[19]

The final scene of *Salò* presents two young male fascists dancing together, one having changed the radio frequency to replace Orff's cantata with the 1930s popular tune "These Foolish Things (Remind Me of You)." Here, the concept of reeducation through the Sadean imagination brings the film to a close. In the very last line of dialogue in the film, one of the young men names his girlfriend, "Margarita"—a name that might suggest rebirth, as it symbolizes the daisy, which often denotes the Christ-child in religious iconography.[20] Given Pasolini's subversion of religious iconography in the film, however, the name seems more likely to denote the profane than the sacred—that is, the impending crushing of yet another childlike female, or virginal "flower," at the hands of an amoral male. The closing reference to femininity in the name of the flower ensures that Sade's spirit and polemical ideas end the film. This ending recalls Bataille's essay "The Language of Flowers" (1929), in which he writes of the flower as a Sadean sign of the failure of human ideals: "Don't all these beautiful things run the risk of being

reduced to a strange *mise en scène*, destined to make sacrilege more impure? And the disconcerting gesture of the Marquis de Sade, locked up with madmen, who had the most beautiful roses brought to him only to pluck off their petals and toss them into a ditch filled with liquid manure—in these circumstances, doesn't it have an overwhelming impact?"[21]

Such resonances radically differentiate the iconography of Pasolini's *Salò* from the more commercial cinematic approach of Just Jaeckin's *Story of O* (1975), released the same year as Pasolini's film, while aligning it with the longer avant-garde fascination with Sade that I have examined in this book. Pasolini overtly cites five key French authors in that tradition in an "Essential bibliography" in the film's opening credits—Roland Barthes's *Sade, Fourier, Loyola*, Maurice Blanchot's *Lautréamont and Sade*, Simone de Beauvoir's "Must We Burn Sade?," Pierre Klossowski's *Sade My Neighbor*, and Philippe Sollers's *L'écriture et l'expérience des limites* (*Writing and the Experience of Limits*). In an interview with Gideon Bachmann in *Film Quarterly* in 1975, Pasolini explained that he had nurtured the idea of a film like *Salò* for a long time but was prompted to realize it by reading Blanchot, who, as I noted earlier, described Sade in terms of a revolutionary literary "absolute."[22] Alan Stoekl is surely right to interpret Blanchot's appreciation of Sade in terms of the explosive "energy" contained in the characters and situations of Sade's libertine novels, but it must have also interested Pasolini that Blanchot drew out their class structure as well, reading them as reflections of revolutionary and prerevolutionary France: "[H]is heroes are recruited from two opposite milieux: the highest and the lowest, from the most privileged class and from the most disadvantaged class, from among the world's great individuals and from the cesspool of society's dregs."[23]

In another interview in 1975, Pasolini explained how his ideas for the enactment of the ritual of death and execution were drawn from both Blanchot and Klossowski. As Pasolini put it, they viewed Sadean victims' bodies as "nothing more than gods on earth—that is, their model is always God; at the moment they passionately deny Him, they make Him real and accept Him as a model."[24] An atheist who was nonetheless shaped by his strongly Catholic upbringing, Blanchot was drawn to the work of Klossowski and welcomed being introduced to him by their common friend Georges Bataille, who also argued for the interdependence of the sacred and profane. Blanchot admired Klossowski's theological reading of Sade, notably his logic that "the sacred requires sacrilege."[25] Klossowski brought a form of *theologis teatrica* into play in his interpretation—insulting God in order to make him exist. He explored the Sadean imagination in philosophical texts, fiction, drawings, and film, like Pasolini, seeing insight and value in his cruel, life-size *tableaux vivants*.

In citing Beauvoir, Pasolini seems to inject his *tableaux vivants* with existentialist meaning. Writing in 1951, she insisted that Sade's work urgently

demanded a response at a time when indifference to suffering was humanity's greatest threat. Beauvoir described Sade's victims as "frozen in their tearful abjection, the torturers in their frenzy"—words that are surely echoed in the cruel close-ups of people suffering in Pasolini's film.[26] On the other hand, Sollers identified neither a theological nor an existential Sade but promoted him as a vehicle of literary and textual rupture whose aim was "to strip the constitutive neurosis of humanity down to its roots."[27] This anticipated Barthes's *Sade, Fourier, Loyola*, which, as I have discussed in previous chapters, admired Sade's work for its textual transgression and *jouissance*. Not surprisingly, in a review of *Salò* in *Le Monde* on June 16, 1976, Barthes praised Pasolini's film for his homage to Sade, but he also disagreed with Pasolini's use of Sade for a political exposition and criticized him for taking the fascist metaphor too far: "Fascism is too serious and insidious a danger to be dealt with by simple analogy, with fascist masters 'simply' taking the place of the libertines. Fascism constrains us; it *obliges* us to think it exactly, analytically, politically; the only thing that art can do with it, if it handles it, is to make it credible, to *demonstrate* how it comes about, not to show what it resembles."[28]

Sade for Sade's Sake

In the light of the intense debate surrounding Sade among these and other authors, and his evidently widespread and profound influence both in France and internationally, the decision of the French state in December 2017 to designate as a "national treasure" the original manuscript scroll of Sade's *The 120 Days of Sodom* would seem to signal a kind of victory for those who defend Sade over those who would seek to burn his work or align him with fascism (fig. 97). The decision places Sade officially within the history of French literature and, by implication, of Western art and culture too.[29] Whatever one thinks of Sade, he will surely now be more widely read and discussed by the citizenry, including young people, whom the French state fought so passionately to protect from Sade during and long after his lifetime. Today, in an era in which "terrorism" and a "War on Terror" have profoundly reshaped our lives, events seem to reinforce Sade's insistence in *Philosophy in the Bedroom* that if society is to learn and develop, mothers must make the forbidden text required reading for their daughters. Indeed, just a few months before the French state's purchase of Sade's scroll—by an ironic twist of fate, but one that signifies Sade's continuing power—his pamphlet *Yet Another Effort, Frenchmen, if You Would Become Republicans* was among the first titles in a new series of comic-book versions of French literary classics announced by Les Échappés, the literary publishing house of the satirical newspaper *Charlie Hebdo*, so violently subjected to terrorist attack itself in Paris in 2015.[30]

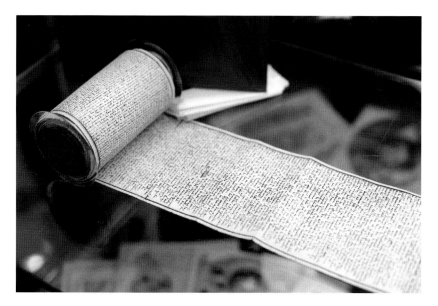

97. Original manuscript scroll of the Marquis de Sade's *Les 120 journées de Sodome, ou L'école du libertinage*, **displayed prior to the auction of the Aristophil Collections, in Neuilly-sur-Seine, west of Paris, November 14, 2017.**

Perpetuations of Sade are evident in many media in the twenty-first century, but the art of the Hong Kong–born, New York–based artist Paul Chan (b. 1973) offers a particularly apposite final example for this study, demonstrating their global reach. In *My birds . . . trash . . . the future* (2004, two-channel digital video, 16 minutes, 37 seconds), Chan presents the murdered corpses of Pier Paolo Pasolini and the deceased rapper Biggie Smalls (Christopher Latore Wallace, 1972–97) in a manner that evokes the two vagabonds, Vladimir and Estragon, in Samuel Beckett's absurdist play *Waiting for Godot* (1949).[31] They are surrounded by a bleak landscape, including a bare tree, twenty predatory birds (a reference to the Book of Leviticus), naked journalists, suicide bombers, blankets, consumer debris such as sneakers and newspapers, and a soundtrack evoking an emergency (car alarms and ringing cell phones). The mise en scène is menacingly loaded, but a sense of paralysis predominates—no Godot, no answer, comes to this contemporary landscape of angry, global terror.

Chan created *My birds . . . trash . . . the future* following a 2002 trip he made to Iraq with the antiwar activist group Voices in the Wilderness. Despite the obvious political intent of his art, in an interview in 2007, he explained his need to retain a sense of *freedom*, especially in not specifying too strongly the terms of exchange between politics and the work of art. He defined freedom as "the closest word that we have to describe the desire to imagine that what we do has meaning beyond instrumentalization."[32] His is an open aesthetic, therefore, in keeping with the Sadean imagination and

demonstrating its resonance today. This is not simple antiwar art; indeed, when interviewed in 2005, Chan described overtly political art as "pornography": "It is sexual whether it's the victimization of Iraqis or the portrayal of them as fundamentalist barbarians. We watch because there's a perverse pleasure in it."[33]

Like Pasolini, Chan adapted Sade's *The 120 Days of Sodom* for his own artistic expression. He has produced a Sadean font, a Sadean book, and a Sadean installation titled *Sade for Sade's Sake* (2009–10), all of which again explore the idea of terror and both pleasure and paralysis before it (fig. 98).[34] His "Sade" font, which is a variant of the well-known Century Schoolbook font available in most current word processors but modified so that each character corresponds to a suggestive sound (moans, ejaculation, screams), profanity, or expletives. For example, typing the word "The" produces the Sadean "poem" "cum yes yes yes" on screen; the word "about" produces "fuck me jesus more ride me oh shit"; and "Sade" generates "you cunt fuck me there, yes."[35] Chan's book project on Sade, *The Essential and Incomplete Sade for Sade's Sake* (2010), includes this poetry in the Sade font, pencil drawings of whipping and masturbation, and abstract ink-on-paper sketches of sexualized, interpenetrating bodies, recalling Hans Bellmer's Sadean works.

An installation with the same title also presents interpenetrating bodies—shadowy figures with articulated limbs projected onto walls, their bodies forming human chains like an orgy (fig. 99). It lends itself to interpretation

98. Paul Chan, *Dumb Luck! Sade for Sade's Sake*, ink on paper, 2009.

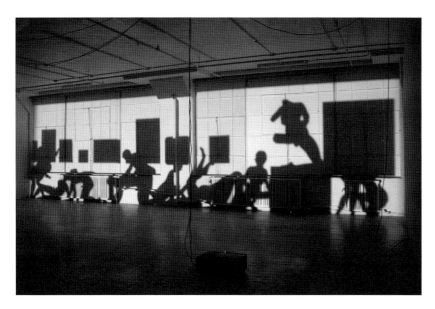

99. Paul Chan, *Sade for Sade's Sake*, a continuous five-hour and forty-five-minute projection, installation view, 2009.

not only in the light of eighteenth-century history and ideas but in terms of the War on Terror declared by the United States and allied nations in response to the terrorist attacks of September 11, 2001. This line of interpretation is fueled by Chan's political activism, writings, and interviews. For example, in an essay in *The Essential and Incomplete Sade for Sade's Sake*, he writes of the US military giving Viagra to the Taliban as part of a practice of bribery, quoting an officer who said, "You're trying to bridge a gap between people living in the nineteenth century and people coming in from the twenty-first century . . . so you look for those common things in the form of material aid that motivate people everywhere."[36] Chan compares this practice to Sade's, who "also wanted to motivate people: to experience hard-ons and headaches in equal measure."[37] But the analogy stops there, as the Sadean imagination and a cold "pornography" soon diverge. Chan contends that "since 2001, the U.S. has waged a campaign to spread freedom and democracy around the world. But ironically, the more this freedom spreads, the more rigid, cruel, and *sexually* inhuman the campaign becomes" (my italics).[38] To support this claim, Chan juxtaposes two images in his book that bridge the gap between eighteenth-century and twenty-first-century sadism: on one page, a reproduction of an original etching from the 1797 edition of *Juliette*, depicting the cruel torture of the pregnant Cornelia by Monsignor Chigi and, on the opposite page, a newspaper photograph of a US soldier, grinning over the corpse of an Iraqi detainee in Abu Ghraib prison in November 2003 (fig. 100). The juxtaposition reflects Chan's words in a contemporary essay: "Sade illuminated Abu Ghraib for me."[39]

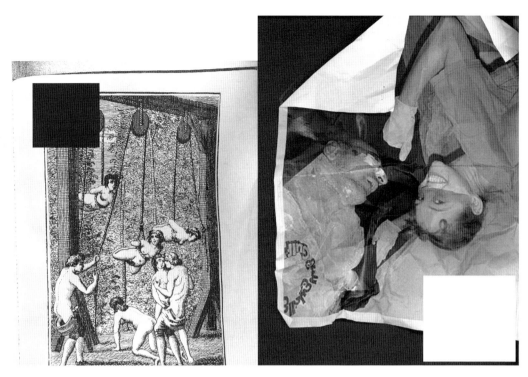

100. Paul Chan, *Untitled Source Material,* **in** *The Essential and Incomplete Sade for Sade's Sake* **(New York: Badlands Unlimited, 2010).**

Although these two images are simply titled *Untitled Source Material* in Chan's book, if we compare their originals, the critical disparity between imagined and real systems of terror resonates powerfully. The tableau from *Juliette* reminds us of the theatricality of Sade's fictional universe in which the reader is drawn into an arena of terror, with the traditional "fourth wall," which might provide a safe distance, removed. As I argue in chapter 1, libertines and victims in Sade's work are presented in a narrative and syntax that is an excessive attenuation and fantastic inversion of Enlightenment ideas and ideals. The photograph taken in Abu Ghraib, in contrast, shows the corpse of an Iraqi insurgent and prisoner, his body under bags of ice to preserve him, part of his battered face visible beside a female US soldier wearing a uniform and plastic gloves, who is bending over him, grinning at the camera and giving a thumbs-up. This is also clearly staged for an audience, while the fact that both images involve women—as object and subject, respectively, partakes in the long-standing Western trope of woman as sign and symbol of the body politic. The former image is from a novel devoted to the Sadean heroine Juliette, who breaks with all the bonds of traditional femininity in her pursuit of libertine pleasure and survival. The US soldier in the latter image became a "poster girl" of military depravity, a pretty, young American woman

seeming to derive immense entertainment from a corpse of which she is the cruel master.[40]

While both images indicate the systems of torture that human beings all too frequently engineer, they also meaningfully counterpoint the imagined and the real—the former a libertine work of fiction, the latter a photograph of the aftermath of an actual torture and homicide. The photograph was just one of many circulated in 2004, which showed naked prisoners being leashed and dragged around Abu Ghraib prison like dogs; hooded, suspended, and posed as if for crucifixion; sexually humiliated; and threatened with and subjected to violence. Investigation soon uncovered further methods of abuse, including anal rape with objects, forced masturbation, and hanging, while the photographs were used variously to argue for changes in US foreign policy, to drive human rights fund-raising campaigns, and even to recruit new waves of terrorists.[41]

In philosophy, religion, art, and popular culture, society continues to associate woman with virtue, family, domesticity, or life itself. Sade exploited this association in everything he wrote, teasing out the furious interaction between virtue and vice, humanity and barbarity, in the enjoyment and abuse of her body. Chan's work makes us reflect on a photograph of a woman at Abu Ghraib who seems a happy collaborator in sadism, the fact of her gender naturally compounding our sense of repulsion and dismay. As Susan Sontag wrote in the *New York Times Magazine* in May 2004, the perpetrators in the photographs from Abu Ghraib "apparently had no sense that there was anything wrong in what the pictures show. . . . [I]t was all fun."[42] The photographs seemed to mark a new normalization of terror, as if suggesting that the secret society of Sade's fiction had expanded globally and openly to become a fundamental element of so-called liberal democracy, or its recent variant, neoliberalism. But the photographs also underlined a distinction between imagined and real criminality, which must be maintained, and which Chan's work keeps in focus. This distinction, which is also a distinction between Sadean terror and totalitarian terror, is crucial to our appreciation of the value of life itself. It returns us to Sade's declaration to his wife in 1781, with which I opened this book: "I am a libertine, but I am neither a *criminal* nor a *murderer*."[43] The Sadean imagination invades our private and public lives and values, making it possible to think the unthinkable; in an era of global terror, it has never been more crucial to defend and learn from its unflinching exploration of man's inhumanity to man.

NOTES

Introduction

Epigraph: Marquis de Sade, letter to Madame de Sade, February 20, 1781 (emphasis in original), in *Letters from Prison*, trans. Richard Seaver (New York: Arcade Publishing, 1999), 176–90, on 188.

1. Throughout this book, I will frequently refer to the "Marquis de Sade" or simply "Sade"; as an author in the endnotes, he will generally be cited as "Sade."

2. Sade, *Justine, ou Les malheurs de la vertu*, 2 vols. (En Hollande: Chez les Libraires Associés [Paris: Girouard], 1791), with frontispiece by Chéry; *La philosophie dans le boudoir: Ouvrage posthume de l'auteur de "Justine,"* 2 vols. (A Londres: Aux dépens de la compagnie, 1795); *La nouvelle Justine, ou Les malheurs de la vertu: Ouvrage orné d'un frontispiece et de quarante sujets gravés avec soin*, 4 vols. (En Hollande [Paris], 1797); *La nouvelle Justine, ou Les malheurs de la vertu, suivie de L'histoire de Juliette, sa soeur: Ouvrage orné d'un frontispiece et de cent sujets gravés avec soin*, 10 vols. (En Hollande [Paris], 1797 [1799–1801]). The dates and places of publication of works by Sade during his lifetime were often deliberately misstated in order to evade censorship.

3. Sade's *Philosophy in the Bedroom* has been translated in *Three Complete Novels: "Justine," "Philosophy in the Bedroom," "Eugénie de Franval" and Other Writings* (1965), trans. Richard Seaver and Austryn Wainhouse (London: Arrow, 1991). The English language translation of the title loses something of the nuance of the French word *boudoir*, which does not necessarily mean "bedroom" but may mean simply "a private room." The word *boudoir* was also in fashion at the time of Sade's writing, having been used in erotic terms in Claude-François-Xavier Mercier de Compiègne's *Le manuel des boudoirs, ou, Essais erotiques sur les demoiselles d'Athènes* (The manual of boudoirs, or, Erotic essays on the young ladies of Athens) (Paris, 1787).

4. I use the term "imagination" in keeping with the discourse of the avant-garde and also in order to distance it from a more overt psychoanalytic term, "fantasy," which is often aligned with neurosis. See Jean Laplanche and J. B. Pontalis, "Fantasy and the Origins of Sexuality" (1964), *International Journal of Psychoanalysis* 49, no. 1 (February 1968): 1–18.

5. Sade cited in Maurice Lever, *Marquis de Sade: A Biography* (London: Harper Collins, 1993), 318.

6. Sade, *Juliette*, trans. Austryn Wainhouse, 6 vols. in 1 (New York: Grove Press, 1968), 163. All quotations are from this 1968 Grove edition unless otherwise indicated.

7. "Libertine" derives from the Latin adjective *libertinus*, "of a freed man," and first appears in French in a

translation of the New Testament in 1477. In the eighteenth century, "libertine" applied to a group of novelists and artists, including the Marquis de Sade, whose work alludes to the "licentious ways of the declining French aristocracy." See Michel Feher, "Libertinisms," in introduction to *The Libertine Reader: Eroticism and Enlightenment in Eighteenth-Century France*, ed. Feher (New York: Zone Books, 1997), 10–47, on 11; and Catherine Cusset, "The Lesson of Libertinage," *Yale French Studies* 94 (1998): 1–14, on 1–2.

8. Maurice Blanchot, "Sade's Reason," in *Lautréamont and Sade* (1949), trans. Stuart Kendell and Michelle Kendall (Stanford, CA: Stanford University Press, 2004), 7–42. Originally published as *Lautréamont et Sade* (Paris: Éditions du Minuit, 1949).

9. Peter Bürger, *Theory of the Avant-Garde* (1974), trans. Michael Shaw (Manchester: Manchester University Press, 1974), 53–54.

10. Conservative estimates of the death toll of the Terror alone usually suggest a figure of just under seventeen thousand executions in 1793–94. See, for example, Christopher Hibbert, *The French Revolution* (London: Penguin Books, 1982), 225. However, Hugh Gough calculates "a minimum of 240,000," including those executed without trial and killed in fighting and all kinds of ancillary violence. See Gough, *The Terror in the French Revolution* (London: Palgrave Macmillan, 2010), 109. For other figures, see Paul R. Hanson, *Contesting the French Revolution*, (Chichester: John Wiley and Sons, 2009), 178.

11. *Dictionnaire de l'Académie française*, 5th ed. (Paris: J. J. Smits et Ce., 1798), 650. Note that this definition was also given in the 4th ed. of 1762, but it went beyond the earlier definition in Jean-François Féraud, *Dictionnaire critique de la langue française* (Marseille: Mossy, 1787), C679a, where it was defined simply as "[d]read, great fear." Unless otherwise indicated, all translations in this book are by the author.

12. Ibid., 775. In the 8th ed. of the *Dictionnaire* of 1932–35, 2:653, the meaning of "terrorist" is divorced from the historical time of the Terror and defined simply as "[p] artisan, agent d'un regime de terreur."

13. See Adriana Cavarero, *Horrorism: Naming Contemporary Violence* (2007), trans. William McCuaig (New York: Columbia University Press, 2009), 4–5, 7–9.

14. Edmund Burke, *A Philosophical Enquiry into the Origins of the Sublime and Beautiful: And Other Pre-revolutionary Writings* (Oxford: Oxford University Press, 2015), 34.

15. Angela Carter, *The Sadeian Woman: An Exercise in Cultural History* (London: Virago Press, 1979), 12.

16. Nancy K. Miller, "Libertinage and Feminism," *Yale French Studies* 94 (1998): 17–28, on 20.

17. Camille Paglia, *Sexual Personae: Art and Decadence from Nefertiti to Emily Dickinson* (1990) (London: Penguin Books, 1991), 235.

18. Ibid., 236–37.

19. Maximilien Robespierre, "Rapport sur les principes de morale politique" ["Speech on the Moral and Political Principles of Domestic Policy"], February 5, 1794, in *The Ninth of Thermidor: The Fall of Robespierre*, ed. Richard Bienvenu (New York: Oxford University Press, 1968), 38.

20. Louis de Saint-Just, "Rapport sur les suspects incarcérés," February 26, 1794, in *Oeuvres choisies* (Paris: Gallimard / Idées Poche, 1968), 192.

21. Joan B. Landes, *Visualizing the Nation: Gender, Representation, and Revolution in Eighteenth-Century France* (Ithaca, NY: Cornell University Press, 2001), 90.

22. Luce Irigaray, " 'Frenchwomen,' Stop Trying" (1976), in *This Sex Which Is Not One* (1977), trans. Catherine Porter (Ithaca, NY: Cornell University Press, 1985), 198–204, on 199.

23. Jane Gallop, *Thinking through the Body* (New York: Columbia University Press, 1988), 3. See also Gallop's insightful reading of Irigaray's essay in "Impertinent Questions: Irigaray, Sade, Lacan," *SubStance* 9, no.1, issue 26 (1980): 57–67.

24. Eugène Dühren [Iwan Bloch], *Der Marquis de Sade und seine Zeit: Ein Beitrag zur Cultur- und Sittengeschichte des 18. Jahrhunderts; Mit besonderer Beziehung auf die Lehre von der Psychopathia Sexualis* (1900); trans. in French as *Le Marquis de Sade et son temps* (Paris: A. Michalon, 1901), and in English as *Marquis de Sade: His Life and Works* (1900), trans. James Bruce (Amsterdam: Fredonia Books, 2002), 95.

25. My understanding of *glissement* is indebted to Susan Rubin Suleiman, who describes it as a transgressive experience "of immense pleasure (at the exceeding of boundaries) and of intense anguish (at the full realization of the force of those boundaries)," where "the limits of the self become unstable, 'sliding.' " See Suleiman, *Subversive Intent: Gender, Politics and the Avant-Garde* (Cambridge MA: Harvard University Press, 1990), 75.

26. Sade, "Notes on the Novel" (1800), *Yale French Studies* 35 (1965): 12–19, on 16 (originally "Idée sur le roman," preface to Sade, *Les crimes de l'amour*, vol. 1 of 4 [Paris: Chez Massé, 1800]).

27. *Dictionnaire universel de la langue française*, 2 vols. (Paris: Chez Lecointe et Pougin, 1834), 642.

28. Jules Janin, "Le Marquis de Sade," *Revue de Paris* 11 (November 1834), republished in Jules Janin, *Le Marquis de Sade* (Paris: Chez les marchands de nouveautés, 1834), 17.

29. Ibid.

30. Ibid., 19.

31. Jean-Jacques Brochier, *Le Marquis de Sade et la conquête de l'unique* (Paris: Le Terrain Vague, 1966), 239; Algernon Charles Swinburne, *The Swinburne Letters*, ed. Cecil Yelverton Lang, 2 vols. (New Haven, CT: Yale University Press, 1974), 1:125.

32. See Will McMorran, "The Marquis de Sade in English, 1800–1850," *Modern Language Review* 112, no. 3 (July 2017): 549–66.

33. Richard von Krafft-Ebing, *Psychopathia Sexualis, with Especial Reference to the Antipathic Sexual Instinct: A Medico-Forensic Study* (1886), trans. and intro. Franklin J. Redman (New York: Aracde Publishing, 1965), 69. See also Will McMorran, "The Marquis, the Monster, and the Scientist: Sade, Sexology, and Criticism," in *New Approaches to Sade*, ed. Kate Parker and Norbert Sclippa (Lewisburg, PA: Bucknell University Press, 2014), 169–94.

34. Sigmund Freud, "Three Essays on the Theory of Sexuality" (1905), in *Standard Edition of the Complete Psychological Works of Sigmund Freud*, ed. and trans. James Strachey (London: Hogarth Press, 1970), 7:125–248, on 171.

35. Freud, "Three Essays on the Theory of Sexuality," 73

36. Guillaume Apollinaire, preface to *L'oeuvre du Marquis de Sade*, ed. Apollinaire, 2nd ed. (Paris: Bibliothèque des curieux, 1909), 5–65, on 17. The Bibliothèque nationale in Paris established its collection of forbidden books (*L'enfer*) between 1836 and 1844. See Marie-Françoise Quignard and Raymond-Josué Seckel, "Où l'on ne parle pas encore d'enfer mais d'ouvrages licencieux," in *L'enfer de la bibliothèque: Eros au secret*, exhibition catalog (Paris: Bibiothèque nationale de France, 2007), 27–32, on 32. Apollinaire cataloged all the pornographic works in the Bibiothèque nationale. See Guillaume Apollinaire, Fernand Fleuret, and Louis Perceau, *L'enfer de la Bibliothèque nationale* (Paris: Mercure de France, 1913).

37. Gilbert Lely, *The Marquis de Sade: A Biography*, trans. Alec Brown (London: Elek Books, 1961), 310–11 (originally, *Vie du Marquis de Sade*, 2 vols. [Paris: Gallimard, 1952–57]).

38. Eugène Dühren [Iwan Bloch], preface to Sade, *Les 120 journées de Sodome ou L'école du libertinage* (Paris: Club des Bibliophiles; Berlin: Max Harrwitz, 1904), iii.

39. Decades later, in 1982, it was stolen from their daughter Nathalie de Noailles by the publisher Jean Grouet, who brought it to Switzerland. He sold it to a collector of erotomania, Gérard Nordmann, whose son later sold it to a foundation specializing in rare manuscripts, Aristophil, who auctioned it in Paris in December 2017.

40. Sade and his manuscript were also lent pride of place in the wonderful exhibition and catalog *La Bastille ou "L'enfer des vivants," travers les archives de la Bastille*, ed. Élise Dutray-Lecoin and Danielle Muzerelly (Paris: Bibiothèque nationale de France, 2010).

41. Paul Éluard, "Poetic Evidence" (June 24, 1936), in *Surrealism*, ed. Herbert Read (London: Faber and Faber, 1936), 169–83, on 179.

42. Jules Janin and Paul L. Jacob, *Le Marquis de Sade* (Paris: Chez les marchands de nouveautés, 1839 [1834]), 152.

43. Henri d'Alméras, *Le Marquis de Sade: L'homme et l'écrivain* (Paris: Albin Michel, 1906).

44. In a letter to his wife of March 22, 1779, Sade writes of Mademoiselle Rousset and his preference for her portrait over "Van Loo's canvas," alluding to the artistic and sexual skill of her fingers. Sade, *Letters from Prison*, 112.

45. Jean-Jacques Lebel, interview with the author, January

11, 2018. Robert Lebel published extensively on art, including the first major book-length study of Marcel Duchamp in 1959. In the mid-1950s, Lebel and Bataille planned a new journal, *Genèse* (Genesis), with Patrick Waldberg, André Masson, Pascal Pia, Gilbert Lely, and other Sade enthusiasts—however, the journal was never realized.

46. Bloch, *Marquis de Sade*, 151.

47. Lely refers only to "a canvas by Van Loo (was it Carle or one of his three nephews?)," as well as a miniature copy depicting "a young man with blue eyes" by Mlle Marie Dorothée de Rousset, with whom Sade had an affair in 1777–78. The miniature was lost by the Sade family in 1939. Lely, *The Marquis de Sade*, 48 and 51, respectively.

48. Michael Fried, *Absorption and Theatricality: Painting and Beholder in the Age of Diderot* (Berkeley: University of California Press, 1980), 109.

49. Louis Petit de Bachaumont, *Mémoires secrets pour servir à l'histoire de la Republiques des Lettres en France, depuis MDC-CLXII jusqu'à nos jours, ou, Journal d'un observateur* (London, 1780), 13:155–56, cited in Perrin Stein, "Amédée Van Loo's Costume Turc: The French Sultana." *Art Bulletin* 78, no. 3 (September 1996): 417–38, on 419.

50. Neil Schaeffer, *The Marquis de Sade: A Life* (Cambridge MA: Harvard University Press, 2000), 16.

51. Sade, *Oeuvres complètes*, ed. Gilbert Lely, 16 vols. (Paris: Cercle du Livre Précieux, 1966–67), 12:24.

52. Arrangements for the marriage were also hastened owing to Sade's infatuation with a young noblewoman from Provence, Laure de Lauris.

53. Schaeffer, *The Marquis de Sade*, 21–22. Sade was not in a financial position to board alongside the wealthier students in the Lycée and was only a day pupil.

54. Schaeffer, *The Marquis de Sade*, 95.

55. Madame de Montreuil to Gaufridy, December 8, 1778, cited in Lever, *Marquis de Sade*, 306.

56. Annie Le Brun, *Petits et grands théâtres du Marquis de Sade* (Paris: Art Center, 1989), 17.

57. Colin Jones, *The Great Nation: France from Louis XV to Napoleon* (London: Penguin, 2002), 477. Jones also notes that the radical nature of this movement is questionable and that political clubs attracted some one million members during the Revolution, peaking in 1793–94.

58. Sade, letter to Maître Reinaud, May 19, 1790, in Paul Bourdin, *Correspondance inédit du Marquis de Sade, de ses proches et de ses familiers* (Paris: Librairie de France, 1929), 266–68, on 267.

59. Cited in Lever, *Marquis de Sade*, 383.

60. *Feuille de correspondence du libraire* (Paris: Aubry, 1791), no. 1968, 406, cited in Lever, *Marquis de Sade*, 384.

61. *Affiche, announces et avis divers, ou Journal général de France*, September 27, 1792, supplement, 4095–96, cited in trans. in Lever, *Marquis de Sade*, 385.

62. Shaeffer, *The Marquis de Sade*, 475.

63. Sade, "Journal 1814," in *Marquis de Sade: The Passionate Philosopher; A De Sade Reader*, ed. and trans. Margaret Crosland (London: Peter Owen, 1991), 167–72, on 172.

64. Sade, *Histoire secrète d'Isabelle de Bavière*, ed. Gilbert Lely (Paris: Gallimard, 1953), in Crosland, *Marquis de Sade: The Passionate Philosopher*, 163. The text was written in 1813 but not published until 1953.

65. Ronald Hayman, *Marquis de Sade: The Genius of Passion* (1978) (London: I. B. Tauris, 2003), 217.

66. L.-J. Ramon, "Notes sur M. de Sade," in Sade, *Oeuvres complètes*, ed. Lely, 15:43. A cast of the skull made by Johann Spurzheim is now in the collection of the Musée de l'Homme in Paris. See Lever, *Marquis de Sade*, 567.

67. See Éric Marty, *Pourquoi le XXe siècle a-t-il pris Sade au sérieux?* (Paris: Seuil, 2011), 7–27.

68. Simone de Beauvoir, "Oeil pour oeil," *Les Temps modernes* 5 (1946): 813–30; trans. Kristana Arp as "An Eye for an Eye," in *Simone de Beauvoir: Philosophical Writings*, ed. M. A. Simons (Urbana: University of Illinois Press, 2005), 237–60, on 246. This text was written shortly after Beauvoir attended the trial of Robert Brasillach, the editor of the French fascist review *Je suis partout*.

69. See Antony Copley, *Sexual Moralities in France 1780–1980: New Ideas on the Family, Divorce, and Homosexuality* (London: Routledge, 1989), 49.

70. Gwynne Lewis, *France, 1715–1804: Power and the People* (Harlow, UK: Pearson/Longman, 2005), 154.

71. Jacques Lacan, "Kant with Sade" (1963), trans. James B. Swenson Jr., *October* 51 (Winter 1989): 55–75, on 55. Originally published as "Kant avec Sade," in *Écrits* (Paris: Éditions du Seuil, 1966).

72. Ibid., 58.

73. Immanuel Kant, *Critique of Practical Reason* (1788) (New York: Macmillan, 1993), 30.

74. Lacan, "Kant with Sade," 60.

75. Ibid., 61.

76. Roland Barthes, *The Pleasure of the Text*, trans. Richard Miller (New York: Hill and Wang, 1973), 65. Originally published as *Le plaisir du texte* (Paris: Éditions du Seuil, 1973).

77. Elaine Showalter, ed., *The New Feminist Criticism: Essays on Women, Literature and Theory* (London: Virago, 1986), 9.

78. Ibid.

79. See Jane Gallop, "Beyond the Jouissance Principle," *Representations* 7 (Summer 1984): 110–15.

80. Sade, *Juliette*, 544–45.

81. Jean Laplanche and J. B. Pontalis, *The Language of Psychoanalysis* (1967) (London: Karnac Books, 1973), 318, italics in original.

82. Philippe Roger, *Sade: La philosophie dans le pressoir* (Paris: Grasset, 1976), 119.

83. See William Reddy, *The Navigation of Feeling: A Framework for the History of Emotions* (New York: Cambridge University Press, 2001), 182.

84. Joan DeJean, *The Reinvention of Obscenity. Sex, Lies, and Tabloids in Early Modern France* (Chicago: University of Chicago Press, 2002), 127.

85. Ibid., 128. See also Peter Michelson, *Speaking the*

Unspeakable: A Poetics of Obscenity (Albany: State University of New York Press, 1993), xi.

86. Susan Sontag, "The Pornographic Imagination" (1967), in *Styles of Radical Will* (New York: Penguin Books, 2009), 35–73, on 45.

87. Carolyn Dean, "Empathy, Pornography, and Suffering," in *differences: A Journal of Feminist Cultural Studies* 14, no. 1 (Spring 2003): 88–124, on 93.

88. Susan Gubar, "Representing Pornography: Feminism, Criticism, and Depictions of Female Violation," *Critical Inquiry* 13, no. 4 (Summer 1987): 712–41, on 724.

89. Sontag, "The Pornographic Imagination," 38.

90. Ibid.

91. In 1967, when Sontag wrote "The Pornographic Imagination," the true identity of the author of *Story of O* was not yet known, and Sontag, like most commentators, believed it was probably written by a man, Jean Paulhan, who used the name Pauline Réage as a nom de plume; had she known *Story of O* was written by a woman, her analysis might have been more explicitly feminist.

92. André Masson, "Notes on the Sadistic Imagination," trans. R. J. Dent, in *Sade: Sex and Death: The Divine Marquis and the Surrealists*, ed. Candice Black (N.p.: Solar Books, 2011), 183–84, on 184 (originally "Note sur l'imagination Sadique," *Les Cahiers du Sud* 285 [1947]: 716).

93. Robert Darnton, *The Forbidden Best-Sellers of Pre-revolutionary France* (New York: W. W. Norton, 1995), 73.

94. Walter M. Kendrick, *The Secret Museum: Pornography in Modern Culture* (Berkeley: University of California Press, 1987), 17.

95. Rétif de la Bretonne, *Le pornographe ou idées d'un honnête homme sur un projet de règlement pour les prostituées propre à prevenir les malheurs qu'occasionne le publicisme des femmes: Avec des notes historiques justificatives* (London [Paris], 1776), ed. and intro. Béatrice Didier (Paris: Régine Deforges, 1977).

96. Kendrick, *The Secret Museum*, 1.

97. On Rétif's writing as Sadean "anti-dote," see James Steintrager, "What Happened to the Porn in Pornography? Rétif, Regulating Prostitution, and the History of Dirty Books," *Symposium: A Quarterly Journal in Modern Literatures* 60, no. 3 (2006): 189–204.

98. Lynn Hunt, *The Invention of Pornography, 1500–1800: Obscenity and the Origins of Modernity* (Cambridge MA: MIT Press, 1993), 44–45.

99. Hunt notes that Etienne-Gabriel Peignot's *Dictionnaire critique, littéraire et bibliographique des principaux livres condamnés au feu, supprimés ou censurés* (Critical, literary, and bibliographical dictionary of the principal books burned, suppressed, or censored), 2 vols. (Paris, 1806), 1:xii, uses the term "pornographic" (*pornographique*), but to assess the reasons for books' censorship, explaining it in terms of society's need to censor immoral texts. Hunt, *The Invention of Pornography*, 14.

100. Kendrick, *The Secret Museum*, 17.

101. Lynn Hunt, ed., *Eroticism and the Body Politic* (Baltimore, MD: Johns Hopkins University Press, 1991), 3.

102. Michel Foucault, *The History of Sexuality*, vol. 1: *An Introduction* (New York: Penguin Books, 1979), 146 (originally *La volonté de savoir* [Paris: Gallimard, 1976]).

103. Anonymous, *Les Révolutions de Paris* 17, no. 215 (23rd–30th Brumaire, an II, in the Republican calendar), cited in Richard Sennett, *Flesh and Stone: The Body and the City in Western Civilization* (New York: W. W. Norton, 1994), 282.

104. Gustave Le Bon, *The Crowd: A Study of the Popular Mind* (1895) (New York: Viking, 1960), 33.

105. See Béatrice Didier, "Juliette, femme forte de l'écriture sadienne," *Obliques: La Femme Surréaliste* 14–15 (1977): 271–77, on 271.

106. Sade, *Juliette*, 430.

107. Annie Le Brun, *Soudain un bloc d'abîme, Sade* (1986), trans. Camille Naish as *Sade: A Sudden Abyss* (San Francisco: City Lights Books, 1990), 186.

108. Ibid., 202.

109. Ibid., 75.

110. Ibid.

111. Georges Bataille, "The Use Value of DAF de Sade (An Open Letter to My Current Comrades)" (1930), in Bataille, *Visions of Excess: Selected Writings, 1927–1939*, trans. Allan Stoekl, with Carl R. Lovitt and Donald M. Leslie Jr. (Minneapolis: University of Minnesota Press, 1985), 91–102.

112. Annie Le Brun, *Sade: Attaquer le soleil* (Paris: Gallimard and Musée d'Orsay, 2014), 19.

113. Andrea Dworkin, *Pornography: Men Possessing Women* (London: Penguin Books, 1981), 10.

114. Linda Williams, *Hard Core: Power, Pleasure, and the "Frenzy of the Visible"* (Berkeley: University California Press, 1989; expanded ed., 1999), 20.

115. Jacqueline Rose, "Where Does the Misery Come From?" (1989), in *Why War? Psychoanalysis, Politics, and the Return to Melanie Klein* (Oxford: Blackwell, 1993), 89–109, on 106.

116. Sigmund Freud, "Beyond the Pleasure Principle" (1920), in *Beyond the Pleasure Principle and Other Writings*, trans. John Reddick (London: Penguin, 2003), 43–102, on 93.

117. Freud, *Civilization and Its Discontents*, in *Standard Edition of the Complete Psychological Works of Sigmund Freud*, ed. and trans. James Strachey (London: Hogarth Press, 1970), 7:62.

118. Ibid., 63

119. Ibid., 66.

120. Ibid., 69.

121. Ibid., 74.

122. The catalog at the Freud Museum in London includes no works by Sade or biographies of him, as Elizabeth Roudinesco points out in *Our Dark Side: A History of Perversions* (Cambridge: Polity, 2009), 51.

123. Freud, *Civilization and Its Discontents*, 7:15.

124. Ibid., 7:25.

125. Umberto Eco, *The Open Work* (1962), trans. Anna Cancogni (Cambridge, MA: Harvard University Press, 1989).

126. André Breton, "Manifesto of Surrealism" (1924), in *Manifestoes of Surrealism* (Paris: Jean-Jacques Pauvert, 1962),

trans. H. R. Lane and R. Seaver (Ann Arbor: University of Michigan Press, 1969), 1–47, on 18.

127. Masson, "Notes on the Sadistic Imagination," 184.

128. Pauline Réage, "A Girl in Love," *Return to the Château: Story of O Part II; Preceded by "A Girl in Love,"* trans. Sabine d'Estrée (London: Corgi Books, 1994), 15–16 (originally *Retour à Roissy* [Paris: Jean-Jacques Pauvert, 1969]).

129. Foucault, *The History of Sexuality*, 1:157; Michel Camus, "La question de Sade," *Obliques: Sade* 12–13 (1977): 1–3, on 2.

Chapter One. The Marquis de Sade and the Fairer Sex

Epigraph: Sade, *Three Complete Novels* (1965), trans. Richard Seaver and Austryn Wainhouse (London: Arrow, 1991), 322–23.

1. Lynn Hunt, *Politics, Culture, and Class in the French Revolution* (London: Methuen, 1984), 13.

2. Roland Barthes, *The Pleasure of the Text*, trans. Richard Miller (New York: Hill and Wang, 1973), 65. This translation of *jouissance* aligns it with orgasmic pleasure, but a pleasure that is not organ/gender specific.

3. *Aline and Valcour* was first printed in 1793, but the guillotining of the publisher delayed its release until 1795, when an edition was issued by the publisher's widow, removing the fleuron and the "Citizen S***" and changing the address of the publisher Girouard; it was not republished until 1883.

4. The story *Les infortunes de la vertu* (*The Misfortunes of Virtue*) was only published posthumously, and for the first time, by Maurice Heine in 1930.

5. *Journal general de France*, September 27, 1792, quoted in F. Laugaa-Trait, *Lectures de Sade* (Paris: Armand Colin, 1973), 37–38.

6. *Courrier des spectacles*, 5 Fructidor, an VIII (August 23, 1800), cited in Jean-Jacques Pauvert, "Notice bibliographique," in Sade, *Histoire de Juliette, ou Les prospérités du vice*, ed. Annie Le Brun and Jean-Jacques Pauvert (Paris: Société des Éditions Pauvert, 1987), 8:9–31, on 27.

7. Neil Schaeffer, *The Marquis de Sade: A Life* (Cambridge MA: Harvard University Press, 2000), 475.

8. Ibid., 475.

9. Ibid., 479.

10. John Phillips, *Sade: The Libertine Novels* (London: Pluto Press, 2001), 87.

11. Sade, *The Misfortunes of Virtue and Other Early Tales* (1992), trans. David Coward (Oxford: Oxford University Press, 1999).

12. Sade, "Notes on the Novel" (1800), *Yale French Studies* 35 (1965): 17 (originally "Idée sur le roman," preface to Sade, *Les crimes de l'amour*, vol. 1 of 4 (Paris: Chez Massé, 1800).

13. Ibid., 15.

14. Sade, *Juliette*, trans. Austryn Wainhouse, 6 vols. in 1 (New York: Grove Press, 1968), 1193. All quotations are from this 1968 Grove edition unless otherwise indicated.

15. Sade, *Three Complete Novels*, 234.

16. Sade, *Juliette*, 525–26. This is read from a "paper" given to her (Juliette) by Belmor years before as part of her initiation into libertine ways and logic.

17. Ibid., 478–79.

18. Ibid., 549.

19. Jean-Jacques Rousseau, *The Collected Writings of Rousseau*, vol. 6, *Julie, or the New Heloise* (1761), trans. and ed. Roger D. Masters and Christopher Kelly (Hanover, NH: Dartmouth College Press, 1997), 621.

20. Jean-Jacques Rousseau, *Émile, or Treatise on Education* (1762), trans. William H. Payne (New York: D. Appleton, 1907), 316, 353.

21. Jacques-Henri Bernardin de St. Pierre, cited in Dorinda Outram, *Panorama of the Enlightenment* (London: Thames and Hudson, 2006), 123.

22. Sade, "Florville and Courval," in *The Libertine Reader: Eroticism and Enlightenment in Eighteenth-Century France*, ed. Michel Feher (New York: Zone Books, 1997), 1255–313, on 1277.

23. Ibid., 1312.

24. Pierre Klossowski, "The Father and the Mother in Sade's Work," app. 2, in *Sade My Neighbor* (1947), trans. Alphonso Lingis (Evanston, IL: Northwestern University Press, 1991), 127–35 (first published as *Sade mon prochain*, [Paris: Seuil, 1947; 2nd ed., 1967]).

25. Klossowski, *Sade My Neighbor*, 107. See also Marcel Hénaff's analysis of the sociopolitical role of incest in this tale in his introduction to Sade, "Florville and Courval," 1269.

26. Dorinda Outram, *The Body and the French Revolution: Sex, Class, and Political Culture* (New Haven, CT: Yale University Press, 1989), 23.

27. Rousseau, *Julie, or the New Heloise*, 159.

28. Denis Diderot, *The Nun* (1796), trans. Russell Goulbourne (Oxford: Oxford University Press, 2005), 151.

29. Ibid., 113.

30. Siofra Pierse, "The Spectatorial Gaze: Viewer-Voyeur Dynamics in Book Illustrations of Diderot's *La Religieuse*," *Journal for Eighteenth-Century Studies* 39, no. 4 (2016): 599–620, on 608.

31. See also David Adams, "Les premieres illustrations de *La Religieuse*, ou la via non dolorosa," in *La douleur: Beauté ou laideur*, ed. David Adams (Lleida: Universitat de Lleida, 2005), 41–52, 49–50.

32. Diderot, *The Nun*, 97.

33. Adams, "Les premieres illustrations de *La Religieuse*," 51, also makes this observation.

34. Diderot, *The Nun*, 102.

35. Denis Diderot, "Sur les femmes" (first published in *Correspondance littéraire*, April 1, 1772; later published, with additions, in July 1,, 1772 and April 1, 1777), in Diderot, *Oeuvres*, ed. André Billy (Paris: Gallimard, 1951), 949–58, 952.

36. Ibid., 950.

37. Ibid., 960.

38. Patricia Mainardi, *Husbands, Wives, and Lovers:*

Marriage and Its Discontents in Nineteenth-Century France (New Haven, CT: Yale University Press, 2003), 4.

39. Joseph-François-Edouard de Corsembleu de Desmahis, "Femme (Morale)," in *Encyclopédie ou Dictionnaire raisonné des sciences, des arts et des métiers*, ed. Denis Diderot and Jean le Rond d'Alembert, 17 vols. of text and 11 vols. of plates (Paris: Briasson et al., 1751–65), 6 [1756]: 472–75, on 475, emphasis in original.

40. Robert-Joseph Pothier, *Treatise on the Power of Husbands over the Person and Property of Their Wives* (1768), cited in trans. in Mainardi, *Husbands, Wives, and Lovers*, 6.

41. Lynn Hunt, *The Family Romance of the French Revolution* (Berkeley: University California Press, 1992), 21. Hunt notes that this advance in exploring personal identity was reflected by the very popularity of the novel as literary genre in the century.

42. Sade, *The Misfortunes of Virtue*, 4.

43. Ibid., 3.

44. Robert Rosenblum, *Transformations in Late Eighteenth-Century Art* (Princeton, NJ: Princeton University Press, 1967), 20.

45. Sade, "Notes on the Novel," 19.

46. Sade, *The Misfortunes of Virtue*, 146.

47. Ibid., 148.

48. Ibid.

49. This may be because the early 1790s saw a shortage of paper and fewer illustrations. See Adams, 42, and Henri-Jean Martin, *Histoire de l'édition française*, vol. 2: *Livre triomphant, 1660–1830* (Paris: Promodis, 1984), 545.

50. See Marie-Françoise Quignard and Raymond-Josué Seckel, "Où l'on ne parle pas encore d'enfer mais d'ouvrages licencieux," in *L'enfer de la bibliothèque: Eros au secret*, exhibition catalog (Paris: Bibiothèque nationale de France, 2007), 125.

51. There is not an extensive literature on Claude Bornet, but he has been variously identified as the artist for a series of erotic engravings in Andréa de Nerciat's *Le Diable au corps* (1803) and for three engravings for volume one of Saint-John de Crèvecoeur's study of Revolutionary America, *Lettres d'un cultivateur américain* (3 vols., Paris: Chez Cuchet Libraire, 1787). He is documented in a summary biographical entry in Roger Portalis, *Les Dessinateurs D'illustrations Au XVIIIe Siècle: Soixante-quatorze Études Biographiques D'illustrateurs De Livres, Français, Suivies D'un Appendix De Biographies Sommaires De Dessinateurs Moins Connus Et Étrangers* (1877), Amsterdam: G. W. Hissink, 1970, 664–65. Portalis suggests that the engravings for the ten volumes of *La Nouvelle Justine* (1797) are "dans la manière de Bornet" (in the style of Bornet). See also Tobia Bezzola, Michael Pfister, Stefan Zweifel, *Sade/Surreal: Der Marquis de Sade und die erotische Fantasie des Surrealismus in Text und Bild*, Zürich: Hatje Cantz Verlag, 2001, 113 and 122.

52. Gilbert Lely, *The Marquis de Sade: A Biography*, trans. Alec Brown (London: Elek Books, 1961), 395.

53. Sade, *La nouvelle Justine, ou Les malheurs de la vertu, suivie de L'histoire de Juliette, sa soeur: Ouvrage orné d'un frontispiece et de cent sujets gravés avec soin*, 10 vols. (En Hollande [Paris], 1797 [1799–1801], 1:7.

54. Ibid., 1:37.

55. Ibid., 1:262.

56. Ibid., 1:263

57. Ibid., 1:343.

58. Ibid., 5:1.

59. Ibid., 5:2.

60. Ibid., 5:3.

61. Ibid., 5:15.

62. Ibid., 5:41.

63. Ibid., 5:40.

64. Ibid., 5:96–97.

65. Ibid., 5:99.

66. Ibid., 5:101.

67. Ibid., 5:96–97.

68. Ibid, 5:97.

69. Ibid., 5:72.

70. Ibid., 5:151.

71. Kathyrn Norberg, "The Libertine Whore: Prostitution in French Pornography from Margot to Juliette," in *The Invention of Pornography: Obscenity and the Origins of Modernity, 1500–1800*, ed. Lynn Hunt (New York: Zone Books, 1996), 225–52, 238–39.

72. Ibid., 243, citing the *Nouvelle liste des plus jolies femmes publiques de Paris* (Paris, 1792).

73. Mondor is described as old, though curiously as sixty-six in the original French edition, 284, and as seventy in the English 1968 edition, 160.

74. Sade, *La nouvelle Justine, ou Les malheurs de la vertu, suivie de L'histoire de Juliette, sa soeur: Ouvrage orné d'un frontispiece et de cent sujets gravés avec soin*, 10 vols., 5:284.

75. Ibid., 5:285–86.

76. Ibid., 5:288.

77. Denis Diderot, *Entretiens sur le fils naturel*, in *Diderot: Oeuvres*, vol. 4: *Esthétique—Théâtre*, ed. Laurent Versini (Paris: Robert Laffont, 1996), 1136.

78. Sade, *Three Complete Novels*, 211.

79. Andrea Dworkin, *Pornography: Men Possessing Women* (London: Penguin Books, 1981), 97.

80. Timo Airaksinen, *The Philosophy of the Marquis de Sade* (London: Routledge, 1995), 108.

81. Ibid.

82. Sade, *The 120 Days of Sodom and Other Writings* (1965), trans. Austryn Wainhouse and Richard Seaver (New York: Grove Press, 1987), 348.

83. Ibid., 293.

84. Ibid., 259.

85. Sade, *Juliette*, 523.

86. Ibid., 474.

87. See Caroline Weber, *Terror and Its Discontents: Suspect Words in Revolutionary France* (Minneapolis: University of Minnesota Press, 2003), 225.

88. The Revolutionary Tribunal accused him of "moderantism," a capital crime, and it seems he was expected to stand trial on July 27, 1793, and to be guillotined thereafter, but he was found to be absent. Schaeffer, *The Marquis de Sade*, 449.

89. Phillips, *Sade: The Libertine Novels*, 64.

90. Mary D. Sheriff, *Moved by Love: Inspired Artists and Deviant Women in Eighteenth-Century France* (Chicago: University Chicago Press, 2004), 86.

91. Diderot, *Salon de 1765*, cited in Emma Barker, "Reading the Greuze Girl: The Daughter's Seduction," *Representations* 117 (Winter 2012): 86–119, on 97.

92. Michael Fried, *Absorption and Theatricality: Painting and Beholder in the Age of Diderot* (Berkeley: University of California Press, 1980), 68.

93. Sade, *Three Complete Novels*, 206.

94. Ibid., 236.

95. Ibid., 238.

96. Ibid., 222.

97. Sade, "Notes on the Novel," 18.

98. Sade, *Three Complete Novels*, 280.

99. Ibid., 303.

100. Ibid., 315, emphasis in original.

101. Sade was housed in Picpus for seven months in 1794. Interestingly, Pierre-Ambroise Choderlos de Laclos (1714–1803), author of *Les liaisons dangereuses* (1782) was housed there at the same time, a fact that leads Gilbert Lely to suggest they may have met, quarreled, and Sade's stance on the novel, as expressed in "Idée sur le roman" would become increasingly entrenched. See Lely, *The Marquis de Sade*, 439.

102. Hunt, *The Family Romance*, 125.

103. Ibid., 137.

104. See Mona Ozouf, "Space and Time in the Festivals of the French Revolution," *Comparative Studies in Society and History* 17, no. 3 (July 1975): 372–84, on 374; and Ozouf, *Festivals and the French Revolution* (Cambridge, MA: Harvard University Press, 1991).

105. Theater was only reestablished in April 1800 by Bonaparte, as premier consul, though as emperor he would decree on June 8, 1806, "No play can be performed without authorization by the Minister of Police." By 1807 there were eight authorized theaters in Paris. See Mainardi, *Husbands, Wives, and Lovers*, 122.

106. David Lloyd Dowd, *Pageant-Master of the Republic: Jacques-Louis David and the French Revolution* (Freeport, NY: Books for Libraries Press, 1948), 83.

107. Ozouf, "Space and Time in the Festivals of the French Revolution," 378.

108. Ibid., 380.

109. Sade, *The 120 Days of Sodom*, 197, 206.

110. Ibid., 237.

111. Ibid., 238.

112. Jean-François de Bastide, *The Little House: An Architectural Seduction*, trans. and intro. Rodolphe el-Khoury, preface by Anthony Vidler (New York: Princeton Architectural Press, 1996), 75–76. (Originally, Bastide, *La petite maison* (in installments), *Nouveau Spectateur* 2 [1758–62]).

113. Ibid., 41.

114. Robert Darnton, *The Forbidden Best-Sellers of Pre-revolutionary France* (New York: W. W. Norton, 1995), 76.

115. Ibid.

116. Alexandre Stroev, "Des dessins inédits du Marquis de Sade," *Dix-huitième Siècle* 32 (2000): 323–42.

117. Ibid., 332.

118. Anthony Vidler, *Claude Nicolas Ledoux: Architecture and Social Reform at the End of the Ancien Régime* (Cambridge, MA: MIT Press, 1990), ix.

119. Jean-Claude Lemagny, *Visionary Architects: Boullee, Ledoux, Lequeu* (Houston, TX: University of St. Thomas, 1968), 124.

120. Jacques-François Blondel, cited in *The Architecture of the French Enlightenment*, trans. Allan Braham (Berkeley: University of California Press, 1980, 1989), 175.

121. Sade, *Three Complete Novels*, 322.

122. Ibid., 322–23.

123. Thomas M. Kavanagh, *Enlightened Pleasures: Eighteenth-Century France and the New Epicureanism* (New Haven, CT: Yale University Press, 2010), 214.

124. Jean-Jacques Rousseau, "Letter to M. d'Alembert on the Theatre" (1758), in *Politics and the Arts: Letter to M. d'Alembert on the Theatre*, trans. and intro. Allan Bloom (Ithaca, NY: Cornell University Press, 1968), 3–138, on 125.

125. Ibid., 126.

126. Denis Diderot, *Pensées détachées sur la peinture* (1776), cited in translation in Jacques Guicharnaud, "The Wreathed Columns of St. Peter's," *Yale French Studies* 35 (1965): 29–38, on 32.

127. Ibid.

128. Annie Le Brun, *Petits et grands théâtres du Marquis de Sade* (Paris: Art Center, 1989), 17.

129. Sade, *The 120 Days of Sodom*, 253.

130. Marquis d'Argens (Jean-Baptiste de Boyer), *Thérèse philosophe, ou Mémoires pour server à l'histoire de D. Dirrag & de Mademoiselle Éradice, Tome I* (A La Haye, 1748), 8.

131. Sade, *Juliette*, 186. See also Natania Meeker, "'I Resist It No Longer': Enlightened Philosophy and Feminine Compulsion in *Thérèse philosophe*," *Eighteenth-Century Studies* 39, no. 3 (Spring 2006): 363–76, on 374.

132. Edmund Burke, *Reflections on the Revolution in France* (1790), ed. Conor Cruise O'Brien (Harmondsworth, UK: Penguin Books, 1973), 164–65. See also Joan B. Landes's analysis of Burke in *Women and the Public Sphere in the Age of the French Revolution* (Ithaca, NY: Cornell University Press, 1988), 112.

133. Richard Sennett, *Flesh and Stone: The Body and the City in Western Civilization* (New York: W. W. Norton, 1994), 288.

134. Chantal Thomas, *The Wicked Queen: The Origins of the Myth of Marie-Antoinette*, trans. Julie Rose (New York: Zone Books, 1999), 209.

135. Robert Darnton, *The Great Cat Massacre and Other Episodes in French Cultural History* (New York: Basic Books, 1984).

136. See Jacques Revel, "Marie-Antoinette in Her Fictions: The Staging of Hatred," in *Fictions of the French Revolution*, ed. Bernadette Fort (Evanston, IL: Northwestern University Press, 1991), 111–29.

137. Laura Auricchio, *The Marquis Lafayette Reconsidered* (New York: Alfred A. Knopf, 2014), 230–31.

138. Vivian Cameroin, "Sexuality and Caricature in the French Revolution," in *Eroticism and the Body Politic*, ed. Lynn Hunt (Baltimore, MD: Johns Hopkins University Press, 1991), 97–98; and Auricchio, *The Marquis Lafayette Reconsidered*, 230–31.

139. Auricchio, *The Marquis Lafayette Reconsidered*, 233.

140. Examples include the print *The Hymn to Priapus* from the revolutionary pamphlet *The Patriotic Brothel Instituted by the Queen of France for the Pleasures of the Deputies of the New Legislature* (1791), where the queen and political antagonist Theroigne de Mericou are staged dancing round a sculpture of Priapus in a garden. See Jill H. Casid, "Queer(y)ing Georgic: Utility, Pleasure, and Marie-Antoinette's Ornamented Farm," *Eighteenth-Century Studies*, vol. 30, no. 3 (Spring 1997): 304–18, on 309; Auricchio, *The Marquis Lafayette Reconsidered*, 235.

141. Thomas, *The Wicked Queen*, 107.

142. Sade, *Three Complete Novels*, 239.

143. See Mary Jacobus, "Malthus, Matricide, and the Marquis de Sade," in *First Things: The Maternal Imaginary in Literature, Art, and Psychoanalysis* (London: Routledge, 1995), 83–104, on 86.

144. Angela Carter, *The Sadeian Woman: An Exercise in Cultural History* (London: Virago Press, 1979), 122.

145. Ibid., 123–24.

146. Ibid., 36–37.

147. Nancy K. Miller, "Justine, or, The Vicious Circle," in *French Dressing: Women, Men and Ancien Régime Fiction* (London: Routledge, 1994), 121–31, on 129.

148. Annie Le Brun identifies *Justine* with what she calls a "theatre of atheism." See Le Brun, "Sade, or the First Theatre of Atheism," *Paragraph: A Journal of Modern Critical Theory* 23, no. 1 (March 2000): 38–50, on 47.

149. Lely, *The Marquis de Sade*, 266.

150. Ibid., 263. Simon-Nicolas-Henri Linguet's *Mémoires sur la Bastille*, documents his incarceration from September 27, 1780, to May 19, 1782.

151. Lely, *The Marquis de Sade*, 271.

152. Letter of De Launay to Lord de Villedeuil, quoted in Lely, *The Marquis de Sade*, 272.

153. 6 Frimaire, an II. Jean-Clément Martin, "The Vendée, Chouannerie, and the State, 1791–99," in *A Companion to the French Revolution*, ed. Peter McPhee (Malden, MA: Wiley Blackwell, 2015), 246–59, on 251. Sade was imprisoned for moderantism from December 1793 to October 1794.

154. Lely, *The Marquis de Sade*, 273. The date given in the Republican calendar is 6 Messidor, an II.

155. David quoted in William Vaughan and Helen Weston, eds., *David's "The Death of Marat"* (Cambridge: Cambridge University Press, 2000), 4.

156. *Journal de Paris*, October 22, 1793, no. 295, 1188; cited in ibid., 13.

157. Jacques-Louis David, "Speech to the Convention" (November 14, 1793, i.e., 24 Brumaire, an II), in Vaughan and Weston, *David's "The Death of Marat,"* 28.

158. Ewa Lajer-Burcharth, *Necklines: The Art of Jacques-Louis David after the Terror* (New Haven, CT: Yale University Press, 1999), 10.

159. Ibid., 43–45.

160. Ibid., 43. See also Olwen Hufton, "Women in the Revolution, 1789–1796," in *French Society and the Revolution*, ed. Douglas Johnson (Cambridge: Cambridge University Press, 1976), 148–66.

161. Thomas Crow, *Emulation: Making Artists for Revolutionary France* (New Haven, CT: Yale University Press, 1995), 165–66.

162. Ibid., 169.

163. David cited in Vaughan and Weston, *David's "The Death of Marat,"* 13. See also Dowd, *Pageant-Master of the Republic*, 95.

164. Jacques-Louis David, *Moniteur*, no. 119, January 18, 1794, 480, cited in Stanley J. Idzerda, "Iconoclasm during the French Revolution," *American Historical Review* 60, no. 1 (October 1954): 13–26, on 21.

165. Antoine Schnapper, *David* (New York: Alpine Fine Arts Collection, 1980), 35. Schnapper also notes that in 1780 David met Stanislas Potocki (1757–1821), the minister and president of the Polish state who translated Winckelmann's *History of Art in Antiquity*, in Rome. David painted Potocki's portrait in 1781 in Paris.

166. The day after the assassination, a wax mask was taken from the corpse for Madame Tussaud's waxworks. In Etienne Delécluze's memoirs, he relates the story of a visit to the Paris waxworks where he and Jacques-Louis David were offered a special viewing of the death heads, which were in a back-room coffer and not on display for the general public. See Etienne Delécluze, *Louis David, son école et son temps*,(Paris: Macula, 1983), 342–46.

167. Vaughan and Weston, *David's "The Death of Marat,"* 6.

168. Ibid., 12.

169. Hunt, *The Family Romance*, 79, citing Marc Bouloiseau, Jean Dautry, Georges Lefebvre, and Albert Soboul, eds., *Oeuvres de Maximilien Robespierre*, vol. 9: *Discours, septembre 1792–27 juillet 1793*, Paris, 1961, 94.

170. Dorothy Johnson, *Jacques-Louis David: Art in Metamorphosis*, Princeton, NJ: Princeton University Press, 1993, 48–50.

171. Crow, *Emulation*, 180–181.

172. Alex Potts, "Beautiful Bodies and Dying Heroes: Images of Ideal Manhood in the French Revolution", *History Workshop Journal*, vol.30, Issue 1, 1990, 1–21, 1.

173. Crow, *Emulation*, 184.

174. Potts, "Beautiful Bodies and Dying Heroes," 4.

175. Jean Louis David, "Speech to the National Convention on the commemoration of Bara", cited in Joan B. Landes, *Visualizing the Nation: Gender, Representation, and Revolution in Eighteenth-Century France* (Ithaca, NY: Cornell University Press, 2001), 156.

176. Hunt, *The Family Romance*, 78.

177. Helen Weston, "The Corday-Marat Affair: No Place for a Woman," in Vaughan and Weston, *David's "The Death of Marat,"*128.

178. William Vaughan, "Terror and the Tabula Rasa," in Vaughan and Weston, *David's "The Death of Marat,"* 96.

179. Ibid., 97.

180. For an excellent survey of artists' portrayal of Corday, see Guillaume Mazeau, *Corday contre Marat: Deux siècles d'images*, exhibition catalog, Musée de la Révolution française (Versailles: Art Lys Editions), 2009.

181. Vaughan and Weston, *David's "The Death of Marat,"* 5.

182. Jules Michelet, *Deux héroïnes de la révolution: Madame Roland—Charlotte Corday* (London: Edward Arnold, 1905), 20.

183. Ibid., 21.

184. Ibid., 27.

185. Ibid., 35–36.

186. See Nina Rattner Gelbart, "The Blonding of Charlotte Corday," *Eighteenth-Century Studies* 38, no. 1 (Fall 2004): 201–21.

187. *Adresse de la Société des républicaines révolutionnaires*, ed. Archives Parlementaires (Paris, July 17, 1793), cited in Chantal Thomas, "Heroism in the Feminine: The Examples of Charlotte Corday," *Eighteenth Century*, 30, no. 2 (1989): 67–82, on 72.

188. *Répertoire du tribunal révolutionnaire*, July 20, 1793, cited in trans. in Madelyn Gutwirth, *Twilight of the Goddesses: Women and Representation in the French Revolutionary Era* (New Brunswick, NJ: Rutgers University Press, 1992), 329.

189. Article 10 of Olympe de Gouges, "Les droits de la femme et de la citoyenne" [A Declaration of the Rights of Woman and Citizenship] (Paris, n.d. [1791]), in *Women in Revolutionary Paris 1789–1795: Selected Documents*, ed. Darline Gay Levy, Harriet Branson Applewhite, and Mary Durham Johnson (Urbana: University of Illinois Press, 1980), 87–96, on 91. De Gouges was the author of forty plays (twelve survive), two novels, and around seventy political pamphlets, some collected in de Gouges, *Oeuvres*, ed. Benoîte Groult (Paris: Mercure de France, 1986).

190. *Feuille du salut public* (1793), cited in translation in Gutwirth, *Twilight of the Goddesses*, 329.

191. Landes, *Women and the Public Sphere*, 12. On de Gouges and Roland, see also Linda Kelly, *Women of the French Revolution* (London: Hamish Hamilton, 1987), 100–129.

192. T. J. Clark, "Painting in the Year Two," *Representations*, 47 (Summer 1994): 13–63, on 39.

193. Peter Brooks, "The Revolutionary Body," in Fort, ed., *Fictions of the French Revolution*, 35–53, on 40.

194. Sade, "Discours prononcé à la Fête décernée par la Section des Picques, aux manes de Marat et de Le Pelletier par Sade, citoyen de cette Section, et membre de la Société populaire" [Speech to the shades of Marat and Le Pelletier], September 29, 1793, in *Écrits politiques suivis de Oxtiern* (Paris: Jean-Jacques Pauvert, 1957), 67–74, on 71.

195. Louis-Michel Le Pelletier was murdered by one of the king's cavalry in Palais Royal on January 20, 1793, the night before the execution of Louis XVI, and he was hailed by the Convention as the first martyr of the Revolution. As with Marat, he was interred in the Panthéon, and Jacques-Louis David was commissioned to paint the scene of his death. See Donna Hunter, "Swordplay: Jacques-Louis David's Painting of Le Pelletier de Saint Fargeau on His Deathbed," in *Representing the French Revolution*, ed. James Heffernan (Hanover, NH: Dartmouth College Press, 1991), 169–91.

196. Sade, "Discours prononcé à la Fête décernée par la Section des Picques, aux manes de Marat et de Le Pelletier," 70–71.

197. Ibid., 71.

198. Though ill health led to his resignation as president in August, Sade remained vice-president. Lely writes of him on August 2, 1793 as "spitting blood" and as using his position to intervene against the death sentence where possible, notably putting his in-laws, the Montreuils, on "the list of those who were cleared of plotting against the Revolution" (Lely, *The Marquis de Sade*, 351).

199. Schaeffer, *The Marquis de Sade*, 431n116.

200. Lely, *The Marquis de Sade*, 355. Marat wrote his name incorrectly, as "Marquis de la Salle," but there is no doubt he meant Sade.

201. Schaeffer, *The Marquis de Sade*, 433.

202. Sade, "Discours prononcé à la Fête décernée par la Section des Picques, aux manes de Marat et de Le Pelletier," 68.

203. Sade, *Lettres inédites et documents*, ed. Jean-Louis Debauve (Paris: Éditions Ramsay / Jean-Jacques Pauvert, 1990), 287.

204. Lely, *The Marquis de Sade*, 355–56.

205. Ibid., 353.

206. Marat, "Discours adressé aux anglais" (1774), cited in Rachel Hammersley, "Jean-Paul Marat's 'The Chains of Slavery' in Britain and France, 1774–1833," *Historical Journal* 48, no. 3 (September 2005): 641–60, on 646. This belief that people would only act virtuously out of self-interest did not waver when he left England for France, and his analysis of human nature in this treatise undoubtedly informed both the tone and content of *Le publiciste parisien* and then *L'ami du peuple*.

207. See Germani, *Jean-Paul Marat: Hero and Anti-Hero of the French Revolution* (Lewiston, NY: Edwin Mellen Press, 1992), 74. Marat's coffin was subsequently removed from the Panthéon on February 8, 1795, and placed in the church cemetery of Saint Étienne-du-Mont.

208. Jacques Louis David, cited in Alexandre Lenoir, *David: Souvenirs historiques* (Paris: P. Baudouin, 1835), 7.

209. Clifford D. Conner, *Jean Paul Marat: Scientist and Revolutionary* (New York: Humanity Books, 1998), 258.

210. Schaeffer, *The Marquis de Sade*, 441.

211. The king and his family had attempted to flee Paris to seek the protection of Austria but were apprehended on route to the French border. Sade's claim to have thrown this pamphlet into the king's carriage was a falsification but one that made his allegiances safely with the radicals and not the king. That said, the printer of this very pamphlet, Sade's publisher Girouard, was guillotined on January 8, 1794.

212. Lely, *The Marquis de Sade*, 359.

213. Schaeffer, *The Marquis de Sade*, 446.

214. Charles Baudelaire, "Projets et notes diverses," in *Oeuvres complètes* (Paris: Seuil, 1968), 705.

215. Charles Baudelaire, "The Museum of Classics at the Bazar Bonne-Nouvelle," in *Art in Paris 1845–1862: Salons and Other Exhibitions*, trans. and ed. Jonathan Mayne (Oxford: Phaidon, 1965), 34–45.

216. Sade frequently referred to the work of the physician and materialist philosopher Julien Offray de La Mettrie (1709–51), who saw the physical and emotional as sharing the same material core. La Mettrie's *Treatise on the Soul* (1745) and *Machine Man* (1747) were condemned by the French monarchy and Catholic Church. For comparison of Sade and La Mettrie, see Jesse Molesworth, *Chance and the Eighteenth-Century Novel: Realism, Probability, Magic* (Cambridge: Cambridge University Press, 2010), 246–49; and Jeremy Davies, *Bodily Pain in Romantic Literature* (London: Routledge, 2014), 67–75.

217. Hunt, *Politics, Culture, and Class in the French Revolution*, 20.

218. Ibid., 20–21.

219. Sade, *Juliette*, 319.

Chapter Two. Surrealist Sade

Epigraph: Guillaume Apollinaire, preface to *L'œuvre du Marquis de Sade* (1909), trans. R. J. Dent as "The Divine Marquis" (1909), in *Sade: Sex and Death; The Divine Marquis and the Surrealists*, ed. Candice Black (N.p.: Solar Books, 2010), 47–112, on 65.

1. André Breton, "Manifesto of Surrealism" (1924), in *Manifestoes of Surrealism* (Paris: Jean-Jacques Pauvert, 1962), trans. H. R. Lane and R. Seaver (Ann Arbor: University of Michigan Press, 1969), 26. In the second manifesto, Sade is praised for "the impeccable integrity" of his life and thought and "the heroic need that was his to create an order of things which was not as it were dependent upon everything that had come before him" (Breton, "Second Manifesto of Surrealism," in *Manifestoes of Surrealism*, 117–94, on 123 and 186).

2. The surrealist movement officially disbanded in Paris in 1969, explaining the end of its "historical" action, as recent revolutions had shown history itself to take a surrealist path. See Jean Schuster, "Le quatrième chant," *Le Monde*, October 4, 1969, trans. Peter Wood as "The Fourth Canto," in *Surrealism against the Current: Tracts and Declarations*, ed. Michael Richardson and Krzysztof Fijalkowski (London: Pluto Press, 2001), 198–202.

3. Sade, "Notes on the Novel" (1800), *Yale French Studies* 35 (1965): 14 (originally "Idée sur le roman," preface to Sade, *Les crimes de l'amour*, vol. 1 of 4 (Paris: Chez Massé, 1800).

4. *Les mamelles de Tirésias* was written in 1903, added to in 1916, and first performed in June 1917, and the program notes stated that it exemplified "a kind of Surrealism." See Guillaume Apollinaire, *Oeuvres poétiques* (Paris: Gallimard, 1965), 865.

5. Guillaume Apollinaire, "The Eleven Thousand Rods" (1907), in *Flesh Unlimited: Surrealist Erotica*, trans. Alexis Lykiard (N.p.: Creation Books, 2000), 29. Originally *Les onze mille verges* (Paris: E. Gaucher, 1907), published under the initials "G.A."

6. Ibid., 107.

7. See Christopher Green, *Art in France, 1900–1940* (New Haven, CT: Yale University Press, 2003), 51; and Gaston Bouatchidzé, "Apollinaire en URSS," in *Apollinaire et son temps*, ed. Michel Décaudin (Paris: Presses Sorbonne Nouvelle, 1988), 133–66.

8. Apollinaire, "The Divine Marquis," 51. Apollinaire cites several sources to support this tale in a footnote, including "Répetoire où Journalier du château de la Bastille à commencer le mercredi 15 mai, 1782," published in part by Alfreds Bégis, *Nouvelle Revue*, November and December 1882.

9. Ibid., 60.

10. Guillaume Apollinaire, "Letter to André Breton," March 12, 1916, in *Oeuvres complètes de Guillaume Apollinaire*, ed. Michel Décaudin (Paris: André Balland et Jacques Lecat, 1966), 4:876; André Breton, *Entretiens* (1969), trans. Mark Polizzotti as *Conversations: The Autobiography of Surrealism, with André Parinaud and Others* (New York: Paragon House, 1993), 29–30.

11. Apollinaire "The Divine Marquis," 65.

12. Robert Desnos, *De l'érotisme considéré dans ses manifestations écrites et du point de vue de l'esprit moderne* (1923) (Paris: Gallimard, 2013), 94.

13. Ibid., 57.

14. Robert Desnos, "Description d'une révolte prochaine," *La Révolution surréaliste* 3 (April 15, 1925): 25–27.

15. Margaret Cohen, *Profane Illumination: Walter Benjamin and the Paris of Surrealism* (Berkeley: University of California Press, 1993), 83.

16. Robert Desnos, *Liberty or Love!*, trans. and intro. Terry Hale (London: Atlas Press, 1993), 27. Originally *La liberté ou l'amour!* (Paris: Éditions du Sagittaire chez Simon Kra, 1927). The inspiration for this dedication was the singer Yvonne George (1896–1930). See notes, 131.

17. Ibid., 49.

18. Ibid., 122.

19. Ibid., 123

20. Ibid., 56.

21. Ibid., 68.

22. Ibid., 83.

23. Ibid., 114.

24. Ibid., 118.

25. Ibid., 123.

26. Jean-François Leroux, *Dictionary of Literary Biography: Twentieth-Century French Poets* (Detroit, MI: Cengage Gale, 2002), 181.

27. Sade, *Three Complete Novels: "Justine," "Philosophy in the Bedroom," "Eugénie de Franval" and Other Writings* (1965), trans. Richard Seaver and Austryn Wainhouse (London: Arrow, 1991), 298, emphasis in original.

28. Breton, "Second Manifesto of Surrealism," 125, 128–29.

29. André Breton, *L'air de l'eau* (Paris: Éditions Cahiers d'Art, 1934), 13–14; trans. in Black, ed., *Sade: Sex and Death*, 6.

30. The Exposition Internationale des Arts et Techniques dans la Vie Moderne ran from May 25 to November 25, 1937. André Breton, "Limits Not Frontiers of Surrealism," *Nouvelle Revue Française*, February 1937, in *What Is Surrealism? Selected Writings*, ed. and intro. Franklin Rosemont (New York: Pathfinder, 1978), 199–212, on 207.

31. Ibid.

32. André Breton, *Anthology of Black Humour* (1966), intro. and trans. M. Polizotti (London: Telegram, 2009), 22, 25, respectively.

33. Ibid., 24, emphasis in original.

34. Ibid., 46.

35. Sade, *Juliette*, excerpt in Breton, *Anthology of Black Humour*, 50–54, on 51.

36. Sade, "To Madame de Sade," in Breton, *Anthology of Black Humour*, 55–58, on 55.

37. Ibid.

38. Ibid., 56.

39. Ibid., 47.

40. Maurice Heine had other scholarly interests and produced his own erotic material, including the incestuous tale of a widower father and two daughters *Luce: Les mémoires d'un veuf*, recently published by La Différence, Paris, 1999.

41. Sade, *Dialogue entre un prête et un moribund* (Paris: Stendhal, 1926); and Sade, *Historiettes, contes et fabliaux* (Paris: Simon Kra, 1927).

42. Maurice Heine Papers, Collection Bibliothèque nationale, NAF24397.

43. Ibid.

44. Maurice Heine, introduction to *Recueil de confessions et observations psychosexuelles* (1935), cited in trans. in Henri Pastoureau, "Sado-Masochism and the Philosophies of Ambivalence," *Yale French Studies* 35 (1965): 48–60, on 50–51.

45. Heine, "Martyres en Taille-Douce," *Minotaure* 9 (1936): 51–53.

46. He changed his name to Lely in 1921 because, apparently, he believed the name Lévy was too widespread, though the fact that Lévy was a Jewish name, in an often anti-Semitic Paris, may have contributed to this decision too. Lely was an adaptation of the name of a character in Molière's *L'étourdi*—Lélie. Jean-Louis Gabin, *Gilbert Lely: Biographie* (Paris: Librairie Séguier, 1991), 21–22.

47. Heine wrote on Sade in this journal too; see Maurice Heine, "L'affaire des bonbons cantharides du Marquis de Sade," *Hippocrate* 1 (March 1933).

48. Gabin, *Gilbert Lely*, 94.

49. For further detailed accounts of Lely's life and work, see Emmanuel Rubio, ed., *Gilbert Lely, la passion dévorante: Actes du colloque Gilbert Lely, le centenaire, textes réunis par Emmanuel Rubio* (Lausanne: L'Age d'Homme, 2007); and Sabine Coron, ed., *Hommage à Gilbert Lely* (Paris: Bibliothèque de l'arsenal and William Blake & Co., 2004).

50. Gilbert Lely, "Le Château-Lyre," in *Ma civilisation* (Paris: Maeght, 1947), 57–67, on 59 and 67.

51. Gilbert Lely, *Sade: Études sur sa vie et son oeuvre* (Paris: Gallimard, 1967), 208–9.

52. Bataille, "The Use Value of D.A.F. de Sade," in *Visions of Excess: Selected Writings, 1927–1939*, trans. Allan Stoekl, with Carl R. Lovitt and Donald M. Leslie Jr. (Minneapolis: University of Minnesota Press, 1985), 92.

53. Carolyn Dean, *The Self and Its Pleasures: Bataille, Lacan, and the History of the Decentered Subject* (Ithaca, NY: Cornell University Press, 1992), 162.

54. Neil Cox, "Critique of Pure Desire, or When the Surrealists Were Right," in *Surrealism: Desire Unbound*, ed. Jennifer Mundy, exhibition catalog (London: Tate Modern, 2001), 245–73, on 247.

55. Annie Le Brun, *Sade: A Sudden Abyss*, trans. Camille Naish (San Francisco: City Lights Books, 1990), 119.

56. Paul Eluard, "D.A.F. Sade, écrivain fantastique et révolutionnaire," *La Révolution surréaliste*, December 1, 1926, 9; and Gilbert Lely, epigraph in *Morceaux choisis de Donation-Alphonse-François de Sade* (Paris: Pierre Seghers, 1948).

57. Sade, letter to Madame de Sade, February 20, 1781, in *Letters from Prison*, trans. Richard Seaver (New York: Arcade Publishing, 1999), 177. The last clause is his, the rest an acknowledged citation from *Les Arsacides*.

58. "Inquiry" (*La Révolution surréaliste* 12 [December 15, 1929]), in *Investigating Sex: Surrealist Discussions 1928–1932*, ed. José Pierre, trans. Malcolm Imrie, afterword by Dawn Ades (London: Verso, 1992), 157–58, on 157, emphasis in original.

59. Ibid., 157.

60. André Breton, radio interview with André Parinaud (1952), in Polizzotti, trans., *Conversations*, 111, emphasis in original.

61. James Clifford, *The Predicament of Culture: Twentieth-Century Ethnography, Literature, and Art* (Cambridge, MA: Harvard University Press, 1988), 118.

62. Andre Breton, interview with Jean Duché (*Le Littéraire*, October 5, 1946), in Polizzotti, trans., *Conversations*, 196–208, on 206, emphasis in original.

63. Jean Desbordes, *Le vrai visage du Marquis de Sade* (Paris: Éditions de la Nouvelle Revue Critique, 1939), 81.

64. Breton, *Anthology of Black Humour*, 46.

65. Freud, "Three Essays on the Theory of Sexuality" (1905), in *Standard Edition of the Complete Psychological Works of Sigmund Freud*, ed. and trans. James Strachey (London: Hogarth Press, 1970), 7:159.

66. Breton joined the Communist Party in January 1927 and left it in 1933, though he and other surrealists maintained Marxist sympathies throughout their lives and Breton met with Leon Trotsky, for example, in Mexico in 1938. See Alyce Mahon, *Surrealism and the Politics of Eros, 1938–1968* (London: Thames and Hudson, 2005), 110–16; Mark Polizzotti, *Revolution of the Mind: The Life of André Breton* (London: Bloomsbury, 1995), 359–60; and Mikkel Bolt Rasmussen, "The Situationist International, Surrealism, and the Difficult Fusion of Art and Politics," *Oxford Art Journal* 27, no. 3 (2004): 367–87, on 374–77.

67. Ades in *Investigating Sex*, ed. Pierre, 197.

68. Ibid., 203.

69. Desnos, *Liberty or Love!*, 123.

70. Man Ray's *Homage to D.A.F. de Sade* was reproduced in *Le Surréalisme au service de la Révolution* 2 (October 1930): 37; Man Ray also included an extract from *Justine* in the catalog for his 1939 exhibition at the Galerie de Beaune in Paris. Pierre Bourgeade, *Bonsoir, Man Ray* (Paris: Pierre Belfond, 1990), 91.

71. Katharine Conley, *Surrealist Ghostliness* (Lincoln: University of Nebraska Press, 2013), 48.

72. See also Peggy Schrock, "Perpetual Sadism," *Art International* 9 (Winter 1989): 63–68; and Janine Mileaf, *Please Touch: Dada and Surrealist Objects after the Readymade* (Hanover, NH: Dartmouth College Press, 2010), 75–83.

73. William B. Seabrook, *No Hiding Place: An Autobiography* (Philadelphia: J. B. Lippincott, 1942), 328. See also Marjorie Worthington, *The Strange World of Willie Seabrook* (New York: Harcourt, Brace and World), 1966.

74. See Janine Mileaf, "Between You and Me: Man Ray's Object to Be Destroyed," *Art Journal* 63, no. 1 (Spring 2004): 4–23, on 18–19.

75. This image also extends Man Ray's earlier 1926 series, *Noire et blanche*, where he posed the head of Kiki de Montparnasse with a tribal mask, again exploring fetishism in the animate and inanimate form.

76. Jane Livingston, "Man Ray and Surrealist Photography," *L'amour fou: Photography & and Surrealism* (Washington, DC: Corcoran Gallery of Art; New York: Abbeville Press, 1985), 115–52, on 125, 128.

77. Sade, *Juliette*, trans. Austryn Wainhouse, 6 vols. in 1 (New York: Grove Press, 1968), 802. All quotations are from this 1968 Grove edition unless otherwise indicated.

78. Bourgeade, *Bonsoir, Man Ray*, 100.

79. Man Ray, *Self-Portrait* (New York: Penguin, 2012), 6.

80. Paul Eluard and Man Ray, *Les mains libres* (Paris: Bucher, 1937), 177.

81. Bourgeade, *Bonsoir, Man Ray*, 76–85. In a letter to Man Ray dated June 20, 1938, Maurice Heine also praised the "magnificent" drawings in this book. Heine Papers, Collection Bibliothèque nationale, NAF24397.

82. Man Ray, quoted in Arturo Schwartz, *Man Ray: The Rigour of Imagination* (London: Thames and Hudson, 1977), 186.

83. Man Ray, text on Sade in "Hollywood Album" (ca. 1940–48), in Getty Research Institute archive, "Man Ray: Letters and Album, 1922–1976," Getty Research Institute, accession no. 930027.

84. André Masson, "Tyrannie du temps," *La Révolution surréaliste* 6 (March 1, 1926): 29.

85. André Masson, letter to Michel Leiris, December 21, 1926, in André Masson and Françoise Levaillant, eds., *Les années surréalistes: Correspondance 1916–1942* (Paris: La Manufacture, 1990), 130.

86. Masson saw Sade and Nietzsche as "the creators of new values, great shatterers of conventional horizons." See André Masson, "45 rue Blomet" (*Atoll*, no. 2, 1968), in *Le rebelle du surréalisme: Écrits* (Paris: Hermann, 1976), 76–84, on 77.

87. Georges Charbonnier, *Entretiens avec André Masson* (Marseille: Ryôan-ji, 1985), 21.

88. Otto Hahn, *Masson* (New York: Harry N. Abrams, 1965), 6–7.

89. In *La mémoire du monde* (Geneva: Albert Skira, 1974), André Masson first spoke of his experience of World War I.

90. André Masson (referring to Paul Eluard, "D.A.F. Sade, écrivain fantastique et révolutionnaire," *La Révolution surréaliste*, December 1, 1926, cited above), in a letter to Michel Leiris, December 21, 1926, in Masson and Levaillant, *Les années surréalistes*, 130.

91. André Masson, letter to Daniel-Henry Kahnweiler, May 2, 1928, in Masson and Levaillant, *Les années surréalistes*, 139.

92. Masson, "Notes on the Sadistic Imagination," trans. R. J. Dent, in *Sade: Sex and Death: The Divine Marquis and the Surrealists*, ed. Candice Black (N.p.: Solar Books, 2011), 183.

93. Leiris also finds a "voluptuous dialogue between love and conflict" ("dialogue voluptueux de l'amour et combat") in *The Rope*. See Michel Leiris, *André Masson et son univers* (Paris: Trois Collines, 1947), 49.

94. Ibid.

95. Ibid., 49.

96. Ibid., 50.

97. Georges Bataille, *The Absence of Myth: Writings on Surrealism*, trans. and intro. Michael Richardson (London: Verso, 1994), 31. The Almanach was to include Bataille's essay "The Use Value of D.A.F. de Sade," an unpublished text by Sade given to him by Maurice Heine, and a text by Michel Leiris that would later be published as "Manhood." The book was not realized, however, Bataille blaming the onset of the Depression and its impact on the trade in luxury books.

98. Le Brun, *Sade: A Sudden Abyss*, 15.

99. We recall Justine/Thérèse describing her brutal first day of abuse at the hands of Dom Séverino and his monks. See Sade, *Justine* in *Three Complete Novels*, 572.

100. Masson, "45 rue Blomet," 77.

101. Sade, *Three Complete Novels*, 686.

102. Ibid., 687.

103. André Masson, "Origines du cubisme et du surréalisme" (1941), in *Le Rebelle du surréalisme*, 18–23; and Masson, *Le plaisir de peindre* (Nice: La Diane Française, 1950), 27, cited in translation in Clark V. Poling, *André Masson and the Surrealist Self* (New Haven, CT: Yale University Press, 2008), 32.

104. Sigmund Freud, "The Uncanny" (1919), trans. James Strachey, in Sigmund Freud, *Art and Literature*, vol. 14 of Penguin Freud Library (London: Penguin Books, 1990), 335–76, on 356.

105. See Caroline van Eck and Stijn Bussels, "The Visual Arts and the Theatre in Early Modern Europe," *Art History* 33, no. 2 (April 2010): 208–23, on 212.

106. Masson, "Notes on the Sadistic Imagination," 183.

107. Ibid., 184.

108. Breton, *L'air de l'eau*, 13.

109. Georges Limbour, "André Masson: Dépeceur universel," *Documents* 2, no. 5 (1930): 286–89.

110. Pascal Pia, *André Masson* (Paris: Gallimard, 1930), 6, cited in William Jeffett, "André Masson: Painting as

Bullfight," in *André Masson: The 1930s*, ed. William Jeffett (St. Petersburg, FL: Salvador Dalí Museum, 2000), 10.

111. Jeffett, *André Masson*, 9.

112. Jean-Paul Clébert, *Mythologie d'André Masson* (Geneva: Éditions Pierre Cailler, 1971), 44.

113. Carl Einstein, "André Masson: Étude ethnologique" (*Documents* no.2 [1929]), trans. Krzysztof Fijalkowski and Michael Richardson as "André Masson: An Ethnological Study," in *Undercover Surrealism: Georges Bataille and DOCU-MENTS* (London: Hayward Gallery; Cambridge, MA: MIT Press, 2006), 245–47.

114. Ibid., 247.

115. Georges Bataille, "The Lugubrious Game," in *Visions of Excess*, 24–30, on 28.

116. See Georges Bataille, "Abattoir," *Documents* 6 (November 1929): 329.

117. Robin Greeley, *Surrealism and the Spanish Civil War* (New Haven, CT: Yale University Press, 2006), 119.

118. Ibid., 120.

119. Masson quoted in ibid.

120. André Masson to Jean Paulhan, letter of August 1936, cited in Jeffett, *André Masson*, 146.

121. Georges Bataille, "The Sacred Conspiracy" (April 29, 1936), in *Visions of Excess*, 179–80.

122. Ibid., 181.

123. Ibid.

124. The Italian librettist Lorenzo da Ponte famously drew on the tales of the notorious Giacomo Casanova, a friend of his, for ideas in his libretto.

125. Some scholars of music have noted the similarities between Mozart and Sade in this respect. See, for example, Charles Ford, *Music, Sexuality and the Enlightenment in Mozart's Figaro, Don Giovanni and Così Fan Tutte* (New York: Routledge, 2012), 207.

126. Georges Bataille, "Popular Front in the Streets," *Cahiers de Contre-Attaque* (May 1936), in *Visions of Excess*, 162.

127. Freud's essay offers an analysis of Wilhelm Jensen's *Gradiva: Ein pompejanisches Phantasiestück* (1903). The essay was translated into French in 1931 by Marie Bonaparte with an illustration of an ancient relief showing Gradiva and two other figures.

128. André Breton, "Gradiva," in *La clé des champs* (Paris: Sagittaire, 1953), 25–28.

129. André Breton, *Mad Love* (1937), trans. Mary Ann Caws (Lincoln: University of Nebraska Press, 1987), 94.

130. Masson, *Écrits*, 69, cited in trans. in David Lomas, "Time and Repetition in the Work of André Masson," in *André Masson: The 1930s*, 37–53, on 52. See also André Masson, "Antille," in André Breton and André Masson, *Martinique, charmeuse de serpents* (Paris, 1948), in which Masson writes of a mythical volcanic eruption and "spermatic lava" that covered the earth.

131. André Masson, "Anatomie de la peur, souvenirs de la guerre 14," in *La mémoire du monde*, 83.

132. Roland Barthes, "Masson's Semiography" (1973), in *The Responsibility of Forms*, trans. Richard Howard (Berkeley: University of California Press, 1985), 153–56, on 154.

133. André Masson, letter to Georges Bataille, cited in Michel Suyra, *Georges Bataille: La mort à l'oeuvre* (Paris: Gallimard, 1992), 233.

134. Raymond Queneau, "Lectures pour un front" (November 3, 1945), in *Bâtons, chiffres et lettres* (Paris: Gallimard, 1965), 216.

135. Tony Judt, *Past Imperfect: French Intellectuals 1944–1956* (Berkeley: University of California Press, 1992), 255.

136. Saint-Just, *Oeuvres complètes* (Paris: Éditions Vellay, 1908), 478.

Chapter Three. *Story of O*: Slave and Suffragette of the Whip

Epigraph: Pauline Réage, "A Girl in Love," *Return to the Château: Story of O Part II; Preceded by "A Girl in Love,"* trans. Sabine d'Estrée (London: Corgi Books, 1994). Although we know that Réage was Dominique Aury (born Anne Desclos, 1907–98), all notes will cite the pen name used for publications.

1. Jean-Paul Sartre, *What Is Literature?* (1947), trans. David Caute (London: Routledge, 1993), 185–86.

2. I have written about the role of Sade in Klossowski's writing and art at length in "The Sadean Imagination: Pierre Klossowski and the 'Vicious Circle,'" in *Pierre Klossowski*, ed. Anthony Spira and Sarah Wilson (London: Whitechapel Art Gallery; Ostfildern: Hatje Cantz Verlag, 2006), 30–42; and "Pierre Klossowski, Theo-Pornologer," in Pierre Klossowski, *The Decadence of the Nude / La décadence du nu*, ed. Sarah Wilson (London: Black Dog Publishing, 2002), 33–101.

3. Gilles Deleuze, "Pierre Klossowski ou Les corps-langage," *Critique* 214 (March 1965): 199–219, on 200.

4. Pierre Klossowski, "Le mal et la negation d'autrui dans la philosophie de D.A.F. de Sade," *Recherches philosophiques* 4 (1934–35): 268–93.

5. Pierre Klossowski, *Sade My Neighbor* (1947), trans. Alphonso Lingis (Evanston, IL: Northwestern University Press, 1991), 100.

6. Ibid., 110.

7. Jean-Jacques Pauvert, interview with the author, Paris, October 8, 1996.

8. Iris Marion Young, "Humanism, Gynocritcism, and Feminist Politics," *Women's Studies International Forum* 8:173–83, on 173.

9. Simone de Beauvoir, *The Second Sex*, trans. and ed. H. M. Parshley (Harmondsworth: Penguin Books, 1989), 740 (originally, *Le deuxième sexe* [Paris: Gallimard, 1949]), 29.

10. See Rosemarie Tong, *Feminist Thought: A More Comprehensive Introduction* (Boulder, CO: Westview Press, 2009), 33–34. This humanist feminism would come under critique with later generations as an all-too-liberal, white, bourgeois position (the "sameness" approach rather than later, radical "difference" approaches); however, the term best reflects the stance of Beauvoir, Aury, and Thomas.

11. In March 1945, Charles de Gaulle, as the head of the

Provisional Government of the French Republic (1944–46), called on French citizens to produce "twelve million beautiful babies for France in ten years" and instigated a system of support and tax relief for families with over three children, or *familles nombreuses*. Jean-Claude Gégot, *La population française aux XIXe et XXe siècles* (Paris: Editions OPHRYS, 1989), 76.

12. Pauvert, interview with the author.

13. This was Pauvert's request to Dominique Aury in a letter dated November 24, 1966, when he invited her to write the preface to Sade's *Historiettes, contes et fabliaux* (vol. 7 of *Oeuvres complètes du Marquis de Sade*). Fonds Hachette Livre, Institut mémoires de l'édition contemporaine (IMEC), Caen, France.

14. Jean-Jacques Pauvert, ed., *L'affaire Sade: Compte-rendu exact du procès intenté par le Ministère public* (Paris: Éditions Jean-Jacques Pauvert, 1957), 9.

15. Garçon had defended art against censorship laws throughout his career and in 1931 had published a very influential article in defense of the freedom of expression. See Maurice Garçon, "Les livres contraires aux bonnes moeurs," *Mercure de France*, August 15, 1931, 5–38.

16. Pauvert, *L'affaire Sade*, 19.

17. Ibid., 33, 38.

18. Maurice Garçon, *Plaidoyer contre la censure* (Paris: Jean-Jacques Pauvert, 1963), 22.

19. Ibid., 22.

20. Ibid. The Charter of 1830 established the so-called July Monarchy of King Louis Philippe, a compromise between French monarchist and republican interests, which followed the July Revolution of that year against his predecessor, Charles X, and lasted until the monarchy collapsed again in 1848.

21. Jeanne Galzy, "Signal d'alarme! Censure et liberté d'expression," *Nouvelles Littéraires*, August 8, 1969, 1 and 10, on 10.

22. Pauvert, *L'affaire Sade*, 46.

23. Jean-Jacques Pauvert, *Anthologie historique des lectures érotiques*, vol. 1: *De Sade à Falliéres (1789–1914)* (Paris: Gallimard, 1982), xxi.

24. Ibid., 1:xxvi.

25. Ibid., 1:66.

26. Ibid.

27. Ibid.

28. Ibid., 1:62. Cocteau's words were meant humorously, but perhaps went too far. Pauvert, in an interview with the author, Paris, October 8, 1996, stated that he felt Cocteau put little effort into his words because he did not really appreciate Sade.

29. Pauvert, *L'affaire Sade*, 56.

30. Ibid., 54–55.

31. Michel Suyra, *Georges Bataille: La mort à l'oeuvre* (Paris: Gallimard, 1992), 582.

32. Pauvert, *L'affaire Sade*, 59.

33. Ibid., 5.

34. See Jean Paulhan, *Lettre aux directeurs de la Résistance* (Paris; Éditions de la Minuit, 1952).

35. Tony Judt, *Past Imperfect: French Intellectuals 1944–1956* (Berkeley: University of California Press, 1992), 58.

36. The Comité national des écrivains included Jacques Debú-Bridel, Raymond Queneau, Paul Éluard, Gabriel Marcel, and Jean Bruller. The Commission d'épuration de l'édition included Jean Bruller, Pierre Seghers, Francisque Gay, and Jean Fayard. See editions of *Les Lettres françaises*, September 30 and October 7, 1944, for other members. The term *épuration* was first coined in Sade's era in 1791, according to François Victor Alphonse Aulard's *La société des Jacobins*, as "l'élimination des membres qu'on juge indésirables dans une association, un parti, une société." See *Grand Robert Dictionnaire de la langue française*, 2nd ed., 1985.

37. François Mauriac, *Mémoires politiques* (Paris: Éditions Grasset, 1970), 179, quoted in translation in Judt, *Past Imperfect*, 71.

38. Other intellectuals included Albert Camus, Jean Cocteau, and Paul Valéry. See Pierre Assouline, *L'épuration des intellectuels, 1944–45* (Brussels: Editions Complexe, 1990), esp. appendix 3 (petition to de Gaulle) and appendix 4.

39. See Frédéric Badré, *Paulhan le Juste* (Paris: Éditions Grasset, 1996), 268.

40. Dominique Aury, cited in Dorothy Kauffman, *Édith Thomas: A Passion for Resistance* (Ithaca, NY: Cornell University Press, 2004), 14.

41. Jean Paulhan, *Les fleurs de Tarbes ou La terreur dans les letters* (Paris: Gallimard, 1941), 63.

42. Ibid., 66.

43. Jean Paulhan, "Entretien," *L'Infini* 62 (Summer 1998): 12, cited in Julien Dieudonné, "The Power of Poetics, the Poetics of Power," trans. Michael Syrotinski, *Yale French Studies* 106 (2004): 189–204, on 204.

44. Jean Paulhan, "A Slave's Revolt" (1954), preface to Pauline Réage, *Story of O*, trans. Sabine Desire (London: Corgi Books, 1994).

45. As Gallimard declined to publish the novel, its publication was delayed until June 1954, when Pauvert readily printed it.

46. Badré, *Paulhan le Juste*, 271. Pauvert claimed that most people in the Gallimard circle knew it was penned by Aury and *none* suspected that Paulhan himself might have written the novel. Pauvert, interview with the author.

47. Paulhan's "Le Marquis de Sade et sa complice" was originally published as a preface to Sade's *Les infortunes de la vertu* (Paris: Éditions du Point du Jour, 1946). Later it was published in book form as Jean Paulhan, *Le Marquis de Sade et sa complice, ou Les revanches de la pudeur* (Paris: Éditions de Lilac, 1951). Earlier versions of the essay had been published as "Le Marquis de Sade et sa complice" in *Le Table ronde* in July 1945 and "Sade, ou Le pire est l'ennemie du mal" in *Labyrinth* in August 1945.

48. Pauvert, *L'affaire Sade*, 51. The English language title of the book does not translate "Les revanches de la pudeur," which roughly translates as "The revenge of modesty."

49. Here Paulhan reiterated the stance he had voiced in his essay "La douteuse Justine, ou Les revanches de la

pudeur," first published in 1945 and reprinted as the preface to Sade's *Justine* (Paris: Éditions du Point du Jour, 1946), and subsequent editions by Pauvert (1959), Livre du Poche (1970), and Gallimard's Folio (1977).

50. Pauvert, *L'affaire Sade*, 49.

51. Ibid., 49–50.

52. Ibid., 80.

53. Pauvert, interview with the author.

54. Maurice Girodias, *Une journée sur la terre*, vol. 2: *Les jardins d'Eros* (Paris: Éditions de la Différence, 1990), 176. Girodias published such controversial authors as William Burroughs, J. P. Dunleavy, Henry Miller, and Vladimir Nabokov into French, continuing the business of his father, Jack Kahane, who set up the English language Obelisk Press in Paris in 1929.

55. Jean-Jacques Pauvert, *Anthologie des lectures érotiques*, vol. 1: *De Pierre Louÿs à André Gide* (Paris: Stock-Spengler, 1995), xvi.

56. The case against three French publishing houses—Denoël, Gallimard, and Éditions du Chêne—for publishing translations of Henry Miller's trilogy of "auto romances," *Tropique du Cancer*, *Printemps noir*, and *Tropique du Capricorne*, in 1945–46 had made this official stance clear.

57. See André Pieyre de Mandiargues, "Un héro de notre temps," in *L'univers de Jean-Jacques Pauvert*, ed. Chérif Khaznadar, exhibition catalog (Rennes: Maison de la Culture de Rennes, 1980).

58. Jean-Jacques Pauvert, preface to "Irène" (1968), in *L'Érotisme des années folles: Lectures érotiques de Jean-Jacques Pauvert* (Paris: Éditions Garnier, 1983), 11–20, on 17.

59. Paulhan, "A Slave's Revolt," 272–73.

60. Jean Paulhan, statement to the Brigade mondaine, August 5, 1955, in his house on 5, rue des Arènes in Paris, reproduced in Régine Deforges, *O m'a dit: Entretiens avec Pauline Réage* (Paris: Jean-Jacques Pauvert, 1975), 9–10, on 10.

61. Réage, *Story of O*, 48. The novel was translated into English twice, the first a very poor translation criticized by the author and publisher; the second, a vastly improved product. See an account of his role as translator of the novel in Richard Seaver, *The Tender Hour of Twilight: Paris in the '50s, New York in the '60s: A Memoir of Publishing's Golden Age*, ed. Jeannette Seaver (New York: Farrar, Straus and Giroux, 2012), 362.

62. Réage, *Story of O*, 27.

63. Ibid., 98, 105.

64. Ibid., 94.

65. Ibid., 95.

66. Ibid., 107.

67. Ibid., 132.

68. Ibid., 187.

69. Ibid., 216.

70. Ibid., 117. Sir Stephen also emphatically insults O by rejecting her "belly" (i.e., her vagina) in favor of her anus, in keeping with the preferences of most of Sade's male libertines.

71. Ibid., 120.

72. Ibid., 258–59.

73. Ibid., 261.

74. Ibid., 262.

75. Ibid., 263.

76. John de St. Jorre, *The Good Ship Venus: The Erotic Voyage of the Olympia Press* (London: Hutchinson, 1994), 224.

77. Ibid.

78. Réage, *Return to the Château*, 22.

79. Dominique Aury, *Vocation: Clandestine* (Paris: Gallimard, 1999), 13.

80. Réage, *Return to the Château*, 10.

81. Angie David, *Dominique Aury* (Paris: Éditions Léo Scheere, 2006), 196.

82. Aury, *Vocation: Clandestine*, 17.

83. Ibid., 18–19.

84. Deforges, *O m'a dit*, 24–25.

85. Thierry Maulnier, *Nietzsche* (Paris: Gallimard, 1935). See Mark Antliff, "Classical Violence: Thierry Moulnier and the Legacy of the Cercle Proudhon," chap. 5 in *Avant-Garde Fascism: The Mobilization of Myth, Art, and Culture in France* (Durham, NC: Duke University Press, 2007), 203–46.

86. Paul Mazgaj, *Imagining Fascism: The Cultural Politics of the French Young Right, 1930–1945* (Newark: University of Delaware Press, 2007), 180.

87. Antliff, "Classical Violence," 204.

88. David Carroll, *Literary Fascism: Nationalism, Anti-Semitism, and the Ideology of Culture* (Princeton, NJ: Princeton University Press, 1995), 14.

89. David, *Dominique Aury*, 298–99. The year 1942 saw the end of Maulnier's work for the collaborationist newspaper *L'Action française*.

90. Dominique Aury, ed., *Anthologie de la poésie religieuse française* (Paris: Gallimard, 1943); Dominique Aury and Jean Paulhan *Poètes d'aujourd'hui* (Lausanne: Guilde du livre, 1947).

91. Aury, *Vocation: Clandestine*, 107. François Fénelon's key works include *Treatise on the Education of Daughters* (1684) and the novel *The Adventure of Telemachus* (1699).

92. Dominique Aury, *Lecture pour tous* (Paris: Gallimard, 1958), 20.

93. Deforges, *O m'a dit*, 136.

94. Ibid., 110.

95. Ibid., 80.

96. *The Thousand and One Nights; or, The Arabian Nights* (Boston: Phillips, Sampson and Co., 1854), 12.

97. St. Jorre, *The Good Ship Venus*, 211.

98. Ibid., 210. Aury repeated the same anecdote in *Vocation: Clandestine*, 114–17. Jean-Jacques Pauvert's version was a little different: he believed the book was saved from the censorship board owing to the pressure put on the Brigade by his lawyer, Maurice Garçon, who carried much legal weight in Paris in the 1950s. Pauvert, interview with the author.

99. Paulhan, "A Slave's Revolt," 270.

100. In the contract between Pauvert and Aury, it was agreed that the novel would always be published with

Paulhan's preface and that Aury would receive a royalty of 12 percent and Paulhan, 3 percent.

101. See Michael Syrotinski, introduction to Jean Paulhan, *Progress in Love on the Slow Side*, trans. Christine Moncera Laenned and Michael Syrotinski (Lincoln: University of Nebraska Press, 1994), ix; and Jean Paulhan, interview with Jean Paget in *Jean Paulhan: Qui suis-je?*, ed. André Dhôtel (Lyon: La Manufacture, 1986), 116.

102. Jean Paulhan, "Aytré Gets out of the Habit" (1921), in Paulhan, *Progress in Love on the Slow Side*, 77–96, on 88.

103. Ibid., 90.

104. Ibid., 93.

105. Ibid.

106. See John Culbert, "Slow Progress: Jean Paulhan and Madagascar," *October* 83 (Winter 1998): 71–95, on 72, 95.

107. Paulhan, "A Slave's Revolt," 272.

108. Ibid., 271.

109. In Peter Cryle's opinion, Paulhan ought to have written "a woman who finally *avows* (avoue)"—rather than "admits," as O's submission draws on the confessional narrative tradition. See Cryle, *Geometry in the Boudoir: Configurations of French Erotic Narrative* (Ithaca, NY: Cornell University Press, 1994), 246–48.

110. Paulhan, "A Slave's Revolt," 282.

111. Édith Thomas, "L'humanisme féminin," unpublished ms, trans. in Kaufmann, *Édith Thomas*, 138–49, on 140. Thomas wrote the 322-page typed manuscript between 1947 and 1949, and it is now in the Archives nationales (reference number 318AP3).

112. Édith Thomas, *The Women Incendiaries* (1963), trans. James Atkinson and Starr Atkinson (Chicago: Haymarket Books, 2007), vii.

113. Ibid., xiv.

114. Louis Martin-Chauffier, "Édith Thomas (1909–1972)," in *Bibliothèque de l'école des chartes* (Paris: Librairie Droz, 1974), 130:681–84, on 681.

115. Angela Kershaw, "Autodidacticism and Criminality in Jean-Paul Sartre's *La Nausée* and Édith Thomas's *L'Homme criminal*," *Modern Language Review* 96, no. 3 (July 2001): 679–92, on 679.

116. Édith Thomas, "J'ai visité le Maquis," *Femmes françaises*, September 28, 1944, 1 and 4, on 4.

117. See Dorothy Kaufmann, "The Story of Two Women: Dominique Aury and Edith Thomas," *Signs* 23, no. 4 (Summer 1998): 883–905, on 891.

118. Ibid., 886. When Kaufmann asked Aury why Thomas was not better known, she replied, "She had a thunderous voice, she was very headstrong, and she wasn't the wife of Aragon."

119. Dominique Aury, "Une disciple d'Epictète: Étude des femmes par Édith Thomas," *Femme françaises*, September 7, 1945, 4.

120. Édith Thomas, unpublished diary entry, October 27, 1946, cited in Kaufmann, "The Story of Two Women," 892.

121. Ibid.

122. Ibid., 895.

123. Deforges, *O m'a dit*, 24.

124. Beauvoir, *The Second Sex*, 730–31.

125. Ibid., 660, emphasis in original.

126. Thomas, "L'humanisme féminin," 314, cited in Kaufmann, *Édith Thomas*, 141.

127. Letter from Andrée Delamain to Jean Paulhan, February 24, 1955, Fonds Jean Paulhan, IMEC.

128. André Pieyre de Mandiargues, "Les fers le feu la nuit de l'âme," *Critique* 97 (June 1955): 510–14, on 511.

129. Ibid., 513.

130. François Mauriac, *L'Express*, November 5, 1954, Fonds Jean Paulhan, IMEC.

131. Letter from Jean Paulhan to Mauriac, July 10, 1958, Fonds Jean Paulhan, IMEC.

132. Ibid., emphasis in the original.

133. Ibid., emphasis in the original.

134. François Mauriac, *Le Figaro littéraire*, February 9, 1963, cited in Jean-Jacques Pauvert, *Sade's Publisher: A Memoir* (2004), trans. Lynn Jeffress (Paris: Writers Press, 2016), 299.

135. Sarane Alexandrian, *Histoire de la littérature érotique* (1989) (Paris: Éditions Payot & Rivages, 1995), 278. The jury consisted of Henri Philippon, Dr. Fatou and Dr. Masle, Jean Follain, Jean-Marc Campagne, Teulé, Rocca, Bersani, Yves Dartois, and Raoul André.

136. André Pieyre de Mandiargues (Pierre Morion), *Portrait of an Englishman in His Château* (Sawtry: Dedalus, 1998) (originally *L'anglais décrit dans le château fermé* [Sceaux: Jean-Jacques Pauvert, 1953]). Neither the author nor publisher gave their real names for the 1953 edition. Bellmer also produced illustrations for this novel, but they were not produced in time for the publication.

137. Jean-Louis Bedouin, "Eros et l'instinct de mort," *Medium, Communication Surréaliste* 2 (February 1954): 23–26.

138. Ibid., 25.

139. Ibid.

140. André Berry, "Chambre rouge et chambre des supplices," *Combat*, March 14, 1955, Fonds Jean Paulhan, IMEC.

141. Georges Bataille, "Le paradoxe de l'érotisme," *Nouvelle Nouvelle Revue Française* 29 (May 1, 1955): 834–39, on 838–39.

142. Gérard de Nerval, "Artemis," in *Les filles du feu* (Paris: D. Giraud, 1854), 332.

143. Bernard Noël, "Le langue du corps," in "Hans Bellmer," special issue, *Obliques* (Paris: Éditions Borderie, 1975), 37.

144. Nora Mitrani, *Rose au coeur violet* (Paris: Terrain Vague, 1992), 13–14.

145. Hans Bellmer, *Petite anatomie de l'inconscient physique ou L'anatomie de l'image* (Paris: Terrain Vague, 1957), 5–36. I have analyzed the collaboration of Bellmer and Mitrani in detail in an earlier essay. See Alyce Mahon, "Hans Bellmer's Libidinal Politics," in *Surrealism, Politics, Culture*, ed. R. Spiteri and D. LaCoss (Aldershot, UK: Ashgate, 2003), 257–61.

146. Agnès de la Beaumelle, *Hans Bellmer: Anatomie du Désir* (Paris: Gallimard / Centre Pompidou, 2006), 230. This

edition of *Story of the Eye*, published by Bataille under the pseudonym Lord Auch, was released by K. Éditeur in Paris in an edition of 199 copies with six engravings by Bellmer.

147. Nora Mitrani, "Des chats et des magnolias," *Le Surréalisme même* 1 (1956): 6–10, on 8.

148. Joan Riviere, "Womanliness as Masquerade" (1929), in *The Inner World and Joan Riviere: Collected Papers, 1920–1958* (London: Karnac Books, 1991), 90–101.

149. Nora Mitrani, "Des esclaves, des suffragettes, du fouet," *Le Surréalisme même* 3 (Autumn 1957): 60–61; reproduced in *Rose au coeur violet*, 97–101.

150. Nora Mitrani, "Une solitude enchantée," in *Exposition internationale du surréalisme* [EROS] (Paris: Galerie Daniel Cordier, 1959); reproduced in *Rose au coeur violet*, 103–7, on 103.

151. Paulhan, "A Slave's Revolt," 284.

152. Réage, *Story of O*, 256.

153. Anne-Marie Dardigna, *Les châteaux d'Eros ou Les infortunes du sexe des femmes* (Paris: François Maspero, 1981), 46.

154. Ibid., 88.

155. Ibid., 319. See also Kristin Ross, *Fast Cars, Clean Bodies: Decolonization and the Reordering of French Culture* (Cambridge, MA: MIT Press, 1995).

156. Margaret Collins Weitz, *Sisters in the Resistance: How Women Fought to Free France 1940–1945* (New York: John Wiley and Sons, 1995), 2. The testimonies of women who survived Nazi camps further increased the public's knowledge of the sexual "occupation" of France's womenfolk, and thus the cruel effectiveness of sexual analogy when depicting the war in text and image.

157. Alain Brossat, *Les tondues: Un carnaval moche* (Paris: Éditions Manya, 1992).

158. Marie Gatard, *La guerre, mon père* (Paris: Seuil, 1978), 135, cited in Weitz, *Sisters in the Resistance*, 277.

159. Deforges, *O m'a dit*, 31.

160. Paulhan, "A Slave's Revolt," 272.

161. Women exercised this right for the first time on April 29, 1945, for the election of municipal councilors, and on October 21, 1945, for the general elections, when 35 women deputies were elected out of 545. Most were from the Communist Party, as it was more open to women.

162. See chap. 1, "The Post-War Period," in Claire Laubier, *The Condition of Women in France 1945 to the Present: A Documentary Anthology* (London: Routledge, 1990).

163. See Evelyne Sullerot, *La presse féminine*, Collection Kiosque (Paris: Armand Colin, 1964).

164. Robert Prigent, *Cahier* (Institute des études démographiques) 18 (1953): 309, quoted in Claire Duhen, "Occupation Housewife: The Domestic Ideal in 1950s France," *French Cultural Studies* 2 (1991): 1–11, on 2.

165. J. A. Neret, *Les carrières féminines* (Paris: Éditions Lamarre, 1953), 23, quoted in Duchen, "Occupation Housewife," 3.

166. Alfred Charles Kinsey's groundbreaking reports on male and female sexuality, first published in the United States in 1948 and 1953, were translated and published in France in 1948 and 1954, respectively. See Alfred C. Kinsey and Wardell B. Pomeroy, *Le comportement sexuel de l'homme*, trans. Eugène Bestaux, Pierre Bobaut, Pierre Gruénais, René Surleau, and Y. Surleau (Paris: Éditions du Pavois, 1948); and Alfred C. Kinsey, Clyde E. Martin, Wardell B. Pomeroy, *Le comportement sexuel de la femme* (Paris: Amiot-Dumont, 1954).

167. Marie Bonaparte, "De la sexualité de la femme," *Revue française de psychanalyse*, in two parts (January–March 1949): 1–52, and (April–June 1949): 161–227 (reprinted in book form, [Paris: Presses Universitaires de France, 1951]).

168. Marie Bonaparte's translation of Sigmund Freud's "The Question of Lay Analysis" appeared in *La Révolution surréaliste* 9–10 (October 1, 1927): 25–32.

169. She published "Considérations sur les causes anatomies de la frigidité chez la femme" in *Revue bi-hebdomadaire des sciences médicales et chirurgicales*, April 27, 1924, under the pseudonym A. E. Narjani. Here she argued that the female genitalia lent themselves to frigidity or "teleclitoridian" women, leading her to argue for corrective surgery. See Peter Cryle and Alison Moore, "Relocating Marie Bonaparte's Clitoris," in *Frigidity: An Intellectual History* (London: Palgrave Macmillan, 2011), 222–47.

170. Beauvoir, *The Second Sex*, 21. Emphasis in original.

171. Simone de Beauvoir, *The Force of Circumstance*, trans. Richard Howard (Harmondsworth, : Penguin Books, 1968), 198 (originally *La force des choses* [Paris: Gallimard, 1963]).

172. Dominique Aury, "Qu'est-ce que l'existentialisme? Escarmouches et patrouilles" (with Simone de Beauvoir, Gabriel Marcel, and Francis Ponge), *Les Lettres françaises*, December 1, 1945, 4. She also interviewed Sartre in "Qu'est-ce que l'existentialisme? Bilan d'une offensive," *Les Lettres françaises*, November 24, 1945, 6.

173. Dominique Aury, "Le visage de Méduse," *Contemporains* 2 (December 1950): 188–95, on 189.

174. Beauvoir, *Force of Circumstance*, 125.

175. Beauvoir, interview by Alice Schwarzer in Paris in 1976, in *Simone de Beauvoir Today: Conversations 1972–1982*, trans. Marianne Howarth (London: Chatto and Windus / Hogarth Press, 1984), 71.

176. Albert Camus, *Caligula and Cross Purpose*, trans. Stuart Gilbert, intro. John Cruickshank (London: Penguin Books, 1965), 54.

177. Albert Camus, *The Rebel* (1951), trans. Anthony Bower (London: Penguin Books, 1971), 36.

178. Ibid., 43

179. Ibid., 40.

180. Albert Camus, "Reflections on the Guillotine" (1957), in *Resistance, Rebellion and Death*, trans. and intro. Justin O'Brien (New York: Modern Library, 1963), 134–35. This essay was from a symposium that Camus and Arthur Koestler held in 1957. Koestler's stance on capital punishment was published at this time too, namely, *Reflections on Hanging* (London: Gollancz, 1956).

181. Simone de Beauvoir, "Must We Burn Sade?," in D.A.F. de Sade, *The 120 Days of Sodom and Other Writings*, trans. Austryn Wainhouse and Richard Seaver, with intro. by Simon de Beauvoir (New York: Grove Press, 1966), 3–64.

182. Ibid., 12–13.

183. Ibid., 18.

184. Ibid., 58.

185. Ibid.

186. Beauvoir, *The Second Sex*, 73.

187. Deforges, *O m'a dit*, 101.

188. Beauvoir, *The Second Sex*, 420.

189. Ibid., 639.

190. For a detailed analysis of Beauvoir's Catholicism, see Joseph Mahon, *Simone de Beauvoir and Her Catholicism: An Essay on Her Ethical and Religious Meditations* (Galway: Arlen House, 2007).

191. Beauvoir, *The Second Sex*, 659.

192. Deforges, *O m'a dit*, 104.

193. Ibid., 109.

194. Judith Butler, "Beauvoir on Sade: Making Sexuality into an Ethic," in *The Cambridge Companion to Simone de Beauvoir*, ed. Claudia Card (Cambridge: Cambridge University Press, 2006), 168–88.

195. Accurate records of the first printing of *Story of O* are difficult to come by, and bibliophiles give varying estimates. Of the first six hundred copies, 580 were printed on textured *vergé* paper (laid paper) of a kind that was commonly used prior to nineteenth century and 20 were printed on commercially available Arches artists' paper. Of the first six hundred copies, approximately two hundred are thought to have contained the Bellmer engraving. Pauvert emphasizes that initially he expected the book to be banned and that sales were slow at first. Pauvert, *Sade's Publisher*, 167–69.

196. Sade, *Justine*, Collection Le Soleil Noir (Paris: Presse du livre français, 1950), with frontispiece by Hans Bellmer and preface by Georges Bataille. Louis Aragon, *Le con d'Irène*, with frontispiece by Hans Bellmer and preface by André Pieyre de Mandiargues (Paris: Chez l'auteur [Jean-Jacques Pauvert], 1952); translated by Alexis Lykiard as *Irene's Cunt* (London: Creation Books, 1996).

197. Peter Webb, *The Erotic Arts* (New York: Farrar Straus and Giroux, 1983), 369.

198. This special, limited, edition of 1962 for the Cercle du Livre Precieux, Paris, was used in a 1968 edition by Cercle du Livre Précieux but with photo-reproductions of these illustrations and limited to two thousand copies. A 1968 edition with the same photo-reproductions, in a gold leatherette casing, was also produced by Edition Claude Tchou in Paris, limited to eight thousand copies. In 1975, a further luxury edition was produced by Édition Jean-Jacques Pauvert, limited to 790 copies with one signed and numbered lithograph by Fini.

199. See Xavier Gauthier, *Leonor Fini* (1973) (Paris: Le Musée de Poche, 1979), 102; and Leonor Fini, "Leonor Fini s'explique," *Lire, le magazine des livres* 16 (1976): 22–46, on 39–41.

200. Sade, *Juliette* (Rome: Colophon, 1944), with twenty-two offset illustrations (black-and-white etchings made from photo-lithographs) and two culs-de-lampe (tailpieces) by Fini.

201. Ibid., 544–45.

202. Jean Genet, "Letter to Leonor Fini" (1950), in *Fragments of the Artwork*, trans. Charlotte Mandell (Stanford CA: Stanford University Press, 2003), 8–15, on 8.

203. Soon after Fini's portraits of Genet, Jean-Paul Sartre penned *Saint Genet, comédien et martyr* (Paris: Gallimard, 1952).

204. See Edmund White, *Genet: A Biography* (New York: Knopf Doubleday Publishing Group, 2010), 410–11.

205. Keith Botsford, "Jean Gênet," *Yale French Studies* 8 (1951): 82–92, on 83.

206. Fini in Nina Winter, *Interview with the Muse: Remarkable Women Speak on Creativity and Power* (Berkeley, CA: Moon Books, 1978), 58. She did marry Fedrico Veneziani in 1938, but this relationship soon dissolved.

207. I discuss the role of the sphinx in greater detail in my essay "La Feminité triomphante: Leonor Fini and the Sphinx," *Dada/Surrealism* 1, no. 19 (December 2013): https://doi.org/10.17077/0084-9537.1274.

208. Alberto Moravia, "Leonor Fini et l'intelligence," in *Leonor Fini*, ed. Edmond Jaloux et al. (Rome: Editions Sansoni, 1945), 28, quoted in translation in Peter Webb, *Sphinx: The Art and Life of Leonor Fini* (New York: Vendome Press, 2009), 112.

209. Leonor Fini and José Alvarez, *Le livre de Leonor Fini* (Lausanne: Éditions Mermoud-Clairefontaines, 1975), 198.

210. Pierre Borgue, *Leonor Fini, ou, Le théâtre de l'imaginaire: Mythes et symboles d'univers Finien* (Paris: Bibliothèque de Circé / Lettres Modernes, 1983), 11.

211. Deforges, *O m'a dit*, 36.

212. André Pieyre de Mandiargues, *Masques de Leonor Fini* (Paris: La Parade, 1951). This publication included four plates of sketches by Leonor Fini and ten photographs of her masks by André Ostier.

213. Armand Lanoux, "Leonor Fini, la sourcière du merveilleux," *Le Jardin des Arts* 14 (December 1955): 96–100, on 100.

214. Georges Bataille, "Le paradoxe de l'érotisme," *Nouvelle Revue Française*, May 29, 1955, 386.

215. Dominique Aury, "Les eaux noires," *Nouvelle Revue Française*, November 1, 1960 (also in *Songes* [Dreams] [Paris: Les Éditions Perpétuelles, 1991], n.p.)

216. Susan Sontag, "The Pornographic Imagination" (1967), in *Styles of Radical Will* (New York: Penguin Books, 2009), 55.

217. Fini and Alvarez, *Le livre de Leonor Fini*, 5.

218. Marc Perlman, "Un entretien avec Leonor Fini," *Beaux Arts*, June 27, 1970, cited in translation in Webb, *Sphinx*, 231.

219. In 1951, Fini explained she had to obey an "automatism" in her drawings, where her paintings were freer, distinguishing between them as "two separate worlds" of expression. Fini quoted in Denise Bourdet, "Images de Paris: Leonor Fini," *Revue de Paris*, December 1951, 137–40, on 139.

220. In a letter dated September 5, 1969, Fini explained

she was repulsed by the maternal imago. See Gauthier, *Leonor Fini*, 74. It should be noted that in Catholic teaching, a distinction is often made between *maternité physique* (physical pregnancy or motherhood) and *maternité spirituelle* (spiritual pregnancy or motherhood).

221. Max Ernst, preface to *Leonor Fini*, exhibition catalog (London: Kaplan Gallery, 1960), n.p.

222. Fini and Alvarez, *Le livre de Leonor*, 215, emphasis in original.

223. Leonor Fini, interview with Peter Webb, Paris, May 21, 1993, cited in Webb, *Sphinx*, 143.

224. Fini, "Leonor Fini s'explique," 39–41.

225. Peter Webb, *Leonor Fini: Une grande curiosité*, exhibition catalog (San Francisco: Weinstein Gallery, 2009), 9.

226. Transcript of an interview with "M. R.," undated, Leonor Fini archive, Paris, 4.

227. Constantin Jelenski, *Leonor Fini* (Lausanne: Guilde du livre, 1968), 13–14. See also Estella Lauter, "Leonor Fini: Preparing to Meet the Strangers of the New World," *Woman's Art Journal* 1, no. 1 (Spring–Summer 1980): 44–49, on 48, where Lauter uses the term *guérillères* in a lovely allusion to Minique Wittig's novel *Les Guérillères* (1969).

228. Leonor Fini, unpublished text (ca. 1972), in Gauthier, *Leonor Fini*, 76.

229. Leonor Fini in "A.K.," "Leonor Fini: Un livre, une exposition," *Gazette de Lausanne*, November 2–3, 1968, n.p. visible, in Leonor Fini archive.

230. *Story of O* was a 35-mm color feature film, with a running time of 112 minutes, by the Prodis-Yang Film production company. Corrine Cléry was born Corinna Piccolo in Paris in 1950 and after *Histoire d'O* went on to star in other B-movies such as *Christmastime in a Brothel* (1976) and *The Con Man* (1980). Her most famous role was as the Bond girl Corinne Dufour in *Moonraker* (1979). Udo Kier was born in Cologne, Germany, in 1944, and his other film roles include the lead in Paul Morrissey and Andy Warhol's horror films *Flesh for Frankenstein* (1973) and *Blood for Dracula* (1974).

231. There is not a lot of critical literature on Jaeckin, but he is referred to, at least briefly, in many histories of the so-called sexploitation cinema that flourished in Europe and North America in the 1960s and '70s, although the relatively high production values and philosophical pretensions of his work are often noted. See, for example, Ernest Mathijs and Xavier Mendik, eds., *Alternative Europe: Eurotrash and Exploitation Cinema since 1945* (London: Wallflower Press, 2004); Karen A. Ritzenhoff and Karen Randell, *Screening the Dark Side of Love: From Euro-Horror to American Cinema* (New York: Palgrave Macmillan, 2012).

232. Just Jaeckin, "Interview with Director," *The Story of O*, limited edition DVD, Arrow Films, 2005.

233. Ibid.

234. The film achieved a respectable box office and critical reception outside France, too. For example, the well-known reviewer Moskowitz reviewed it quite favorably in the US film trade daily *Variety*, where he described it as "[a] big-budgeted, glossy, sadomasochistic 'softcore' item" that "could bridge the gap between regular and porno aud[iences]." Moskowitz called the film "campy" and "more decorative than serious" but predicted that it was likely to attract "femme libber protests." Moskowitz, "Histoire d'O", Film Reviews, *Variety*, September 3, 1975, 18.

235. Madeleine Chapsal, "Le choc d'*Histoire d'O*," and Jean Paulhan, "O et l'équilibre mystérieux de la violence," *L'Express*, no. 1260, September 1–7, 1975, 70–75 and 79–82, respectively. Paulhan's essay was retitled for the purposes of its republication in the magazine.

236. *L'Express*, editorial, September 8–14, 1975, 39.

237. Pauline Réage, interview with Régine Deforges, *L'Express*, September 8–14, 1975, 86–88, on 86. This interview consisted of excerpts of a longer interview of Réage by Deforges that was published in Deforges's book *O m'a dit* the same year (Paris: Jean-Jacques Pauvert, 1975).

238. Ibid.

239. Deforges, *O m'a dit*, 102.

240. The name for her protagonist began as Odile, based on a friend of Aury's who was in love with Albert Camus. Aury explained, "after a few pages I decided that I couldn't do all those things to poor Odile, so I just kept the first letter. It has nothing to do with erotic symbolism or the shape of the female sex." Aury cited in St. Jorre, *The Good Ship Venus*, 228. She also explained here that René was based on an adolescent love that never happened and that Sir Stephen was based on a man she saw at a bar.

241. Odile Hellier quoted in St. Jorre, *The Good Ship Venus*, 229–30.

242. Subsequently, Vadim directed *Le vice et la vertu* (Vice and virtue, 1963), whose characters were "vaguely inspired" by those of the Marquis de Sade, according to Vadim. See Roger Vadim, *Bardot, Deneuve, Fonda* (New York: Simon and Schuster, 1986), 184; Vadim attended a performance of Sade's *Philosophy in the Bedroom* staged at Maurice Girodias's theater La Grand Séverine in Paris in 1965, and his work and Sade's were frequently referred to side by side. See *L'Express*, December 16–22, 1968, 41; and "Roger Vadim and the New Morality," *Penthouse* 1, no. 2 (1965): 298.

243. Roger Vadim, quoted in Peter Lennon, *Foreign Correspondent: Paris in the Sixties* (London: Picador, 1994), 136–37.

244. See Simone de Beauvoir, "Brigitte Bardot and the Lolita Syndrome," trans. Bernard Frechtman, *Esquire*, August 1, 1959, 32–38, on 32.

245. Ibid., 36.

Chapter Four. Screaming for Sade

Epigraph: Peter Weiss, *Marat/Sade: The Persecution and Assassination of Marat as Performed by the Inmates of the Asylum of Charenton under the Direction of the Marquis de Sade* (1964), intro. Peter Brook (London: Marion Boyars, 1982), 107.

1. Marshall McLuhan, *The Gutenberg Galaxy* (1962), in *Essential McLuhan*, ed. Eric McLuhan and Frank Zingrone (New York: Basic Books, 1995), 21, 126. My periodization of art and intellectual history in this chapter is informed by

Fredric Jameson's essay "Periodizing the 60s," in "The Sixties without Apology," special issue, *Social Text* 9/10 (Spring–Summer 1984): 178–209. Jameson proposes a flexible periodization of the '60s that has since become widely used by social and cultural historians.

2. Susan Sontag, "The Pornographic Imagination" (1967), in *Styles of Radical Will* (New York: Penguin Books, 2009), 71.

3. Georges Bataille, "Sade," in *Literature and Evil* (1957) trans. Alastair Hamilton (London: Penguin, 2012), 89–106, on 90. Bataille names Jean Paulhan, Pierre Klossowski, and Maurice Blanchot in the main text, and Swinburne, Baudelaire, Apollinaire, Breton, and Éluard in a footnote, as writers who have helped "confirm" Sade's genius.

4. Theodor Adorno and Max Horkheimer, "Juliette or Enlightenment and Morality," in *Dialectic of Enlightenment: Philosophical Fragments*, ed. Gunzelin Schmid Noerr, trans. Edmund Jephcott (Stanford CA: Stanford University Press, 2002), 63–93.

5. Ibid., 68.

6. Ibid., 74.

7. Ibid., 86.

8. Ibid., 93.

9. Klaus Theweleit, *Male Fantasies*, vol. 1: *Women, Floods, Bodies, History* (1977), trans. Chris Turner, Erica Carter, and Stephen Conway (Minneapolis: University Minnesota Press, 1987).

10. Martin Jay, *The Dialectical Imagination: A History of the Frankfurt School and the Institute of Social Research 1923–1950* (Berkeley: University of California Press, 1973), 265.

11. Bataille first saw this Chinese method of torture in a photograph reproduced in Georges Dumas's *Traité de psychologie* of 1923. He acquired his own copy of the photograph in 1928 from his psychoanalyst, Dr. Borel, which he printed in *Documents*.

12. Sade, *Juliette*, trans. Austryn Wainhouse, 6 vols. in 1 (New York: Grove Press, 1968), 338. All quotations are from this 1968 Grove edition unless otherwise indicated.

13. Henri Alleg, *La question* (Paris: Éditions de Minuit, 1958); trans. John Calder as *The Question* (Lincoln: University of Nebraska Press, 2006). Jean-Paul Sartre's article on Alleg in *L'Express*, March 6, 1958, brought further attention to his case. The case of Alleg's friend and comrade Maurice Audin, a mathematics professor at Algiers University and member of the FLN, who was arrested in his home in Algeria on June 11, 1957, the day before Alleg was arrested, and who subsequently "disappeared" in El Biar, was also the subject of heated debate among intellectuals. Pierre Vidal-Naquet would document his torture to death in his book *L'affaire Audin*, published in May 1958.

14. Simone de Beauvoir, "Must We Burn Sade?," in D.A.F. de Sade, *The 120 Days of Sodom and Other Writings*, trans. Austryn Wainhouse and Richard Seaver, with intro. by Simon de Beauvoir (New York: Grove Press, 1966), 3–64.

15. Simone de Beauvoir, *Djamila Boupacha: The Story of the Torture of a Young Girl Which Shocked Liberal French Opinion*,

trans. Peter Green (New York: Macmillan, 1962), 197. Beauvoir's call for intervention followed Jacques Vergès and Georges Arnaud's 1957 manifesto "For Djamila Bouhired," in defense of another young female member of the FLN who was arrested and tortured; Georges Arnaud and Jacques Vergès, *Pour Djamila Bouhired* (Paris: Éditions de Minuit, 1957).

16. Simone de Beauvoir, *The Force of Circumstance*, trans. Richard Howard (Harmondsworth, UK: Penguin Books, 1968), 384.

17. Umberto Eco, *The Open Work* (1962), trans. Anna Cancogni (Cambridge, MA: Harvard University Press, 1989), 12.

18. Ibid., 39–40.

19. Ibid., 4.

20. Ibid., xiv.

21. Antonin Artaud, "The Theater and Cruelty" (1933), in *The Theater and Its Double* (1938), trans. Mary Caroline Richards (New York: Grove Press 1958), 84–88, on 84.

22. Antonin Artaud, "The Theater of Cruelty (First Manifesto)" (1932), in *The Theater and Its Double*, 89–132, on 109.

23. Ibid., 99.

24. The play was censored from French radio (it was scheduled to air on February 2, 1948) but resurrected by Jean-Jacques Lebel and a friend of his who worked in French television in 1958, as discussed below.

25. Marcel Hénaff, *Sade: The Invention of the Libertine Body* (1978), trans. Xavier Callahan (Minneapolis: University of Minnesota Press, 1999), 66–67.

26. Albert Camus, *The Rebel* (1951), trans. Hamish Hamilton (London: Penguin, 1971), 28, emphasis in original.

27. Guy Debord, *Hurlements en faveur de Sade / Howlings in Favour of Sade* (1952), script of realized film, in Guy Debord, *Society of the Spectacle and Other Films* (London: Rebel Press, 1992), 9–22, on 11. The final film script was published in the pages of the Belgian surrealist review *Les lèvres nues* in December 1955.

28. Debord, *Society of the Spectacle and Other Films*, 11–12.

29. Isidore Isou, *Traité de bave et d'éternité*, 35mm, black and white, sound, 175 mins., 1951, with scenario in Isou, *Oeuvres de spectacle* (Paris: Gallimard, 1964), 7–88, on 15. Isou dedicated this film to Charlie Chaplin. It must be noted that Isou would later retract his admiration for *Hurlements* in his 1979 pamphlet *Contre le cinéma situationniste, néo-nazi* (Against neo-Nazi situationist cinema) in which he decried Debord as a "sub-ersatz Jean Genet."

30. Isidore Isou, *Mémoires sur les forces futures des arts plastiques et sur leur mort* (1946) (Paris: Cahiers de l'externité, 1998); and Isou, *Esthétique du cinema* (Paris: Ur, 1953). Maurice Lemaître explained the Lettrist era as "the period in which art turns in upon itself" in his essay "What Is Lettrism?" trans. in Lowell Blair, *Ur: La dictature lettriste* 3 (1952): 47–48.

31. Isou, *Traité*, 23.

32. Ibid., 20.

33. Debord, *Society of the Spectacle and Other Films*, 22.

34. Guy Debord and Gil Wolman, "A User's Guide to

Détournement," in *Situationist International Anthology*, ed. Ken Knabb (Berkeley, CA: Bureau of Public Secrets, 1981), 14–21, on 15.

35. The first script for the film, as published in *Ion* (Paris, 1952), is reproduced in Gérard Berréby, *Documents relatifs à la foundation de l'Internationale Situationniste 1948–1957* (Paris: Allia, 1985), 109–23.

36. Roland Barthes, *Sade, Fourier, Loyola* (1971), trans. Richard Miller (London: Jonathan Cape, 1977), 143–44. Barthes points out that this is exemplified in the account of Madame de Verneuil's torture in *La nouvelle Justine*, where a helmet was placed to her head "so that the screams drawn from her by the pain inflicted on her resembled the lowing of a cow."

37. Debord, *Society of the Spectacle and Other Films*, 11, 15, 17, respectively.

38. Ibid., 15.

39. Ibid., 17, 19.

40. Ibid., 12.

41. See Jean-Marie Apostolidès and Marie Pecorari, "The Big and Small Theatres of Guy Debord" *TDR/The Drama Review* 55, no. 1 (Spring 2011): 84–103, on 87n7.

42. In 1958, Lebel managed to get a copy of the censored recording and shared it with Allen Ginsberg, Gregory Corso, William Burroughs, and Brion Gysin in Paris and sent copies to Julian Beck and Judith Malina (who set up the Living Theatre in New York in 1947), LeRoi Jones, and Michael McClure in the United States. See "What's Happening Man? Interview with Jean-Jacques Lebel by Bernard Blistène," in *A Theater without Theater*, ed. Alain Badiou et al. (Barcelona: Actar/Museu d'Art Contemporani de Barcelona, 2007), 36–45, on 37.

43. Kaira M. Cabañas, "Hurlements en faveur de vous," *Grey Room* 52 (Summer 2013): 22–37, on 26–27.

44. Michèle Bernstein in Greil Marcus, *Lipstick Traces: A Secret History of the Twentieth Century* (Cambridge, MA: Harvard University Press, 1990), 337. Berna also responded to an irate member of the audience who asked why Sade was not in the film by claiming there had been a misunderstanding and that the title referred to a friend of Debord's named Ernest Sade, not the famous libertine.

45. See also Thomas Y. Levin, "Dismantling the Spectacle: The Cinema of Guy Debord," in *On the Passage of a Few People through a Rather Brief Moment in Time: The Situationist International 1957–1972*, ed. Elisabeth Sussman (Boston: Institute of Contemporary Art; Cambridge, MA: MIT Press, 1989), 72–124; and Allyson Field, "*Hurlements en faveur de Sade*: The Negation and Surpassing of Discrepant Cinema," in "Guy Debord," special issue, *SubStance* 28, no. 3, issue 90 (1999): 55–70.

46. CoBrA stood for Copenhagen, Brussels, and Amsterdam, the three home cities of the founders of the movement in 1948.

47. The photograph is contained in an article, "L'avant-garde de la présence," *Internationale Situationniste* 8 (January 1963): 14–22, on 19.

48. See Kelly Baum, "The Sex of the Situationist International," *October* 126 (Fall 2008): 23–43, on 25. Baum does not fully engage with the element of Sadean sexual violence/taboo in the images in the *Internationale Situationniste*, describing them only as "sexually charged" and opting to leave Sade to a footnote in her essay.

49. Ibid., 31.

50. Ibid., 36.

51. "Editorial Notes," *Internationale Situationniste* 2 (December 1958): 6–8, on 8.

52. *Violette Nozières* (Brussels: Éditions Nicolas Flamel, 1933). It included poems by Breton, René Char, Paul Eluard, Maurice Henry, Benjamin Péret, E.L.T. Mesens, César Moro, and Gui Rosey; illustrations by René Magritte, Salvador Dalí, Victor Brauner, Yves Tanguy, Max Ernst, Marcel Jean, Hans Arp, and Alberto Giacometti, and a photograph by Man Ray was used for the cover.

53. Bouhired was part of the same Algiers network as Djamila Boupacha, and her torture was documented in Arnaud and Vergès, *Pour Djamila Bouhired*.

54. Frantz Fanon, "Concerning a Plea" (*El Moudjahid*, no. 12, November 15, 1957), in *Toward the African Revolution: Political Essays*, trans. Haakon Chevalier (New York: Grove Press, 1967), 73–75, on 75.

55. Guy Debord, "One More Try if You Want to Be Situationists (The SI in and against Decomposition)," *Potlatch*, no. 29, November 5, 1957, in *Guy Debord and the Situationist International: Texts and Documents*, ed. Tom McDonough (Cambridge, MA: MIT Press, 2002), 51–60, on 51.

56. Helmut Sturm, Heimrad Prem, Lothar Fischer, Dieter Kunzelmann, Hans-Peter Zimmer, Staffan Larsson, Asger Jorn, Jørgen Nash, Katja Lindell, and Maurice Wyckaert, "The Avant-garde Is Undesirable," point 10 of a thirteen-point tract, Muenchener Kammerspiele (Munich Intimate Theater), January 1961. See http://www.notbored.org/spur-manifesto.html.

57. Marcusm *Lipstick Traces*, 178.

58. "Le commencement d'une époque," *Internationale Situationniste* 12 (September 1969): 4, trans. as "The Beginning of an Era" in *Situationist International Anthology*, ed. Knabb, 226.

59. André Breton, "The Grand Ceremonial Restored to Us at Last by Jean Benoît," in *Surrealism and Painting*, trans. Simon Watson Taylor (Boston: MFA Publications, 2002), 386–90, on 388.

60. Jean Benoît, interview with the author, Paris, May 5, 1996.

61. Joyce Mansour, *Cris* (Paris: Seghers, 1953); Mansour, *Les gisants satisfaits* (Paris: Jean-Jacques Pauvert, 1958).

62. Breton, "The Grand Ceremonial Restored to Us at Last by Jean Benoît," 390.

63. Annie Le Brun, "De l'exhibitionnisme considéré comme un des beaux-arts," *Jean Benoît*, (Paris: Galerie 1900–2000, 1996), 9, 247.

64. See Mahon, *Surrealism and the Politics of Eros, 1938–1968* (London: Thames and Hudson, 2005), 154–58.

65. Jean Benoît, "Notes concernant l'exécution du testament du Marquis de Sade," *EROS* (Paris: Galerie Daniel Cordier, 1959), 66.

66. Ibid.

67. Breton praised the performance, and the impulsive demonstration of Roberto Matta, who stood up to be branded too. See "Dernière heure" (December 4, 1959), in José Pierre, *Tracts surréalistes et déclarations collectives: 1940–1969* (Paris: Terrain Vague, 1980), 2: 182–83.

68. Benoît, "Notes concernant l'exécution du testament du Marquis de Sade," 68. The works he critiqued were Paul Bourdin, *Correspondance inédite du Marquis de Sade, de ses proches et de ses familiers* (Paris: Librairie de France, 1929); Jean Desbordes, *Le vrai visage du Marquis de Sade*; and Louis Parrot, "Sade blanc, Sade noir," *Cahiers du Sud* 285 (1947): 707–14.

69. *Finance*, December 31, 1959, Archives Mimi Parent, Paris. The review assumes some local knowledge, as the actual offices of the French Ministry of the Interior were (and remain) close to what was the location of the Galerie Daniel Cordier, on rue du Miromesnil and rue des Saussaies, respectively.

70. For a longer analysis of this exhibition, see chap. 4 of Mahon, *Surrealism and the Politics of Eros, 1938–1968*, 143–72.

71. See Radovan Ivsic, "When the Walls Sighed in Paris," trans. Roger Cardinal, in Alyce Mahon, "Staging Desire," in *Surrealism: Desire Unbound*, ed. Jennifer Mundy (Princeton, NJ: Princeton University Press, 2001), 287. The walls were designed by Pierre Faucheux following Marcel Duchamp's conceit.

72. Rosalind Krauss, *The Optical Unconscious* (Cambridge MA: MIT Press, 1994), 172.

73. This was a letter penned by Sade to his wife from the "donjon de Vincennes" after his arrest on September 7, 1778, and it had never been published until Maurice Heine secured it for his collection of Sade's works.

74. Sade, *Juliette*, 1120.

75. Ibid., 1125.

76. Unica Zürn, *The House of Illnesses*, trans. M. Green (London: Atlas Press, 1993), 29.

77. Hans Bellmer, *Obliques: Numéro spécial sur Hans Bellmer* (Paris: Borderie, 1975), 111; Unica Zürn, *Hextentexte—Zeichnungen und Anagramme* (Berlin: Springer, 1954); translated as *Oracles et spectacles* (Paris: Georges Visat, 1967).

78. Bellmer, *Petite anatomie de l'inconscient physique ou L'anatomie de l'image* (Paris: Terrain Vague, 1957), 39–40. See also Alyce Mahon, "Twist the Body Red: The Art and Lifewriting of Unica Zürn," *n.paradoxa* 3 (1999): 56–65.

79. The original feast also involved three couples and food on a nude female, to be shared and eaten without cutlery, but it was a much more intimate affair. Bice Curiger, *Meret Oppenheim: Defiance in the Face of Freedom*, (Cambridge, MA: MIT Press, 1989), 70.

80. Sade, *Juliette*, 582, 603. Sade learned about cannibalism from his readings on other so-called primitive societies, but in his own novels stripped them of their ritualistic and religious significance. See Lucienne

Frappier-Mazur, *Writing the Orgy: Power and Parody in Sade*, (Philadelphia: University of Pennsylvania Press, 1996), 114.

81. Sade, *Juliette*, 584–85.

82. Robert Belton, "Androgyny: Interview with Meret Oppenheim," in *Surrealism and Women*, ed. Mary Ann Caws, Rudolf F. Kuenzli, and Gwen Raaberg (Cambridge MA: MIT Press, 1991), 63–75, on 70. After the *vernissage* of the EROS exhibition, this woman was replaced with a mannequin, because a model would have been too expensive to hire for the duration of the show. Ruth Henry (a close friend of Oppenheim), interview with the author, Paris, April 24, 1996.

83. Patrick Waldberg, "Le surréalisme et ses affinités à Paris," *Quadrum* 8 (1960) 135–42, on 135. Waldberg was a member of the *Acéphale* group in the second half of the 1930s and part of the surrealist circle until 1951, when a disagreement led to his being ousted.

84. Robert Benayoun, *Érotique du surréalisme* (Paris: Jean-Jacques Pauvert, 1965), 231.

85. Pierre Descargues, "Succès complet pour la huitième exposition surréaliste," *Tribune de Lausanne*, December 20, 1959, archives Mimi Parent, Paris.

86. Jean-Jacques Lebel, "A Point of View on Happenings from Paris," *ICA Bulletin*, London 1965, in *Jean-Jacques Lebel: Retour d'exil, peintres, dessins, collages, 1954–1988* (Paris: Galerie 1900–2000, 1988), 68–69, on 69.

87. Radiodiffusion-Télévision Française (RTF—French Radio and Television Broadcasting).

88. Blistène, "What's Happening Man?," in Badiou et al., *A Theater without Theater*, 37. Artaud's play was discovered by Lebel in 1958, and he in turn shared it with his friends: Allen Ginsberg, Gregory Corso, William Burroughs, Brion Gysin, Julian Beck and Judith Malina, LeRoi Jones, and Michael McClure. Lebel worked closely with all these artists and translated their work/interviews for French audiences in his anthology *La poésie de la Beat Generation* (Paris: Denoël, 1965), and *Entretiens avec le Living Theatre* (Paris: Belfond, 1969).

89. See Jean-Jacques Lebel, "Art as Upheaval," 2009 interview with Jean de Loisy, in Axel Heil, Robert Fleck, and Alyce Mahon, *Jean-Jacques Lebel: Barricades* (Cologne: Walter König, 2014), 225–42, on 227; and my essay, "Outrage aux bonnes moeurs: Jean-Jacques Lebel and the Marquis de Sade," in *Jean-Jacques Lebel: Paintings, Sculptures, Installations*, ed. Uli Todoroff and Sophie Haaser, exhibition catalog (Vienna: Museum Moderner Kunst, 1998), 93–112, on 100–101.

90. Allan Kaprow, "The Legacy of Jackson Pollock", in Kaprow, *Essays on the Blurring of Art and Life* (Berkeley: University of California Press, 2003), 1–9, on 6.

91. Jean-Jacques Lebel and Androula Michaël, *Happenings de Jean-Jacques Lebel ou L'insoumission radicale* (Paris: Hazan, 2009), 177.

92. Jean-Jacques Lebel, interview with the author, Normandy, August 10, 2006.

93. Jean-Jacques Lebel and Arnaud Labelle-Rojoux, *Poésie directe des happenings à Polyphonix* (Paris: Opus International, 1994), 99.

94. Sade, *Sade: Oeuvres*, ed. Michel Delon (Paris: Gallimard, 1998), 3:463.

95. Lebel and Michaël, *Happenings de Jean-Jacques Lebel*, 40.

96. Enrico Baj, "Qu'est-ce qu'un tableau?" in *Grand tableau antifasciste collectif*, ed. Laurent Chollet (Paris: Éditions Dagorno, 2000), 11–13, on 11.

97. Simone de Beauvoir and Gisèle Halimi, *Djamila Boupacha* (Paris: Gallimard, 1962); trans. Peter Green (London: Macmillan, 1962), 195. Drawings by Pablo Picasso and Robert Lapoujade and a painting by Roberto Matta, all protesting the Algerian War, were printed in Beauvoir and Halimi's book. Matta's painting, titled *La question* (1958), was also exhibited alongside the *Grand tableau antifasciste collectif* in Lebel's *Anti-Procès* exhibition (third stage) in Milan in 1961.

98. *Front Unique* began as a protest poster when it was launched by Lebel and Schwartz in 1956, but by 1959 it was in journal format, and in 1960 it published the "Manifesto of 121" against the Algerian War, which Lebel had signed. Its contributors included Breton, Joyce Mansour, Gregory Corso, and others. Schwarz was born in Alexandria, Egypt, to a German father and Italian mother and was based in Milan from 1952; in 1961, he launched a gallery there that exhibited avant-garde art up until its closure in 1975.

99. Nine days after it was exhibited, it was seized by the police and only returned to Enrico Baj in 1985.

100. Jean-Jacques Lebel, *The Epic Story of a Painting by Erró, Kidnapped for Fifty-Two Years* (Bergamo: Rafael Edizioni, 2014), 3.

101. Jean-Jacques Lebel, interview with the author, Normandy, August 8, 2006.

102. *Le workshop de la libre expression*, statement of May 1964, Archives Jean-Jacques Lebel, Paris.

103. Ibid.

104. Lebel and Labelle-Rojoux, *Poésie directe des happenings à Polyphonix*, 73.

105. Ibid., 182.

106. For an insightful analysis of Laure's stance on sacrifice and debt to Sade, see Sean Connolly, "Laure's War: Selfhood and Sacrifice in Colette Peignot," *French Forum* 35, no. 1 (Winter 2010): 17–37.

107. Laure, *The Collected Writings* (San Francisco: City Lights, 1995), 41. The collection was first published by Société Nouvelle des Éditions Jean-Jacques Pauvert in 1977.

108. "Jean-Jacques Lebel, oppositionnel, interview par Catherine Millet," *Art Press* 213 (May 1996): 20–27, on 22.

109. Goldmann (1913–70) survived the heart attack and lived until 1970. His best-known work, then and now, is *Dieu caché: Etude sur la vision tragique dans les "Pensées" de Pascal et dans le théâtre de Racine*, first published in French in 1959, and since widely translated. See Lucien Goldmann, *The Hidden God: A Study of Tragic Vision in the "Pensées" of Pascal and the Tragedies of Racine*, trans. Philip Thody (London: Verso, 2016).

110. Rivette also looked to a 1963 stage adaptation of the novel that had been written by Jean Gruault. See "Le temps deborde: Entretien avec Jacques Rivette," *Cahiers du cinema* (September 1968): 17.

111. Jean-Luc Godard, open letter to French minister of culture, André Malraux, *Le Nouvel Observateur*, April 6, 1966, reprinted in *Cahiers du cinéma*, April 8–9, 1966, 177. The ban was subsequently lifted, and *La religieuse* (*Suzanne Simonin, la religieuse de Diderot /* The nun by Diderot, 2 hours, 15 minutes, 1966), was released in five cinemas in Paris in November 1967. See Jean-Claude Bonnet, "Revoir La religieuse," in *Interpreter Diderot aujourd hui*, ed. E. de Fontenay and J. Proust (Le Sycomore: S.F.I.E.D, 1984), 50–65, on 60.

112. Here I refer to Laura Mulvey's sense of voyeurism and traditional visual pleasure as expressed in her seminal essay "Visual Pleasure and Narrative Cinema," *Screen*, 16, no. 3 (Autumn 1975): 6–18.

113. Jean-Jacques Lebel, interview with the author, Paris, October 9, 1996.

114. Carmen Tessier, "Sachez tout sur le happening, 'art total,' qui vient d'être découvert à Paris," *France-Soir*, June 3, 1964, quoted in Laurence Bertrand-Dorléac, "Demain, vous serez tous des artistes," *Les sixties: Années utopie*, ed. Laurent Gervereau and David Mellor (Paris: Éditions Somogy, 1996), 30–55, on 43.

115. Jean-Paul Sartre, in *Le Nouvel Observateur*, January 18, 1967, quoted in *Jean-Jacques Lebel* (Milan: Edizione Gabriele Mazzotta, 1999), 141.

116. "Declaration against Censorship," dated April 27, 1966, Archives Jean-Jacques Lebel, Paris.

117. Lebel coined the term "poésie directe" in 1963 to denote a sense of direct action through art. See Lebel and Labelle-Rojoux, *Poésie directe des happenings à Polyphonix*, 13.

118. "The Most Admired of Europe's Underground Artists, Jean-Jacques Lebel, put on a Monstrous Marathon of Happenings in Paris," *Life* magazine, February 7, 1967, quoted in *Jean-Jacques Lebel* (1999), 142.

119. See Jean-Jacques Lebel, "Pourquoi Giorgio Baffo aujourd'hui?," in *Jean-Jacques Lebel*, (Paris: Galerie 1900–2000, 1991), 75.

120. Jean-Jacques Lebel, in Badiou et al., *A Theater without Theater*, 41.

121. This section's title is a line spoken by Coulmier, the director of the asylum, in Weiss, *Marat/Sade*, 51. The original German title of Weiss's play was *Die Verfolgung und Ermordung Jean Paul Marats, dargestellt durch die Schauspielgruppe des Hospizes zu Charenton unter Anleitung des Herrn de Sade.*

122. Weiss, "Author's Note on the Historical Background to the Play," in *Marat/Sade*, 112–16, on 112.

123. Weiss, *Marat/Sade*, 35, 42, 107, respectively.

124. Ibid., 42.

125. Ibid., 10. The character was based on Claude-Romain Lauze Duperret (1747–93), whom Corday sought out in Paris with a letter of introduction before she murdered Marat.

126. Ibid., 48.

127. Ibid., 9–10, 15.

128. Ibid., 25.

129. Gunilla Palmstierna-Weiss worked with Peter Weiss from 1952 until their marriage (1964–82); she

received a Tony Award for her costume design for the play in 1965, and she also worked on the costumes for the film.

130. The association between uncontrollable hysteria and sexual ecstasy was celebrated by the avant-garde as I discuss in my essay "Sexology and the Artistic Avant-Garde," in *The Institute of Sexology* (London: Wellcome Trust, 2014), 36–49.

131. Weiss, *Marat/Sade*, 93.

132. Ibid., 28, 92.

133. Ibid., 32.

134. Peter Cohen, *Understanding Peter Weiss* (Columbia: University of South Carolina Press, 1993), 6.

135. See Derek Sayer, *Prague, Capital of the Twentieth Century: A Surrealist History* (Princeton NJ: Princeton University Press, 2013).

136. Günter Schütz, "Peter Weiss à Paris," in *Peter Weiss à Paris: Actes du colloque international, Paris, du 16 au 19 janvier 1997*, ed. Günter Schütz (Paris: Éditions Kimé, 1998), 13–23, on 16. For a detailed history of surrealism in Prague, see Derek Sayer, *Prague, Capital of the Twentieth Century: A Surrealist History* (Princeton, NJ: Princeton University Press, 2013).

137. Peter Weiss, "Aus dem Pariser Journal," in Weiss, *Rapporte*, 2nd ed. (Frankfurt am Main: Suhrkamp, 1981), 83–85, cited in trans. in Cohen, *Understanding Peter Weiss*, 47.

138. Weiss did not name the action, but this must have been the one given the date and description. See Günter Schütz, *Peter Weiss und Paris: 1947–1966* (St. Ingbert: Röhrig, 2004), 172.

139. Peter Weiss, *Notizbücher 1960–1971* (Notebooks 1960–1971), 2 vols. (Frankfurt am Main: Suhrkamp, 1982), 19–23, cited in trans. in Cohen, *Understanding Peter Weiss*, 47.

140. His experience of the Frankfurt Auschwitz trials led more specifically to his next work, the play *The Investigation* (1965), which featured aspects of the trials, including the case of Lilly Tofler and the "Boger swing," an instrument of torture created by Wilhelm Boger. For a detailed account of the trials, see Rebecca Wittmann, *Beyond Justice: The Auschwitz Trial* (Cambridge MA: Harvard University Press, 2005).

141. Peter Brook, "Introduction" (1964) to Weiss, *Marat/Sade*, n.p.

142. Ibid. Brook is here using a complex critical term "total theater," which was very current, internationally, in the 1960s and which had previously been associated with a variety of dramatists, including Erwin Piscator, Jean-Louis Barrault, and Artaud. See Christopher D. Innes, *Avant-Garde Theatre, 1892–1992* (London: Routledge, 2003), 95–107, 125–36.

143. Ibid.

144. Peter Brook, "From Zero to the Infinite," *Zero* (November-December 1960): 6–10, on 15.

145. Peter Brook, *The Shifting Point: Forty Years of Theatrical Exploration, 1946–87* (London: Harper and Row, 1987), 37.

146. Ibid., 43.

147. Charles Morowitz, *Burnt Bridges* (London: Hodder & Stoughton, 1990), 88.

148. Weiss, *Marat/Sade*, 55.

149. Ibid., 56.

150. Ibid., 101.

151. He was reported as stating: "These plays do not belong, or should not, to the Royal Shakespeare. They are entirely out of keeping with our public image and with having the Queen as our patron." *Daily Telegraph*, August 25, 1964, cited in John Elsom, *Post-War British Theatre Criticism* (London: Routledge, 2014), 154.

152. Peter Brook, "An Interview: On 'Marat/Sade,'" *Daily Mail*, August 24, 1964, cited in Steve Nicholson, *Modern British Playwriting: The 1960s; Voices, Documents, New Interpretations* (London: Methuen Drama, 2012), 57.

153. Peter Brook in "We Are All Accomplices," *Flourish*, Royal Shakespeare Theatre Club newspaper 2 (Autumn–Winter 1964–65): 4. This discussion was held on August 23, 1964, and involved Brook, R. D. Laing, Angus Wilson, Jonathan Miller, and was chaired by Michael Kustow, Theatre Club Organiser; the newspaper printed an excerpt from the live discussion.

154. Brook, "Introduction" to Weiss, *Marat/Sade*, n.p.

155. Ibid.

156. Susan Sontag, "Marat/Sade/Artaud," in *Against Interpretation and Other Essays* (London: Penguin Books, 2009), 163–74, on 167.

157. Ibid., 164–65.

158. Brook had come up with the idea of sunken baths, and Jacobs built them under a floor of duckboard; each had hinged flaps that the actors could open to peep up from or descend into as needed. Jacobs said of Brook that he had "a sort of genius for throwing everything into chaos and then working to let the essentials emerge." Sally Jacobs cited in Penelope Gilliatt, "Peter Brook: A Natural Saboteur of Order," *Vogue*, January 1, 1966, 103–5, on 104.

159. The forum took place at the Playhouse on January 28, 1965, and its stated aim was to discuss "the relevancy of the Marat/Sade production, achieved through its function of Artaudian and Brechtian techniques, to the revolutionary currents of our time." See Peter Brook, Leslie Fiedler, Geraldine Lust, Norman, Podhoretz, Ian Richardson, Gordon Rogoff, "Marat/Sade Forum," *Tulane Drama Review* 10, no. 4 (Summer 1966): 214–37, on 216. It should also be noted that *Commentary* later became right-wing but was then on the center-left.

160. On July 2, 1964, President Johnson signed the Civil Rights Act. On December 19, 1964, there were nationwide protests against racial segregation with over fifteen thousand people marching to Times Square in New York alone.

161. Norman Podhoretz, "Marat/Sade Forum," 222–23.

162. Geraldine Lust, "Marat/Sade Forum," 216.

163. Peter Brook, "Marat/Sade Forum," 228.

164. Ian Richardson, "Marat/Sade Forum," 222.

165. See *Collage* (Denison Hall, 296 Vauxhall Bridge Road, London, June 8, 1964) in Lebel and Michaël, *Happenings de Jean-Jacques Lebel*, 124–29.

166. Jean-Jacques Lebel, interview with the author, Normandy, August 11, 2006. See also Michael White, *Empty Seats* (London: Hamish Hamilton, 1984), 77.

167. Brook, *The Shifting Point*, 189. Michael Birkett was producer and David Watkin the cinematographer of the film; the budget was $250,000.

168. Ibid., 190.

169. Peter Brook, letter to Max Waldman, April 12, 1966, Collection Max Waldman Archive, Westport, CT.

170. Peter Brook, *The Empty Space* (1968) (New York: Touchstone, 1996), 136.

171. Tom Prideaux, "A Sensational Drama of Lunacy," *Life*, March 11, 1966, 24–27.

172. David Roberts, "Marat/Sade, or the Birth of Postmodernism from the Spirit of the Avant-Garde," in "The German-Jewish Controversy," special issue, *New German Critique* 38 (Spring–Summer 1986): 112–30, on 118.

173. Michel Beaujour, "Peter Weiss and the Futility of Sadism," *Yale French Studies* 35 (1965): 114–19, on 114. In aligning it with the happening, he also distanced his reading of the play from those who wanted to "pigeon-hole" it as theater of cruelty, such as Sontag.

174. Beaujour, "Peter Weiss and the Futility of Sadism," 117, 118, 119, respectively. Lumumba (1925–61) the first legally elected prime minister of the Democratic Republic of the Congo (DRC) was assassinated on January 17, 1961. Fanon argues in *The Wretched of the Earth* that "[t]he colonized man finds his freedom in and through violence," with each generation discovering its own political mission, or betraying it, words that greatly influenced the student and Black Power movements of the 1960s. See Frantz Fanon, *The Wretched of the Earth* (*Les damnés de la terre*, 1961), with a preface by Jean-Paul Sartre (New York: Grove Press, 1963), 86.

175. Front matter, *Yale French Studies* 35 (1965): n.p.

176. Roberto Matta, "L'illumination," *Nouvelle Revue Française* 172 (April 1, 1967): 906–8, on 907.

177. See *Tel Quel*, "La pensée de Sade," 28 (Winter 1967).

178. Alain Jouffroy, "What's to Be Done about Art?," in *Art and Confrontation: France and the Arts in the Age of Change* (1968), trans. Nigel Foxell (London: Studio Vista, 1970), 175–201, on 175.

179. Ibid., 180–81.

180. Ibid., 210.

181. Jean-Jacques Lebel, "The Night of May 10," *Black Dwarf* 13, no.1 (June 1, 1968): 3.

182. Jean-Jacques Lebel, "Notes on Political Street Theatre, Paris: 1968, 1969," *The Drama Review: TDR* 13, no. 4 (Summer 1969): 111–18, on 112.

183. Daniel Cohn-Bendit, interview with Stéphane Baillargeon, in *Global Village: The 1960s*, ed. Stéphane Aquin (Montreal: Montreal Museum of Fine Arts, 2003), 107–9, on 108.

Conclusion

Epigraph: Interview with Pasolini in Furio Colombo, "We're All in Danger," November 1, 1975, trans. Pasquale Verdicchio, in *In Danger: A Pasolini Anthology*, ed. and intro. Jack Hirschman (San Francisco: City Lights, 2010), 233–42.

1. Angela Carter, *The Sadeian Woman: An Exercise in Cultural History* (London: Virago Press, 1979), 81.

2. Ibid., 111.

3. Roland Barthes, *Sade, Fourier, Loyola* (1971), trans. Richard Miller (London: Jonathan Cape, 1977), 35.

4. See Colleen Ryan-Scheutz, *Sex, the Self, and the Sacred: Women in the Cinema of Pier Paolo Pasolini* (Toronto: University of Toronto Press, 2007), 6–7, 202; Fabio Vighi, *Traumatic Encounters in Italian Film: Locating the Cinematic Unconscious* (Bristol, UK: Intellect Books, 2006), 88–94.

5. Giuliana Bruno, "The Body of Pasolini's Semiotics," in *Pier Paolo Pasolini: Contemporary Perspectives*, ed. Patrick Allen Rumble and Bart Testa (Toronto: University of Toronto Press, 1994), 88–105, on 90.

6. See Paul Ginsborg, *A History of Contemporary Italy, 1943–1980* (London: Penguin, 1990), 348–405.

7. In *Salò: Yesterday and Today* (2002), Pasolini states, "I gave the screenplay a kind of Dantesque verticality and order." He also explains that this demanded an ordered directorial style, with only a little improvisation on the part of actors; furthermore, where he wanted improvisation or greater emotional rawness, he would only notify the actor of the details of the scene five or ten minutes before he shot it. See *Salò: Yesterday and Today* (Amaury Voslion, Carlotta Films, documentary, 33 mins., 2002).

8. Gideon Bachmann, "Pasolini on de Sade: An Interview during the Filming of *The 120 Days of Sodom*," *Film Quarterly* 2 (1975–76): 39–45, on 42.

9. Armando Maggi, *The Resurrection of the Body: Pier Paolo Pasolini from Saint Paul to Sade* (Chicago: University of Chicago Press, 2009), 306.

10. Pier Paolo Pasolini, "Il sesso come metafora del potere" (self-interview), *Corriere della sera*, March 25, 1975, in Pier Paolo Pasolini, *My Cinema* (Bologna: Fondazione Cineteca Di Bologna, 2012), 182–87, on 185.

11. Pasolini, cited in Joseph Francese, "Pasolini's 'Roman Novels,' the Italian Communist Party, and the Events of 1956," in *Pier Paolo Pasolini: Contemporary Perspectives*, ed. Patrick Allen Rumble and Bart Testa (Toronto: University of Toronto Press, 1994), 22–55, on 37n21.

12. Robert Gordon, *Pasolini* (Oxford: Oxford University Press, 1996), 216.

13. This Catholicism is echoed at the end of the film when the libertines' daughters sit in a bath of excrement and one shouts, "God, why have you forsaken me!," as the camera pans to boys playing cards, oblivious to the females' torment.

14. Pasolini cited in Sam Rohdie, *The Passion of Pier Paolo Pasolini* (London: BFI, 1995), 122.

15. Ibid., 78–79.

16. Pasolini, "Il sesso come metafora del potere," 184.

17. Pier Paolo Pasolini, "Manifesto for a New Theatre," trans. Thomas Simpson, *PAJ: A Journal of Performance and Art* 29, no. 1 (January 2007): 126–38, on 129, 138n6.

18. Pasolini, "Il sesso come metafora del potere," 183.

19. This can be said of all the soundtrack, created by Ennio Morricone, and the selection of piano pieces performed by the fourth storyteller (Sonia Saviange), which allows music to serve as the fourth "voice" in the film. They vary from pop music to Chopin's Preludes in C minor and E minor. The choice of artworks is less obvious; although the futurists favored technological advance and geometry and can be read in light of fascist aesthetics, the Bauhaus and Duchamp did not, and they represented the very avant-garde deemed "degenerate" and persecuted by the Nazis.

20. George Ferguson, *Signs and Symbols in Christian Art* (Oxford: Oxford University Press, 1959), 30. It is well-established that Pasolini was influenced by symbolism, from his earliest poetry of the 1940s, including Baudelaire, Rimbaud, and Lautréamont. See Stephen Sartarelli, "Pier Paolo Pasolini: A Life in Poetry," in *The Selected Poetry of Pier Paolo Pasolini: A Bilingual Edition* (Chicago: University of Chicago Press, 2014), 1–58, on 13. References to flowers are frequent in Pasolini's work. See Mary Di Michele, *The Flower of Youth: Pier Paolo Pasolini Poems* (Toronto: ECW Press, 2011), 84.

21. Georges Bataille, "The Language of Flowers" (*Documents* 3 [June 1929]: 160–68), in *Visions of Excess: Selected Writings, 1927–1939*, trans. Allan Stoekl, with Carl R. Lovitt and Donald M. Leslie Jr. (Minneapolis: University of Minnesota Press, 1985), 10–14, on 14.

22. See Bachmann, "Pasolini on de Sade," 41. Neither Pasolini nor Bachmann explicitly remarks on the fact that the five authors whom Pasolini cites in the opening titles of his film are all French, but it is worth noting here as an example of the important and well-documented exchange of ideas between Italy and France, in literature and in cinema, in the mid-twentieth century. For example, see Rohdie, *The Passion of Pier Paolo Pasolini*, 35, on the links between Pasolini, Italian neorealism, and the French New Wave in cinema. It should be noted, however, that a critique of incarceration and penal regimes was already evident in Pasolini's work much earlier—for example, in the final sequences of *Mamma Roma*, in which the boy Ettore is unjustly imprisoned and shackled, and whose jailers recite terrifying passages from Dante's *Inferno*.

23. Maurice Blanchot, "Sade's Reason" (1949), in *Lautréamont and Sade*, trans. Stuart Kendell and Michelle Kendall (Stanford, CA: Stanford University Press, 2004), 12.

24. "Salò o Le 120 giornate di Sodoma" (1975), from "Conversazione con Pier Paolo Pasolini," August 1975, in Pier Paolo Pasolini, *My Cinema*, 191.

25. Maurice Blanchot, "The Laughter of the Gods" (1965), in Pierre Klossowski, *The Decadence of the Nude / La décadence du nu*, ed. Sarah Wilson (London: Black Dog Publishing, 2002), 161–91, on 175.

26. Simone de Beauvoir, "Must We Burn Sade?," in D.A.F. de Sade, *The 120 Days of Sodom and Other Writings*, trans. Austryn Wainhouse and Richard Seaver, with intro. by Simon de Beauvoir (New York: Grove Press, 1966), 3–64.

27. Philippe Sollers, *Writing and the Experience of Limits*, ed. David Hayman, trans. David Hayman and Philip Barnard (New York: Columbia University Press, 1983), 83 (originally published as *L'écriture et l'expérience des limites* [Paris: Éditions du Seuil, 1968]).

28. Roland Barthes, "Sade-Pasolini," *Le Monde*, June 16, 1976, 25, emphasis in the original.

29. For the official statement of the French government on the state's purchase of the scroll, see *Communiqué de presse: Classement en tant que Trésors nationaux, d'un manuscrit du Marquis de Sade et d'un ensemble d'écrits d'André Breton*, French Ministry of Culture, December 19, 2017: http://www.culture.gouv.fr/Presse/Archives-Presse/Archives-Communiques-de-presse-2012–2018/Annee-2017/Classement-en-tant-que-Tresors-nationaux-d-un-manuscrit-du-Marquis-de-Sade-et-d-un-ensemble-d-ecrits-d-Andre-Breton.

30. The new series by Les Échappés also included illustrated editions of Sophocles's *Antigone* and Molière's *Don Juan*, and has more recently been joined by editions of Voltaire's *Candide* and Baudelaire's *Les fleurs du mal*. See http://lesechappes.com/fr/ouvrages?type=84.

The series has been extensively publicized and reviewed in the mainstream media in France—for example, in an interview with *Charlie Hebdo* illustrators that links the new series, the newspaper, and the 2015 attack: https://www.20minutes.fr/medias/2131995–20170914-peu-epee-damocles-tete-explique-riss-charlie-hebdo.

31. Pasolini was murdered on the beach at Ostia on November 2, 1975. A young man by the name of Giuseppe Pelosi (1958–2017) was convicted of the murder in 1976 but in 2005 retracted his confession. Biggie Smalls was murdered in a drive-by shooting in Los Angeles on March 9, 1997.

32. Paul Chan, "An Interview with Paul Chan," by George Baker, New York, July 16, 2007, *October* 123 (Winter 2008): 205–33, on 215.

33. Paul Chan, "Paul Chan," interview by Nell McClister, *BOMB* 92 (Summer 2005): 22–29, on 28.

34. In 2010, Chan also moved his art into publishing and founded Badlands Unlimited, a press that publishes e-books, paper books, erotica, and artists' works in digital and print forms. See https://badlandsunlimited.com.

35. See *Oh Juliette* (2008), font in George Baker and Eric Banks, eds., *Paul Chan: Selected Writings 2000–2014* (Basel: Laurenz Foundation; New York: Badlands Unlimited, 2014), 264–65. See also Brian Droitcour, "Man of Letters," *Art in America*, March 26, 2015, 78–85.

36. Paul Chan, *The Essential and Incomplete Sade for Sade's Sake* (New York: Badlands Unlimited, 2010), 101.

37. Ibid., 102.

38. Ibid., 102–3.

39. Paul Chan, "A Harlot's Progress: On Pier Paolo Pasolini," a 2012 lecture presented at PS1 MOMA, New York, reproduced in Baker and Banks, *Paul Chan: Selected Writings*, 348–54, on 352.

40. When the widespread abuse of prisoners at Abu Ghraib prison was exposed in the international media, the soldier was soon identified as Specialist Sabrina Harman from Virginia, who was stationed as a guard, and the prisoner as Manadel al-Jamadi, an insurgent who died during interrogation on November 4, 2003. Harman was not involved in the torture of al-Jamadi but was subsequently sentenced to six months' imprisonment in the Naval Consolidated Brig in San Diego for inflicting sexual, physical, and psychological abuse on prisoners of war, acts that were commonplace in a systematic regime of torture, or "enhanced interrogation," on the front lines of the United States' War on Terror. See Philip Gourevitch and Errol Morris, "The Woman behind the Camera at Abu Ghraib," *New Yorker*, March 24, 2008, 44–57; and Philip Gourevitch and Errol Morris, *Standard Operating Procedure* (New York: Penguin, 2008).

41. Susie Linfield, *The Cruel Radiance: Photography and Political Violence* (Chicago: University of Chicago Press, 2010), 152.

42. Susan Sontag, "Regarding the Torture of Others," *New York Times Magazine*, May 23, 2004, 24–30.

43. Sade, *Letters from Prison*, trans. Richard Seaver (New York: Arcade Publishing, 1999), 188, emphasis in original.

SELECT BIBLIOGRAPHY

Key Works by D.A.F. de Sade

Les 120 journées de Sodome ou L'école du libertinage. Paris: Club des Bibliophiles, 1904.

The 120 Days of Sodom and Other Writings (1965). Translated by Austryn Wainhouse and Richard Seaver. New York: Grove Press, 1987.

Les infortunes de la vertu (1787). Paris: Éditions du Point du Jour, 1946.

Juliette. Rome: Colophon, 1944.

Juliette. Translated by Austryn Wainhouse. 6 vols. in 1. New York: Grove Press, 1968.

Justine, ou Les malheurs de la vertu. 2 vols. En Hollande: Chez les Librairies Associés [Paris: Girouard], 1791.

Justine. With frontispiece by Hans Bellmer and preface by Georges Bataille. Paris: Presse du Livre Français, Collection Le Soleil Noir, 1950.

Letters from Prison. Translated and introduced by Richard Seaver. New York: Arcade Publishing, 1999.

"The Misfortunes of Virtue" and Other Early Tales (1992). Translated by David Coward. Oxford: Oxford University Press, 1999.

"Notes on the Novel" (1800). *Yale French Studies* 35 (1965): 12–19.

La nouvelle Justine, ou Les malheurs de la vertu, suivie de L'histoire de Juliette, sa soeur: Ouvrage orné d'un frontispiece et de cent sujets graves avec soin. 10 vols. En Hollande [Paris], 1797 [1799–1801].

Oeuvres complètes. Edited by Gilbert Lely, 16 vols. Paris: Cercle du Livre Précieux, 1966–67.

Oeuvres complètes du Marquis de Sade. Paris: Jean-Jacques Pauvert, 1947–72.

La philosophie dans le boudoir: Ouvrage posthume de l'auteur de "Justine." 2 vols. A Londres: Aux dépens de la compagnie, 1795.

Three Complete Novels: "Justine," "Philosophy in the Bedroom," "Eugénie de Franval" and Other Writings (1965). Translated by Richard Seaver and Austryn Wainhouse. London: Arrow, 1991.

Introduction

Blanchot, Maurice. *Lautréamont and Sade* (1949). Translated by Stuart Kendall and Michelle Kendall. Stanford, CA: Stanford University Press, 2004.

Bloch, Iwan. *Marquis de Sade: His Life and Works* (1900). Translated by James Bruce. Amsterdam: Fredonia Books, 2002.

Bürger, Peter. *Theory of the Avant-Garde*. Translated by Michael Shaw. Manchester: Manchester University Press, 1974.

Carter, Angela. *The Sadeian Woman: An Exercise in Cultural History*. London: Virago Press, 1979.

d'Alméras, Henri. *Le Marquis de Sade: L'homme et l'écrivain*. Paris: Albin Michel, 1906.

Darnton, Robert. *The Forbidden Best-Sellers of Pre-revolutionary France*. New York: W. W. Norton, 1995.

DeJean, Joan. *The Reinvention of Obscenity: Sex, Lies, and Tabloids in Early Modern France*. Chicago: University of Chicago Press, 2002.

Didier, Béatrice. "Juliette, femme forte de l'écriture sadienne." *Obliques: La Femme Surréaliste* 14–15 (1977): 271–77.

Dworkin, Andrea. *Pornography: Men Possessing Women*. London: Penguin Books, 1981.

Eco, Umberto. *The Open Work* (1962). Translated by Anna Cancogni. Cambridge, MA: Harvard University Press, 1989.

Freud, Sigmund. *Beyond the Pleasure Principle and Other Writings*. Translated by John Reddick. London: Penguin, 2003.

———. *Standard Edition of the Complete Psychological Works of Sigmund Freud*, vol. 7. Edited and translated by James Strachey. London: Hogarth Press, 1970.

Hunt, Lynn, ed. *Eroticism and the Body Politic*. Baltimore, MD: Johns Hopkins University Press, 1991.

———, ed. *The Invention of Pornography: Obscenity and the Origins of Modernity, 1500–1800*. New York: Zone Books, 1993.

Irigaray, Luce. *This Sex Which Is Not One* (1977). Translated by Catherine Porter. Ithaca, NY: Cornell University Press, 1985.

Janin, Jules. *Le Marquis de Sade*. Paris: Chez les marchands de nouveautés, 1834.

Kant, Immanuel. *Critique of Practical Reason* (1788). New York: Macmillan, 1993.

Lacan, Jacques. "Kant with Sade" (1963). Translated by James B. Swenson Jr. *October* 51 (Winter 1989): 55–75.

Le Brun, Annie. *Sade: A Sudden Abyss* (1986). Translated by Camille Naish. San Francisco: City Lights, 1990.

———. *Sade: Attaquer le soleil*. Paris: Gallimard and Musée d'Orsay, 2014.

Lely, Gilbert. *The Marquis de Sade: A Biography* (1952–57). Translated by Alec Brown. London: Elek Books, 1961.

Lever, Maurice. *Marquis de Sade: A Biography* (1991). Translated by Arthur Goldhammer. London: Harper Collins, 1993.

Miller, Nancy K. "Libertinage and Feminism." *Yale French Studies* 94 (1998): 17–28.

Paglia, Camille. *Sexual Personae: Art and Decadence from Nefertiti to Emily Dickinson* (1990). London: Penguin Books, 1991.

Schaeffer, Neil. *The Marquis de Sade: A Life*. Cambridge, MA: Harvard University Press, 2000.

Sontag, Susan. *Styles of Radical Will*. New York: Penguin Books, 2009.

Suleiman, Susan Rubin. *Subversive Intent: Gender, Politics, and the Avant-Garde*. Cambridge MA: Harvard University Press, 1990.

Williams, Linda. *Hard Core: Power, Pleasure, and the "Frenzy of the Visible"* (1989). Berkeley: University California Press, 1999.

Chapter One

Airaksinen, Timo. *The Philosophy of the Marquis de Sade*. London: Routledge, 1995.

Barker, Emily. "Reading the Greuze Girl: The Daughter's Seduction." *Representations* 117 (Winter 2012): 86–119.

Bastide, Jean-François de. *The Little House: An Architectural Seduction* (1758–62). Translated and introduced by Rodolphe el-Khoury. Preface by Anthony Vidler. New York: Princeton Architectural Press, 1996.

Burke, Edmund. *Reflections on the Revolution in France* (1790). Edited by Conor Cruise O'Brien. Harmondsworth, UK: Penguin Books, 1973.

Crow, Thomas. *Emulation: Making Artists for Revolutionary France*. New Haven, CT: Yale University Press, 1995.

Diderot, Denis. *The Nun* (1796). Translated by Russell Goulbourne. Oxford: Oxford University Press, 2005.

Fort, Bernadette, ed. *Fictions of the French Revolution*. Evanston, IL: Northwestern University Press, 1991.

Hunt, Lynn. *The Family Romance of the French Revolution*. Berkeley: University California Press, 1992.

———. *Politics, Culture, and Class in the French Revolution*. London: Methuen, 1984.

Johnson, Dorothy. *Jacques-Louis David: Art in Metamorphosis*. Princeton, NJ: Princeton University Press, 1993.

Klossowski, Pierre. *Sade My Neighbor* (1947). Translated by Alphonso Lingis. London: Quartet Books, 1992.

Lajer-Burcharth, Ewa. *Necklines: The Art of Jacques-Louis David after the Terror*. New Haven, CT: Yale University Press, 1999.

Landes, Joan B. *Visualizing the Nation: Gender, Representation, and Revolution in Eighteenth-Century France*. Ithaca, NY: Cornell University Press, 2001.

———. *Women and the Public Sphere in the Age of the French Revolution*. Ithaca, NY: Cornell University Press, 1988.

Levy, Darline Gay, Harriet Branson Applewhite, and Mary Durham Johnson, eds. *Women in Revolutionary Paris 1789–1795: Selected Documents*. Urbana: University of Illinois Press, 1980.

Mainardi, Patricia. *Husbands, Wives, and Lovers: Marriage and Its Discontents in Nineteenth-Century France*. New Haven, CT: Yale University Press, 2003.

Michelet, Jules. *Deux héroïnes de la révolution: Madame Roland—Charlotte Corday*. London: Edward Arnold, 1905.

Miller, Nancy K. *French Dressing: Women, Men and Ancien Régime Fiction*. London: Routledge, 1994.

Outram, Dorinda. *The Body and the French Revolution: Sex, Class, and Political Culture*. New Haven, CT: Yale University Press, 1989.

Ozouf, Mona. *Festivals and the French Revolution*. Cambridge, MA: Harvard University Press, 1991.

———. "Space and Time in the Festivals of the French Revolution." *Comparative Studies in Society and History* 17, no. 3 (July 1975): 372–84.

Pierse, Síofra. "The Spectatorial Gaze: Viewer-Voyeur Dynamics in Book Illustrations of Diderot's *La Religieuse*," *Journal for Eighteenth-Century Studies* 39, no. 4 (2016): 599–620.

Potts, Alex. "Beautiful Bodies and Dying Heroes: Images of Ideal Manhood in the French Revolution." *History Workshop Journal* 30, no. 1 (1990): 1–21.

Rosenblum, Robert. *Transformations in Late Eighteenth-Century Art*. Princeton, NJ: Princeton University Press, 1967.

Rousseau, Jean-Jacques. *Émile, or Treatise on Education* (1762). Translated by William H. Payne. New York: D. Appleton, 1907.

———. *Politics and the Arts. Letter to M. d'Alembert on the Theatre* (1758). Translated and introduced by Allan Bloom. Ithaca, NY: Cornell University Press, 1968.

Sheriff, Mary D. *Moved by Love: Inspired Artists and Deviant Women in Eighteenth-Century France*. Chicago: University Chicago Press, 2004.

Thomas, Chantal. "Heroism in the Feminine: The Examples of Charlotte Corday." *Eighteenth Century* 30, no. 2 (1989): 67–82.

———. *The Wicked Queen: The Origins of the Myth of Marie-Antoinette*. Translated by Julie Rose. New York: Zone Books, 1999.

Vaughan, William, and Helen Weston, eds. *David's "The Death of Marat."* Masterpieces of Western Painting. Cambridge: Cambridge University Press, 2000.

Chapter Two

Apollinaire, Guillaume. *The Eleven Thousand Rods* (1907). In *Flesh Unlimited: Surrealist Erotica*, translated by Alexis Lykiard. N.p.: Creation Books, 2000.

Bataille, Georges. *The Absence of Myth: Writings on Surrealism*. Translated and introduced by Michael Richardson. London: Verso, 1994.

Black, Candice, ed. *Sade: Sex and Death; The Divine Marquis and the Surrealists*. N.p.: Solar Books, 2010; distributed by University of Chicago Press.

Bourgeade, Pierre. *Bonsoir, Man Ray*. Paris: Pierre Belfond, 1990.

Breton, André. *Anthology of Black Humour* (1966). Translated and introduced by M. Polizotti. London: Telegram, 2009.

Dean, Carolyn. *The Self and Its Pleasures: Bataille, Lacan, and the History of the Decentered Subject*. Ithaca, NY: Cornell University Press, 1992.

Desnos, Robert. *Liberty or Love!* (1927). Translated and introduced by Terry Hale. London: Atlas Press, 1993.

Éluard, Paul. "D.A.F. Sade, écrivain fantastique et révolutionnaire." *La Révolution surréaliste*, December 1, 1926, 9.

Éluard, Paul, and Man Ray, *Les mains libres*. Paris: Bucher, 1937.

Gabin, Jean-Louis. *Gilbert Lely: Biographie*. Paris: Librairie Séguier, 1991.

Greeley, Robin. *Surrealism and the Spanish Civil War*. New Haven, CT: Yale University Press, 2006.

Heine, Maurice. "Martyres en Taille-Douce." *Minotaure* 9 (1936): 51–53.

Jeffett, William, ed. *André Masson: The 1930s*. St. Petersburg, FL: Salvador Dalí Museum, 2000.

Leiris, Michel. *André Masson et son univers*. Paris: Trois Collines, 1947.

Livingston, Jane. "Man Ray and Surrealist Photography." In *L'amour fou: Photography and Surrealism*, 115–52. Washington DC: The Corcoran Gallery of Art; New York: Abbeville Press, 1985.

Masson, André. *Le rebelle du surréalisme: Écrits*. Paris: Hermann, 1976.

Masson, André, and Françoise Levaillant, eds. *Les années surréalistes: Correspondance 1916–1942*. Paris: La Manufacture, 1990.

Pierre, José, ed. *Investigating Sex: Surrealist Discussions 1928–1932*. Translated by Malcolm Imrie. Afterword by Dawn Ades. London: Verso, 1992.

Poling, Clark V. *André Masson and the Surrealist Self*. New Haven, CT: Yale University Press, 2008.

Ray, Man. *Self-Portrait*. New York: Penguin, 2012.

Suyra, Michel. *Georges Bataille: La mort à l'oeuvre*. Paris: Gallimard, 1992.

Chapter Three

Antliff, Mark. *Avant-Garde Fascism: The Mobilization of Myth, Art, and Culture in France*. Durham, NC: Duke University Press, 2007.

Aury, Dominique, *Lecture pour tous*. Paris: Gallimard, 1958.

———. *Vocation: Clandestine*. Paris: Gallimard, 1999.

Beauvoir, Simone de. "Must We Burn Sade?" In D.A.F. de Sade, *The 120 Days of Sodom and Other Writings*. Translated by Austryn Wainhouse and Richard Seaver, with intro. by Simon de Beauvoir. New York: Grove Press, 1966. Originally published as "Faut-il brûler Sade?" in two parts in *Les Temps modernes*: 74 (December 1951): 1002–33; and 75 (January 1952): 1197–230.

———. *The Second Sex*. Translated and edited by H. M. Parshley. Harmondsworth, UK: Penguin Books, 1989.

Bellmer, Hans. *Petit anatomie de l'inconscient physique ou L'anatomie de l'image*. Paris: Terrain Vague, 1957.

Bonaparte, Marie. *De la sexualité de la femme* (1949). Paris: Presses Universitaires de France, 1951. Translated as *Female Sexuality*, New York: International Universities Press, 1953.

Camus, Albert. *The Rebel* (1951). Translated by Anthony Bower. London: Penguin Books, 1971.

———. *Resistance, Rebellion, and Death*. Translated and introduced by Justin O'Brien. New York: Modern Library, 1963.

Dardigna, Anne-Marie. *Les châteaux d'Eros ou Les infortunes du sexe des femmes*. Paris: François Maspero, 1981.

David, Angie. *Dominique Aury*. Paris: Éditions Léo Scheere, 2006.

Deforges, Régine. *O m'a dit: Entretiens avec Pauline Réage*. Paris: Jean-Jacques Pauvert, 1975.

Gauthier, Xavier. *Leonor Fini* (1973). Paris: Musée de Poche, 1979.

Kauffman, Dorothy. *Édith Thomas: A Passion for Resistance*. Ithaca, NY: Cornell University Press, 2004.

———. "The Story of Two Women: Dominique Aury and Edith Thomas." *Signs* 23, no. 4 (Summer 1998): 883–905.

Mahon, Alyce. "Hans Bellmer's Libidinal Politics." In *Surrealism, Politics, Culture*, edited by R. Spiteri and D. LaCoss, 257–61. Aldershot, UK: Ashgate, 2003.

———. "Pierre Klossowski, Theo-Pornologer." In *Pierre Klossowski: The Decadence of the Nude / Pierre Klossowski: La décadence du nu*, edited by Sarah Wilson, 33–101. London: Black Dog Publishing, 2002.

Mandiargues, André Pieyre de. *Masques de Leonor Fini*. Paris: La Parade, 1951.

Mitrani, Nora. "Des chats et des magnolias." *Le Surréalisme même* 1 (1956): 6–10.

———. *Rose au coeur violet*. Paris: Terrain Vague, 1992.

Paulhan, Jean. *Les fleurs de tarbes ou La terreur dans les letters*. Paris: Éditions Gallimard, 1941.

———. *Progress in Love on the Slow Side*. Translated by Christine Moneera Laenned and Michael Syrotinski. Lincoln: University of Nebraska Press, 1994.

Pauvert, Jean-Jacques, ed. *L'affaire Sade: Compte-rendu exact du procès intenté par le Ministère public*. Paris: Éditions Jean-Jacques Pauvert, 1957.

Réage, Pauline. *Story of O*. Translated by Sabine Desire. London: Corgi Books, 1994.

———. *Return to the Château: Story of O Part II; Preceded by "A Girl in Love."* Translated by Sabine d'Estrée. London: Corgi Books, 1994.

St. Jorre, John de. *The Good Ship Venus: The Erotic Voyage of the Olympia Press*. London: Hutchinson, 1994.

Thomas, Édith. *Eve and the Others*. Translated by Estella Eirinberg. Sioux City, IA: Continental Editions, 1976. Originally published as *Eve et les autres*. Paris: Gizard, 1952.

———. *The Women Incendiaries* (1963). Translated by James Atkinson and Starr Atkinson. Chicago: Haymarket Books, 2007.

Chapter Four

Adorno, Theodor, and Max Horkheimer. "Juliette, or Enlightenment and Morality." In *Dialectic of Enlightenment: Philosophical Fragments*, edited by Gunzelin Schmid Noerr, translated by Edmund Jephcott, 63–93. Stanford CA: Stanford University Press, 2002.

Artaud, Antonin. *The Theater and Its Double* (1938). Translated by Mary Caroline Richards. New York: Grove Press, 1958.

Bataille, Georges. "Sade." In *Literature and Evil* (1957). Translated by Alastair Hamilton, 89–106. London: Penguin, 2012.

Baum, Kelly. "The Sex of the Situationist International." *October* 126 (Fall 2008): 23–43.

Bellmer, Hans. *Obliques: Numéro special sur Hans Bellmer.* Paris: Borderie, 1975.

Breton, André. "The Grand Ceremonial Restored to Us at Last by Jean Benoît." In *Surrealism and Painting,* translated by Simon Watson Taylor, 386–90. Boston: MFA Publications, 2002.

Brook, Peter. *The Shifting Point: Forty Years of Theatrical Exploration, 1946–87.* London: Harper & Row, 1987.

Brook, Peter, Leslie Fiedler, Geraldine Lust, Norman Podhoretz, Ian Richardson, and Gordon Rogoff. "Marat/Sade Forum." *Tulane Drama Review* 10, no. 4 (Summer 1966): 214–37.

Chollet, Laurent, ed. *Grand tableau antifasciste collectif.* Paris: Éditions Dagorno, 2000.

Cohen, Peter. *Understanding Peter Weiss.* Columbia: University of South Carolina Press, 1993.

Debord, Guy. *"Society of the Spectacle" and Other Films.* London: Rebel Press, 1992.

Hénaff, Marcel. *Sade: The Invention of the Libertine Body* (1978). Translated by Xavier Callahan. Minneapolis: University of Minnesota Press, 1999.

Jay, Martin. *The Dialectical Imagination: A History of the Frankfurt School and the Institute of Social Research 1923–1950.* Berkeley: University California Press, 1973.

Lebel, Jean-Jacques, and Arnaud Labelle-Rojoux. *Poésie directe des happenings à Polyphonix.* Paris: Opus International, 1994.

Lebel, Jean-Jacques, and Androula Michaël. *Happenings de Jean-Jacques Lebel ou L'insoumission radicale.* Paris: Hazan, 2009.

Mahon, Alyce. "Twist the Body Red: The Art and Lifewriting of Unica Zürn." *n.paradoxa* 3 (1999): 56–65.

Sontag, Susan. "Marat/Sade/Artaud." In *"Against Interpretation" and Other Essays,* 163–74. London: Penguin Books, 2009.

Sussman, Elisabeth, ed. *On the Passage of a Few People through a Rather Brief Moment in Time: The Situationist International 1957–1972.* Cambridge, MA: MIT Press; Boston: Institute of Contemporary Art, 1989.

Weiss, Peter, *Marat/Sade: The Persecution and Assassination of Marat as Performed by the Inmates of the Asylum of Charenton under the Direction of the Marquis de Sade* (1964). Introduction by Peter Brook. London: Marion Boyars, 1982.

Conclusion

Bachmann, Gideon. "Pasolini on de Sade: An Interview during the Filming of 'The 120 Days of Sodom.'" *Film Quarterly* 2 (1975–76): 39–45.

Baker, George, and Eric Banks, eds. *Paul Chan: Selected Writings 2000–2014.* Basel: Laurenz Foundation; New York: Badlands Unlimited, 2014.

Chan, Paul. "An Interview with Paul Chan." By George Baker. New York, July 16, 2007. *October* 123 (Winter 2008): 205–33.

Gourevitch, Philip, and Errol Morris. "The Woman behind the Camera at Abu Ghraib," 44–57. *New Yorker,* March 24, 2008.

Maggi, Armando. *The Resurrection of the Body: Pier Paolo Pasolini from Saint Paul to Sade.* Chicago: University of Chicago Press, 2009.

Pasolini, Pier Paolo. *In Danger: A Pasolini Anthology.* Edited and introduced by Jack Hirschman. San Francisco: City Lights Books, 2010.

Sontag, Susan. "Regarding the Torture of Others." *New York Times Magazine,* May 23, 2004.

INDEX

Note: Illustrations are indicated by **bold** page numbers.

Eco, Umberto, 24, 184–85

education: Enlightenment focus on children and, 32, 51, 54; festivals as public, 56, 61–62; *The Good Education* (Chardin), **50**, 51; iconography of, 51–52; illustrations as sexual, 53; imagination and, 23; libertine pedagogy in Sade, 3–4, 23, 31, 38, 41–44, 51–54, 61, 95–96; literature as moral education, 51–52; politics and, 79; punishment and, 63; Sade's childhood education, 10–11; schools as sites of libertine, 63, 94–95; sexual knowledge in *Justine*, 41–42; of women's flesh linked to moral education, 36

Ehrmann, Gilles, 213

18 Happenings in 6 Parts (Kaprow), 201

Einstein, Carl, 115

The Eleven Thousand Rods (Apollinaire), 90–92

Éluard, Nusch, 102

Éluard, Paul, 7–10, 100, 106–9, 192

Embirikos, Andreas, 156

Émile (Rousseau), 15

emotives, 17

The Empty Space (Brook), 218

Encyclopedia (d'Alembert), 37

The End of the World (Fini), 172

engraving, 99

Enlightenment: Adorno and Horkheimer on Sade and, 182–83; and anti-clericalism, 15; children as idealized, 32, 51–52; and "coming of age" in fiction, 33; and domination, 182–83; the Great Terror linked to, 123, 182, 235; and instrumental rationalism, 182; Sade's critique and rejection of Enlightenment ideas and ideals, 1, 15–16, 24, 31, 54, 182, 234; Sade's *Philosophy in the Bedroom* as critique of, 15–16; sexual codes and social controls, 15, 20; women's role and status during, 29, 182–83

Ernst, Max, 172

Eros (life drive): Eros/Thanatos dichotomy, 23, 89, 93–94, 115–16; and surrealists, 89

EROS exhibition (Exposition InteRnatiOnale du Surréalisme), 194–96, 199–200

erotica: audience and market for, 13, 174; Diderot on erotic art as source of corruption, 62; and the female victim's perspective, 153; French cultural tradition, 129; literary tradition, 134, 150

"Erotic Almanac" (Bataille/Pia, planned publication), 111

Eroticism and Art (Mahon), 17

érotisme noir, 89, 100, 126, 133

Erró (Guðmundur Guðmundsson), 218

"Essay on Women" (Diderot), 36

The Essential and Incomplete Sade for Sade's Sake (Chan), 232–33

Eve and the Others (Thomas), 147, 148

evil, 2, 15, 16, 86, 111, 123, 125; Sade and "philosophy of evil," 129; vice and the accumulation of, 63

"Evil and the Negation of Others…" (Klossowski), 125

excess: Masson and expression of Sadean excess, 116–17; Sade and hyperbole, 112–13

Execution of the Testament of the Marquis de Sade (Benoît, performance, 1959), 26, 181, 194–95, 213; costume for, **195**

existentialism, 2, 155, 157–60

Exposition InteRnatiOnale du Surréalisme (EROS), Galerie Daniel Cordier, Paris, December 15th, 1959–January 29th, 1960, 194–96, 199–200

family as institution: and "fraternity" as social model, 37; French Revolution and celebration of idealized, 56; gender roles in the Republican family, 36–37, 75–76; incest as plot in Sade's works, 32–33; *jeune fille* role within, 33, 36; law and patriarchal authority within, 36–37; monarchy associated with patriarchal, 37; Rousseau and idealized, 49; Sade and disownership of, 85; Sade and subversion of, 12, 16, 29, 32–33, 37–38, 48–49, 100, 193, 197–98; situationism and, 193; as stage and space for obscenity, 49–51, 66–67, 133, 197; surrealists and rejection of, 95, 100, 193. *See also* father figures; mother figures

Fanon, Frantz, 192, 220

fascism, 24; as aesthetic, 228; and the anarchy of power, 226; avant-garde and confrontation of, 25; Bataille and opposition to, 117–18; Camus on Sade and, 158; Lebel and art as protest, 203–4; Maulnier and, 139–40; neo-fascism as context for art, 228; Pasolini's *Salò* as critique of, 223–24, 230; Sadean imagination and, 15–16; and Sade as hero of freedom, 107; surrealists and resistance to, 122; Thomas and anti-fascist journalism, 146

father figures, 23, 76; Freud on, 23, 102; legal authority over the family, 36–37; monarchy and paternal power, 37; Oedipal role and, 23–24, 32–33; Revolution and rejection of, 76; role as protector of virtue, 42–43; in Rousseau's *Julie*, 33; Sade and defiance of, 192–93; in Sade's works, 4–5, 13, 32–33, 42–43, 52–53; as victims, 49–50, 99, 133

la fautromanie (fuckomania), 13

female protagonists: agency of, 37–38, 63–64; and the body, 4–5; and challenges to gender norms, 21, 29, 46 (*see also* phallic virility assigned to *under this heading*); and "coming of age" in Enlightenment fiction, 33; curiosity as character trait, 34; as depersonalized or objectified, 175; Diderot's, 29, 33–34, 36; education of, 23, 51–53, 63–64; as embodiment of philosophical arguments, 63–67; feminism and Sade's, 21; identification with, 172; as instigators of violence, 63; *jeunes filles* and, 36–37, 51–52, 135; *jouissance* and, 16–17, 29, 154; and libertine philosophy, 4, 30–31, 37–38, 41–42, 45–46, 63–67; as monstrous, 29, 32–33, 82; and personalized violence in Sade, 87; phallic virility assigned to, 21, 37–38, 155, 174–75, 196, 211; Sadean heroines as virtuous figure, 112; in Sade's historical novels, 14; and sexual knowledge, 37–38, 53–54; as storytellers in Sade, 21, 48, 223–24; traditional gender roles challenged or subverted by, 4–5; as victims, 63; virginal purity of, 38; and virtue as feminine, 3–4; and virtue/vice dichotomy, 33–34, 37–48, 87; virtuous depictions in Enlightenment fiction, 32–33

female roles: Corday and, 72–73, 77, 80–82; Freudian psychology and, 23; interiority and private spaces, 10; as Other, 157–58; patriarchal ideal and, 153, 157–58; political agency and, 80–81; and the private domestic sphere, 77; in Sadean imagination, 4; in Sade's libertine philosophy, 4; social roles as state policy, 155; as surrealists, 102–3 (*see also specific artists*); traditional feminine roles, 4. *See also* female protagonists

Female Sexuality (Bonaparte), 156

feminism: Aury on, 177; and Aury's *Story of O*, 153, 156–60, 170, 177; avant-garde and, 16–17, 123, 144; Beauvoir

IMAGE CREDITS

...rt Capa; © International Center of Photog-
...m Photos

...ne Saint Paul / Bridgeman Images

Fig. 61. Ubu Gallery, New York; © ADAGP, Paris, and DACS, London, 2019

Fig. 62. Estate of Leonor Fini, Paris

Fig. 63. Estate of Leonor Fini, Paris

Fig. 64. Photo © André Ostier; courtesy of Estate of Leonor Fini, Paris

Fig. 65. Estate of Leonor Fini, Paris

Fig. 66. Private collection / Photo © Christie's Images / Bridgeman Images

Fig. 67. Estate of Leonor Fini, Paris

Fig. 68. Estate of Leonor Fini, Paris

Fig. 69. Just Jaeckin, *Histoire d'O*, 1975, Yang Films, SN Prodis; DVD screenshot by author

Fig. 70. Just Jaeckin, *Histoire d'O*, 1975, Yang Films, SN Prodis; DVD screenshot by author

Fig. 71. Just Jaeckin, *Histoire d'O*, 1975, Yang Films, SN Prodis; DVD screenshot by author

Fig. 72. Photo by author

Fig. 73. Isidore Isou, *Traité de bave et d'éternité*, 1951, Films M. G. Guillemin, 1951; DVD edition, Re:Voir, Paris, 2008; DVD screenshot by author

Fig. 74. Photo © Rene Saint Paul / Bridgeman Images

Fig. 75. From *Internationale Situationniste*; screenshot by author

Fig. 76. Photo © Dazy Rene / Bridgeman Images

Fig. 77. From *Internationale Situationniste*; screenshot by author

Fig. 78. Centre Pompidou / Musée national d'art moderne

Fig. 79. Ubu Gallery, New York, and Galerie Berinson, Berlin; © ADAGP, Paris, and DACS, London, 2019

Fig. 80. Ubu Gallery, New York; © ADAGP, Paris, and DACS, London, 2019

Fig. 81. Ubu Gallery, New York; © ADAGP, Paris, and DACS, London, 2019

Fig. 82. Photo courtesy of Gilles Berquet / © Verlag Brinkmann & Bose, Berlin.

Fig. 83. © Fonds de dotation Jean-Jacques Lebel, Paris

Fig. 84. © Fonds de dotation Jean-Jacques Lebel, Paris

Fig. 85. © Fonds de dotation Jean-Jacques Lebel, Paris

Fig. 86. © Fonds de dotation Jean-Jacques Lebel, Paris

Fig. 87. © Fonds de dotation Jean-Jacques Lebel, Paris

Fig. 88. Jacques Rivette, *La religieuse*, 1966, Rome Paris Films / Société Nouvelle de Cinématographie (SNC); DVD screenshot by author

Fig. 89. Bridgeman Images

Fig. 90. © Dennis Stock / Magnum Photos

Fig. 91. Victoria and Albert Museum, Peter Brook Archive; photo by author

Fig. 92. © Max Waldman, 1966 / Max Waldman Archives, Westport, CT

Fig. 93. Photo by author

Fig. 94. Pier Paolo Pasolini, *Salò, or The 120 Days of Sodom*, 1975, Produzioni Europee Associate S.P.A., Rome / Les Productions Artistes Associés S.A., Paris; DVD screenshot by author

Fig. 95. Pier Paolo Pasolini, *Salò, or The 120 Days of Sodom*, 1975, Produzioni Europee Associate S.P.A., Rome / Les Productions Artistes Associés S.A., Paris; DVD screenshot by author

Fig. 96. Pier Paolo Pasolini, *Salò, or The 120 Days of Sodom*, 1975, Produzioni Europee Associate S.P.A., Rome / Les Productions Artistes Associés S.A., Paris; DVD screenshot by author

Fig. 97. AP/Shutterstock

Fig. 98. Courtesy the artist and Greene Naftali, New York

Fig. 99. Courtesy the artist and Greene Naftali, New York

Fig. 100. Courtesy of Badlands Unlimited